STANLEY
SPENCER

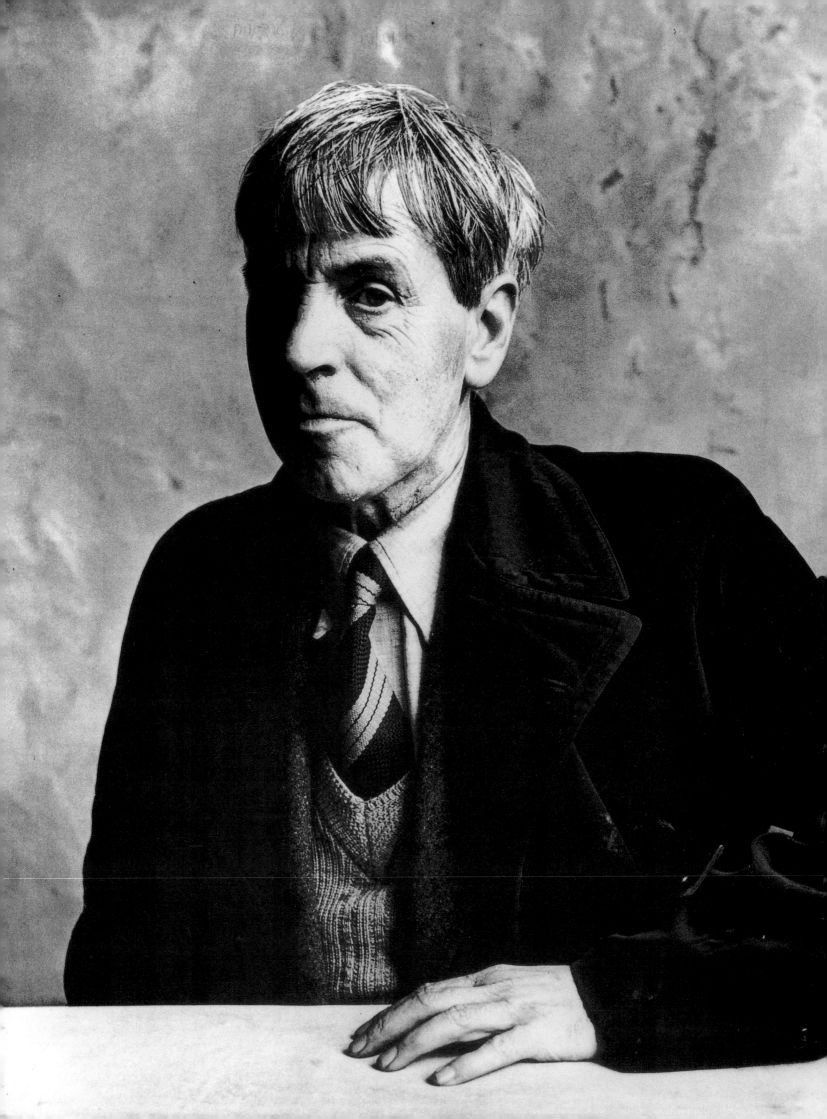

STANLEY SPENCER

Edited by
Timothy Hyman and Patrick Wright

with contributions by
Adrian Glew, David Fraser Jenkins,
Katharine Stout and Robert Upstone

TATE PUBLISHING

Exhibition sponsored by Prudential plc

Published by order of the Tate Trustees by
Tate Gallery Publishing Ltd
Millbank
London SW10 4RG

This catalogue is published to accompany
the exhibition at Tate Britain
22 March – 24 June 2001
and touring to
The Art Gallery of Ontario
14 September – 16 December 2001
The Ulster Museum
25 January – 7 April 2002

A catalogue record for this book is available
from the British Library

ISBN 1 85437 377 3

Designed and typeset by Isambard Thomas
Printed by Snoeck-Ducaju & Zoon NU, Ghent

Dimensions of works are in centimetres,
height before width

FRONT COVER:
Zacharias and Elizabeth (detail, no.14)
Tate. Purchased jointly with Sheffield Galleries & Museums
Trust with assistance from the National Lottery through the
Heritage Lottery Fund, the National Art Collections Fund,
the Friends of the Tate Gallery, Howard and Roberta
Ahmanson and private benefactors 1999

BACK COVER:
Self-Portrait (no.59)
Stedelijk Museum, Amsterdam

FRONTISPIECE:
Stanley Spencer in London, 1950
Photograph by Irving Penn

SPONSOR'S FOREWORD

Prudential is delighted to be associated with this celebration of the life and works of one of Britain's most influential artists, Stanley Spencer. He is acknowledged to be one of the most important British figurative painters of the twentieth century. This is the first exhibition of his work at Tate Britain for fifty years and brings together his celebrated masterpieces and also his lesser known works, to provide a fuller insight into his extraordinary achievements.

As a Founding Corporate Partner of Tate, Prudential is proud to have contributed towards the building of Tate Modern and the redevelopment of Tate Britain. Investing in the community is part of our business philosophy and we believe that everyone should be given the opportunity to enjoy access to the arts and take pride in our cultural heritage.

Prudential is delighted to be working in partnership with Tate in organising this outstanding exhibition. We very much hope that visitors to the gallery enjoy the experience.

JONATHAN BLOOMER
Group Chief Executive
Prudential plc

FOREWORD

The standing of the art of Sir Stanley Spencer (1891–1959) has taken some time to emerge.
In 1955, writing in the introduction to the catalogue of the last Tate retrospective of his work,
Spencer himself suggested that 'My work falls into various periods in which I appear to be
developing some theme or some particularised outlook and then abruptly it stops without point
or purpose' – a self-deprecating view, undoubtedly shared by many of his mid-twentieth-century
critics. But earlier in the century his precocious originality had been recognised by Roger Fry,
who selected Spencer's *John Donne Arriving in Heaven* for inclusion in his renowned Second Post-
Impressionist Exhibition of 1912, and also by the Tate Gallery, which acquired his monumental
The Resurrection, Cookham in 1927. And later, at the other end of the century, helped along by
the major Royal Academy exhibition of 1980, by the Barbican's *Apotheosis of Love* show of 1991,
and by the scholarship of Keith Bell, Kenneth Pople, Duncan Robinson and others, a richer
understanding and clearer ordering of his work finally began to illuminate his contribution to the
history of European art and his entanglement with many distinctive strands of contemporary
culture. He should not, certainly, now be cast simply as heir to William Blake, as eccentric visionary
working within an essentially insular native tradition. True, Spencer shared with Blake a belief
in the primacy of the imagination and a conviction that, as he put it, 'only goodness and love
and Christian and other benign beliefs are capable of creative works'; as prolific painters of
religious subjects they do both stand apart from the mainstream of British art. But, as the present
exhibition aims to suggest, his work not only bears comparison with some of the most memorable
European art of the century; it may also be explored quite as productively through the unfolding
social and political patterns of modern Britain as through the complex and intriguing psychology
of the artist himself.

The exhibition has been devised and selected by the artist and writer Timothy Hyman and the
cultural historian Patrick Wright. It takes a wide-ranging view of Spencer's work, bringing together
a strong selection of paintings, drawings and archival material from all periods of his life. Born
and raised in the Berkshire village of Cookham, Spencer travelled daily to London to attend the
Slade School of Art, where his talents were swiftly recognised. The first section of the exhibition
is devoted to his early work. These paintings betray influences ranging from Giotto to Gauguin,
and introduce the biblical themes which were to engross Spencer for the rest of his life.
The second section of the exhibition offers a broad representation of his work both during and
after the First World War, reaching a climax in his murals painted for the Sandham Memorial
Chapel at Burghclere. We could not attempt to recreate the chapel's interior for this exhibition,
but with generous assistance from the BBC, a short film has been made to enable its virtual
inclusion in the show. The central focus of the exhibition is the 1930s, the inter-war period when
marital and stylistic crisis fuelled Spencer's imagination and brought about a flow of extraordinary
and often very contradictory works. We bring together a range of these, including several of the
naked portraits of Spencer's second wife Patricia Preece, alongside the contrasting and often
under-appreciated landscapes. There is a separate section devoted to the *Beatitudes of Love* series,
bringing to light a number of lesser known works of closely related significance. Within the
exhibition we also convey by means of a video projection Spencer's ambitious 'Church-House'
scheme, a project which shows how the artist envisaged special, sacred spaces in which to house
all of his paintings from the *Last Day* series and *Christ in the Wilderness*. The final part of the
show takes a selective look at Spencer's later work, including drawings and paintings from the
Shipbuilders on the Clyde series, made during the Second World War, when he was commissioned
to record the war effort at Port Glasgow, and concluding with more intimate portraits such as
Love Letters of 1950, depicting the artist and his first wife, Hilda Carline, and his final *Self-Portrait*
of 1959.

I cannot adequately express my admiration for the way in which Timothy Hyman and Patrick Wright accepted and met the challenge of creating together a fresh exploration of Spencer and his many contexts. I would also like to thank Judith Collins, with whom I first discussed undertaking a major review of Spencer's work and whose ideas for the project and its possibilities were many and influential. Adrian Glew, Curator, Tate Archive, was also a central participant from the start and he was joined by Tate Collections Curator David Fraser Jenkins, who has contributed substantially and crucially to the show and its catalogue. Further catalogue entries were expertly provided by Robert Upstone. This close collaboration between scholars within and beyond Tate has been happy and fruitful. All efforts have been co-ordinated with exemplary efficiency by the exhibition's organisers, Tate Britain Curators Mary Horlock and Katharine Stout, supported by Head of Exhibitions and Displays Sheena Wagstaff, who have contributed creatively at every level of the project from selection to catalogue, and without whom a show of this ambition and complexity could not have happened at all. They also worked with, amongst many others, Professor Robert Tavernor of Bath University, who undertook the daunting task of bringing Spencer's Church-House scheme to life through computer technology. We are grateful as well to Keith Alexander and Francis Whately from the BBC for providing the film footage of Spencer's work at Sandham Memorial Chapel, Burghclere. Particular acknowledgement must be made to the architect Claudio Silvestrin, assisted by Carolina Baroni and Simona Pieri, who responded so intelligently to Spencer's work and created a breathtaking design for the exhibition. Our very special thanks are reserved for the artist's daughters, Shirin and Unity Spencer, who have helped us enormously at every step with information, enthusiasm and advice.

We owe a great debt, of course, to each of the many lenders to this exhibition. Several institutions parted willingly with key works in their care: in particular we should thank Robert Crawford and Angela Weight at the Imperial War Museum and Richard Hurley of the Stanley Spencer Gallery. Many individual owners have also been exceptionally kind. Howard and Roberta Ahmanson were generous supporters from the outset. We are delighted that after London the exhibition will be seen at the Art Gallery of Ontario in Toronto, Canada, and then at the Ulster Museum, Belfast. It has been a pleasure to work with colleagues in both places and we would like to acknowledge the enthusiasm and commitment of Matthew Teitelbaum, Michael Parke-Taylor and Lisa Milrod in Toronto, and Brian Kennedy in Belfast.

In London the exhibition has been sponsored by Prudential, our partners in a number of past shows – *Grand Tour* in 1996, *Symbolism* in 1997 and *The Art of Bloomsbury* in 1999. We look forward to working with them again in the strong exhibitions programme that lies ahead at Tate Britain.

STEPHEN DEUCHAR
Director
Tate Britain

ACKNOWLEDGEMENTS

Many people have been involved in the realisation of this project. In addition to the comments made in the Foreword, we would like to acknowledge the contributions of a number of institutions and individuals who have helped over several years to make this exhibition possible.

Any Spencer exhibition is dependent on the research and writings of distinguished art historians and scholars, and we must acknowledge in particular the work of Keith Bell, whose catalogue raisonné was invaluable, and also Judith Collins, Richard Lofthouse, Carolyn Leder and Duncan Robinson. Timothy Hyman is especially indebted to Kenneth Pople, Spencer's biographer, who was a wonderful and tireless correspondent; and to Michael Dickens, who generously shared his soon to be published study of Patricia Preece. We should also acknowledge Judith Nesbitt, who curated the Spencer exhibition at Tate Gallery Liverpool in 1993.

We are very grateful for the advice and support of Stephen Deuchar, Director, Tate Britain, Sheena Wagstaff, Head of Exhibitions and Displays, and Richard Humphreys, Head of Interpretation and Education. In addition we must also single out the efforts of many members of Tate staff for their various contributions to the project. This has been a collaborative project, and we have greatly enjoyed working closely with David Fraser Jenkins from Tate Collections: we would like to thank him and Katharine Stout for their constant support and hard work. We must also thank Adrian Glew, from Tate Archive, for all the time and energy he has devoted to the project. Thanks are also due to Sarah Derry and Tim Holton in Tate Publishing, who undertook the task of editing and producing the catalogue with enthusiasm and skill, with Katherine Rose, picture researcher, and designer Isambard Thomas. We are also grateful to Joanna Banham, Head of Public Programmes, with Kitty Hauser, for overseeing the interpretation of the exhibition. There are a great many others who have assisted us: Gillian Buttimer, exhibitions registrar, who co-ordinated loan agreements and transportation; Helen Brett, Rosie Freemantle and Roy Perry, Tate conservators, who gave us their expertise and advice throughout the planning and installation of the exhibition; David Dance and Mark Edwards, who managed the extensive building work involved in realising the exhibition design; the team of art handlers, led by Andy Shiel and supported by Mikei Hall, who were responsible for the installation of the works; and Tate Photography, whose patience and generosity cannot be overstated.

In addition we would like to thank the following individuals and institutions who have assisted and advised us on the whereabouts of works: Jane Alison at the Barbican Art Gallery, Jules Breeze, formerly at the British Council, Ivor Braka, Desmond Corcoran of Reid and Lefevre Ltd., Thomas Gibson, Philip Harley of Christie's, James Holland-Hibbert of Spink-Leger, Richard Hurley of the Stanley Spencer Gallery, Bernard Jacobson, Massimo Martino, Richard Nagy, Mark Pomery of the Royal Academy of Arts, Simon Matthews, Dr Albert Taliano and Nicholas Tite.

Among many others who have helped us over a number of years, we would like to thank Peter Abbs, Gillian Barlow, Julian Bell, David Bindman, Robin Blaser, Clive Boutle, Jeffery Camp, David Carbone, Frances Carey, Joyce Carter, Gerard Casey, Michael Collins, Ken Currie, Caroline Cuthbert, John Davies, Patricia Dawson, Claes Enckel, Alec Gardner-Medwin, David Gervais, David Goodway, Lyndall Gordon, Anthony and Mary Green, Red Grooms, Josef Herman, Nicholas Hyman, Andrzej Jackowski, Merlin James, Neil Jeffries, Bhupen Khakhar, Ken Kiff, Simon Lewty, Norbert Lynton, David Mellor, Roy Miki, Lynda Morris, Toine Moerbeek, Gladys Nilsson, Jim Nutt, Nicky Pattison, Judith Ravenscroft, Anna Greutzner Robins, Alan Ross, Eddie Smyth, Frances Spalding, Louis Spitalnick, Clara Diament Sujo, Ray Ward, Angela Weight, Sarah Whitfield and Rosamund Williams. Special thanks must also go to Louise de Brüin, who contributed friendly editorial and practical assistance to Timothy Hyman throughout.

TIMOTHY HYMAN, MARY HORLOCK, PATRICK WRIGHT

TIMOTHY
HYMAN

STANLEY SPENCER:
ANGELS AND DIRT

I am on the side of angels and dirt.

PROLOGUE: 'TO TELL EVERYBODY EVERYTHING'

For Stanley Spencer, so much of whose energy went into the reclamation and contemplation of his own past, a retrospective comes naturally. His life (1891–1959) was exceptionally rich in dramatic incident, altering in condition and circumstance several times over, with each of these changes reflected in his painting. Much of his art was created from memory; in his *Scrapbook Drawings* he would set out to illustrate his own personal history, and part of the function of his Church-House would be to accommodate this autobiographical project, a 'Church of Me'. When, in 1923, he wrote of his 'natural exuberance and desire to tell everybody everything', he was touching on a defining impulse, a kind of total disclosure that would eventually become central both to his painting and his writing.[1] Spencer could have, at the end of his life, the sense of having used up, scooped out, all that was in him.

He seems to have experienced a few near-perfect early years painting at home in Cookham, in the womb of a prolonged and still unbroken childhood. Well into his twenties he'd spent hardly a night away from Fernlea, the village house built by his grandfather, where he'd grown up surrounded by seven, mostly elder, siblings, and where, in the next-door garden shed, his sisters had given him almost his only formal schooling. His nickname at the Slade would be 'Cookham'. Because so exceptionally rooted in place, Spencer would register more vividly than any other British painter the experience of disorientation, the loss of selfhood, that followed the return from the First World War. By the mid-1930s, Spencer himself had moved to centre stage: the regaining of the self a project of remembrance and reconstruction, the Church-House a cathedral of memory by which the lost self could be reconstituted.

His intellectual background was less circumscribed than has usually been suggested. The Fernlea household was cultivated, gifted, inquiring: music was central (Spencer played Bach piano fugues all his adult life) and literature scarcely less important. In recent years the work of Keith Bell, Kenneth Pople and others has revealed the extent of Spencer's links as a young man to many of the leading intellectual circles of his day. He was never merely a village marginal; as with Blake, we should not overemphasise the isolation and eccentricity of his vision.[2]

The shift in his art in the 1930s is partly a move towards comedy, with Spencer himself often becoming his own comic lead, in painting and in words. In 1922 he'd written to Hilda Carline:

Of course, I love myself more than anybody … I collect 'Stanley Spencers' just as George collects stamps … I love myself in much the same way as a baby loves a tin soldier.[3]

To scorn Spencer as an infantile solipsist is to miss a comic rhetoric – the kind of self-obsessed, eternal-adolescent comic persona we recognise in, say, Woody Allen. Those child-selves that we encounter in some of *The Beatitudes* (nos.62–6), or *On the Tiger Rug* (no.68), allow him to tell of amatory adventure and misadventure in the third person. Meanwhile, in his self-portraits from the mirror, and especially in the *Double Nude Portrait* of 1937 (*The Leg of Mutton Nude*, no.58), Spencer achieves a raw self-revelation altogether outside his pre-war range.

He paints at least one marvellous picture in each of his fifty working years. His vision is complex, inclusive, contradictory; hence his refusal to be only 'on the side of the angels', and his allegiance to 'dirt' – to the lowly or commonplace – as well as to the elevated.[4] Implicit also in the title of this essay is a view of Spencer's development: that after an almost exclusively 'angelic' youth, much nourished by early Italian painting – and within an aesthetic climate where Giotto and the Primitives were endorsed above all as being

'anti-descriptive' – he nevertheless found himself so altered by the experience of war and sexuality that his art also needed to change. Only through description, of the most detailed and sharp-focused kind, could his painting now do justice to the materiality of things – to 'dirt'. The drama of Spencer's art in the mid-1930s comes partly from that conflict: from the pulling-apart of the once harmonised visionary and realist strands in his imagination.

INNOCENCE 1909–1915

I was innocent and all that there was to stimulate my artistic desires was what an innocent state could supply.[5]

The terse, beautiful little painting of 1911 that first brought Spencer to public notice, *John Donne Arriving in Heaven* (no.4), was born out of that heady moment in London when Italian Primitives and recent French painting were being discovered together. The poet-pilgrim is skirting heaven's high plateau, a landscape variously identified by Spencer as 'nowhere' and 'a part of Widbrook Common' – but surely a schematised essence of the green-and-white Berkshire chalk down; the praying figures like shining menhirs casting their late-afternoon shadows along the turf. This composition, as Spencer later recognised, 'came more from my imagination than any I have ever done'.[6] The structure of white forms on a green ground will remain a constant. It always retains some vestige of pastoral – of sheep in the field – and, as we'll see, it runs also to gravestones in leafy churchyards, and to the white vestments of the newly risen.

fig.1
MAURICE DENIS
April 1892

Oil on canvas
Collection Kröller-Müller
Museum, Otterlo,
The Netherlands

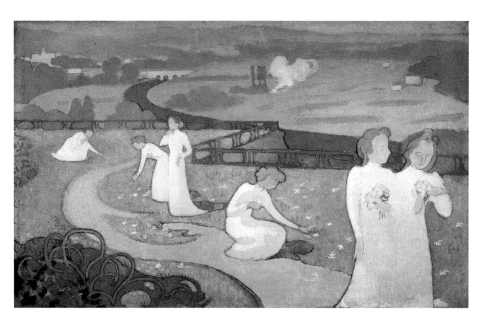

In its stark, flattened simplicity, *John Donne* conforms to the taste of its era. Spencer is now known to have attended from 1909 the Slade lectures of Roger Fry, preaching his gospel of Giotto-and-Cézanne.[7] Whereas for Ruskin's generation Giotto stood for a lost medieval purity, Fry's Giotto-and-Cézanne is the new hero of a formalist future. As Fry explained, introducing Maurice Denis's article on Cézanne in the *Burlington Magazine* early in 1910,

This new conception of art, in which the decorative elements preponderate at the expense of the representative, is not the outcome of any conscious archaistic endeavour such as made, and perhaps inevitably marred, our own Pre-Raphaelite movement.[8]

fig.2
GIOTTO
*Joachim Among the
Shepherds* c.1305

Fresco
Arena Chapel, Padua

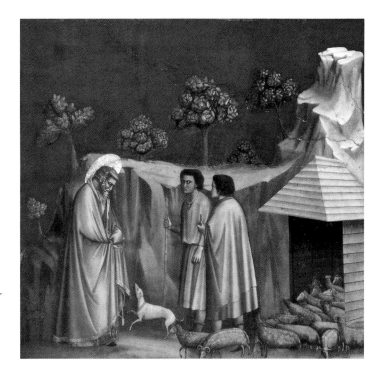

The contemporary who most comes to mind in front of Spencer's *John Donne* is Maurice Denis himself – the ex-Nabi and apostle of painting's flatness, whose own white soul-figures float across a flattened green Elysium (fig.1). Several works by Denis had been interspersed among the more than forty Gauguins in Fry's exhibition *Manet and the Post-Impressionists* in November 1910. By 1911, the Slade, as Paul Nash recalled, was 'seething under the influence of Post-Impressionism … now all the cats were out of the bag'.[9] Spencer was associated with a Slade grouping known as the 'Neo-Primitives', alongside such even younger fellow-students as William Roberts (b.1895) and Mark Gertler (b.1894), all of them nourished by that same convergence of Italian Trecento and French modernity.[10] But his closest Slade friendship was with a couple six years older: Gwen Darwin (granddaughter of Charles) and the French painter she would soon marry, Jacques Raverat. It was they who gave Spencer in 1911 two key texts, Donne's sermons, and Ruskin on Giotto (fig.2). They would also be the purchasers of his newly completed picture. And in 1912 *John Donne* was selected for Fry's *Second Post-Impressionist Exhibition*, where Rupert Brooke would pronounce it 'a most remarkable picture … with a passion of design and form and a crude and moving nobility'.[11]

But the nineteen-year-old who painted *John Donne* was already split, his art divided. He drew factually in the Slade life-rooms; he painted imaginatively in Cookham. His earliest compositions had been in pen-and-ink, emulating the Victorian illustrated books he'd devoured in childhood: Dicky Doyle, *Struwwelpeter*, Tenniel's *Alice*, as well as the Bible illustrations made by Millais and other young Pre-Raphaelites when still close to the German Nazarenes. (Some of these influences remain evident around 1909 in *The Fairy on the Waterlily Leaf*, no.1.) Those home underpinnings would never be lost. Despite so many years of the cool forensic study prescribed by Henry Tonks (with the point of a hard pencil, always in the presence of a model) almost all Spencer's significant drawings before the war are in a thick, emphatic pen-and-ink, from *Man Goeth to his Long Home* (1911) – with its massive Trecento robed figure – to the preliminary studies for *Joachim among the Shepherds* (c.1912) and *Zacharias and Elizabeth* (1914). That division between fact and imagination would return to haunt him later. In 1926 he writes:

I quite agree (damn it) that my John Donnes are preferable infinitely to my landscapes …
If I do a drawing of a head it's utterly worthless, it's nothing but a Slade drawing of a head …
If I do a … resurrection or a visitation it's got something marvellous about it. It's awful after four years at the Slade to find oneself not in possession of an imaginative capacity to draw, but to find instead that one has contracted a disease.[12]

Walls and Fugues

Three of Spencer's finest early paintings are linked by a consistent architecture of enfolding and enclosure. 'My religious consciousness began my feeling for *places*',

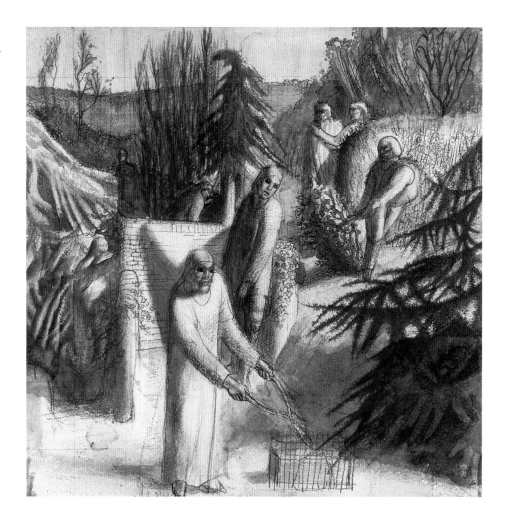

he explained to Hilda in a letter of 1930, 'and that was later related to a child memory of a cosiness'.[13] In *Two Girls and a Beehive* (no.2) the sisters are strangely slotted, almost confined, between paling and fence. The water-meadow and lush foliage so characteristic of Cookham are glimpsed through the metal screen, as well as, in phantasmal double-take, the striding silhouette of the Good Shepherd. The touch is warm and painterly, and the flat yellow-and-white dappled foreground confirms Spencer's early awareness of Gauguin and his Nabi heirs.

In *The Nativity* (no.7) the same round-headed palings lead steeply in from the left, the centre dominated by the enfolding trellis-fence. Two embracing couples, perhaps magi or shepherds, seem extensions of this rustic weather-beaten construction. Liberated by the example of the fragmentary architecture in Trecento frescoes, Spencer now composes with a kind of spatial lyricism. As Florence, elder sister and one-time teacher of Stanley and his younger brother Gilbert, wrote perceptively,

Neither is it strange that the grandchildren of a builder who was also a fine musician should have been consciously or subconsciously interested in the structural significance of walls and fugues. Cowls, walls and railings have from the first, I think, provided the fugue subjects for many of their works.[14]

Out of the atmosphere of a late-summer muffled Thameside stillness – all nature holding its breath – Spencer constructs his five-foot altarpiece of place. His touch is now smaller and more various, as in the white blossoms whose jewel-like clusters so delicately articulate the upper section. Fragile grasses and leaves are apprehended with the wonder and vulnerability of the tiny naked infant in the manger.[15]

In its unresolved narrative, *The Nativity* shares something of the fugitive character of those earlier attempts at traditional figure-compositions (by Degas among others) whose 'failure' identifies them as works of modernity. *Zacharias and Elizabeth* (no.14), conceived in the winter of 1913–14, is much more full-blooded, reprising the green-and-white of *John Donne* across a twenty-five-square-feet expanse with a saturated, sunlit intensity. The angled brick wall of the early studies (see fig.3) is transformed into a smooth white curve, oddly akin to a bathtub's comforting embrace.[16] Again, the figure action is barely legible; meaning resides not in the biblical text (the angel's words, 'Fear not, Zacharias, for thy prayer is heard, and thy wife Elizabeth shall bear thee a son'), but in the mood of trance and ritual created by the entire structural and spatial arrangement. Zacharias at sacrifice, his garden altar ringed with little palings; wingless white Gabriel stalking him like some strange sleepwalker; the Christ-like gardener dragging the dead branch behind – all these are emanations of place, of a landscape conceived as allegory.

Spencer's 'primitive' or childlike vision of the natural world, the honouring of every separate leaf and branch, has I think little to do with the naturalism of the Pre-Raphaelites. It is closer to the young Samuel Palmer of the 1820s (fig.4), being rediscovered at last by several young artists such as Paul Nash and Gwen Raverat; while behind Palmer lies Blake's series of Virgil woodcuts, certainly known to Spencer. And he would have seen in Fry's 1912 show a forest-scene by the 'naive' Rousseau, as well as the most recent works of Derain with their sense of a renewed, 'Byzantine' figuration. All these seem components not only in Spencer, but in the burgeoning English 'Neo-Romantic' landscape synthesis, whose full flowering would come after 1918. Wordsworth and Blake provided poetic equivalents for that recovery of childhood vision; and no writer seems more at one with Spencer than the newly discovered Thomas Traherne, the seventeenth-century mystic whose transcendent

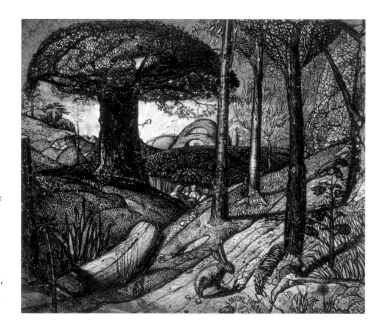

fig.4
SAMUEL PALMER
Early Morning 1825

Pen and brush in
sepia on paper
Ashmolean Museum,
Oxford

prose *Centuries* had first been published as recently as 1908: 'I seemed as one Brought into the Estate of Innocence … I saw all in the Peace of Eden'.[17]

Zacharias and Elizabeth is perhaps the single most compelling work by any British painter of the early twentieth century. But its fusion of landscape and religion is inherently fragile: there is a missing centre, which no walls or fugues can altogether replace. The wild vitality of the barren winter trees about to become fertile, the amazing evergreen bursting into the foreground, remain more convincing than Zacharias himself, who is, Spencer lamented from his Swiss Cottage limbo in 1938,

the only weak thing in the picture and is the most important thing so that the picture is a very good shell and nothing in it … Jesus was the trouble from my babyhood. I had hitched my chariot to that star and that star unfortunately for me was completely invisible.[18]

'A Certain Fateful Strangeness'

Less realised than *Zacharias*, but far more influential among Spencer's contemporaries, *Apple Gatherers* (no.9) was first exhibited at the Contemporary Art Society in the summer of 1913. The idea originated in a Slade set subject the previous year. But the handsome

boys and girls so decorously grouped in that prize-winning drawing were transformed, probably by the impact of Gauguin's Tahiti, into massively awkward, turgid-faced primitives. Paul Nash called them 'dwarfs'; Rupert Brooke, 'The Bogeys'.[19] The painting is almost all 'figure' – eleven of them, hands and heads and arms crammed together, with peculiar shifts of scale. Its influence was immediately apparent among Spencer's fellow Neo-Primitives, in the repeated arms of Roberts's powerful biblical drawing (fig.5), as well as in Gertler's *Jewish Family* (fig.6). Gertler was reported to 'admire "Cookham" more than anyone else'.[20]

More surprising perhaps was the effect of *Apple Gatherers* on a painter eight years older than Spencer, the sophisticated Henry Lamb, back in London after stints in Paris and Pont-Aven. Lamb tried to get the picture purchased by the Contemporary Art Society, but was blocked by Clive Bell. The subsequent chronology is important, since it has often been assumed the younger artist was influenced by the older.[21] But Lamb went off to Ireland in August, from where he wrote offering to buy *Apple Gatherers* for himself. Only in October, living on the remote island of Gola, did he embark on *Fisherfolk* (fig.7), his poetic and beautiful composition painted unmistakably in the light of *Apple Gatherers*. For a few weeks, after Spencer delivered it to Lamb's Hampstead studio in November, the two pictures must have been visible side by side, with Lamb's enormous *Lytton Strachey* (fig.8) behind.

Lamb soon had two leading collectors – Eddie Marsh and Michael Sadler – bidding against one another for *Apple Gatherers*, with Marsh the eventual victor.[22] The London art world into which Spencer was now introduced was in the grip of a hectic modernity. Even at the Slade, according to Roberts, 'we were all familiar with the work of the French cubists'.[23] But by 1914, the influence of Marsh and Lamb, both hostile to Fry's formalist aesthetic, and sceptical towards his cult of Cézanne, had pushed Spencer away from his erstwhile comrades. When he accused Gertler, now veering towards Bloomsbury, of having misunderstood Cézanne, it broke their friendship. Roberts meanwhile had joined Fry's Omega workshop, and, shortly after, the breakaway group that became the Vorticists. A critic in May 1914 commented how Roberts had 'managed to compress the development of a lifetime into six months … but one instance of the general insolvency which has

fig.5 [below]
WILLIAM ROBERTS
Unidentified Biblical subject c.1913

Pencil and watercolour on paper
Collection: Lord and Lady Irvine

fig.6 [below left]
MARK GERTLER
Jewish Family 1913

Oil on canvas
Tate. Bequeathed by Sir Edward Marsh through the Contemporary Art Society 1954

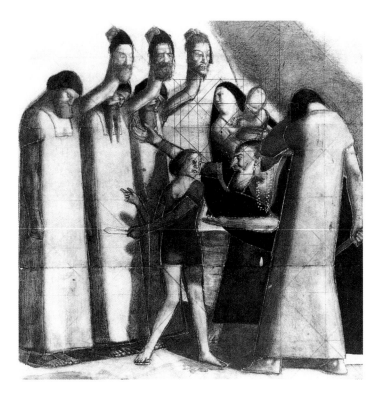

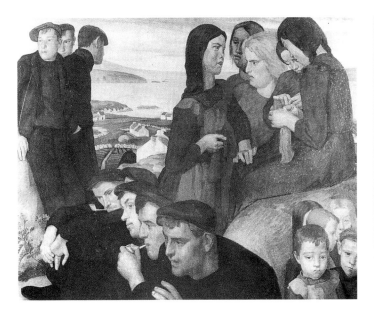

fig.7
HENRY LAMB
Fisherfolk, Gola Island
1913

Oil on canvas
Private Collection

fig.8
HENRY LAMB
Lytton Strachey 1914

Oil on canvas
Tate. Presented by the
Trustees of the Chantrey
Bequest 1957

followed an overdose of modernism'.[24] Suddenly, in the space of a year, *Apple Gatherers* had passed from radical to almost retrograde, placed somewhere in the purlieus of Augustus John at the Whitechapel Gallery's 1914 *Review of Modern Movements*, where Sickert now identified Lamb and Spencer as sharing 'a certain fateful strangeness' – a territory far removed from the forced marches of the avant-garde.[25]

'So Unhappening, Uncircumstantial and Ordinary'

Spencer's pictures up to 1913 are 'timeless'; as Isaac Rosenberg put it, 'they have that sense of everlastingness, of no beginning and no end.'[26] But that autumn he embarked on a *Self-Portrait* (no.13) to be painted directly from the life over the following year, with a fidelity to appearance that can only be called 'realist'. 'It is just twice the size of my own head', he wrote. 'I fight against it, but I cannot avoid it.'[27] This scale increases the impact, the sense of closeness, of Spencer pushing into our space. The shock of the reflective flesh and the dramatically contrasted chiaroscuro brings to mind Caravaggio, while the nearest English parallel would be the twenty-year-old Samuel Palmer's wonderful self-portrait drawing, gazing out with a similar uncorrupted immediacy.

In summer 1914 he was painting in the open air. That first Cookham 'pure landscape' is charged with an almost hallucinatory light, hedgerow and foliage rendered with such a sharp-focused intensity that they become strange, uncanny. In these two masterpieces of transcendent naturalism (both purchased by Marsh), Spencer seemed to be moving into an aesthetic as distant from modernist strategies as Marsh's own *Georgian Poets*.[28] What is most striking is his versatility – his art running an enormous gamut of styles and genres, yet each painting remaining robust, complete, full of conviction. His next image of altarpiece scale, *The Centurion's Servant* (no.15) which he always referred to as 'The Bed

Picture', was another new departure; not just an interior, but an inwardness, a child-self thrashing about in a bare windowless room. The bed itself is free-standing, an archetype. Its wrought metal and china knobs, its disordered mattress and covers, its red fabric valence – all are felt both as modern realities, and as a state of mind. (The concerned figures behind perhaps exist only in the boy's fevered imagination.) Whatever its relation to the biblical text – 'my servant lieth at home, sick of the palsy, grievously tormented' (Matthew 8:5–6) – *The Centurion's Servant* creates an image of mental distress more psychologically acute than any British painting since Fuseli's *The Nightmare*.

Spencer's typical day as he moves about Cookham in those pre-war years is vividly recreated in one of the most beautiful of all his writings, the long letter sent to Desmond Chute from Salonica in 1917 and published in 1919.[29] It is really an extended experience of rapture, with some affinity to Traherne, only set in modern England, with the ecstasy coming out of the commonplace. 'Everything is so dull … so unhappening, uncircumstantial and ordinary. I go home to breakfast thinking as I go of the beautiful wholeness of the day. During the morning I am visited and walk about being in that visitation. How at this time everything seems more definite and to put on a new meaning and freshness you have never before noticed. In the afternoon I set my work out and begin the picture, I leave off at dusk feeling delighted with the spiritual labour I have done.'

Two of Cookham's most striking landmarks were its malthouses and its bridge. In *Mending Cowls, Cookham* (no.17) we are made to feel the half-abstracted strangeness of the angel-like workmen enfolded in their white mysterious constructions. (A sky world that recalls the builders on the roofs above Ambrogio Lorenzetti's *Well-Governed City* in Siena.)[30] Both here and in *Swan Upping* (no.18), he seems back in his Primitive flattened idiom; and he consciously avoids naturalism, preferring to reconstruct Cookham Bridge as a far more substantial and beautiful object than the original. Whereas *The Nativity* seems to have grown organically across the entire surface, *Swan Upping* was begun from the left top corner and then finished patch by patch across the white canvas. By the summer of 1915 he had reached a little less than halfway down – just below the topmost swan – when the pressure to join the war became too much.

WAR AND ITS AFTERMATH 1915–1931

Nothing other than complacence could produce another Zacharias. Anyway, whether he should or should not have done, he felt the all withering and icy blast of the war … He felt suspended. Question was, how and in what way to hibernate.[31]

Thus Spencer, writing of himself in the third person from the vantage of 1948, when the whole of the 1920s could be viewed as a difficult transition. In the 'divine sequence', of the pre-1914 paintings, each and every one had been a success.[32] Now *Swan Upping* provided the first experience of failure. It was, he wrote, 'a very difficult matter getting back to this painting'.[33] Its completion was 'not done with the care and intensity with which I had begun it' – especially obvious in the river, so magical above, so lifelessly 'filled-in' below. 'The nearest water could have been more water than I made it.' *Travoys* (no.21) is a majestically impressive formal design, but cold, without lyricism. While painting it, he drafts a letter to Gwen Raverat in his sketchbook: 'I get precious little ease or comfort from my work. I look at it furtively, knowing that at any moment it may turn and rend me.'[34] Soon after its completion, he writes: 'I did not feel entirely happy with that picture, only in parts';[35] and a decade later: 'I always felt that picture of mine was a triumph over some

of the most horrible doubting periods I have ever had.'[36] Again and again, he finds himself disappointed by the outcome of his larger compositions: *The Last Supper* 'has not got the nice feeling that the drawing has got, somehow' (see no.22).[37] He wants to destroy *The Bridge*; *Unveiling Cookham War Memorial* is another flop. Some of the most promising ideas – *The Paralytic*, *The Sword of the Lord*, the Macedonian *Crucifixion* – he fails to develop beyond sketch-stage.

Unable to paint throughout his four war years, he'd steeped himself in the little Gowans and Grey pocket monographs he carried with him, with their black-and-white reproductions of early Italian mural cycles. Now he'd returned, programmed not for oil, but fresco; not for altarpieces, but entire monuments:

When I come home I am going to learn fresco painting and then, if Jacques Raverat's project holds good, we are going to build a church, and the walls will have on them all about Christ. If I don't do this on Earth, I shall do it in Heaven.[38]

Fresco tends to eschew the detail and expressive handling of easel-painting, to be lighter and more even in tone. *Christ Carrying the Cross* (no.27) is in that sense fresco-like, conceived as a patchwork of pale flat shapes. The light-filled energy of the preparatory drawings, driven by slanting shadows, is damped-down, formalised; the nearly invisible cross-bearer moves past a phantasmal Fernlea, and even the largest foreground heads remain undifferentiated, schematic. *The Betrayal* (no.32) was to have weighed heavier, a night-scene with a dramatic action set in the Fernlea back garden, the culmination of all those 'walls and fugues' compositions. As Spencer explained to Michael Sadler, he had been 'harking after it since 1912': 'I don't mind how long I spend on it. I think my recent pictures have been done in too much of a hurry … *Christ Carrying the Cross* suffered in that way.'[39] Yet a few months later, Spencer wrote to Henry Lamb: 'I am not displeased with it, but it is not one of my best.'[40] He was floundering: 'I knew in 1922–3 that I was changing or losing grip or something … I was I feared forsaking the vision and I was filled with consternation.'[41]

A Hampstead Resurrection

In May 1922 his mother died. He'd spent little time in Cookham over the past two years. Increasingly his family of adoption was the Carline household in Hampstead, with Hilda Carline, a gifted painter, the focus of a newly awakened love. The Carlines lived together as another big tribe. They were leftist, international-minded, linked to some of the liveliest London artists. From 1919 onwards, as many as ten or more might meet there at least one evening a week. Henry Lamb (introduced by Spencer) called them the '*cercle pan-artistique* of Downshire Hill'. It reassembled veterans of the Neo-Primitives and the Marsh circle: Roberts, Gertler, Nevinson, as well as the Nash and Spencer brothers, all developing something of a shared idiom. The matt surface and chalky colour of *Christ Carrying the Cross* recalls the paintings of Paul Nash (fig.9); Spencer's Dorset landscapes are close to John Nash (fig.10); the small, semi-mechanised figures crowding *Bond's Steam Launch* (no.34) parallel those in William Roberts's London scenes (fig.11). In their lucidly structured formality, the works of all these artists could be related to

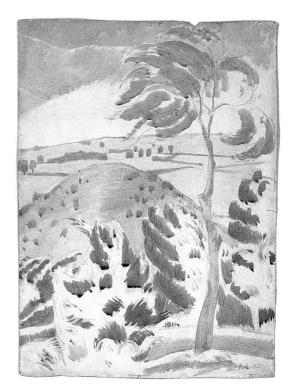

fig.9
PAUL NASH
Hill and Tree 1920

Pencil, ink and watercolour on paper
Peter Nahum at the Leicester Galleries

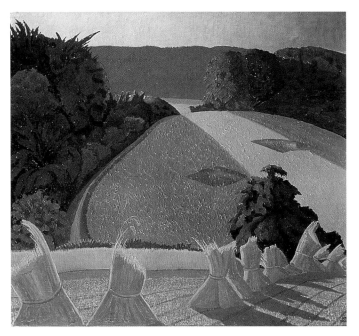

fig.10
JOHN NASH
The Cornfield 1918

Oil on canvas
Tate. Presented by the
Contemporary Art Society
1952

fig.11
WILLIAM ROBERTS
The Cinema 1920

Oil on canvas
Tate

that wider post-war European climate, sometimes known as the 'call to order' (*rappel à l'ordre*) and shared, for example, by Picasso, Carrà, Léger, Rivera and Derain. After the fragmentations of modernism, the image must be reconstructed, the world once again remade or retrieved as a kind of Neo-Classical wholeness.

But conversation also ranged through literature, philosophy and music, providing some of the richest intellectual exchanges of Spencer's life. A diary entry of 1922 (by a Downshire habituee, Kate Foster) records the impact of the Spencer brothers:

They are perfectly gorgeous kind of hatless 'farmers boys' with red cheeks, blue eyes, and thick long black hair … who suddenly come out with clever remarks about Bach.[42]

That summer Spencer accompanied the Carlines on a painting expedition across Central Europe to Bosnia, becoming engaged to Hilda by their return. En route they'd stopped for several days to see paintings in Vienna, Munich and Cologne. These were the only foreign collections Spencer would ever explore; and they were predominantly neither Italian nor French, but Northern. The slow-burn effect of this encounter with Brueghel,

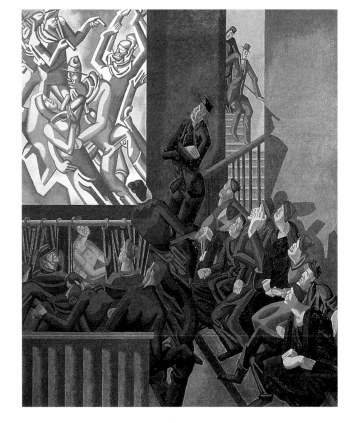

Cranach, Altdorfer – with innumerable early German altarpieces crowded with more or less grotesque figures (I'm thinking here especially of the blubbered dwarfs of the Cologne school) – will begin to appear a decade later. It seems also likely that the Carlines would have insisted on seeing some contemporary German art.[43]

The following summer, Spencer joined Henry Lamb in Dorset (fig. 13). (Badly gassed, Lamb suffered from chronic insomnia, and spent less and less time in Hampstead.) 'Stanley sits at a table all day', wrote Lamb to Richard Carline, 'evolving acres of Salonica and Bristol war compositions' (figs. 14 and 15), elaborate wash drawings for his imaginary chapel, his 'castle in Spain', as he called it in a letter to Hilda.[44] And then, almost miraculously, Louis and Mary Behrend appeared, offering to fund what would become Burghclere Chapel, and promising Spencer an income through all the years of building and painting.[45] At last his art had a setting and purpose. He took over the sublet of Lamb's studio (above a pub in the Vale of Health), and embarked on a painting eighteen foot wide. (According to legend, the only way he could see it at any distance was to take a ride on the helter-skelter in the next-door fair-ground, glimpsing his picture as the window flashed past.) *The Resurrection, Cookham*

(no.35) is in some ways the glorious climax of that green-and-white thread running through all his pre-war work; and yet, set beside *Zacharias*, it can seem almost a falsification, exploiting in a very grand manner emotions he no longer felt. In December 1924, the image still at an early stage, he wrote to Hilda:

I know it was not Cookham that gave me ideas, but just the degree of consciousness that God … has brought me to. I must hope for this consciousness to return & not in the meantime fill up the emptiness with Cookham 'padding'.[46]

The danger was of perpetuating an 'innocent' atmosphere, when Spencer was now – through war, through Hilda – irretrievably adult:

having grown up and having more developed sex feelings than I had before the war … they made the earliest feelings of religion and Cookham so almost die out as to be memories of consciousness rather than consciousness itself.[47]

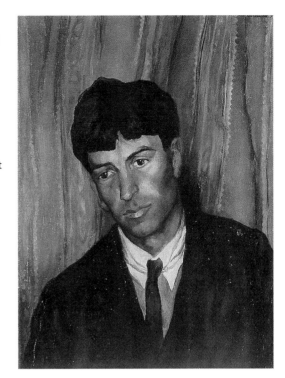

But in *The Resurrection*, Spencer manages to infiltrate the old 'Religion-and-Cookham' with echoes of the trenches, with the urgently present themes of sexuality and selfhood. As he puts it: 'The subject of the picture is Resurrection, but the "story" of it is more or less a notion of my own.'[48] The setting, likewise, is 'more or less' not 'Cookham padding' but a simplified architecture surprisingly unlike Cookham's actual flint

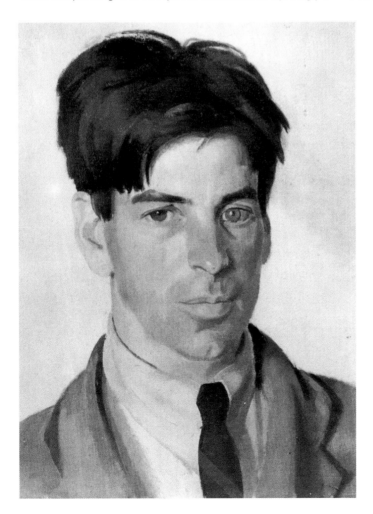

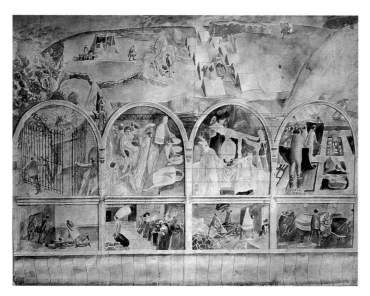

church. Despite so much that remains obscure in this narrative, in its multiple Stanleys and Hildas and assorted Carlines, the general feeling is, as Spencer hoped, 'thick and solid';[49] in the words of Carel Weight, 'intensely three-dimensional'.[50]

A Five-Year Plan

Burghclere was inherently less malleable. For the next five years (1927–32) Spencer was locked into an even more sustained *tour-de-force*, much of it already mapped out in 1923, and referring to experiences as far back as 1916. It was a world without women – of very young men, almost children. There was no place for Hildas or Carlines here. Aesthetically also, it answered aspirations first articulated in his Neo-Primitive adolescence – hence his exclamation, on first receiving the commission, 'What ho, Giotto!' The Behrends had at first wanted a secular memorial, but Spencer insisted on a functioning chapel, albeit one oriented north-south, and consecrated to the implicitly non-denominational *All* Souls.

Yet whereas *The Resurrection, Cookham* is still blockishly Primitive in idiom (with Giotto's *Prudence* from the Arena Chapel grisailles quoted on one of the tombstones), Burghclere manifests a slightly different aesthetic, more open to the minutiae of the everyday, relishing the depiction of mosquito-nets, duck-boards, bandages, shampoo. Spencer is concerned to sacramentalise and redeem these unheroic aspects of soldiery; they are depicted within a recognisably 'Italian', idealising mode. But the garrulous accumulation seems now more Quattrocento than Primitive – not so much Giotto, as Gozzoli. Spencer had begun *The Resurrection, Cookham* with an overall tonal underpainting; at Burghclere (painting not in fresco, but mostly *in situ*, in oil on canvas) he reverts to the steady daily patch-by-patch. Some of the most original of all his paintings are those continuous, irregular-shaped strips above the lunettes, a diffuse imagery which operates by extension rather than concentration. Burghclere as a whole – and especially the astonishing end wall, *The Resurrection of the Soldiers*, with its repeated white crosses distributed almost evenly across a surface twenty-one by seventeen-and-a-half feet – raises this

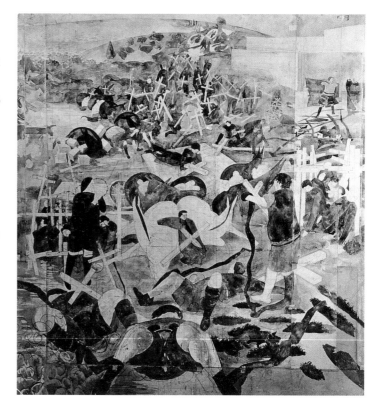

diffuseness, this refusal of rank, into a vehicle of new religious meaning.

In the early 1920s Spencer had tried to continue the Neo-Primitive/Georgian vein. When the poet Gordon Bottomley came across his little 1921 *Resurrection* (no.33) (the ranks of white figures rushing forward, clasping their gravestones almost as shields), he thought it

'almost as good as the best of the Lorenzettis'.[51] Paul Nash replied: 'I am afraid I am a little unsympathetic about S. Spencer. I used to admire him inordinately & believed him to be the real thing … something perfectly his own which caught one by a strange enchantment … I used to pin my faith to him but', he concludes, 'it would have been better for him and us if he hadn't been born behind his time.' For Nash, Spencer's vision had become an anachronism. When the first Spencer monograph was published in 1924, Lamb wrote, half in exasperation, to Richard Carline of

the astounding novelty of such a personality stepping in at this time of day to restore narrative art to its primitive purity, lost in history since Fra Angelico and in every child after the age of 12 or 13.[52]

None of Spencer's contemporaries could have carried through such an 'impossible' task as Burghclere Chapel. But this achievement was also an isolating experience, which left him as much suspended as fulfilled. It delayed, but could not forestall, a gathering crisis.

FORSAKING THE VISION 1932–1938

The crisis was both in his personal life, and in his stylistic identity as an artist, each feeding the other, intensifying the conflicts and contradictions, until by the end of the decade the painter we knew as Spencer seems to have exploded into several distinct artistic personalities whose procedures and mind-set may seem utterly opposed. The pulling-apart of Spencer is one of the strangest episodes in twentieth-century painting.

The personal crisis centred on Hilda. She was as rooted in Hampstead as Spencer in Cookham, and the move to Burghclere had been an intolerable wrench. 'I knew of no place in England that seemed to me more meaningless than this', she wrote.[53] She mostly ceased to paint. Spencer was always fierce (his childhood name was Tiger) but since 1930 he had suffered from terrible pain, later diagnosed as kidney-stone, rendering his temper increasingly uncertain until his final operation in 1935. For Hilda, alone all day with two young children, the temptation was to spend more and more time in Hampstead, in Carline-land, where the death of her brothers Sydney (1929) and then George (1932), made her presence seem necessary. Like both of them, Hilda was a Christian Scientist, and a profound disagreement on all questions of body and soul pushed her ever further apart from Spencer. 'He was extremely sacramental', commented Shirin Spencer recently, 'and his adored wife wasn't sacramental at all.'[54] For Spencer, all material things had a divine significance, were 'a physical sign of an inward and spiritual grace'. Loving acceptance of the physical world became for him almost a principle, fuelling much of his later work. As he wrote in *Sermons by Artists*, 'Every thing or person other than myself is a future potential part of myself.'[55]

The beautiful drawings of Hilda made in the evenings of 1931, on his return from the chapel, testify to their continuing love – even in the wary, hunted gaze of *Hilda with Hair Down* (no.50). But when Spencer finally opted to settle in Cookham in January 1932, having purchased 'Lindworth', a seven-bedroom house, set behind the High Street only a few doors from Fernlea, the separations became longer. The focus of his emotional life turned away from Hilda, towards that strangely constructed muse and man-trap, Patricia Preece.

Landscape and 'Vulgarity'

I am telling the story of this complacent stream of landscapes. Suspension of what I am doing and want to do. Money need ... Doggedness.[56]

Spencer had always been equivocal about landscape; but he lived (as all English painters do) in a landscape culture. First in Dorset and Bosnia, then in Cookham and Burghclere, he turned out a few modest pictures each year, painted on the spot. They sold. In 1926 he responded to a letter from his erstwhile admirer Desmond Chute exhorting him not to lose touch with his biblical vein. Spencer had just been sent a discussion of *The Carnegie International* in the *New York Times*:

The contrast of the two things was glorious: American vulgarity & your request to continue Joachimising ... I feel really that everything in one that is not vision is mainly vulgarity ... It has always puzzled me the way people have always preferred my landscapes. I can sell them but not my Joachims. This fact of recent years has had a wearing effect on me ... I don't understand and feel very muddled. If what an artist does comes from the stem of Jesse, it should be clearly apparent in everything that artist does.[57]

And yet, he does concede that he is excited and challenged by close study of any complex thing, be it plant or portrait. 'I want to be able to see John Donnes and Joachims in the shapes of peoples noses and mouths.'[58] By the time of Burghclere, a quality of inventory, of the enumeration of heaps of the inanimate (ammunition-belts, bread-and-jam) has passed from the landscape practice into the core of his art.

Among his first pictures back in Cookham was *The Blacksmith's Yard* (no.42). He finds a new significance in the humdrum, the discarded: the beautifully harmonised reds and browns do not hide the hard facts of the broken window, the raw brick terrace, the pile of scrap. Not only the choice of motif, but the manner of depiction, implies a refusal of hierarchy. Is this rendering of the world, without aura, without heightening or subjective presence, a betrayal of the earlier vision? In early 1920s Germany, the aesthetic known as *Neue Sachlichkeit* – a return to objectivity, or 'sobriety', or 'matter-of-factness' – had sometimes given rise to art of a parallel character (fig.16).[59] (Something of this would have been known to Richard Carline, and could have been glimpsed by Spencer in Cologne in 1922.) More generally, across Europe, a revived realism was one of the inter-war options in painting, even if increasingly polarised against abstraction and other 'advanced' modes. But in England, where almost all intellectual art-life was orientated to Bloomsbury and 'significant form', Spencer was putting himself absolutely beyond the pale. 'Finish' had been outlawed by Fry twenty years earlier, yet here was Spencer developing an extraordinary talent for highly controlled sharp-focused detail, crowded with tiny forms, a kind of invention that might be admired in the early Flemish, but which made any 'progressive' art-person bristle when encountered throughout much of the twentieth century. This 'finish' appealed to the Enemy – to the

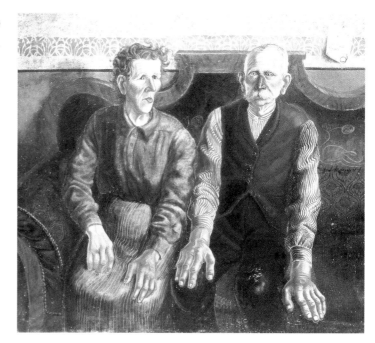

fig.16
OTTO DIX
Portrait of the Artist's Parents 1924

Oil on canvas
Neidersachsische
Landesmuseum, Hanover,
Germany

anti-modernist, the academic, the provincial, the conventional, the Philistine. Keith Bell writes of Spencer, later in life, receiving

numerous commissions from the commuter-belt ruralists who increasingly made up the population of the Maidenhead area, and who now took up Spencer as the portraitist of their comfortable lifestyle.[60]

As Spencer's 'money need' deepened, his landscape output accelerated. Landscapes dominated his 1936 exhibition at Tooth's, many of them purchased for public collections within months of completion. Between 13 February and 16 August 1938, he ground out twenty-four landscapes and still-lifes, complaining in a notebook of the 'continual breaking-in of landscape work':

I do my landscapes with a great deal of application and care, but they are dead, dead. They are done in the same spirit that I did company drill on the parade ground.[61]

Spencer himself excluded all these landscapes from his Church-House *summa*. Yet I'd want to distinguish between, say, those thoroughly 'vulgar' home-counties horticulturals, and those several compositions where he achieves such a complexity that each can stand as a microcosm, as a complete self-contained world. In *The Boatbuilder's Yard* (no.45) he passes from foreground aquarium and crazy paving, back through rockery, brick wall, boats, water and riverbank – each juxtaposed in their separateness, each tensely subjected to the pull of space. Here (as in *Cookham Rise* (no.47) where he tackles the working-class, wrong-side-of-the-tracks neighbourhood where he himself will live after the war) Spencer creates a structure of horizontal bands, a kind of 'zoning' common to many of his best landscapes. And what finally justifies all this 'doggedness' is not just that it paid for such weird, mostly unsaleable works as *The Beatitudes*, but that his landscape practice would feed so directly into some of his most original works, in which the Nude will be transformed to a very different genre, the 'Naked Portrait' – the individual stripped bare, and confronted close to, without defences.

Naked Portraits

Patricia Preece first modelled for Spencer in 1933, in a relatively conventional clothed portrait, hand self-consciously posed above her braceleted wrist, a gramophone behind. Yet the effect is raw, and almost brutal: we feel Preece's heavy build as the humped shoulders lurch towards us; her squint is strongly emphasised.[62] By the time of the first naked portrait their relationship had come to be centred on Spencer's gifts of extremely valuable jewellery, as well as the lingerie evident in the 1936 *Girl Resting* (no.54).[63] Paid to come over on winter evenings to Lindworth (which Spencer transferred to Preece's name in 1935) she poses under a strong, almost interrogatory lamp; there's something here of the animal caught in the headlights. To either side of the wide-open eyes are buttons of black leather upholstery – the dark concave swirls reversed in her massively swollen breasts and nipples.

We now know more about Preece than Spencer ever did. She was born, not in 1900 (as she would claim even on her marriage certificate) but in 1894, and met her lifelong partner Dorothy Hepworth at the Slade in 1918.[64] Encouraged by Fry, and supported by an allowance from Hepworth's father, they spent four years in Paris. By the time they reached Cookham in 1928 they were locked in an elaborate masquerade: the retiring Hepworth did the paintings, but Preece signed them and played the artist, receiving help over several years from Fry, as well as from Duncan Grant and Clive Bell.[65] (Both would write on 'her' work.) In 1930 Hepworth's father died, and the family business collapsed: the two women faced destitution. Soon after the Spencers' arrival in Cookham early in 1932, Preece took

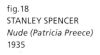

'her' paintings up to London: 'I went to see Roger Fry yesterday … I told him how Stanley Spencer made so much money selling his work & he said "I am sick of his muck".'[66] There is a bizarre irony in our listening-in now to Fry as Cultural Arbiter, counselling Preece over paintings she hasn't done, while testily damning the best English artist of his time. Fry's view of art was all about discrimination, about the hierarchy of forms and the necessity of exclusion. Spencer had just completed at Burghclere a monument to the indiscriminate – an army without officers, where all forms are given equal significance.

Spencer was baffled by the mystery of Preece's work: 'just grass I have to keep off … spiky Bloomsbury grass designed to damage intruders'.[67] His own deadpan landscape idiom was perfectly matched to her inaccessible terrain. Only in the great 1935 reclining figure (fig.18, sadly not available for this exhibition) does Preece appear at all participatory – her body in lively torsion, the head smiling at the periphery, as her limbs fill the enclosure. But in the two double-portraits, both completed in the winter of 1936–7, Spencer is the 'intruder', stripping himself naked only to encounter Preece as vacant shell. It was of the first of these pictures that Spencer likened the slow movement of his brush to an ant crawling over every inch of her body. In practice, the design must be a kind of collage, with his bespectacled profile 'set into' Preece, black hair juxtaposed to her dark bush, painted at quite different times (no.55).

Instead of the vigorous self of a few weeks earlier – the picture now in the Stedelijk Museum, Amsterdam (no.59), which Keith Bell believes may have consciously reprised the 1914 *Self-Portrait* – Spencer's profile seems here that of a half-smiling fool. In the Tate picture (no.58), he turns to face us directly, miserably down-at-mouth, abjectly squatting, his drooped shoulders echoing the curve of the stove door. He is absorbed in contemplation of the blank expanse of Preece's torso; the untenanted flesh, for which the foreground meat is such a startling metaphor. When Spencer himself later comments half-wonderingly: 'There is in it male, female and animal flesh', he is pointing to its character as an *anthology* of the flesh.[68]

In May 2000, in the opening hang of Tate Modern, Spencer's *Leg of Mutton Nude* was exhibited alongside the German Christian Schad's *Self-Portrait* (fig.19), and seemed at first

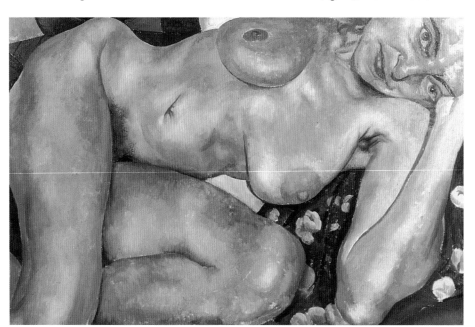

uncannily alike. In both, the artist faces us naked, his sinister muse in profile. Both are harshly illuminated nocturnes; both share a crowded collage space, and even a nearly identical purple-striped bedlinen. Yet the icy-smooth flesh of Schad is impermeable; the narcissist and his scarred partner enact their sordid, cynically amusing, comedy. (We note the wit of the little segment of stockinged thigh at the left edge.) But *The Leg of Mutton Nude* is without irony, and Spencer's

disclosure is not of decadence, but of Fall. Out of a 'dogged' effort of perception (contour and flesh tone far more varied than in the Schad) Spencer's committed verism attains the stature of a tragic vision – an image which packs a psychological charge few other British paintings have ever rivalled.

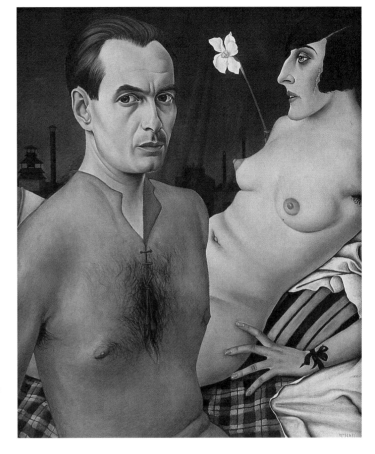

'THOSE COUPLE THINGS' 1937–1938, AND THE 1940S

Marriage is usually where a novel breaks off, but I cannot imagine anything more dramatic than the life that begins with marriage … There is the land, the great land of each other before us to wander about in.[69]

Some of Spencer's most powerful imagery erupted out of the winter of 1937–8 when he was alone at Lindworth. His wedding to Patricia Preece had taken place on 29 May, just two months after he'd completed *The Leg of Mutton Nude*; there immediately followed – whether set up by Preece, or of Spencer's own making – his overnight reunion with Hilda. Then, on his so-called honeymoon, he'd hung on for weeks in St Ives with Preece and Hepworth, painting bread-and-butter landscapes; journeyed to Hampstead, where in a brief stay at the Carlines he'd painted the very moving *Hilda, Unity and Dolls* (no.60);[70] and when Hilda refused to join him, had travelled to Suffolk alone, painting a compelling beach scene at Southwold. But all these were in his 'realist' mode. Now, back in Cookham – and Preece, mission completed, partnered with Hepworth for the rest of her life – Spencer abruptly changes gear.

In *The Beatitudes of Love* (nos.62–6) – which he sometimes refers to as 'Husbands and Wives' or 'Those Couple Things' – the solitary Spencer conjures a world of purely imaginary pairings. Early Italian art had served Spencer's Innocence; now, in his Fallen state, the Northern grotesque comes into full play, as the visual language appropriate to Experience. In *Knowing*, he seems closest to German sixteenth-century painting; like Cranach, he rebuilds the human body through feeling. The immense male dominates his fragile butterfly mate (barely a quarter his size) almost crushing her out of the picture. Her fingers reach out like antennae; her arm, in order to touch his waistcoat, needs to be enormously extended. His mighty fist clasps a stick, like an ogre's. They rise up towards us out of darkness, figures almost inconceivably weird.

Degenerate Art

It is as though, rebounding from the numb naturalism of *The Leg of Mutton Nude*, Spencer now needs to create figures that are wholly invented – their anatomies as wrenched and rearranged by love as the woman's endless neck in *Toasting*, probably begun from a memory of Hilda and Spencer naked together in the Vale of Health studio, their bared flesh transformed by infernal oranges and reds:

Being naked … gives them the feeling that they are some kind of wild animal that has got into someone's sitting room, and it helps them in the proper realisation that the species called civilised conventional beings is different from the species husband and wife.[71]

In notebooks written after the completion of the paintings, all become fictional characters: *Toasting* a story about a sweetshop assistant and a greengrocer's; *Knowing*, a cowman and his wife; *Desire*, 'Charley and Bertha', though these identities often overlap confusingly. As Spencer explains, 'These people are all me, really … only I make it other people as much as I can'.[72] Taken together, *The Beatitudes* also embody a moral position: in Gilbert Spencer's words, 'the triumph of love over every physical disadvantage'.[73] The couple in *Consciousness* seem so wilfully, monstrously ugly that we can hardly bear to look at them. She is bespectacled, chinless, her mouth all gristle and teeth: he strains his scraggy raw neck towards her, one hand almost like a dog begging, desperate in his open-mouthed devotion and need.

I call it consciousness because it is like waking up and realising all one has been missing while asleep … He knows that she is a dressmaker, and she knows that he is a grocer's assistant. They know that they are both strong, and that they are going to exert their physical strength on each other … She feels 'This is the first time I've ever talked sense' … She has never met this situation before … he is thinking of her legs. Later on they wrestle in the bedroom, and male and female strength is felt.[74]

When Cranach (fig.20) or Gillray depicts an ill-matched couple, we know how to respond. But this fly-blown pair are obviously made for one another, and any potential mockery dies in our throat. And so we are made to feel the force of Spencer's vision: that human love is most truly mediated not through beauty, but through the grotesque. Ugliness, awkwardness, gaucheness – in *The Beatitudes* these become almost a value. In his notes Spencer is concerned that we may respond in the wrong spirit to these 'distorted' figures. We should not imagine him to be 'poking fun':

It would be better and truer to say 'Spencer likes degenerate and deformed-looking people' than to impute me with sniggering and laughing derisively … These people, every one of them, are the beloved of my imaginings.[75]

fig.20
LUCAS CRANACH
THE ELDER
Ill-Matched Couple
1530s

Oil on panel
Museum of Fine Arts,
Budapest, Hungary

The word 'degenerate' may be significant here; Spencer would have been aware, through Richard Carline and his Artists' International Association connections, of the 'Degenerate Art' campaign unfolding in Germany just as *The Beatitudes* were being painted. In turning his attention away from the monumental figures of his youthful work, to these, so much more difficult to love, Spencer was fulfilling a special vocation.[76] It certainly alienated faithful patrons:

I shall never forget Eddie Marsh confronted with them … it fogged his monocle; he had to keep wiping it and having another go … 'Oh Stanley, are people really like that? … Terrible, terrible, Stanley!' Poor Eddie.[77]

All the surviving *Beatitudes* might be described as 'overtures'. But some uncertainty remains whether other, more sexually explicit designs are still hidden away. *Age* was probably destroyed in 1950 in response to Sir Alfred Munnings's police prosecution of Spencer for obscenity (see p.158), and our only record of it is an exceptionally moving text, too long to quote in full:

As she stands before him she responds & acquiesces by her inertia. She has been felt and fingered by him for fifty years. He has emptied himself into her about eighteen thousand times … Her age seemed to have joined her more closely to the animals and birds … Her carcass is the harmony of his body, she says nothing but with all her weight she praises him … Each new fold in her skin appearing as her age increased was a new joy to him … her old joints ached for the affection of his gnarled hands. She remained standing like a cow in the stall being milked as he smoothed out the creases between her knees and joints … She stood and he surveyed her as [he] does in the picture only now he does so from every angle.[78]

In his sketchbooks, Spencer was constantly exploring the dynamics of couples. As early as 1934, he drew from Degas's *Interior* (sometimes known as *The Rape*) where the male blocks the door, and the half-dressed woman cowers (fig.21).[79] In later small notations, a man watches a woman peeing into a pot; two standing men, trousers down and braces dangling, caress one another. Would such ideas have been incorporated as 'serious' elements in his temple of universal love – or are they mere light-hearted erotica? Looking back at all his love-images of the

1930s, Spencer writes of them as 'premature', because he'd been unable to bring them all together within the architectural context of the Church-House – where, he believes, 'all those fantastic elements, all those indecencies, would at once disappear'.[80]

To Illustrate His Own Life

From 1938 onward, Spencer spent several hours each day writing passages for his abortive *Autobiography*. *The Beatitudes*, as we've seen, were extensions of the self. The first to be painted, *Desire*, sets a tiny childlike male (Spencer was five feet two inches and eternally boyish) beside his much bigger and more mature partner – who, we're told, 'is going to let loose on him the legions of herself. She is going to give birth to herself into the world made of him.'[81] In the 1940s a similar imagery continued, but in a more openly anecdotal and comic vein. Late in the summer of 1939, a year after his flight to London, Spencer had

met a Slade-trained Hampstead couple, the Charltons. That winter, as the war got underway, with George Charlton in Oxford all week reorganising the Slade, Daphne and Spencer settled into a turbulent ménage à trois in a Gloucestershire village. *On the Tiger Rug* (no.68) shows the lovers communing across the absurd stuffed visage of the stripey beast, one claw tucked under Stanley's chin. The rug protects them from the cold floorboards (Daphne's hand is outstrectched towards the unseen fire), but it also transforms English cottage-cosiness into something more dangerous. It was about this time that Spencer noted: 'I would wish my heaven to be a kind of Jungle, but with all the people and animals on a love footing with each other.'[82] Big Daphne appears again, rearing up above little Stanley, in a marvellous squared-up drawing (no.69) – although this image may also relate to a passage in the 'Charley and Bertha' narrative, where Spencer switches tellingly from third to first person:

her bottom was up towards him, its ridiculous appearance making it more passionately wonderful … and the emphatic presentation and exhibition of her buttocks to him thrilled him.
 I love them both and will see that they will come to no harm.[83]

The so-called *Scrapbook Drawings* (begun in Gloucestershire, but worked on intermittently throughout the 1940s) are also squared for transfer, intended eventually to find their way into the various chapels of the Church-House. For the 'Patricia Chapel', Preece dances wildly to the gramophone in her underwear, as Stanley rummages blindly in a sack. But they are not alone; as in several other drawings, an old bearded gentleman in a long robe edges in, extending an arm in exhortation or blessing – displaced vestige of Giotto's God and of 'the Good Shepherd' in *Two Girls and a Beehive* thirty years before. The shared rituals of couples – undressing, bathing together, towelling, combing hair, having tea together in bed – are thereby consecrated, and Spencer's actual experiences of domestic cosiness raised up to altarpiece status. In two of the most extreme, small-man and big-woman sit side by side on companionable lavatory seats; and in one, the male is erect. Since both drawings are prepared for transfer, Spencer must have intended these also for full-scale 'altarpieces'.
 All these compositions are of a wonderfully sustained invention. Yet Spencer's later line is oddly detached, almost unfeeling: a light, hard pencil, without body or calligraphic verve. It is a kind of blueprint line, not unlike a tracing – the contour seeming often unconnected to the interior of the form, and merely dividing one thing from another. Here, as in so many of the Church-House paintings, one has to accept an obvious mismatch between the imagery, so fecund and celebratory, and the dryness, the absence of any sensual delight, in its delineation.

THE CHURCH OF ME 1932–1939

In the place in heaven which comes in Cookham High Street the disciples revealed and preached peace and joy … At the bottom of the village round by the Wesleyan chapel a disciple bandaged an old man's foot & the old man was grateful and some children so moved that they knelt … A grocer's shop & the grocer & the people shopping were adored by a disciple … And into the whole village and into all its varied life the disciples penetrated.[84]

The religious tradition out of which Spencer emerged was biblical, but not ecclesiastical. His father was essentially a freethinker, happy for his children to attend both Church and Chapel, yet questioning and sceptical of all dogma, and even of the divinity of Christ.

When in the 1930s Spencer turns to apocalyptic and sexual themes, we suddenly see him not as a landscape-romantic, but in a much less genteel English tradition of ranters and antinomians, sectaries of new dispensations and isolated makers of Blakean home-baked mythologies. At the end of the decade, Spencer would be considered for a possible mural at Campion Hall, Oxford, leading to a telling exchange with Father D'Arcy:

When asked by D'Arcy what I thought of Rouault I said I should have thought the catholic & traditional & ecclesiastical element in his work would be likely to appeal … The only way in which I could hope to produce work suitable would not be through tradition, but simply through the degree of feeling I could express in the work itself.[85]

When Spencer chose to return to his home village in 1932, he already had in mind a new architectonic painting-cycle. If much of the previous ten years had gone into memorialising a war he'd always viewed as an interruption, this new monument would be centred on the much more present theme of love – and, above all, love in its boundless, eschatological future. *The Dustman* (or *The Lovers*) (no.78), completed in 1934, is among the first in a long sequence where 'The Last Day' is enacted within the Cookham village community. Dirt is here explicitly exalted, not only in the little dustman himself, his bald head outlined against the topiary, raised up in the arms of his enormous wife, but also in the emblems of his trade, salvaged from the foreground bins by kneeling figures and held forward as though in homage. In Spencer's explanation:

This is the glorifying and magnifying of a dustman … Nothing I love is rubbish, and so I resurrect the tea-pot and the empty jamtin and cabbage stalk, and, as there is a mystery in the Trinity, so there is in these three objects and in many others of no apparent consequence.[86]

The first of Spencer's paintings which might be termed 'preposterous', *The Dustman* was among those rejected from the 1935 RA Summer Exhibition, leading to his resignation from the Academy. A previously sympathetic critic, Frank Rutter, complained in the *Sunday Times* of 'peculiar mannerisms and distortions', that 'recall the experience of a nightmare' – earning, a week later, Sickert's riposte: 'Why should Mr Spencer not have peculiar mannerisms? Why should his distortion of form not be agressively prominent? … What is the matter with a nightmare?'[87] Spencer's new figure-types, a race of rag dolls, bring him close to the world of Lear's *Nonsense* and Tenniel's *Alice* – to the comic genres of childhood; he now has need of an idiom that has jettisoned all authority and dignity. In *The Adoration of Old Men* (no.80, intended in the Church-House to hang next to *The Dustman*)[88] we are confronted by a phalanx of tubers-in-tweeds, grouped with something of *Apple Gatherers*' random shifts of scale – odd magnifications or diminishments, perhaps also in emulation of medieval altarpieces. This theme of a tight English small-town society being turned upside-down by millennial forces can be paralleled in the contemporary fiction of both the Powys brothers; John Geard, the gross and smelly Holy Man who, in John Cowper Powys's *A Glastonbury Romance* (1933), transforms the town into a visionary commune, would be a prophet very much after Spencer's heart. As Cookham's perpetual church fête and garden party is overtaken by orgy, as canvases fill with carnival-like processions and public undressings, I think also of Bakhtin's vindication of the grotesque 'disclosing the potentiality of an entirely different world … It always represents in one form or another, the return of Saturn's Golden Age upon Earth – the living possibility of its return.'[89]

Love Among the Nations (no.82) seems to move along its nine-foot length from the Near East, through Africa to China: all are, in Spencer's phrase, 'assembled in sexuality'. 'There is a girl adoring a negro's toes and an English woman in ecstasy as she feels a Turk's cheek.'[90] In *The Turkish Window*, a yet further extension to the composition, we see a love

that literally 'breaks down all barriers' – wrenching the metal grilles of the harem, hugging the veiled inmates. It is of course 'childish', a kind of Toy Story; and when he returns to *The Nursery* in 1936 (a childhood memory first explored in the *Chatto & Windus Almanack* of 1927) the dolls and jointed puppets emerge out of the Christmas stockings endowed with their own vivid life. The liberation of later Spencer, his silly-profundity, often comes from his speaking to us in the medium of arrested development.

The Sacred Self

The Church-House may be best understood in the context of other contemporary mural artists in Italy, Mexico and the United States – all of them looking to early Italian fresco painting as model for a reformed relationship between artist and society.[91] Richard Carline had travelled in America in 1928, and would have told his brother-in-law of his enthusiasm for Thomas Hart Benton, and later, for the New Deal and the Works Project Administration mural initiatives. The *Studio*, certainly read by Spencer, published an article on 'The Mexican Modern Movement' as early as 1927. Diego Rivera, whose imagery shared so much of Spencer's aesthetic of crowding, would become extremely prominent after his show at the Museum of Modern Art in New York in 1931, his Detroit mural of 1932, and the scandal of the Rockefeller Centre murals, destroyed in 1934.

Like his contemporaries Spencer sought a new public role, but was, it seems, in one important episode of 1932-3, blocked by Fry. Gwen Raverat wrote:

Re: Cambridge Library Project

> Dear Cookham,
> I'm afraid I do know that Roger Fry is against you as a painter. I went to see him, and he laid out his views. The only good thing you ever did was John Donne! You have no sense of spatial values or composition, or anything, except oddness.[92]

So the public commission that could have sustained Spencer's art after Burghclere was lost to him. Once again, it should be emphasised how rejection by England's most respected critic led to Spencer's marginalisation from the 1930s onwards, an exclusion that contributed in turn to the tame formalist orthodoxy that was Roger Fry's enduring legacy to British art over the next fifty years.

However private Spencer's themes may now appear, it is important to keep in mind that the Church-House was always conceived as a public monument. His belief in the healing and redeeming power of sex went back many years:

fig.22
Carving from the Hindu temples of Khajuraho, India c.950-1050

During the war, when I contemplated the horror of my life and the lives of those around me, I felt that the only way to end the ghastly experience would be if everyone suddenly decided to indulge in every degree and form of sexual love, carnal love, bestiality, anything you like to call it.[93]

A Village in Heaven (no.86) – a pivotal work in Spencer's *Last Day* sequence – is centred on Cookham War Memorial, which provides a platform from which the white-robed disciple directs the general love-in.[94] That undistinguished monument is transformed, not only by the exaggerated Gruyère-cheese rustication but by representing the shaft so that it resembles a lingam. In Munich in 1922, Spencer had purchased a book on Indian sculpture, and the temple-complex of Khajuraho (fig.22) became one of the guiding inspirations for the Church-House, a temple of love similarly organised as a cluster of chambers of varying

fig.23
STANLEY SPENCER
*Sunflower and Dog
Worship* 1937

Oil on canvas
Private Collection

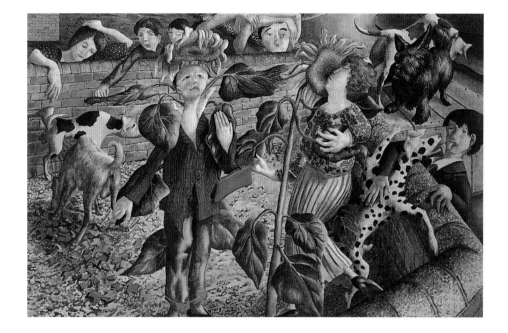

size. At Khajuraho, the largest of all is encrusted with almost 900 sculpted figures, many of them making love in groups and couples; as Spencer intuitively understood, the total effect is not licentious, but rather an affirmation and celebration of the multifariousness of love.[95] The very extended format of many of these paintings corresponds to temple friezes such as the *Life of the Buddha* at Borobadur, particularly admired by Spencer. In terms of Western altarpieces, it is as though the *predella* – the small-scale narrative strip at the foot of the monumental image – has usurped the central role in Spencer's art of the 1930s. The *Promenade of Women* (or *Women Going for a Walk in Heaven*) (no.87) are setting out to join the massed lovers at the War Memorial – dressed to kill, encountering two disciples on their way, and with a couple of distinctly nervous husbands in tow. As they move along the seven-foot stage ledge from right to left (the last leaving her doorkey under the mat) everything becomes unstable. The varying width of the pavement, and the altering direction of the brick wall, implies a series of slithering shifts of focus. 'Down this familiar street I pass through the unknown land of women … I see them like a number of small hills, some rising strongly, some covered in flowers and some plain.'[96] The logic of this universal love is that not only human beings, but animals and even plants, must be swept up in it. Hence the tree-huggings, the swooning ecstasies and incontinences of *Sunflowers and Dog Worship* (fig.23, one of the pictures whose unavailability for loan is most to be regretted), and the drawings where a naked, unfallen Adam and Eve not only name rhino (fig.24) and elephant, but seem to make love to them.

By the end of the 1930s, the Church-House has become an amorphous structure, whose many compartments can accommodate Spencer's multiple identities – his stylistic contradictions, his erotic conflicts – and, in the act of bringing all together, can rebuild the shattered self (fig.25). Spencer in his 'Church of Me' can move unblushingly between biblical narrative and, say, his affection for a maid-servant, embodied in the 'Elsie Chapel'. And each of his own best-loved images, going right back to *Zacharias* and *The Bed Picture*, must also be given its place – even *The Leg of Mutton Nude*, serving as altarpiece for the 'Patricia Chapel'. In the 1920s, Spencer had written of his painting

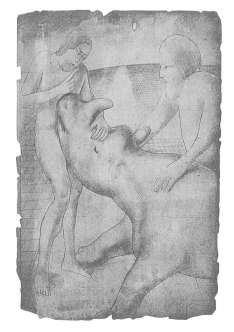

as 'solemnising and celebrating ... by taking solid chunks of my own life and putting it on canvas. I like my own life so much that I would like to cover every empty space with it.'[97] This visionary solipsism has many parallels: I think of Fellini in *Otto e Mezzo*, of Max Beckmann's self-mythologising in the *Triptychs*; of Charlotte Salomon in her testament, *Life? or Theatre*?; of Blake's vast, cosmic and cyclic narrative of Albion in *Jerusalem*.

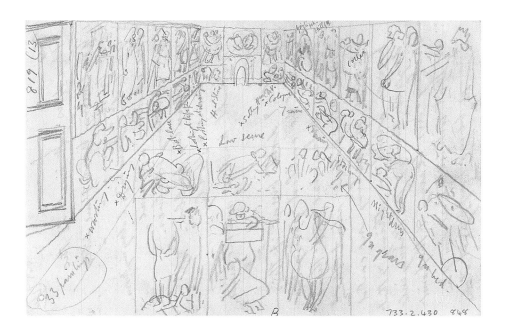

David Jones felt the significance of Spencer's inclusiveness for his own work: '"All must be safely gathered in", as Mr Spencer said to me ... (A more apt expression of the artist's business I never heard).'[98] But it is possible also to view the Church-House as the work of an 'outsider'. A recent definition of Outsider Art 'requires that the artist create a vast, encyclopaedically rich and detailed world – not as art – but as a place to live in over the course of a lifetime.'[99] Spencer the painter/writer of the late 1930s often seems closer to the asylum cosmographer Adolf Wölfli, and to Henry Darger's narrative of *The Vivian Sisters*, than to Giotto.[100]

In the Wilderness

I am full of self-pity and I need it, it will come from nowhere else.[101]

Spencer's flight from Cookham in the autumn of 1938 was probably unpremeditated. Preece had let 'Lindworth', confining Spencer to the garden studio; his punishing landscape schedule was designed to pay off his own debts, as well as to keep both Hilda and the Preece-Hepworth household afloat. Turning up at the Rothensteins in Hampstead for a party one night in October, he stayed six weeks, throughout which he did almost no painting or drawing. But by early December he was at work on the *Christ in the Wilderness* series, at the top of a house near Swiss Cottage, and was reading Thoreau's *Walden*.[102] Thoreau 'went to the woods because I wished ... to drive life into a corner', to rediscover, by finding his place in solitude, his role among men. For Spencer also, it was

a finding of myself after being lost for such ages ... I would sit down in one of the two chairs and think & look at the floor: Oh the joy of just that ... I did not use the bath at all, only the lavatory ... I got a bit out of step as to what was day or night.[103]

After the endless crowdings and couplings, the concentrated, still monumentality of *Christ in the Wilderness* reasserts the biblical and Trecento 'Primitive' vein in Spencer's art. This

Christ is experienced close-up, a white silhouette beautifully composed within the square. By 1939 the Swiss Cottage area had become a haven for Middle-European refugees, and Spencer's Christ is strikingly 'Jewish'. No previous artist had ever explored this imagery of Christ as homeless 'displaced person': 'The foxes have holes … but the Son of Man hath nowhere to lay his head' (Matthew 7:20). He becomes a kind of crazed vagrant, lying immobile on the bare earth while eagles rend beside him the corpse of a young deer. He is, like Thoreau at Walden Pond, a part of nature, engaging in solitary communion with a scorpion. Jane Alison characterises the series as 'reparative' and that is the wider significance of this nine-month episode in Spencer's life – a stripping-away (embodied in the two life-size naked self-portrait drawings also made in Adelaide Road) and at the same time a kind of rebirth out of loss.[104]

'A WONDERFUL DESECRATION' 1940–1959

In *Burners* (no.97), painted very rapidly at Leonard Stanley between July and August of 1940, that grotesque note that had troubled the 1930s is entirely absent. While still working at *On the Tiger Rug*, Spencer had been summoned in January for an interview as a possible War Artist. His own proposal – a *Crucifixion* in homage to the sufferings of Poland – was rejected. But in May he had travelled up to Port Glasgow, drawing for several days at the Lithgow shipyard, and was cautiously commissioned to make a first sample.[105] The triptych format solved the problem of his small bedroom studio at the White Hart Inn, where the fifteen-foot picture could be completed in three sections. Once again, Spencer exalts everyday activity to visionary altarpiece. The composition of the central panel, with each man so separate on his metal island, carries allegorical overtones: the childlike, vulnerable figure, who has removed his goggles and cap, a kind of artist-witness surveying the endlessly extended inferno.

In the nineteen-foot sequel, *Welders*, the kneeling self-figure is located in one of the side panels, which are altogether more exciting than their *Burners* counterparts: figures juxtaposed in violent torsion, and rocketing about like fallen angels. Echoes of *Mending Cowls*, of workaday figures transformed into apparitions, of the Burghclere upper strips, of the nocturnal illuminations of *The Beatitudes* and Preece portraits (though here Spencer differentiates between yellow flares in *Burners*, and the cool white light of *Welders*): all these are brought together within a new public engagement. The process of turning out tramp steamers (Lithgow's speciality) must be presented step by step: we learn about protective visors and gloves, about torches fed through snaking metal cables from testicular bags. (Diego Rivera's Detroit frescoes of 1932–3, fig.26, had similarly anatomised the construction of a Ford combustion engine.) Yet in the whole of *Shipbuilding on the Clyde*, we see neither boat nor river. All takes place in the belly of the whale, a vision of complexity and compartmentalisation that is as much psychic as physical, and whose nearest equivalent might be in Max Beckmann's *The Cabins*.

In summer 1942 Hilda suffered a mental breakdown.[106] Much of Spencer's energy went into visiting her at the asylum, writing letters and copying those she exchanged with him. She only slowly recovered, over the next two years, in the care of a psychoanalyst, Dr Bierer. By this time Spencer had commenced a new relationship with a married woman in Glasgow, Charlotte Murray, a German-born analyst trained by Jung. Murray persuaded him to undertake analysis with a fellow-Jungian, Dr Karl Abenheimer; and other Jungians were consulted later, in London and Cookham.[107] Keith Bell believes the calmer character of Spencer's later work may be partly attributable to these contacts. Yet his mental geography

was perhaps already 'Jungian', not least in creating a new narrative-of-self at each stage of his life.

Working always in small improvised studios in Epsom, Cookham and Port Glasgow, and, from 1945 onwards, in the front bedroom of his very modest house in Cookham Rise, he continued to make pictures of the most ambitious scale, completed piece by piece along an unstretched roll of canvas, pinned to the wall. His procedures may have first taken shape in emulation of the bold, swift medium of fresco – the direct unfolding of the image. But in his later *Shipbuilding* pictures, his Port Glasgow *Resurrections*, and his unfinished *Regatta* and *Apotheosis of Hilda*, Spencer will crawl tiny brushes across an impoverished surface, devoid of all touch or impasto, of density or intensity; the squared-up drawing mechanically filled-in, silted-up. We hear of him at work on the twenty-two-foot *Resurrection* by the light of a single candle, and explaining: 'Well, of course I cannot see clearly what the colour is, but the effect in the morning is sometimes tremendous.'[108] Perhaps the least disappointing of Spencer's later religious narratives is the relatively small-scale triptych, *The Resurrection with the Raising of Jairus's Daughter* (no.104). Here the almost cinematic plungings of space create a fascinating architectural complexity – not only the drama inside the central terrace house, but the newly risen who break through the paving-stones of the curved street, as well as the embracings in the gardens behind. The compositional invention is unflagging, and astonishing. But when Spencer writes to Hilda in 1949, 'I would almost prefer that other people should paint them in order to leave me to write about them', he is only half joking.[109]

The Unregarded

I am always taking the stone that the builders rejected and making it the cornerstone in some painting of mine.[110]

After four years making epic altarpieces to Lithgow's gleaming metal, Spencer in Port Glasgow now set up his easel facing a forgotten corner of the shipyard. What he discovered in *The Scrapheap* is truly wondrous; a range of rusts, shot with a delicate silvery grey, and off to the left, transcribed alongside other graffiti with absolute fidelity, floating above the black corrosion, the image of a three-funnelled boat. Spencer's 'dogged' procedures are once again vindicated. *Goose Run*, *Cookham Rise*, five years later, is a

further retrieval of the overlooked, in a different key. It is a world made up entirely of scattered, weightless elements: the slight branches of the sparsely flowered tree hardly registering more than the wire fence, the untidy flotsam, the foreground wisps of down.[111] A fine passage from Spencer's autobiographical writing can also be closely aligned with this non-imagery:

Cooped up as I am in myself, I gaze out on my own chicken run and feel I could write a chapter on each ridge of mud, or scratched hole or nettle or claw mark. I prefer to have no greater world.[112]

Spencer was not of course the first to attend to such unpromising motifs: as Van Gogh explained in 1889, 'I often paint things like that – as insignificant and dramatic as a dusty blade of grass by the roadside'.[113] But Spencer articulates almost a doctrine of *un*composition: we might call it Insignificant Form.

Merville Garden Village belongs to this same vein, of Spencer at his least cosy or 'picturesque', but patiently recording, and accepting, the facts of things as he finds them. Out of this greyness, out of the fissured wall and the Nissen hut, emerges a distinctive and even a beautiful image, that today appears less rhetorical than the comparable observational modes practised in English painting of the same period – whether 'Euston Road' or 'Kitchen Sink'. Among Spencer's final altarpieces (for once, functionally so, since it was commissioned for a school chapel) was *The Crucifixion* (no.113) whose ultimate source was *The Scarecrow*, painted from life almost a quarter of a century earlier. That interchange between Man of Straw and Son of Man is significant: the best paintings in his observational vein are infused with the numb suffering of all things, a pathos easily transferred to the Christian incarnation. And in *The Scarecrow*, wooden stakes that closely resemble crosses lie close by, while distantly, on the right, we glimpse Cookham War Memorial – a white mound surmounted by a cross. Even so, in its violence, its pale, almost anaemic tonality, and its wrenched space 'like a crashed airliner', *The Crucifixion* is altogether unexpected.[114]

Love Letters

Pining to get home and back to that happy realm of thinking about myself – my special brew of thoughts when all the Stanleys, this me and that me, can come out like children coming out of school.[115]

It has taken many years for Spencer to be recognised as an extraordinary writer – at his best, I believe, one of the greatest English autobiographers. Like Traherne and Clare, his closest cousins, he needs a lot of editing, and some skipping; as he put it himself, 'It is a job to keep track of my writings', and memory lane is cratered with confessions, or constantly peters out into day-to-day contiguities.[116] At Burghclere from about 1930 onwards he began to write two kinds of letter to the absent Hilda: his 'currant' (*sic*) and 'deposit' accounts, the latter sometimes over a hundred pages long. She remained his ideal recipient, though many letters were never posted. In his visits to Banstead Mental Hospital in 1942, the exchanging and reading of one another's letters became a central ritual for both of them (fig.27).

The first drawings for the masterpiece of all Spencer's later paintings, *Love Letters*, originated as early as 1930. But by the time he actually set brush to canvas in 1950, he probably knew Hilda was dying, and the image became a summation or emblem of all that they had experienced together, designated as altarpiece for the 'Hilda Chapel'.[117] Its overtones are complex: a return to childhood, with Stanley and Hilda at play, dwarfed within the ultimate 'cosiness' of a sofa that more resembles a giant English armchair; but

also, a disjunction – he blindly absorbed, she thwarted. It is often hard to say whether word or image is primary in later Spencer. In 1943 he'd written to Hilda:

And in my writing I would find what I had missed … My soul will as before in that room go out into the unknown hours stretched before it & flower & flower & buds will come anywhere, in a pocket or from my pencil & from my pocket will come love letters to you.[118]

The painting is in some ways an advance on this; still rhapsodic, but more self-critical. As Merlin James has pointed out, 'the male in the painting is in oblivious delirium, the female distant, perhaps rueful. Beyond desired togetherness is still estrangement …'[119] Spencer must have been working on *Love Letters* when news broke of Sir Alfred Munnings initiating a police prosecution against some of Spencer's sexual imagery of the late 1930s, culminating, Keith Bell believes, in the destruction of at least one of *The Beatitudes*.[120] Spencer wraps *The Leg of Mutton Nude* and hides it under the bed for the remainder of his life. And *Love Letters* becomes a kind of commentary on all those earlier 'Couple Things', part of his continuing meditation on past relationships.

Later, with Hilda already five years dead, Spencer is still writing to her; their love has developed, to become

a wonderful desecration of most of the childhood hopes because it is sexual and non-innocent but it *is* grown-up … This non-innocent disillusioned you-hugging me feels so much compensated for the joy of being conscious me, that I feel it is in great degree a fulfilment of the childhood hope & need.[121]

fig.27
STANLEY SPENCER
Stanley and Hilda Reading Letters, sketch in a letter to Hilda, 22 May 1930

Estate of Stanley Spencer

That 'wonderful desecration' may provide the most helpful perspective by which to understand Spencer's later achievement. His *Self-Portrait* of 1951 (no.110), with its thoughtful tilt and searching gaze, is the most subtle of the entire sequence. The sagging vest could imply a kind of endgame of solitude and destitution, but the scrutiny is calm, undeluded. When we look back – as he so often did – at Spencer's work as a whole, we can locate much of it within that twentieth-century tendency for which German critics coined the term *Selbst-Kunst* [Self-Art]. I would place Spencer, alone among British artists of his generation, alongside, for example, Munch, Bonnard, Kirchner, Beckmann and Guston, each of them exploring the relation between the self and the world. *Hilda and I at Pond Street* (no.111) is another autobiographical episode, commemorating the period, six or seven years earlier, when she was convalescing from her first cancer operation, and Spencer often visited her in Hampstead. The male figure was originally an 'archangel', with his two attendant 'cherubs', kneeling to announce her impending death. But the substitution of the self has resulted in a strange gesture. It is as though he *assaults* her with his loving-lilies, crowding her in, even as his other hand is held above her in blessing: the tissue-paper in the box made to resemble a white shroud.

By the time of his own final *Self-Portrait* (no.115) Spencer himself had been unsuccessfully operated on for cancer, and knew he was dying. Knighted on 7 July, he visited a friend in Dewsbury, Yorkshire, and the painting was completed over five days (12–16 July) 'in the drawing-room', and, he tells us, holding a mirror between his knees.[122] If the *Self-Portrait* of 1914 embodied Innocence, in a rich, almost voluptuous tonal realism that carried a promise of transcendence, the seer of forty-five years later personifies Experience, the gaze absolutely disillusioned; the mode of representation desiccated, restricted, factual. No previous painter had ever shown how a powerful lens enlarges and distorts the eye; how the two eyes, behind lenses of different strengths, pull apart. The head registers as extraordinarily intense and three-dimensional, using the simplest means: shadow to the left, dots just sufficiently conveying the recession of the wall behind. Wary, battered but undaunted, Spencer takes his leave in one of the most compelling of all twentieth-century portraits.

EPILOGUE: RESURRECTING SPENCER

He immediately descended into a near-complete critical limbo. By the time the first posthumous exhibition of any substance was mounted in 1976, Spencer was, in the words of *The Times*, 'regarded by many as a kind of joke';[123] or, as another reviewer put it, he 'hadn't been thought of much, or much thought of' in the seventeen years since his death, and was now seen as 'a parochial artist without much influence and without standing in the international stakes'.[124]

Spencer first lost his reputation in the 1930s and he never entirely regained it in his lifetime. His popular comeback in 1950 with the Port Glasgow *Resurrections* – the least convincing of all his imaginative cycles – soon rebounded, in the ridicule of Wyndham Lewis ('His naivety is painful, like the oppressive archness of a self-conscious little girl')[125] and in the more nuanced criticism of the young David Sylvester, in terms of 'formal defects'. Spencer's colour is 'either insipid or harsh … the quality of his paint is repellently lifeless'; 'the world he creates is not the *incarnation* of his idea, only the *illustration* of it'.[126] In Spencer's own famously self-critical preface to his 1955 Tate retrospective, the decline had begun a long way back: 'Today I was shown the list of works that were included in this exhibition and I found my interest waning as I came chronologically into the 1930s'.[127]

Certainly the retrospective failed in the eyes of his fellow-painters. John Rothenstein (Spencer's lifelong supporter and director of Tate) admitted that 'the artists active today whose work seems to me most likely to withstand the erosion of time have expressed, in my hearing, their small regard for his work'.[128] The painter William Townsend would register in his obituary of Spencer his 'dismay at the dry and joyless process by which patterns of tweed coats, print frocks, foliage, bricks are all reduced to a mesh-like mechanism'.[129]

The year before Spencer's death, Herbert Read wrote in his preface to *A Concise History of Modern Painting*:

I have excluded all 'realistic' painting ... I do not deny the great accomplishment and permanent value of such painters as Edward Hopper, Christian Bérard, Balthus or Stanley Spencer (to make a random list); they certainly belong to the history of art in our time. But not to the style of painting that is specifically 'modern'.[130]

For the next fifteen years the entire spectrum of European and American figurative painters from between the wars would become almost invisible. Spencer was displaced from the main galleries of Tate, to be hung only in the stairwell leading down to the lavatories. In 1962 Maurice Collis published his Spencer biography, a pioneering work, yet one which probably reinforced the popular misconception of him as a village eccentric mired in sexual misery.[131] As a young student at the Slade in the mid-1960s, I thought of Spencer as a kind of reprobate uncle, condemned to live for years on the frontiers of taste, excluded from the family of art. We knew him, but we nearly all disowned or denied him. Something of that dismissal comes through in a 1969 essay by the painter John Bratby: 'Today some people say that Spencer's work is pathetically idiosyncratic, and insular, and that the extent of his reputation in past years is a sure indication of the former parochialism and purblind chauvinism ... prevalent in England.'[132]

In 1974, Tate purchased Spencer's *Leg of Mutton Nude*, a picture previously almost unexhibited, which immediately went far to dispel any idea of him as a reassuring English ruralist. By setting in question the prevailing taboo, endorsed by Francis Bacon, by which tight description had been equated with mere 'illustration', it legitimised the naked portraits of Lucian Freud, and became a key icon for younger British painters in their project to retrieve or reinvent realism. Spencer had been thought of as isolated from the art of his time; but in the later 1970s a new generation had begun to look again at his European and American contemporaries, and to place him alongside, say, Balthus, Rivera, Beckmann, Dix, Schad and Hopper, as well as such English masters as Burra and Roberts.[133]

Thus by the time of Keith Bell's 1980 Royal Academy retrospective the climate was ripe for rehabilitation. As the reviewer of the *New York Times* explained:

In the heyday of modernist orthodoxy, Spencer seemed hopelessly provincial and out of date ... I found far more to admire in this retrospective than I would have thought possible a decade ago. This, I suppose, is one of the things we mean when we say that the age of modernism is over.[134]

True, in the following year Charles Harrison in his influential *English Art and Modernism* could write loftily of 'the lack of sophistication which limits all of Spencer's work', conceding only that the Burghclere series 'catch a quality which we miss in the works of many more intelligent artists'.[135] But in general, notions of 'progressive' or 'retrograde' art no longer appeared convincing. The centenary exhibition mounted in 1991 by the Barbican Art Gallery in London, bravely concentrating on the Church-House sequences, revealed an English art world still divided. The most positive responses came from younger painters such as Merlin James, who saw Spencer's refusal of *belle peinture*, his 'linearity', as parallel

to that of Blake; in both cases, 'a literary artist who writes his paintings'. Spencer's linearity signals 'a commitment to content over form – to the descriptive, narrative line … over the abstracting, anti-anecdotal painterly touch'.[136] Introducing the catalogue of a Spencer show at Tate Liverpool in 1992, the sculptor Anthony Gormley went further, presenting him as a hero for a new, post-modern generation. 'Through the vicissitudes of the contemporary debate on Art, Spencer persists … Spencer's position is radical.' The 'modernist trajectory', Gormley suggests, ended in 'anonymity'. But Spencer 'stands for the absolute subjectivity of the artist. His commitment to the personal and the parish is a celebration of the provincial, as the necessary texture of the global.'[137] From the early 1990s, with the publication of Bell's monumental catalogue and Pople's biography, the materials at last existed to see Spencer whole. He had been associated too exclusively with Cookham, and with a kind of 'essence of England' – a green road that beckoned with downland walks and teashops (with Samuel Palmer and Paul Nash) yet from which most post-war intellectuals had drawn back, because it seemed to lead only to nostalgia. Spencer's work appeared too much in denial of our multicultural, metropolitan present, to be of any real concern or relevance. Today that seems far too limited a framework by which to confine so complex an artist. With Spencer, as with so many other figures of the 1930s (I'm thinking here again of the West Country romances written from an anarchist milieu in America by John Cowper Powys), it is not so easy to separate the radical from the reactionary.

When, three years ago, the British Council toured a Spencer retrospective through Washington and San Francisco to Mexico, a new range of responses was heard. In Britain we'd always cast Spencer in, at best, a character role, but here were artists of all generations who seemed to be taking him seriously as a lead player. What other artist, they asked, has painted more courageously, more searchingly, about the self, about issues of sexuality? The Chicago painters Jim Nutt and Gladys Nilsson could enthuse about the way Spencer 'puts pattern and volume together'; above all they loved his art for being 'generated from the inside'. 'His internal personality really drove him.' In New York, Red Grooms told of his admiration for Spencer's 'compositional ambition'.[138]

Today I would assess Spencer as the most fulfilled and wide-ranging British painter of the twentieth century. He is more original (more 'irreplaceable') than Sickert, less formulaic than Bacon.[139] Like Sickert and Wyndham Lewis and David Jones, he is also a remarkable writer, and his vision is expanded by putting image and word alongside. Inherent in his art is a challenge to formalist orthodoxies – those of Fry and 'French taste' in his lifetime, and of New York abstraction immediately after. And this challenge is not only in his 'literary' or even 'illustrational' vein, but in his commitment to what I've called 'dirt' – to the most unsublime incarnate everyday object. Whatever my continuing reservations and disappointments in, say, Spencer's handling of paint, I am constantly moved and astonished by the unfolding of his art as a narrative of the self, unmatched in his time.

PATRICK
WRIGHT

PURPOSEFUL ART IN A CLIMATE OF CULTURAL REACTION: STANLEY SPENCER IN THE 1920S

The last decade has been one of anarchy in ideal and practice. Revolt as a good in itself: theosophy, Christian Science, patriotism, pacifism, magic, spiritualism, psycho-complexities and auto-suggestions, beliefs in majorities and, later, in minorities; all these have in turn been offered to a bewildered people struggling to the light. Against these ephemeral doctrines we offer the old yet ever-living dogma of the Catholic Faith as a balm and corrective to our present discontents.

Henry Slesser, 1927[1]

RESURRECTION AND WAR AT BURGHCLERE

However inadequate the available plot of land appeared in the early 1920s, the approach to the Sandham Memorial Chapel in Burghclere now seems quite classic in a southern English way. The National Trust's seasonally varied opening times are displayed on a noticeboard planted in the oak-shaded Berkshire hedge; and the gate opens onto a brick pathway that proceeds, straight as a ley-line, through a little grove of apple trees set in flowery native meadow grass. The building itself is made of red brick trimmed with white stone. Flanked by low, somewhat bungaloid wings designed as alms houses, the rectangular chapel is capped with a small and awkwardly proportioned pitched roof, said to be the consequence of disagreement between the architect, Lionel Pearson and his commissioning client. Though inspired by Giotto's Arena Chapel in Padua, Stanley Spencer's 'holy box' is, from the outside, more reminiscent of an early twentieth-century municipal crematorium or perhaps even a water board pumping station from the same era.

The First World War may be counted sufficient explanation for the fact that the path to one of Stanley Spencer's greatest works leads to an 'Oratory of All Souls' rather than an art gallery. And yet, considering Spencer's enduring reputation for eccentricity or 'oddness', it is still worth pausing by the steps to register that a much broader case was being made for 'purposeful' art in those post-war years. Introducing an album of 'modern art' reproductions published in 1919, the novelist and critic Charles Marriott identified two contrary traditions, and placed them on opposed sides of the wider and, in that politically fraught post-war year, aggravated division between capital and labour. The planners of national reconstruction looked forward to a world with more 'picture galleries', but Marriott (who had made satirical use of Roger Fry's second Post-Impressionist exhibition in

a novel called *Subsoil,* published in 1913)[2] responded to this thought by reminding his readers that the masterpieces of old had been produced for churches and palaces rather than picture galleries. Whether it be rooted in an isolated idea of 'nature' or an equally 'heretical' idea of 'abstract form', Marriott was in no doubt that 'the picture gallery view of art' would 'stand or fall together' with 'the capitalistic system'. In his view, which was in the tradition of John Ruskin and William Morris, authentic art was not 'an esoteric something with arbitrary rules invented by professors', but 'a refinement of labour' which must find its place outside a gallery system predicated on 'the chances of the market'.[3] It was aligned with craftsmanship, which 'demands not galleries but purpose'.

fig.28
The Sandham Memorial
Chapel at Burghclere.

There is nothing to be gained from trying to reduce Stanley Spencer's work to the scheme of a forgotten critic – even one as sympathetic as Marriott, who would eventually declare that the century had produced 'nothing so truly original' as Spencer's Burghclere paintings.[4] However, Marriott's insistence on the contrary, non-gallery based idea of art epitomised by Eric Gill does serve to suggest that the extraordinary singularity of Spencer's work is not merely a product of personal idiosyncrasy. Spencer shared that suspicion of the 'picture gallery' and its associated values. Though obliged to make much of his living through commercial galleries, Spencer rarely tired of deprecating the 'pot-boilers' he produced for them, especially the landscapes. He would describe his dealer as 'a kind of undertaker',[5] and he disliked high-faluting art talk too, paying no respects to the battery of 'isms' advocated by highly educated critics and collectors, or to Bloomsbury's aesthetic bureaucracy of 'significant form'. Although not a sculptor or letter-cutter like Eric Gill,

Spencer understood painting as a form of labour, and, as his own kind of 'primitive' medievalist, he would surely also have answered to what Marriott called 'an old belief that the processes of art are parallel to the process of Redemption – in which nothing of human nature must be left out in the return to God. It is the artist's parallel to the mystery of the Incarnation'.[6]

Spencer may have balked at the Roman Catholicism of Eric Gill, whom he visited in January 1919, but he certainly dreamed of more 'purposeful' spaces for his figure paintings. Before the First World War, he had conceived his first resurrection images with the spandrels of Cookham church in mind, and there were to be other, less conventionally holy halls that would exist only in Spencer's imagination, such as the Church-House with its various 'chapels'. There were also more practical schemes that came to nothing: the pictures of slum-life Spencer sketched for Leeds Town Hall in 1920, and the mural that Muirhead Bone invited him to paint in the club room at Steep village hall in 1921. Yet Burghclere's Oratory of All Souls was actually built, thanks to the more or less miraculous generosity of Mr and Mrs J.L. Behrend, who commissioned the Sandham Memorial Chapel to house Spencer's paintings and dedicated it to the memory of Mrs Behrend's brother, Lieutenant Henry Willoughby Sandham, who had died of illness contracted during the Macedonian campaign.

It took Spencer five years from 1927 to 1932 to complete the murals; and nothing, including familiarity, can insulate the visitor from the astonishment of walking into his work. *The Resurrection of the Soldiers* (fig.29) on the east wall confronts the visitor with an avalanche of white wooden crosses, not held aloft in the traditional Christian gesture but apparently tumbling out into the chapel's interior and piling up around the altar, which itself seems to be sucked into the world of the picture and, thanks to the faces of the men resurrecting in the trench behind (and Spencer's decision to '"holy" them up a bit'), converted into the table of an unexpected Last Supper.[7] It's only after registering the disorientating effect of that redemptive explosion that we begin to notice other details: the men rising up from the dead; the platform of the bombed cart, apparently inspired by one that Spencer had seen at Kosturino with its Bulgarian driver lying dead in the wreckage; and, surely quite late to emerge, the strangely diminished figure of Christ. Looking above the rectangular and arched panels on the lower reaches of the walls to left and right, one sees two river banks which seem to convert the floor on which the viewer is standing into a dry river bed. Not, in fact, a single river but a bank from each of two Macedonian rivers, the Varda and the Struma, which lay respectively to the west and east of the allied theatre of operations – and perhaps an allegorical hint of the river Jordan too.

Spencer's style of remembrance is quite unlike the stately ceremonials of Armistice

fig.29
STANLEY SPENCER
The Resurrection of the Soldiers 1928–9

Sandham Memorial
Chapel, Burghclere

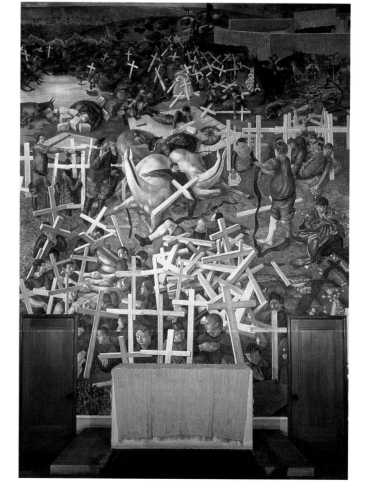

Day, or the formalised and impersonal presentation of the Imperial War Graves Commission's cemeteries, with their uniform Portland stone monuments. Presenting the story of the war as he experienced it, he starts with everyday scenes from the Beaufort War Hospital in Bristol, a vast 1600-bed institution housed in the former Bristol Lunatic Asylum, where Spencer started his service with the Royal Army Medical Corps. There's an image of kit inspection from the RAMC Training Depot at Tweselden Camp in Hampshire, and then the paintings open up into the huge vistas of Macedonia, where Spencer served both with the RAMC and later as a soldier with the Seventh Royal Berkshires. If these images are arresting, this is partly because they show a very different Great War than is remembered through the latter-day cult of the western front. Spencer's is a war without weapons, a landscape without mud, an army without purblind generals ordering their men into fruitless slaughter from comfortable chateaux sequestered miles behind the front line. Its locations include not just dug-outs and field kitchens but Arcadian stream banks and a bed in a made-over house in Salonika too – the one in which Spencer lay as a malaria patient surrounded by the intimate, home-like pictures he had pinned to the wall (fig.30). Spencer shows the vast unhoused world of an encamped army, but he reserves his details for scenes involving the symbolic removal of puttees, bilberry picking, dogs nosing around in empty bully beef tins, and exquisitely rendered mosquitoes caught in the apex of a hanging net.

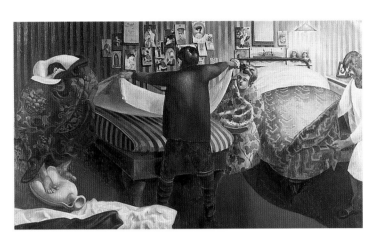

fig.30
STANLEY SPENCER
Bed Making 1932

Sandham Memorial Chapel, Burghclere

Simon Schama has called Spencer's Burghclere paintings 'the most powerful art to emerge from the carnage of the Great War'.[8] Samuel Hynes describes them as 'the last important war paintings of the First War, the largest, and the greatest', and declares their completion in 1932 a 'visual act of closure' in which the war was drawn to a conclusion.[9] Certainly, the work shows the institutions and experience of war infiltrated by the redemptive spirit that Spencer understood as 'peace'. Spencer himself wrote of 'what a marvellous thing peace was',[10] and the Burghclere paintings combine that marvel, which was the end of fighting, with, so Hynes suggests, three versions of the resurrection: the biblical resurrection in which Christ returns from the dead; the everyday resurrection of men waking into the morning, making preparations for breakfast, or stirring under their chrysalis-like mosquito nets as in *Reveille*; and the end of the war as represented by the Armistice of 11 November 1918. This layered and pervasive sense of resurrection is there in the tending of wounds, in the images of men drying one another with towels or cutting each other out of barbed wire, and in the gestures with which the crosses are presented to Christ, like rifles being surrendered to a store-keeper. It is also there in the absence of guns – weapons are as rare as officers who are, in turn, as rare as managers will be in the industrial *Shipbuilding on the Clyde* murals of the 1940s. As for the image called *Dug-out,* in which men come out of the ground and gaze around in amazed surprise, Spencer arrived at that by 'thinking how marvellous it would be if one morning, when we came out of our dug-outs, we found that somehow everything was peace and that war was no more … It is a sort of cross between an "Armistice" picture and a "Resurrection"'.[11]

Writing to his sister Florence during the Burghclere years, Spencer observed that 'They don't look like war pictures; they rather look like Heaven, a place I am becoming very familiar with'.[12] Yet the documentary intensity of the work, its careful rendering of ordinary

worldly activities and things, demonstrates that Spencer's sense of heavenly 'peace' was also deeply embedded in modern actuality. Spencer's resurrection takes place amongst tin cans, tea urns and hot water bottles. These delightfully rendered things of the world support Spencer's description of the work as 'a symphony in rashers of bacon' with a 'tea-making obligato',[13] but they also demonstrate that, while Spencer was indeed a religious painter, he was by no means otherworldly or blind to what he once called 'the joy of everyday things'.[14] Indeed, he is an artist of the secular in Geoffrey Hartman's sense: 'The secular is the sacred integrated, rather than degraded or displaced'.[15] Spencer's Burghclere paintings are not visual slogans content to offer formulaic 'salvation' to the fallen; and neither are they merely soft or elegaic in their pastoralism. They are engaged in a formidable struggle to integrate the sacred with a modern reality that has found so many ways of abandoning it. Spencer was very much in this world when he recalled the sense of perfection that had come over him once in Macedonia, making him feel like a 'walking altar of praise' as he plodded along behind a mule with a loaf of bread tucked under his arm.[16] He needed the mule and the loaf of bread as well as the thought of God to achieve that.

English 'Peace'

The murals in the Sandham memorial chapel are the work of an artist who thinks as well as sees, and one who was deeply read. Spencer carried books to Macedonia, and his mind was full of Homer, the Bible, St Augustine, Shakespeare, Ruskin, Dickens, Milton and metaphysical poets like John Donne and Crashaw. These texts resounded deep within his experience, and their thought is embedded in the images at Burghclere. Spencer would later provide even his mules with footnotes, remarking that while the two white specimens with heads turned back towards the disintegrated cart in the main *Resurrection of the Soldiers* may have come from the Vale of Health in Hampstead ('I saw the oil-cart, which was always drawn by two sleek-looking horses, and they were both looking round in this manner'),[17] the others were inspired by the herds of whales described in Melville's *Moby Dick*.[18] As for the resurrected men who can be seen gazing in thought or happy amazement at their crosses, they are transfixed by Christ's words: '"He that loses his life for my sake shall save it" … they are thinking of ideas arising from the words quoted … that it is actually impossible for anything good to be lost'.[19] These textual references are not offered as dry thought, or in the spirit of desiccated Bloomsbury intellect. Indeed, for Spencer they are connected to the love that comes from realising 'spiritual truth'.

There is a fugue-like musicality in the conception of the Burghclere murals, with recurring themes and motifs and refrains. Yet, as Sue Malvern has recently pointed out, Spencer also worked as a painter of narrative.[20] He himself spoke of the absorption one felt when reading a book, and asserted that it was 'a legitimate and proper thing for a painter to aim at … I wish people would "read" my pictures'.[21] And yet 'reading' Spencer's painting is not the same as tracing out an explicitly delineated story such as might be found in a Pre-Raphaelite portrayal of a scene from legend or history. In Spencer's biblical modernism, narratives are secreted or buried beneath surface appearances, like spells or little motors, which help power the process of resurrection.

As Spencer himself once wrote of the Burghclere paintings, 'When you approach truth you are approaching not just one single intellectual point; you are approaching an intellectual realm'.[22] That 'reading' a painting like this is not at all the same as reading a newspaper may quickly be deduced from Spencer's own treatment of the *Balkan News,* which was published in Salonica for the British forces in Macedonia. In *The Camp at Karasuli*, Spencer portrays it only as waste paper. As he wrote to Henry Lamb, 'I am just

about to paint the portrait of "me", striding past a bivouac and delivering the "coup de grace" with an old rusty bayonet to bits of the *Balkan News* lying about (see fig.58).'[23] If the *Balkan News* is being skewered on the south wall, it reappears opposite, this time being put to the flame, in an image called *Firebelt.* Spencer has painted himself into this scene too: one of four soldiers screwing up pages of the paper and using them as spills to burn off grass around the evening camp. The war correspondent who became its editor looked back on the *Balkan News* as a great blessing for the British army in Macedonia, claiming that it was well loved for keeping 'the mind uplifted and the spirits bright in men who are so long away from their homes'.[24] Yet Stanley Spencer's treatment of the *Balkan News* may suggest a view of the press rather closer to that expressed by H.J. Massingham during the last year of the First World War. In his book *People and Things: An Attempt to Connect Art and Humanity* (which is dedicated to and takes its title from Charles Marriott), Massingham denounced the 'scarlet press', which had sustained the war by stuffing people's heads with preconceived clichés, thereby creating a 'Man in the Street' who 'becomes actually a kind of incarnated headline; so that he does not talk, he rustles like the leaves of a newspaper'.[25] Richard Carline remarks that the bayoneted pages were included because 'Stanley liked painting litter for the interesting forms it could provide'.[26] Yet a resurrected newspaper is apparently also a material freed from its own sound and fury, and transformed by an artist who, years later, would tell John Read's television camera, that Cookham was really his newspaper: a village where minds certainly did not rustle with stately or plutocratic purpose, and of which Spencer could say 'I find something of myself all over the place'.[27]

It may be a relatively simple matter for an artist of Spencer's talent to convert a newspaper into mere stuff, but the Burghclere murals are also suffused with an Arcadian quality that seems to enter the very earth itself. Samuel Hynes describes them as being filled with 'a kind of pastoral innocence, as though the news of the death of landscape on the Western Front had not yet reached the outskirts of the war in Macedonia'.[28] It certainly hasn't reached the very top of the main picture, *The Resurrection of the Soldiers.* In Giotto's *Last Judgement,* this area is reserved for Heaven with its saved souls and attendant angels, but Spencer devotes it to a ridge of hills which rise up to form a horizontal line against the sky. As it appears to the centre right of this wall, Spencer's ridge looks unobtrusively Macedonian, but it changes to the left, becoming lighter in colour and wooded with deciduous trees: Macedonia recedes as the eye moves along that dull ridge, its limestone giving way, or perhaps resurrecting, into what is surely a radiant stretch of southern English chalk downland (fig.31).

The National Trust has a theory to account for this curious transformation. Their

fig.31
Detail showing the ridge at the top of Spencer's *The Resurrection of the Soldiers* 1928–9

Sandham Memorial Chapel, Burghclere

custodian explains that Stanley Spencer, who had initially planned an arched rather than rectangular image, found himself with a corner to fill. He turned round and saw Watership Down through the oratory's windows, and promptly decided to paint its likeness into the gap. Perhaps that story is overstated, and Spencer's green hill actually the expression of a less literal feeling of sympathy between two distant landscapes. Yet Spencer did call the Macedonian landscape 'chalky' in his letters home and he also noticed various affinities between the different geographies: declaring, for example, that the track from Karasuli to Kalinova reminded him of the track along Cockmarsh Hill at Cookham.[29]

fig.32
Gabriel Atkin's drawing on the cover of Mary Butts's novel *Ashe of Rings* 1933

Spencer was by no means alone in imaginatively blending the English countryside with a foreign battlefield in his recollection of the war. Many of the poets of the First World War made comparable connections. The Severn became interfused with the Somme in Ivor Gurney's mind; while for Edmund Blunden, it was the landscape near Yalding on the upper Medway in Kent: 'I suppose I liked the River Ancre between Hamel and Thiepval in the autumn of a year of holocausts because it resembled this little nook of our village. In my dreams nowadays they merge into an identity.'[30]

Landed estates and farmworkers came under severe pressure during the post-war years, but others were finding the countryside a place of compensatory attractions. The promise of pastoral recuperation drew various war-traumatised urbanites for whom, in the novelist Mary Butts's phrase, a cow was 'an obscene vision of the night'.[31] A more pulsating idea of renewal came with the vitalism and 'blood-contact' of D.H. Lawrence, whose short story, *The Blind Man* (written in November 1918), considers the case of Maurice Pervin, who has come home from Flanders blinded and hideously disfigured. Pervin has returned to his considerable grange in Oxfordshire, but now finds himself more at ease among the steaming and grunting farm animals than in the drawing room: a phallic figure rendered primal by his wound, he is a throbbing 'dark tower' who mortifies his intellectual rival and brings a 'dark, palpable joy' to his sighted, book-reviewing wife.[32]

The 'ley-hunters' who took to scouring the British countryside in the 1920s ranged over diverse geological formations, but there were others who concentrated their post-war dreams of re-enchantment on the chalk downlands of southern England – Sussex and Dorset, as well as Watership Down in Berkshire. As Edmund Blunden wrote in 1931, 'To us, the purity of the Downs, the "chain of pearls", is everything; but others are already fashioned by the human mart into another way of seeing, another beauty.'[33] And it wasn't just a sense of natural beauty that was formed up in that awareness of opposition. In the post-war years, the downland, with its barrows, sarsen-stones and other prehistoric residues came to be endowed with a utopian sense of 'peacefulness' that was often invoked against the memory of the war.

H.J. Massingham, who was surely the leading prophet of this post-war downland tendency, spared no effort to convert the southern English downs into a high country of the mind. He used pastoral conventions to heighten those characteristically low and rolling hills, lifting them up until they loomed over the modern world like a towering mountain range.[34] He then romanced their barrows, hill-top forts and other prehistoric relics, celebrating them as monuments to the 'antique dance' between man and nature that had once been lived on these deserted heights. Drawing on 'diffusionist' anthropological and archaeological ideas that have since been discredited, Massingham announced that the downs had been the chosen land of prehistoric man. He saw their prehistoric relics as evidence of a golden age, arguing that 'Downland Man' had not been the primitive 'raging

beast' of the Victorian imagination but was, rather, a co-operative, peace-loving creature whose culture, thought to derive from ancient Egypt, was far superior to that of the early twentieth century, and far more in touch with the benign essentials of human nature.

Massingham cited many archaeological and anthropological sources, but the key to his downland vision is actually to be found in his pre-war association with a magazine called *The New Age*. Edited by A.R. Orage, *The New Age* was a leading advocate of guild socialism, and therefore opposed both to plutocratic financial power and to the centralised bureaucratic state advocated by members of the Fabian Society. The guild socialists were exponents of a looser decentralised model, based on the craft guilds of the medieval age, and considerably influenced by the ideas of the great dissenting Victorians John Ruskin and William Morris. In the name of this vision, they had embarked on a 'crusade against the money power' as represented by a financial system that had broken up the old world of craft, uprooted the people, destroyed their common culture, and concentrated them in the industrialised city.

The war, which was quickly attributed to the same evil cause, had shattered the Frith Street circle in which Massingham had mixed with Arthur Penty, Jacob Epstein, W.H. Davies, Gaudier-Brzeska, T.E. Hulme and other affiliates of *The New Age*. It had been an abomination, a terrible 'abscess' bursting in the heart of the community, yet Massingham was scarcely more tolerant of the official post-war 'peace', which he placed inside distancing inverted commas. Despite the Armistice, 'the war went on, but underground, the war of exchanges, of fluctuating prices, of capital and labour, of getting something out of nothing. The "conquest" of nature was intensified … The moneylender bled the producer; cheap foreign food downed the good English stuff. Big business swallowed little craftsmanship. The town invaded the country, the machine conquered man. Debt declared war on security, economics on life, finance on God'.[35]

Massingham would later claim that the war had 'virtually exterminated'[36] his generation but, thanks partly to Massingham's own efforts, the project associated with *The New Age* was actually displaced rather than extinguished. Massingham quit Soho for the country, yet he continued to espouse the purposeful and 'communal art' of 'usefulness' that he hoped to see emerge between the morbidly polarised traditions of the time, that of the 'superintellectual' as against that of the tawdry 'vulgarian'.[37] He also continued to insist that 'modernism' should mean not 'the conquest of Nature' but the idea of 'the equality and freedom of men, irrespective of classes and nations', and that it would be nothing but a 'distraction' if it did not 'identify itself with the rebellion of the human soul against externalisation and of human life against mechanisation'.[38] He became a militant bird-watcher, fighting against the use of plumage in hats and, with the memory of his late friend W.H. Hudson in mind, celebrating birds as 'the art of nature'.

As for the guild socialist virtues of *The New Age,* Massingham rehoused them in an idea of traditional country life and, in particular, of the prehistoric people who had once lived on the 'skywedded' chalk uplands. If the English downlands were essentially democratic hills, this was not just because of the rolling egalitarianism of their topography (which allowed for no towering or dominant peaks), but because Downland Man, as Massingham now theorised him, was effectively a guild socialist projected back into the mists of time. Massingham tramped the downs in search of evidence of the prehistoric golden age that had once been lived among the hill-top towns – idealised green 'rings' such as Gabriel Atkin drew for the cover of Mary Butt's novel *Ashe of Rings* (fig.32), and which Paul Nash would eventually oppose to the cancerous industrial city spreading through the valley

fig.33
Paul Nash's cover for
H.J. Massingham's
Remembrance 1942

below in the image he made for the cover of Massingham's autobiography *Remembrance* (fig.33). Having strolled over the residues of 'the archaic civilization', Massingham was convinced that ancient downland settlements such as Maiden Castle and Badbury Rings had been 'camps of peace', amicably linked together like the 'Federation of Independent communities' described in William Morris's *News From Nowhere*. In Massingham's thought, the peaceable communities of Downland Man had been the antithesis of the degenerate modern 'machinist' view of life, a portmanteau concept in which many evils were combined – money-power, the industrial factory system, war, and the destructive urban culture that was steadily advancing along 'metal' roads in the valleys below, reducing the countryside to a dead, picturesque view. In his essay 'Maiden Castle: a Theory of Peace in Ancient Britain', published in 1924, Massingham hurled the thought of that idealised prehistoric town at the post-war British politicians who mocked the idea of peace advocated by the newly established League of Nations as a ludicrous fantasy that ran contrary to human nature.[39]

fig.34
STANLEY SPENCER
Landscape with Cultivator 1920

Oil on canvas
Whereabouts unknown

Stanley Spencer had painted the southern English downs before he started work at Burghclere. Staying at the Dorset village of Durweston in the summer of 1920, he had painted Hod Hill, and Bulbarrow, which Massingham would describe as 'the two great frontier camps of the Wiltshire and Dorset downs'.[40] Some of Spencer's Durweston landscapes were painted in an anti-picturesque spirit, with an eye for despised weeds like the charlock in *Durweston, Hod Hill* (no.28), as well as for the folded turf of ancient ramparts. Yet they also seem far less arresting than the uncanny downland imagery of Paul Nash. Spencer himself was inclined to belittle these works, and his criticism would be repeated by John Rothenstein, who dismisses Spencer's landscapes as 'purely retinal' things, 'pedestrian' by comparison with his religious pictures, and done for money.[41]

That description may adequately characterise some of the landscape paintings Spencer later produced of the downland near Burghclere too – of Watership Down, Highclere and Inkpen Beacon. However, a contrary idea of 'peace' still penetrates deep into the rocks of his Burghclere murals. It can be elucidated with the help of a partly hidden 'avenue of incidence' (Gilbert Spencer's phrase) in *Camp at Karasuli*.[42] This painting, on the oratory's upper north wall, is dominated by the scene in which the carcass of a pig is butchered, and distributed to the soldiers as breakfast rashers. The image of dismemberment, which justifies Spencer's description of the work as 'a symphony in rashers of bacon', is echoed in the drama of the land itself. Above the bacon scene, and easily overlooked at the very top of the canvas, is a white rectangular hole cut into the hillside. This minor detail may be the diminished residue of Spencer's earlier study, produced in 1923, which envisaged a large dug-out in the area that was eventually covered by the bacon cutting scene. Yet it is possible to pick up a different thread of meaning here, which suggests that a kind of butchery is being practised on the land itself. The distant dug-out is rendered more suggestive by the rocks that lie scattered like clues on the ground in front of it, and also by the men who are seen further over to the right, pulling Avebury-like stones out of the ground and carrying them off past the camp (fig.35). According to George Behrend, this image records how the Seres military road was built: stones were gathered, broken down into smaller pebbles and then rammed into the ground to make a hard surface.[43]

This theme of breaking the earth is reprised in *Riverbed at Todorova* on the opposite wall. Here too men are shown cutting at the ground, and gathering stones at the water's edge. On this side, however, the pebbles are being pressed back into the earth in the form of mosaics. Some of these show regimental badges but the decisive symbol is a red cross made of pebbles and fragments of shattered tile (fig.36). This may well have been a 'recognition symbol' for aircraft, as Kenneth Pople suggests, but in Spencer's symbolic drama it serves to draw the many wooden crosses of the east wall's *The Resurrection of the Soldiers* into a final statement of peace. Spencer

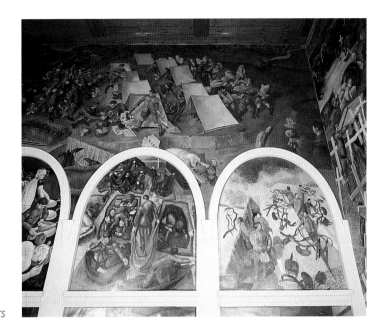

will have known it in its national use with the Royal Army Medical Corps, but the red cross also evokes the humanitarian spirit of the Geneva Convention of 1906, and of the International Committee of the Red Cross, founded in 1863 in response to the horrifying and unattended sufferings of those wounded in the Battle of Solferino. The mosaic is an image of reintegration, and not just for the stones pressed back into the cut and broken earth. It belongs in the same moral world as the last words of the executed army nurse Edith Cavell: 'patriotism is not enough, I must have no hatred or bitterness for anyone'.

'It was not a landscape, it was a spiritual world'.[44] So Spencer once said of Macedonia, and the same thought applies to the Burghclere murals. Here as elsewhere in Spencer's work, a biblical resonance is discovered in the basic materials of everyday life: enduring stuffs like cloth, wool, twine, leather, or the loaves of bread which may, as Sue Malvern suggests, evoke the life of Christ. The stone bearers in *The Camp at Karasuli* have an Old Testament shadow too. On 7 June 1917, after the trek that brought his unit to Todorova, Stanley had written to his sister Florence to say that he had been reading the book of Joshua, and especially chapters IV and V, which tell of the Israelites' divinely assisted advance across the Jordan and their subsequent assault on Jericho. On God's instructions,

the procession is led by priests bearing the Ark of the Covenant, and the moment their feet enter the water, the river is miraculously broken and dried to form 'a heap' under the feet of the advancing priests. Forty thousand armed warriors pass over the riverbed, and God commands Joshua to pick one man from each of the twelve tribes, and order these chosen ones to lift up a stone from the riverbed where the priests had stood. The raised stones were to be carried to the place where Joshua's host camped that night, and there set in the ground as 'a memorial unto the children of Israel for ever'. The stones were duly erected at

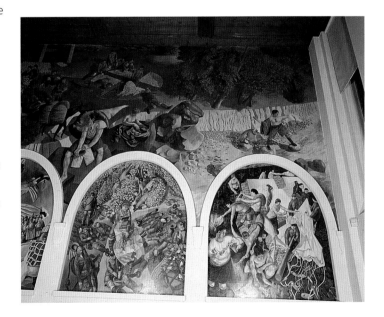

Gilgal, and Joshua then went on to besiege Jericho, compassing the city about for six nights as the Lord required of him. On the seventh night the walls fell flat as Joshua's trumpets sounded. The Israelites poured in and, with the exception of the harlot Rahab who had assisted Joshua's spies, 'utterly destroyed all that was in the city, both man and woman, young and old, and ox, and sheep, and ass, with the edge of the sword'.

Spencer described reading these verses in 1917: 'Well I saw the High Priests and the mighty men of valour going round the walls of Jericho and blowing on their ram's horns, and then I heard the sound of falling walls and buildings, and then I saw men rushing in on every side massacring men, women and children. Well, I thought, this seems all very nice but something very nearly stopped me getting to this 'very nice' part; it was the part where God commands Joshua to detail one man out of every tribe to carry a stone from out of the centre of Jordan where the Priest's feet stood firm and to take them to where they would lodge that night. Oh, I thought, if God's going to be detailing fatigue parties, I'll be a Hun!'

Light-heartedness was an agreed precondition of that correspondence with Florence. Yet at Burghclere, Spencer seems to have resurrected the story of Joshua's stones and the fall of Jericho with the more serious purpose of purging its violence. His stone-bearing men appear to be uprooting Joshua's planted menhirs and carrying them back towards the dry riverbed from which they had been lifted. Joshua's camp at Gilgal was close to the walled town of Jericho, and Spencer's *Resurrection of the Soldiers* also shows men camped outside a walled town of sorts. As Spencer describes it, the village of Kalinova 'had a wall round it, which gave it a feeling of being a big place. In the picture, the only thing that is like the place is the bit of wall of the town in the top right-hand corner.'[45] Kalinova is not merely a symbolic stand-in for Jericho. Once evoked, however, the thought of Jericho's destruction lends weight to the fact that the walls of Spencer's town have not fallen.

Metal – Bad Stuff

If Stanley Spencer found his own ways of installing a post-war idea of 'peace' in his resurrection murals, he also surrounded it with metal: a symbolic material that was not so easily resurrected as other 'stuffs' of everyday life. And here too, H.J. Massingham's post-war thought may be suggestive. In this outlook, the very idea of metal could hardly be mentioned without implying all that was wrong with the world. In his polarised vision, metal spoke at once of the rupture that had destroyed his megalithic Arcadia, and of the mechanised weaponry that had carved up humanity in the recent war. Thanks to his roots in the pre-war guild socialist tradition, the metaphoric 'metal' against which Massingham railed also reprised the pre-war thought of figures like Hilaire Belloc and William Morris, for whom iron was often synonymous with the evils of industrial capitalism. It was a composite evil: war-forged, but also quite capable of symbolising the motor car, the metalled road and even the metal ploughshare, which some of Massingham's wilder agricultural associates would come to revile as more damaging to the soil than its traditional wooden precursor.[46]

The Burghclere murals show Spencer participating in the metallic symbolism of his time, but taking it in a direction that is strikingly his own. In Spencer's original conception, the whole of the east wall was to show men rising up in barbed wire, caught in 'different attitudes, but all praying to a figure supposed to be Christ, who is disentangling them'.[47] That scheme was discontinued, but we may doubt that the wire lost all meaning when Spencer relegated it to 'a secondary idea'. In the paintings from pre-war Cookham, metal may have been the comparatively stable, even symbolically inert material of door knobs and railings, and 'our back iron gate.'[48] But in the Burghclere images (where, despite Spencer's pruning of his initial idea, men are still to be seen cutting each other out of the wire), metal denotes both the brutality of modern warfare, and its harsh

institutionalisation of experience. The first image on the north wall shows a bus full of wounded men arriving at the gate of the Beaufort War Hospital (fig.37). Spencer later described this as 'a vile cast iron structure', the 'gate of Hell' guarded by a terrifying man ('his eyes were beefy') who also 'did the cutting up at post-mortems'. Arriving in 1915, he had found it a kind of Hell mouth and all his 'patriotic ardour' seemed to leave him as he stepped through it. The reality he encountered in this institution was so contrary to everything he had known in Cookham that he felt that the men at Beaufort would evaporate into nothing 'should they journey to where my home is'.[49] The hardened ground at Beaufort War Hospital had 'a ring' of iron about it, and 'the lamposts, sign posts railings, the trees seemed to be rivetted to the ground: a steel-like uniformity prevailed and nought would prevail against it'.

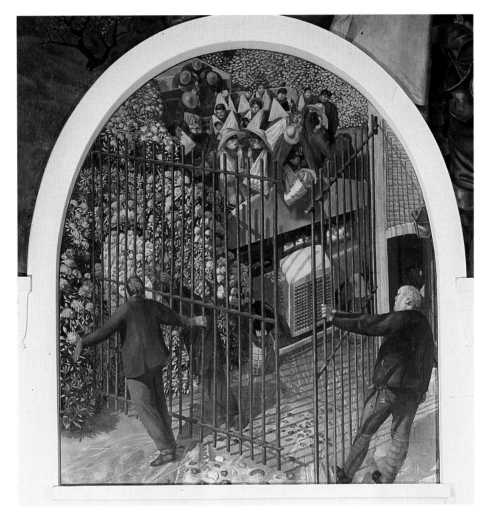

fig.37
STANLEY SPENCER
*Convoy of Wounded
Soldiers Arriving at
Beaufort Hospital Gates*
1927

Sandham Memorial
Chapel, Burghclere

Even before the war, artists were seeking to improve the world by taking metal out of it. In *News From Nowhere,* William Morris had condemned the new bridges on the Thames as 'hideous iron abortions' or '"Gothic" cast iron bridges' and imagined them replaced by handsome stone or solid oak framed structures.[50] Perhaps it was partly in tribute to Morris's anti-industrialism that Spencer converted Cookham's iron bridge into a stone structure in one of his early post-war paintings, *The Bridge* (fig.54). In general, however, he was not inclined to subtract metal from the world in the name of peace or beauty. Indeed, he became a virtuoso painter of that evocative post-war material. Thus the painting *Landscape with Cultivator* (fig.34), also known as *Durweston with Harrow*, has a quality that lifts it out of the category of merely 'retinal' art. Spencer records that this image 'took ages to do', partly because he 'felt nervous of man cutting hedge I was

behind'.[51] He also 'disliked the way I did hill on right and the cornfield'. Yet the result is a carefully composed image of earth and metal integrated, a picture of fructification rather than of chaos and destruction. Two years after the guns ceased, here is a metal instrument harmoniously arrayed at the centre of the historical landscape it has helped to create. It is surely the precise opposite of a war painting.

Metal remains symbolically active material in Spencer's work from that point on. In some pictures, it seems merely part of an observed scene, as in *The Blacksmith's Yard, Cookham* (no.42). But it is more evocative in other works – in *The Jubilee Tree, Cookham* (no.43), say, in which stately dedication is embodied by the protective iron surrounding a decidedly frail-looking young tree, and echoed by the war memorial behind; or *The Turkish Window*, where metal bars seem to intervene between people and their Godly-carnal pleasures. But Spencer's greatest metal works are to be found in the Port Glasgow *Shipbuilding on the Clyde* murals, painted during the 1940s on commission for the War Artists' Advisory Committee. In this remarkable sequence, men are shown literally wrapped in steel: 'at home' in this unlikely material just as soldiers in the Burghclere paintings were in their enfolding mules, and yet also winning it over – burning it, shaping it, pulling it out

fig.38
Roman arrow head in the spine of an ancient Briton discovered at Maiden Castle, Dorset in the 1930s.

of fiery furnaces in images of heroic labour. The most powerful of Spencer's Port Glasgow work is to be found in murals like *Burners* or *Welders*, conceived, once again like the Burghclere pictures, to be shown together in a 'purposeful' or 'chapel-like' display. Yet there were other, smaller works including a painting called *The Scrapheap* (no.105). This is a powerfully rendered image of rusting iron, a portrayal of roughly sorted war material at rest in its latency. It is surely not wholly remote from the imagery favoured by the League of Nations between the wars, in which iron was imaginatively suspended between its possible uses as sword or ploughshare, or even from the pacifist insistence that 'steel has no fatherland'. That phrase is quoted from Fenner Brockway and Frederic Mullally's *Death Pays a Dividend* (1944), an indictment of the armament manufacturers ('merchants of death') published that same year, which opens with an accusing photograph of a mountain of scrap steel, in this case 'No. 2 Heavy Metal Steel Scrap', being loaded onto a Japanese freighter at the quayside in Long Beach, California.[52]

For H.J. Massingham, the celebrant of 'Downland Man', iron may have lain in the body of the old organic nation as fatally as the Roman arrow-head lodged in the spine of the ancient Briton so famously unearthed by Sir Mortimer Wheeler at the west gate of Maiden Castle in the 1930s (fig.38).[53] But Spencer's metal found a different final resting place. However successfully he may have transfigured the world of the riveters and furnace-men of Port Glasgow, he reserved some of that lethal early twentieth-century stuff for his last crucifixion painting of 1958. *The Crucifixion* (no.113) is set on Cookham High Street, and the unresurrected iron is in the black nails being hammered into Christ's hands, while the ordinary thieves crucified beside him get away with rope.

COMING HOME TO 'THE CHANGE'

2 September 2000 was Regatta Day in Cookham. In the Stanley Spencer Gallery, housed in the old Methodist chapel at the bottom of the High Street, a voluntary attendant pointed

to Spencer's huge unfinished canvas, *Christ Preaching at Cookham Regatta* (fig.39), and in particular to the gestures of the smart-shoed hotel keeper and his wife. The pair are standing on the bank in their hotel garden, gazing out at the punt-filled river. They may be pretending to listen to Christ who is firing fierce words straight into their faces, but Spencer leaves little doubt that they are really appraising the lucrative crowd. She has a hand behind her back, and is using her fingers to gesture about the fat pile she and her husband can expect to have made by the end of the day. Plainly, Spencer understood the financial dynamic that defined the summer season at his Thames-side village.

Further along the car-choked High Street, there were signs of transformation behind the rampant privet hedge outside the Spencer's family house. Built by 'Grandpa Julius' in the late nineteenth century, Fernlea has recently been sold by the owner of the nearby Tandoori restaurant, who for many years had used it to accommodate his waiters and kitchen staff. The unmistakable figure of Eddie Smyth (fig.40) came into sight a few paces later. He was walking with the help of two sticks, and wearing a great smile under a straw hat adorned with colourful woollen string, old regatta passes, the business card of a favoured building surveyor, and a large sign berating the parish council for its plan to deal with the ever rising tide of summer visitors by building a new car park in Marsh Meadow. This defender of old Cookham looked gloriously out of place on a high street that has disappeared so far upmarket that an unaccustomed villager could search its entire length and still not be able to find a pint of milk or a tin of beans for sale.[54] Yet he was immediately identifiable from *The Crucifixion* of 1958 (see no.113), a painting that was commissioned by members of the Worshipful Company of Brewers for the chapel at Aldenham School in Elstree. 'I've got you at last', Smyth remembers Spencer saying

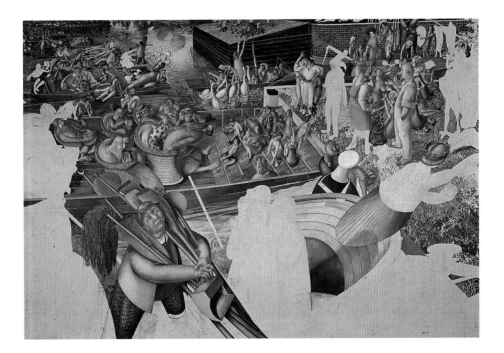

fig.39
STANLEY SPENCER
Christ Preaching at the Cookham Regatta
(unfinished)

Oil on canvas
Private Collection, on loan to the Stanley Spencer Gallery, Cookham

when he first saw the work, exhibited in Cookham Church that same year. It was as if Spencer had spent his life casting a medieval mystery play and had finally found a suitable role for this long-noted local character who, at that time, still worked as a project manager for a high-class Scottish building firm. So there was Eddie Smyth, gazing out from a picture that has been likened to an 'explosion' of malice.[55] Spencer has placed a red brewer's cap on his head, in bitter tribute to the ancient if hardly worshipful guild that had commissioned the work. Smyth has four of those horrible iron nails in his mouth, and is

gleefully hammering a fifth into Christ's hands, extended as they are along a cross that stretches over Cookham High Street like the 'crashed airliner' of Spencer's own description.

Stanley Spencer is remembered in Cookham, yet it could hardly be said that his memory is adequately contained by the prevailing invocations. There is a restaurant called 'Spencer's', a café named 'Two Roses' (after the painting that Spencer tried, unsuccessfully, to present to the Queen Mother when he was knighted), and the tourism agency duly promotes the place as 'A Village in Heaven'. But these attempts to anchor Spencer's memory will not close the growing distance between present-day Cookham and the singular artist who pulled airliners out of the sky as crosses, planted a muddy trench full of African natives in the churchyard, turned a scarecrow into a vision of the Crucifixion, and eroticised the local scene, right down to its plants, matrons and swans. During that John Lewis-sponsored exhibition of his works in Cookham Church in 1958, Spencer declared that Christ was crucified every day on Cookham High Street, and Eddie Smyth is surely not the only old Cookhamite who is still looking around and wondering exactly what Stanley might have meant by this characteristically provocative remark.

Soldier's Return

The facts of Spencer's 1915 departure from Cookham are well-known. Many have described him slipping away in his mackintosh, reciting Spencer's own retrospective account of how he left the village of his childhood for the straitened world of Beaufort War Hospital and then the war in Macedonia. Walking out towards Maidenhead, he encountered a huge storm as he crossed North Town Moor. His straw hat disintegrated in the deluge that later came to seem, so Spencer would write in 1944, 'a kind of pre-vision of what I was to see and experience'.[56] Yet the Burghclere paintings encourage curiosity about Spencer's return from the war, the experience of which informed his work far more deeply than his reputation as a cruelly dislodged son of the Thames may acknowledge.

Britain's returning soldiers were released into a country wracked by industrial and political confusion. The slow post-war demobilisation was purportedly designed to meet the needs of employers that could not easily reabsorb armies of returning workers. Yet it was also presided over by a government nervous of events in Russia, Holland and even defeated Germany where revolutionary ferment led by returning soldiers was to be violently suppressed in many cities. Like many serving soldiers, Spencer had expressed socialist inclinations in his letters from the front. As he told his friend Desmond Chute from Macedonia: 'I feel that the poorer classes … are not being given a proper chance to live … their progress seriously impeded towards attaining a really high understanding of truth, purely through the fault of unnecessary, petty, material inconveniences'.[57] Cookham was not Glasgow, where the British government used tanks to overawe strikers in February 1919. However, the thought of socialist insurrection caused agitation here too. Shortly after his return, Stanley and his brother Gilbert were confronted by 'a very excited and belligerent old gentleman with his arms full of armlets, who wanted to despatch us to vulnerable points on the railway. We did not know what was the matter. But when, later, we realised that we were now in the nature of shock troops sent to meet the first of the post-war crises, we decided not to parade any more. We were not a bit interested in strike-breaking'.[58]

Spencer had been shipped back to England by overnight boat from Cherbourg to Southampton. According to a retrospective account written in July 1942, 'the first I saw of England after two and a half years away was [a] light apparently going out continually'.[59] This ominous sign was caused by a light house on the Isle of Wight, but Spencer regarded it as an omen – that 'although my work went on without regard to circumstances after leaving Cookham in 1915, still some change in me seems to have occurred and faintly affected all I did as I went from one place and circumstance to another'.

Some came back damaged and ruined, but Spencer would recall feeling more like a character in *The Arabian Nights,* setting out on an adventure, 'with reasonable hope and in a state of happy anticipation'. When the dawn enabled him to gaze at the approaching English coastline, he had imagined himself as 'a future being' of that country: 'I wished both to be involved & to retain this almost detached view of what I then saw and felt.'

The men were bossed about at Southampton, and then put on a troop train to the Berkshire Regiment's depot at Maidenhead. Spencer was given civilian clothes and sent home to Cookham on two weeks' leave. He had his first 'non-soldier human contact' sharing a carriage with a mother and her little girl on the train to Maidenhead. They didn't talk, but the child's hair fell on Spencer's shoulder and it was 'a moment in my life I felt a great deal'. So far so good, as Spencer described thinking to himself. And all seemed fine at the station too, where he heard the voice of the ticket collector he had encountered every evening between 1907 and 1912, when returning to Cookham from the Slade. From Maidenhead, the branch line train took him home. 'There I was back in Cookham' and 'almost bewildered with happiness to be so', as he recalled: feeling 'in bliss' and lying awake at night and listening to 'the Cookham sounds'.

At home by Christmas 1918, Spencer resumed his work as an artist. He tried painting a picture of desolate Macedonia, but found it 'like painting a picture of Hell the minute you arrive in Heaven'. He retrieved his unfinished canvas of *Swan Upping* (no.18) and completed it – although not to his own satisfaction. In response to a commission for the Ministry of Information, stimulated by the former war artist Muirhead Bone, he spent eight months painting his first major post-war work, *Travoys with Wounded Soldiers Arriving at a Dressing Station at Smol, Macedonia* (no.21) – working at first in his bedroom at Fernlea and later in a loose box at nearby Lambert's stables.[60] Shown as they are brought into the dressing station on mule-drawn stretchers, the wounded and blanket-covered men in this powerful picture appear in the 'spiritual ascendancy' that had, so Spencer remembered, lifted the scene above the expected sordidness and terror. They had a divine ambience: 'like Christs on the Cross they belong to another world than those tending them'. Intended to 'convey a sense of peace in the middle of confusion', *Travoys* was to have initiated a whole series of paintings of the war in Macedonia, but Spencer pulled out of the scheme in July 1919, telling the Ministry of Information that he had lost his 'Balkanish' feelings, and wondering, so he recalled in 1942, how he had also misplaced that 'not complacent' serenity he had felt on the homebound boat.

Spencer kept working. In December of that year, he exhibited alongside Matisse, Augustus John, Picasso, Nina Hamnett, Modigliani and others in an exhibition of modern drawings ('to be priced in reach of undergraduates') in the gallery of the *Cambridge Magazine* – a weekly university magazine that, having been turned into a pre-eminent national platform against the war by its pacifist editor Mrs Charles Roden Buxton, was now taking steps to redress 'the inartistic milieu of Cambridge'.[61] Yet he was discontented. He lacked room in which to paint, but he was also struggling to come to terms with what he called 'The Change'. Within weeks of his return from Macedonia, he had discovered that a returning soldier can never really go home. His most admired brother, Sydney, had been killed, and though Cookham remained 'part

of my mind and spiritual sense', it too seemed to have slipped, grievously, into the past. Spencer tried to manage this transformation by observing that 'all things … seemed to have to be memories in order for me to love them'.[62] Yet 'The Change' was more objective than that. He had returned to a village that was full of what Gilbert called 'cooling-off and re-alignments'. 'The old island feeling was going', and Parson's cab was busy ferrying villagers off on the way to Australia and other new worlds: 'Cookhamites were leaving as though it did not matter, and strangers were filling their places'.[63] The war had decentred Spencer, and in some respects even usurped Cookham as the place from which he had come. 'The Change' also coincided with the end of what has been called 'The Golden Age' of the Thames.[64]

Time and the River

Stanley Spencer had grown up in the years that marked the high point in the Thames's history as a place of summer resort, and Cookham lay on the classiest stretch of the river. Cliveden Reach, which extends downstream from Cookham lock to Boulter's lock at Maidenhead, has long been known as one of the lushest and most beautiful sections of the Thames. Cliveden House presided over the scene as a grand bastion of class power, and the river itself resounded as refined admirers of scenic beauty came face to face with lower-class excursionists who pressed in with very different ideas of enjoyment in mind. This battle between aristocratic refinement and vulgar pleasure had been a feature of the Thames season ever since the railways added popularity to a river on which rowing, so long the labour and living of paid watermen, was also being converted into an upper-class 'amateur' recreation. Besides getting congested, the Thames locks, most famously Boulter's lock in Maidenhead, became places of outrageous insult, where drunken 'lock loungers' would delight in offending genteel ladies in boats, or guffawing rudely at the pig-tail of a passing Chinese prince.

By the end of the twentieth century, Cookham Regatta had dwindled to a charitable fun-fair with dragon boat racing thrown in. An enthusiast could be seen showing off a solar-powered Canadian canoe, but the only wooden punt in sight was a motorised eccentricity being used as a posing platform by a faintly ludicrous gentleman who spent the day showing off with a bottle of Chablis. Even in its Victorian and Edwardian 'Golden Age', Cookham Regatta was no match for the Henley Royal Regatta. Yet it drew 10,000 visitors and itinerant banjo players as well as the band of the Grenadier Guards. Famous for its amateur punting races, it was also attended by Venetian gondoliers, houseboats decked out with huge fans, and steam launches adorned with flowers from the riverside meadows. There is no record of opera singers wafting by on punts, accompanied by similarly floated upright pianos, as was recorded in Maidenhead, but there were certainly exotic balloons: 'one year an elephant balloon was reluctant to ascend. On being kicked, he knocked a hedge, turned to scowl, and finally roosted on the top of a high elm'. In August 1888, it was a gassy replica of Mr Gladstone that floated away with 'arms outstretched in benediction'.[65]

As a result of this historical conversion of the Thames from a working means of transportation into a leisurely amenity, to walk along the river around Cookham in the early years of the twentieth century was to stroll through a whole body of utopian literature. In *News From Nowhere,* William Morris had resented the ostentatious riverside villas that marked the 'Cockneyfication' of this part of the Thames. Kenneth Grahame, a clerk who rose to become Secretary of the Bank of England, had other concerns. He built his memories of childhood in Cookham Dene into *The Wind in the Willows.* He turned Quarry Wood, which Spencer would paint as a straight landscape in 1920, into 'The Wild Wood', and introduced his own creatures to the river: not just Ratty and Mole,

but 'the loafer', a Bohemian type, who hung around Thames villages like Cookham, resisting the strenuous exertions of the skiff or bicycle and preferring to drink, smoke and gaze at the stars.[66]

In the more land-locked world of the contemporaneous novelist T.F. Powys, whose strangely eventful Dorset villages compare tellingly with Spencer's inter-war Cookham paintings, symbolic destabilisation is achieved by rushing cars, the apparent coming of God in the form of a travelling vintner, and the caprice of all-powerful farmers and landlords.[67] But it was the river that made Cookham susceptible to strange and unexpected visitations. Its season was made up of people and presences constantly sweeping into view and then disappearing just as quickly: the King of Siam, perhaps, or just another noisy party of beanfeasters on a day out.

One of the primary machines in this theatre of showy comings and goings was the steam-powered passenger launch, the first of which had gone into service from a Bourne End boatyard in 1880.[68] The example that lodged in Stanley Spencer's imagination was operated by a company called Bond, which worked from a boatyard opposite 'Skindles' hotel in Maidenhead. John Bond, the 'patriarch of Thames boat-builders', had been one of the first to make a living out of 'boat-letting'. Shortly before his death in 1892, he constructed a steam launch that was said to produce 'the merest wrinkle' on the water when travelling at full speed. His son built a launch called *The Empress of India,* which could sleep eight, dine fifty, and accommodate 250 day trippers.[69] *His Majesty,* built for the 1906 season, was even larger. The Bonds never came up with the invisibly propelled 'force-barges' that William Morris imagined replacing steam power on the Cookham Thames in *News from Nowhere.*[70] They did run an electric steamer called the *Formosa,* presumably named after Cookham's Formosa Island, and electric canoes were also

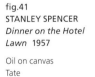

fig.41
STANLEY SPENCER
Dinner on the Hotel Lawn 1957

Oil on canvas
Tate

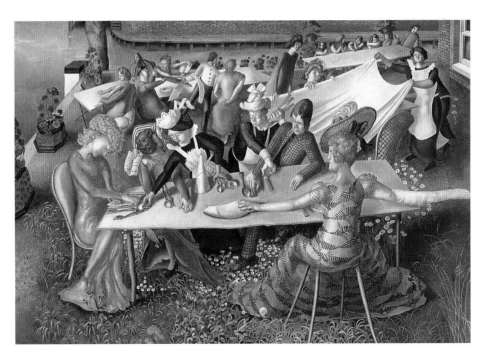

introduced in 1912. However, it was Bond's steam launch that caught Stanley Spencer's imagination.

The coming of these 'tea kettles' caused considerable dismay on the Thames.[71] They vibrated, spewed smuts, belched smoke and made a terrifying noise with their whistles. Passengers sat with their back to the view since, in the bow, wind and spray rendered 'a steady gaze a-head very uncomfortable and a smoke out of the question.'[72] Court records reveal their propensity for capsizing artists, fishermen and birdwatchers; and they

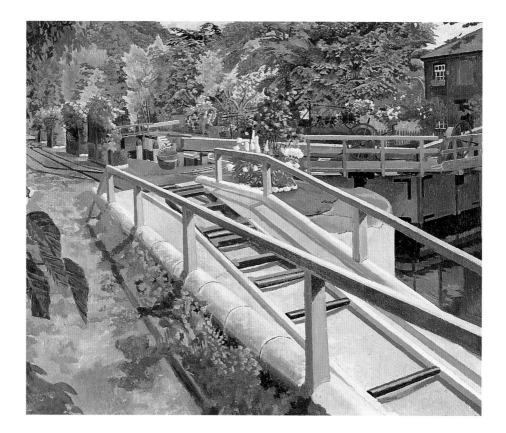

caused nasty incidents in locks too. On one typical occasion, a steam launch smashed into another while leaving Cookham lock (see fig.42), and broke her flagstaff. Refusing to pull over, it ploughed on regardless of the cursing it left behind.[73] Writing in the 1880s, Jerome K. Jerome described the view from a camping skiff caught among steam launches surging upriver for Henley Royal Regatta: 'There is a blatant bumptiousness about a steam-launch, that has the knack of rousing every evil instinct in my nature … The expression on the face of the man who, with his hands in his pockets, stands by the stern, smoking a cigar, is sufficient to excuse a breach of the peace by itself'.[74]

Spencer, of course, saw things quite differently. Just as he would convert the river's swans into the figures of a feathery and strangely angelic sexuality and, for that matter, just as he appears to have favoured demotic punts and skiffs and avoided painting the posh fours and eights of the University boat race or public school competition, he had his own perspective on the whistling visitation that was the Thames steam launch. In his first painting of *Bond's Steam Launch* (no.34), Spencer granted the tightly packed excursionists a detachment similar to the one he attributed to the Christ-like wounded men in *Travoys*: he had, as he later explained, always regarded the passengers on these passing vessels, 'as a special kind of people different from ordinary humans'.[75] Spencer expanded on this point when he painted Bond's crowded steam launch, complete with piano and thronging passengers, into the top left-hand corner of *The Resurrection, Cookham* (no.35). 'This is supposed to be people going to heaven', he wrote, adding that this was 'not as far fetched' as it sounded. As a child, he had watched those pleasure launches coming and going from Maidenhead, Reading or Oxford, but he had never been on one, and they didn't stop at Cookham either: 'They came from a world I did not know and disappeared into an unknown.'[76]

LODGING WITH THE SLESSERS

It was through Mr and Mrs J.L. Behrend, the patrons who would later finance the building of the Sandham Memorial Chapel at Burghclere, that Stanley and his brother Gilbert got to know Henry Slesser and his wife Margaret. The Slessers lived a few miles upstream from Cookham at Bourne End. Their house, 'Cornerways', is pleasantly situated in a leafy and still private enclave called the Abbotsbrook Estate. It will have counted as part of the new suburban world in April 1920 when Spencer, who had already been provided with studio space here, left Cookham at the Slessers' suggestion and moved into Cornerways as their lodger.

The Abbotsbrook Estate is a place of leafy middle-class contentment, built in the knowledge of the train to London and structured around a shallow brook, which circulates between islanded houses before escaping through a small lock into the Thames. Cornerways is by no means a grand house, and Spencer had one of two bedrooms overlooking the brook. Adjacent to the house, the wooden boathouse (fig.43) includes a low space on the ground floor suitable for storing punts and canoes. An external staircase leads to the upstairs room that served as the Slessers' 'oratory'. A windowed and partly panelled space under a pitched roof, it feels like a cross between a cramped attic and a gypsy caravan. Yet for Spencer this boathouse oratory was a forerunner of the 'Oratory of All Souls' at Burghclere: a 'purposeful' space in which the devout Slesser hung his religious pictures. *The Last Supper* (fig.44) was painted for this space, as was the tryptich of 1921, which consists of *Saint Veronica Unmasking Christ* and two paintings entitled *Christ Overturning the Money Changers' Tables* and *Christ Overturning the Money Changer's Table*.

Long afterwards, in Port Glasgow in 1942, Spencer looked back rather dismissively on the year he spent with the Slessers. He recalled having liked his bedroom, looked forward to mealtimes and enjoyed the walks. Yet he also ventured that a psychologist looking at him during what he called 'my Cornerways or Bourne End period' might have had quite a lot to say about the self he displayed at that time, and particularly about his 'eagerness to talk'.[77] It had, he concluded, been 'a very difficult period' of his life. From 1915, when he left Cookham (where he had felt 'married to the entire world'), his life 'ceased to be part of my work & conscious being'; and he had not regained his bearings until 1925, when he married Hilda, the artist and Christian Scientist sister of his friend Richard Carline. His circumstances at the Slessers, so Spencer recalled, allowed him 'no personal life of my own'. If he was pleased to leave Cornerways after a year or so, that had been because 'I did not want my life confined to the lavatory as it more or less was'. As for the work he produced while with the Slessers, he judged it to have 'the cooped up look' of 'staying at some house'. As 'work done by a lodger', it looked, so he said of one of his Bourne End landscapes, 'like a lot of nothing'.

fig.43
The Slesser's boathouse at *Cornerways*, photographed in 2000.

Spencer's retrospective judgement has not encouraged art historians to grant much more than summary attention to the Cornerways period. Yet at the time, Spencer felt differently. As he wrote to Henry Lamb in September 1920, having returned to Bourne End after a couple of months in the Dorset village of Durweston, 'If I do not really love the people I live with, I become selfishly indifferent to them. I cannot live with people I "just like"… This is why I feel that living here with the Slessers is the best thing for me. The "atmosphere" of Harry and Margaret Slesser inspires me in the impersonal way as the tree does outside my window.'[78] Numbers are not everything, but this was a year in which Spencer produced some twenty paintings, and certainly not just more of those despised

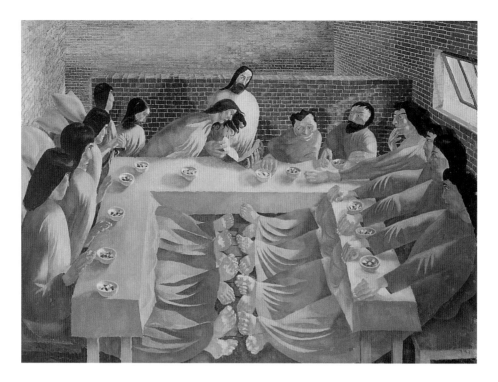

landscapes. Spencer painted *Bond's Steam Launch* while in Bourne End. He painted a specially commissioned portrait of Margaret Slesser, sitting by the fireplace in Cornerways, and he also worked on his studies of the Leeds slums – a world in which everything happens on the pavement and where the blind alleys leading into the street are 'chunk full of washing, all blowing upwards.' More significantly, however, it was while living at Cornerways that Spencer painted a number of works that reflect a deepened post-war interest in the early Italian painting of Giotto and the sculpture of Donatello, and also give new realisation to the religious preoccupations that had earlier, in January 1919, led Spencer to stay with Eric Gill, from whose dogmatic Roman Catholicism he quickly recoiled.[79] These include *Christ Carrying the Cross* (no.27), *The Resurrection, Cookham* (no.33), (one of eight pictures acquired or commissioned by the Slessers), and also *Christ's Entry into Jerusalem*. If Spencer's paintings of the Cornerways period are the work of a lodger, it seems worth asking whether he lodged not just in a house or a makeshift 'oratory' squeezed into a wooden boat-house, but in the Slessers' Christian socialist sensibility too.

The Art of Christian Socialism

Henry Slesser, or his resemblance, can be seen rising out of the ground in Spencer's *The Resurrection, Cookham* (no.35). He is presented as a somewhat severe-looking fellow, shrouded in legal robes and decked neither with the native flowers of Cookham (the cowparsley, dandelion and campion featured elsewhere in the painting), nor with the simple visionary flora that beautifies the rising turf of Spencer's earlier resurrections. Instead, Spencer awards Slesser two wreaths of luxurious florist's blossoms that suggest sophisticated and urbane values.

Slesser may not much have liked this portrayal of him shooting up out of the ground in an explosion of posh vegetation, but there can be little doubt that Spencer had known him as a busy man on the move.[80] Slesser's political and legal career had really taken off in the year that Spencer, by then living in Hampstead, started work on *The Resurrection, Cookham*. It was in 1924 that Slesser had been elected Labour MP for South East Leeds. He was appointed H.M. Solicitor General and also called to the bar in the same year. From there he would go on to become a Lord Justice of Appeal and to be praised, by this

time as Sir Henry Slesser, as the man who 'kept the Labour Party straight upon legal matters'.[81]

The Slesser with whom Spencer had lodged in 1920–1 was a man of some future promise, but he was also disentangling himself from certain aspects of his past, and it is in this struggle that we should allow him greater significance in Spencer's life. Before the war, Slesser had been an energetic member of the Fabian Society, which advocated a 'peaceful revolution' to be brought about by benign and expert reformers in the new state rather than through class warfare and the Marxist apocalypse. In 1908 Slesser had joined a group of under-thirty year-olds who came to be known as the 'Fabian nursery', and participated fully in its lectures, study circles and country walks or 'rural itineraries'. It was here that he found many of his later friends, including Mr and Mrs Behrend.[82] Slesser wrote pamphlets and drafted bills, with which the Fabian Society would then set out to promote parliamentary debate. As a young lawyer worried by the fact that so few barristers supported the socialist cause, he urged that their training in 'sound argument' should make them amenable to a well-reasoned case for the new politics.[83] In 1909, still writing under his original name as Henry H. Schloesser, he reviewed the 'machinery' that had prompted the industrial revolution and insisted on 'the importance of wresting it from the hands of the capitalist'.[84] Elected to the Executive Committee of the Fabian Society in 1910, he recalled arguing with Hilaire Belloc in the pages of A.J. Orage's periodical *The New Age*, opposing Belloc's view that socialism, with its principle of state ownership, was at odds with the Christian ethic of personal property;[85] and proclaiming, in what he later repudiated as his 'most deplorable' article, that 'Beauty and Art must be social or they are valueless'.[86] That may have been a bid for 'purposeful' art but, in post-war retrospect, Slesser would repudiate it as betraying no sense at all of 'this world being a pattern of the Heavenly Places'.

In 1912, Slesser had been appointed the first 'Standing Counsel' to the Labour Party, and he was soon representing the agents of the very 'unrest' he was also growing to doubt: militant trade unionists but also suffragettes accused of public order offences in Christabel Pankhurst's arson campaign of 1913. Slesser had defended Miss Emily Davison when she was charged with attempting to set fire to a pillar box (incompetently), shortly before she threw herself in front of the king's horse at the 1913 Derby Races.[87] He had stood as a Labour candidate for parliament, contesting York unsuccessfully in 1913.

Slesser was still a busy Labour man in 1920, when he put up Stanley Spencer at Cornerways. He was helping trade unions defend pre-war rights and, in the following year, would represent the Poplar counsellors, including the future Christian Socialist leader of the Labour Party, George Lansbury, who were famously jailed for refusing to set a rate in 1922. Slesser would unsuccessfully contest Central Leeds for the Labour Party three times in 1922–3, but it is hardly surprising that the press were by then wondering to what his socialism actually amounted. Slesser was at odds with the militant anti-capitalism of those strike-ridden times. He may have written the definitive manual on trade union law, yet he portrayed the unions not as proto-communist engines of class war but as legally constituted products of the medieval guild system, empowered by the sovereign to la down conditions governing their members' working practices.

In headlong retreat from the 'dogmas of socialism', Slesser now identified class war with 'wickedness'.[88] Having resigned from the Fabian Society as his doubts about collectivism rose, he had also come to accept the arguments of Hilaire Belloc – his previously rejected warnings about the 'servile state' and his anti-collectivist advocacy of a wide distribution of private property. He would retain his respect for William Morris, but only the Morris whom H.J. Massingham, writing in 1918, had differentiated from cruder advocates of the communist revolution, as the exponent of 'a *passive,* mellow Socialism, which saw life as

it saw art organically, as a growth, as a spiritual redemption, as "the spontaneous expression of the pleasure of life innate in the whole people."'[89]

By the time Spencer moved in, the Labour Party's busy legal expert was a Christian socialist, standing firm against the secular and progressive tide of a world in which history had 'turned vorticist', as H.J. Massingham declared in January 1919.[90] In the years to come Slesser would be regarded as an 'anachronism', famous for the resolutely 'medieval' cast of his outlook. Others, notably G.D.H. Cole, would struggle to match the precepts of guild socialism to the modern industrial system. But Slesser withdrew into a pastoral vision of the good life, predicating his socialism on an idea of the medieval age as an era when 'all human society in every department'[91] was truly constellated by Christian faith. For Slesser, modern history was all about the rot that had set in with 'the permission of usury and monopolistic finance and commerce' as well as a decay in Catholic Faith.[92] That had been followed by looting of the monasteries, and an increasing segregation of the poor and outcast. Eventually, 'the common man, denied his birthright, crowded into factories and slums, a sacrifice to the altar of mammon'. In that benighted condition, he would become 'openly sceptical and hostile to Christ's Church,'[93] and then came the present-day world with its pedants, bureaucrats and Bolshevists: 'Our work is to undo those perversions of value which first crept into the Christian life during the late mediaeval centuries, but have now become such a flood of noise and nastiness as threatens to overwhelm us'.[94]

'Cornerways' may have looked like a pleasantly-appointed suburban house, but it was actually a pious bastion of 'Heavenly service' arrayed against a 'Babylonish Age' in which cleverness had taken 'the place of wisdom, talent of art, and opportunism of saintliness'. It would not be until after Spencer moved out that Slesser outraged some readers of the Labour *Daily Herald,* by insisting that the 'Holy Roman Empire' had been a 'religious international' more complete than either the League of Nations or the International Socialist Federation.[95] But Slesser had already published a philosophical tract called *The Nature of Being* (1919), in which he argued for the existence of a Being beyond human knowledge,[96] a divine Will, suffusing all things. And he was using this idea to condemn the evils of the Godless, mechanistic and materialist world that had found expression in the recent war.

It is not enough to say that Spencer painted while Henry Slesser preached, philosophised and, it may be assumed, rushed back and forth to the railway station. Art historians have drawn attention to the simplified nature of many of Spencer's Bourne End paintings, suggesting a mixture of Giottesque and Vorticist influences. Yet these works are surely 'Slesserean' too. Despite Spencer's later dismissal of his 'Cornerways period', there can be no doubt that he felt in sympathy with the Slessers at the time. The painting known as

fig.45
STANLEY SPENCER
Triptych painted for the Slesser's boathouse: from left,

Saint Veronica Unmasking Christ 1921

Oil on canvas
Stanley Spencer Gallery, Cookham

Christ Overturning the Money Changers' Tables 1921

Oil on canvas
Collection, Art Gallery of Western Australia

Christ Overturning the Money Changers' Table 1921

Oil on canvas
Stanley Spencer Gallery, Cookham

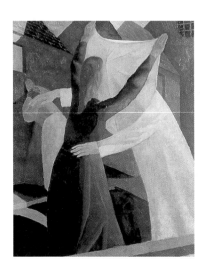

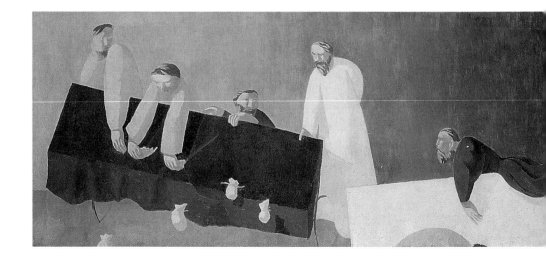

Carrying Mattresses (no.24) is a straightforward picture of life at Bourne End. The placing of the wooden boathouse next to the stuccoed house, the shape of the house's glazing bars, the position of the water in front of the house, even the prominent eyebrows on the standing figure of Slesser himself, reveal this to be, not just another scene from the Cookham river, but rather a painting that is precisely described by the alternative title Spencer applied to it, namely 'Slessers Going on the River'.

Meanwhile, the fact that Spencer responded directly to Henry Slesser's Christian socialist vision is made abundantly evident by the centrepiece of the triptych he painted for the boathouse oratory (fig.45). *Christ Overturning the Money Changers' Tables* is a classic guild socialist image. That is certainly how Sir Henry Slesser saw it in 1975, when writing to a curator of the Art Gallery of Western Australia, which had recently acquired the painting: 'it was a gift to me and the idea in it was his, knowing as he did, my dislike of plutocracy.'[97] If this beautifully composed image seems highly simplified, even cartoon-like, that is not just a consequence of the 'primitive' way Spencer has portrayed his long-armed money-changers and their falling bags of gold. It is also because the painting carries over relatively little from the more detailed account of Christ's visit to the Jerusalem temple provided in John 2:14–16. Unlike that of St John, Spencer's passover temple is not thronging with people selling sheep, oxen and doves, and his Christ has no need of a scourge of small cords either. That simplicity of treatment may be 'Giottesque', but it also reflects the simplified and strongly moralised polarity between Good and Evil that lay behind the Guild Socialist castigation of usury. As H.J. Massingham remembered, the guild socialists around *The New Age* had seen usury as 'the sin of buying cheap to sell dear, of getting something for nothing, of the unjust price, of self-interest as the ruling motive of the social life, the sin of beggar-my-neighbour, the sin of money as the final standard of value and not the medium of exchange between producer and consumer, the sin of confusing ends with means, the sin of the money-changers in the Temple'.[98]

Just as he had earlier bridled at Eric Gill's Roman Catholicism, Spencer preferred his own more diffuse religiosity to Slesser's dogmatic emphasis on 'the narrow way', which involved cleaving to the Church of England because it had been 'chosen by the Lord for the propagation of the Faith'.[99] Yet the interests of the two men overlapped sufficiently to provide plenty of material for the 'talkative' conversations that Spencer would later refer to his imagined psychologist. They shared a sense of the War as a catastrophic break. For Spencer, it marked an end to 'the crucial integrated-with-the-thing' feeling he had felt in Cookham.[100] For Slesser, who had been turned down for military service on grounds of health, the convulsion had been both 'the unavoidable aftermath of spiritual deficiency'[101] and an unforeseen disaster that quite invalidated the naive Fabian belief in 'the cosmic

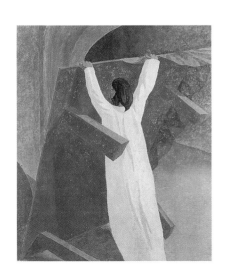

necessity of progress'. Both were moved by a war-enhanced idea of the lost Golden Age, whether it be represented by pre-war Cookham or medieval Christendom. They both thought about locality and its place in the cosmic scheme of things:[102] if the world offered 'a pattern of heavenly places', it was also alive, even in its most ordinary details, with the possibility of transfiguration and redemption. For Slesser, this was connected to a Christian teleology: 'Thus the world must finally be conceived as an incarnation in which the parts may proceed in the Holy Spirit more and more until they reach the everlasting Kingdom'.

The maintaining hand of God was a constant presence at Cornerways. Slesser believed that 'Each moment of existence assumes a continuous creative act, no less than the first act of creation',[103] and he was certainly not prepared to allow the miraculous to dwindle away into a series of improving Bible stories. As he would say, when speaking at the Anglo-

Catholic Congress in the Albert Hall in 1923, 'To those who doubt the possibility of direct, defined inspiration of material things, who grudgingly distort our Lord's assurance as to the reality of His Presence into a mere commemorative festival, we would point out that the whole world, as we understand it, does show very clearly the action of the Divine Will upon matter'.[104]

If the world was an amalgam of Heaven and earth, so too was the individual human being. Wyndham Lewis would later observe of Stanley Spencer that 'even his angels wear jumpers',[105] yet Slesser would surely have considered that amalgam, even in its most carelessly painted manifestations, better than the pervasive mechanistic view of life: 'Either man is an automaton, his brain "secreting thought as the liver secretes bile", or he is a free agent, creative of effects without secular causes; thereby tearing a rent in the smooth texture of inevitable mechanical process'.[106] Horrified by the materialist outlook of his time, he insisted 'We must see in every man and woman a temple for the Holy Spirit, and in all the things of the world and in all the things which are done in the world, shrines, temples, tabernacles in which the Holy Spirit may dwell'.[107]

Both Spencer and Slesser held out for a religious sense of wonder threatened by post-war disenchantment and the rising tide of secular science and mechanistic understanding. Hence Slesser's insistence that 'we have experience of two worlds: the one to which the modern sceptics have exclusively pinned their faith, the repetitive, causal, and uninspired, the world of appearance; and the other, the real world, the experience of which is far more poignant and immediate, the world of the miracle and the spirit, the creative original state which we recognise in creative art.'[108] And since 'Perfection may be manifested to us incarnate in terms of the Good, the Beautiful, and the True',[109] Slesser reserved a noble place in his thought for Art, which served to witness the possibility of Heaven on earth.

Spencer later remarked that he did not believe in miracles,[110] yet he would have understood Slesser's insistence that 'The supreme manifestation of the miraculous is in the Resurrection'. Having already, in 1914–15, painted the Resurrection of the Bad as well as the Good, and shown that their only come-uppance consisted of having to lift clammier soil in order to climb out of the grave, Spencer would also have appreciated the paradoxical modernity of Slesser's idea of the Resurrection. Both men appear to have done without the idea of Hell, and conceived the Resurrection as a kind of heavenly transcendentalism at loose in the world: a redemptive and visionary disclosure of divine reality rather than a medieval warning of Judgement in the world to come. For Spencer as for Slesser, with his Christian Platonist aesthetics of 'the Good, the Beautiful and the True', the Resurrection was something that, in part, had already taken place.

Stepping Out with G.K. Chesterton

There was plenty for Stanley Spencer to discuss with his host Henry Slesser, even though he may later have come to regret his 'eagerness to talk'. But what about the walks that Spencer would also admit having enjoyed? Some may have been solitary undertakings. Yet there were others of a more social kind, for the Slessers were in the habit of welcoming friends at weekends, and then taking to the hills. According to Gilbert Spencer, this company of downland marchers was aimed at 'friendship with an undertone of religion and philosophy in the beneficent conditions of fresh air, blue skies and wayside inns'.[111] Among the members were Sir Edwin Deller, then academic registrar at the University of London, the eminent chemist Alfred Bacharach, who would be associated with both Wellcome Chemical Works and Glaxo, and Wilfrid Evill, who would later put in many hours work as Spencer's solicitor.[112] Slesser had appointed St Ambulans as the patron saint of these perambulations. He eventually also wrote a poem, The Walk, in which he remembered 'gaily treading' the Chilterns, and pausing to gaze out over the weirs built

on the Thames at Bisham Abbey, a few miles upstream from Bourne End (Bisham Abbey is now a sports centre where England's football team trains, but for Slesser it prompted a historical reverie about the pre-Dissolution days when piously observed Catholic tenets had spanned the whole earthly community).[113]

Some of the members of this strolling circle had walked with the Slessers during the pre-war era of the Fabian nursery. Yet, in accordance with Slesser's revised outlook, their post-war excursions were carried out in homage to the Fabian Society's most persistent opponents. One source of inspiration may have been Hilaire Belloc's *The Four Men,* whose argumentative characters stride over the Sussex downs meditating on 'the way in which our land and we mix up together and are part of the same thing'.[114] However, the presiding genius was really that of G.K. Chesterton. This eminent writer (and former Slade student) was listed as a 'non-ambulant' member of the fraternity, and his novel *The Flying Inn* (1914), with its celebration of harried and got-at English virtues, appears to have provided the Slessers' weekend perambulators with their book of conduct. Gilbert Spencer remembers the mock outrage that once greeted the news that an empty cocoa tin had been found in Chesterton's rubbish bin. A party walked over to Chesterton's home at Beaconsfield to try him for this transgression. Stanley and Gilbert Spencer, who between them made up the jury, were not persuaded by the defending council (Evill), who tried to pass the blame onto Chesterton's servants, and the judge (Slesser) imposed a heavy fine when Chesterton eventually threw himself on the mercy of the court. As was customary in Slesser's walking fraternity, Chesterton's fine was paid in the form of beer; and once it had been drunk, the party walked back to Cornerways, singing verses from *The Rolling English Road*, a poem included in Chesterton's *The Flying Inn* ('The rolling English drunkard made the rolling English road /A reeling road, a rolling road, that rambles round the shire').

If beer was 'the sacred beverage', as Gilbert Spencer recalls, cocoa was reviled, in the words of that same poem, as 'a cad and coward' and a 'vulgar beast'. This whimsical differentiation harked back to a political argument that had covered many pages of *The New Age* from 1907 onwards. Hilaire Belloc and G.K. Chesterton had both admitted that 'the present condition of society is intolerable',[115] but they opposed the Fabian solution advocated by H.G. Wells and George Bernard Shaw, and proposed their own alternative, which was 'to distribute property' widely rather than expropriating it in the name of the state or leaving it concentrated in the hands of the plutocracy. Symbolic of the decent English qualities that Fabian reformers yearned to suppress, beer came to be connected to the 'Chesterbellocian' search for a 'more human formula' than socialist collectivism.[116] As Chesterton had announced in an article entitled 'Why I am not a Socialist', ' I believe strongly in the mass of the common people. I do not mean their potentialities, I mean in their faces, in their habits, and their admirable language.'[117] Beer was also linked with the principle of personal property, so opposed by Shaw, the vegetarian teetotaller who was filling *The New Age* with articles entitled 'Driving Capital out of the Country'. As Chesterton wrote, 'Drink and property have been swelled in our world into abominations … The proposed abolition of personal property has its only practical parallel in teetotalism'.[118]

While it contains the famous poem condemning cocoa and praising 'the rolling English road', *The Flying Inn* also imagines the 'nightmare' that follows 'when the English oligarchy is run by an Englishman who hasn't got an English mind'.[119] The man in question, Lord Ivywood, is a cranky aristocratic cabinet minister, who has fallen under the influence of a fatuous Islamic tub-thumper known as 'the Prophet'. Under his influence the government has decided to impose an Islamic ban on alcohol in England. Got at and threatened by this unnatural reform, true English values are forced into a fugitive existence.

Their champion is Humphrey Pump, the 'very English' publican of an hostelry called 'The Old Ship'.[120] Assisted by the romantic Irish hero Patrick Dalroy, who uproots Pump's inn sign (on which the red St George's cross is given appropriate prominence), Pump sets off, pushing a large round cheese and a barrel of rum, as well as the inn sign, which they will erect at chosen locations. Chesterton celebrates the unschooled Humphrey Pump as an English aborigine who has learned by experience rather than through books or 'academically like an American Professor'.[121] Common sense and an 'incorruptible kindliness' lie at the root of Pump's 'Englishry' (along with a thorough contempt for modern art).[122] He also has an instinctive grasp of his native land, knowing the 'English boundaries almost by intuition'.[123] 'The deepest thoughts are all commonplaces', as Dalroy says, lining up plain truth against the eccentric cleverness of the ruling elite: men who are both ignorant, 'like most cultured fellows', and perverse: 'if they have to choose between a meadow and a motor, they forbid the meadow'.

GROUNDED ENGLISH: FROM PEBBLESWICK TO COOKHAM

Spencer was no beer drinker, yet he would surely have appreciated *The Flying Inn*, and especially its opening scene. It takes place on a tiny islet in the Ionian sea, where the 'King of Ithaca' (actually Chesterton's romantic Irish hero, Patrick Dalroy), who has fought tirelessly against Turkish might from his little island, watches as Lord Ivywood, representing the European powers, agrees a settlement entirely along Turkish lines. Having condemned the agreed peace as 'worse than death', Dalroy remarks dreamily 'I am now going to "The Old Ship"'. The Turk asks if this means he is returning to 'the warships of the English King'. But Dalroy replies that he means '"The Old Ship" that is behind apple-trees by Pebbleswick; where the Ule flows among the trees. I fear I shall never see you there'.[124]

Spencer also was inclined to measure all experience against the tiny English world that served as his universe and, indeed, 'newspaper'. He even found use for this habit in 1954 when he journeyed with A.J. Ayer and Hugh Casson to Beijing as a guest of the Chinese authorities to celebrate the fiftieth anniversary of the communist revolution. He met the Chinese leader Chou En-Lai, who informed him that the Chinese were a home-loving people: 'So am I', said Spencer, 'it took China to get me away from Cookham.'[125] In another version, Chou En-Lai was addressing the visitors about 'the New China' when Spencer piped up 'Yes … we ought to know the New China better. And the New China ought to know Cookham better. I feel at home in China because I feel that Cookham is somewhere near'.[126]

By the time he wrote *The Flying Inn,* Chesterton had devoted many years to this struggle for the rooted English spirit of Pebbleswick. In his book *Heretics* (1905), he had taken issue with Rudyard Kipling, and in particular with the epigram in which Kipling asked 'what can they know of England who only England know?'[127] It was, riposted Chesterton, 'a far deeper and sharper question to ask, "What can they know of England who know only the world?"' He asserted that 'The moment we care for anything deeply, the world – that is, all the other miscellaneous interests – becomes our enemy … The moment you love anything, the world becomes your foe.' With his British imperial cosmopolitanism, Kipling may certainly have 'known the world', but his devotion to England was the outcome not of love but of critical thought: something that Chesterton valued far less than the 'real' patriotism of the Irish or, for that matter, the Boers whom Kipling had recently 'hounded down in South Africa'. Kipling did not belong to England or, indeed 'to any place; and the proof of it is this, that he thinks of England as a place. The moment we are rooted in

a place, the place vanishes. We live like a tree with the whole strength of the universe.'[128] Then as now, there would be many who equated parochialism with spiritual cramp, deprivation, and reactionary small-mindedness, but Chesterton was more ambitious: he insisted that 'the "large ideas" prosper when it is not a question of thinking in continents, but of understanding a few two-legged men.'

Retrospectively, we may find quite a lot to commend in Chesterton's defence of grounded English experience. It marks an attempt to separate true Englishness from the militarism and worship of organisational efficiency that Kipling espoused, and also from the imperial British jingoism that Chesterton had opposed during the Boer War. Chesterton's sturdy insistence that 'The globe-trotter lives in a smaller world than the peasant' resonates with Stanley Spencer's presentation of Cookham, and also with more recent concerns about the diminishment of local experience by the global economy and media. And yet, even in 1905, Chesterton was already on the defensive – his Englishness was envisioned against the motor cars, ocean-liners and economic and political systems that were already pulling the world headlong in the opposite direction. And though others would join the parochial English cause over the decades to come, it would be both deformed and defeated by the events of the new century.

The First World War would elicit crudely chauvinistic invocations of an Englishness thought to be lost in the composite identity of imperial Britain – as when *John Bull,* the bloodthirsty tabloid run by the superpatriotic conman Horatio Bottomley, set out to rouse English pride, urging the submerged English majority to 'Cock your bonnet and strut as if you were a Scot, an Irishman or a Welshman.'[129] Yet it was not just the war that shifted the cause of Englishness into the past tense, and made it a matter of defending a traditional and predominantly rural way of life against a threatening modernity. This was how it was by the time Stanley Baldwin got round to praising the English rural scene in 1924. Standing up in a London hotel after the Annual Dinner of the Royal Society of St George, this Tory admirer of W.H. Hudson evoked the 'tinkling of the hammer on the anvil in the country smithy, the corncrake on a dewy morning, the sound of the scythe against the whetstone, and the sight of a plough team coming over the brow of a hill', insisting that 'these things strike down into the very depths of our nature, and touch chords that go back to the beginning of time and the human race'.[130] Baldwin projected a romanticised picture not just of the fields and wildlife he had known as a boy growing up in Worcestershire, but of a traditional rural settlement that glowed with nostalgic promise in a present increasingly characterised by the urban industrial unrest that would culminate in the General Strike of 1926. This sort of compensatory rusticity, differently espoused by H.J. Massingham and his illustrator, Thomas Hennell, would not provide an adequate basis for a modern political vision, and it would not support a major twentieth-century aesthetic either.

Stanley Spencer's blameless painting of *Christ Overturning the Money Changers' Tables* is all the more poignant when viewed in the knowledge that a further deformation, worse than despairing antiquarianism, awaited the guild socialists' pious rage against usury and 'money power'. Hilaire Belloc was at once a defender of old England and an advocate of the removal of the Jews from the European scene.[131] That same shadow, combined with a characteristic mistrust of mass democracy, fell over some of Belloc's followers, including at least one member of Henry Slesser's walking fraternity. As Slesser admits, Val Spalding was a follower of Hilaire Belloc who joined the Catholic Church, favouring its insistence on Authority, and went on to become an 'anti-Parliamentarian' supporter of Mussolini.[132] A pronounced anti-Semitic streak also turned up among the defenders of 'organic' craft culture who, during the Second World War, sat down with H.J. Massingham at meetings of 'Kinship in Husbandry', a group that included people like Rolf Gardiner, the Earl of Portsmouth and the historian Arthur Bryant, each of whom had sided with German fascism

fig.46
Thomas Hennell's
frontispiece to H.J.
Massingham's *Country
Relics*, published in 1939.

in the 1930s. Echoes of that same failure of thought would extend right up into the early 1970s, turning up, disconcertingly, in Edward Ardizzone's illustrations for Graham Greene's *The Little Horse Bus,* a children's story about Mr Potter, whose little grocery store is threatened by the coming of a nasty 'hygienic emporium' foisted on the English scene by an ugly businessman with an all too predictably 'plutocratic' physiognomy.

One of the virtues of Stanley Spencer's much emphasised 'oddness' or 'eccentricity' is that it distances him from the morbid elegists of English country life. Spencer would indeed paint farms, fields and the blacksmith's yard in Cookham, but he did so neither as a despondent illustrator of the dying rural scene, like Thomas Hennell, who made an apocalyptic image of abandoned agricultural implements (fig.46), nor as a celebrant of the time-sanctioned social hierarchy of the aristocratically dominated Anglican village. Perhaps those 'organic' scenarios were not so easily available in the brash, showy and partly non-conformist riverside settlement that was Cookham. Spencer would certainly lament the fact that he was so often dragged away from his home ground. He expressed the hope that the Sandham Memorial Chapel might be built there, rather than at Burghclere (pleading the river tourists as proof that it would be better attended at Cookham). Yet even at his most parochial, he was not just clinging to the details of Cookham for defensive localist purposes. Wyndham Lewis may have imagined (and, indeed, shared) the refined London gallery-goer's discomfort at Spencer's 'homely' faces 'drained of all intelligence', the 'fat check-jumpered Sunday school teachers and charladies'.[133] It may be, as Lewis also pointed out, that 'Spencer's Resurrections invariably occur in the lower middle class section of the cemetery'. Yet Spencer was also attempting, 'a general realisation of what humanity is and its potentiality', and Cookham was his means to that end.[134]

The diverse manner in which the remembered details of Cookham life became expressive of a wider experience is exemplified by what Spencer once described as his 'Over the wall' feeling**.** This sense was rooted in his early perceptions as a small child, a builder's grandson to boot, growing up in a village of high walls that marked off public and private, constantly suggesting the presence of the unknown, and ensuring that different people lived in different worlds even within the same tiny area. This feeling was freighted with metaphysical content from earliest days, enfolding the visible and the invisible, provoking a sense of wonder, and implying the existence of different dimensions within reality. Those lovingly rendered local walls of brick and flint are already suggestive as they appear in early, pre-war works like *Zacharias and Elizabeth*; and they become more so in later compositions like *The Betrayal* (both first and second versions), where the scriptural event is watched over a wall that defines the depth of the composition, or *The Last Supper,* where a very similar wall, this time of red brick, is placed behind Christ and the disciples – creating another unknowable space, albeit without figures peering over it. Spencer's 'over the wall' feeling may be connected to thoughts of God, or the presence of the sacred, but it also had other applications. As he once wrote, 'there is no difference in the child's sense

of wonder when it wonders what is over a wall and a man's sense of wonder when he wonders what is under a woman's clothes'.[135] In Macedonia, Spencer had even applied the memory of Cookham's richly theorised walls to the feared Bulgarian enemy: close by and yet at the same time remote; only a few yards away across no man's land, but entrenched and never to be seen 'as if they belonged to another planet'.[136] He later used them to evoke the mystery of Hilda Carline's interior thoughts and feelings. Writing on 15 June 1922, he told Hilda how he used to admire her from a distance, watching her and experiencing an 'over the wallish' feeling about the things she might say if he knew her better: 'If you would kindly lift me up and let me look over, it would be almost as marvellous to me to hear you speaking, now at this moment, as it would be if St Peter suddenly began to speak in Masaccio's picture of Peter casting his shadow. Would the "magic" disappear, if you were speaking?'[137]

In the 1960s, the Japanese-Canadian artist Roy Kiyooka found a book of more or less ready-made poems in Spencer's notebooks and letters, and also an affirmative, passionate 'project' in his art ('there is no saying "no" in my paintings/all are saying yes').[138] That affirmative vision certainly distinguishes Spencer from a Baldwinite nostalgist who might have been content cherishing Cookham as an organic pastorale against the spirit of the modern age represented by intrusive motor cars, industrial factories, metal ploughs or even noisy steam launches (all of which Spencer painted with exuberance rather than mistrust or fear). It would also propel Spencer through the Christian socialist vision of Henry and Margaret Slesser. By June 1921, he was writing to Henry Lamb from Cornerways lamenting 'arrangements, visits, meetings, committees, telephone bell, and you know "Oh, is that you? How are you? What? Oh yes do, what "frightfully." My head buzzes.'[139] He left Bourne End that same month, just after painting *The Sword of the Lord and of Gideon*

fig.47
Gilbert Spencer's
frontispiece to
T.F. Powys's *Fables*,
published in 1929.

(no.29), and headed for Steep in Hampshire, where he would stay with Muirhead Bone until kicked out by his wife. He then moved to Hampstead, where he started work on his big painting *The Resurrection, Cookham* (no.35) in 1924, and where his difficult, at least twice-cancelled, engagement to Hilda Carline would finally lead to marriage in February 1925.

By leaving Bourne End, Spencer freed himself to develop a larger role for his art than could be achieved within the Christian Platonist aesthetic of Henry Slesser. Spencer would now pursue his idea of divine love among the dustmen as well as the saints, in the Flesh as well as the Spirit. This relocation is visible in the difference between the two paintings entitled *The Resurrection, Cookham*. In the first of these (no.33), painted at Cornerways in 1921 and owned by Henry Slesser, Spencer produced a pastoral affirmation of the dead rising up from their womb-like graves in Cookham churchyard. In the larger painting, started three years later and completed in 1927 (no.35), both the idea of resurrection and its place in the world have been reconceived. The earlier painting is comparatively schematic and ethereal in its relation to the churchyard that Spencer knew, after Donne, as 'a suburb of Heaven'. The second picture, also known as

The Resurrection, Cookham carries out all sorts of adjustments to this significant location, converting the church itself into something much closer to a metaphysical wall of the kind featured in *The Betrayal* and *The Last Supper*. Yet it also feels more grounded in actual experience. No longer an illustrated scriptural thought, the resurrection has become the basis of an autobiographical meditation concerned with memory and death, the relation between generations, between divine love and a forcefully emergent human sexuality. Many of the human figures are now identifiable as individual people who had mattered to Spencer: his sisters, Henry Slesser, Richard Carline and, now with a central role, Spencer's wife Hilda. The figures in the church porch are especially ambiguous – as if the Christian nativity has been crossed with a weird village fable of the sort that Gilbert Spencer would illustrate, complete with a strangely active churchyard, for T.F. Powys in 1929 (fig.47).[140] God leans down to stroke the hair of a Hilda-like Mary, who has three babies in her arms, or, as Pople suggests, two babies and a naked manikin of Stanley himself, with hands folded over its genitals.[141] Individual identities can hardly be applied to the carnal Africans who are shown lolling around in their barge-shaped mudpool close to the church door, and whose stereotyped presence was presumably taken to justify the work's alleged early subtitle: 'An Allegory of the Saving of the Black and White Races: the Instinctive and the Intellectual'.[142] These instinctive, hippo-like creatures represent a primitive way of being at ease with the physical world: they figure as a 'native' experience, a stand-in, perhaps, for the English variety that Spencer had lost since 'the Change' had come over Cookham. It's a crude anthropological image, yet it still puts Spencer at a considerable distance from those who, already in the late 1920s, were coming see the threatened English village as a precious ancestral stock to be defended against alien intrusion.

fig.48
STANLEY SPENCER
The Sausage Shop 1951

Oil on canvas
Newport Museum and Art
Gallery

Troubles in the Churchyard

If an ambitious cruise operator were to draw up a cultural itinerary of the modern Thames, Spencer's *The Resurrection, Cookham* (no.35) would find its place between two monuments to the Gothic sensibility: Mary Shelley's *Frankenstein,* which was written not far away at Marlow in the 1830s, and the Hammer Horror films that would be made downriver at Bray shortly after Spencer's death in 1959 – a series of unredemptive works which culminated in *Plague of the Zombies* (1966), in which ghoulish creatures crawl out from under the gravestones in a country churchyard. That merely geographical

coincidence is curiously suggestive. While working on *The Resurrection, Cookham*, Spencer declared that light is 'the holy presence, the substance of God'.[143] Yet the increased actuality of the picture, be it rampantly herbaceous or nakedly human, may also remind us that the idea of the Death of God entered European thought not through Friedrich Nietszche, whose philosophy G.K. Chesterton was so anxious to counter, but through the German romantic Jean Paul's notorious, and at the time truly shocking, late eighteenth-century evocation of a dream set in a country churchyard.

Having lain down in the afternoon sun to sleep, Jean Paul's dreamer awakens to find himself in a churchyard, where 'all the graves stood open and the iron doors of the charnel house open and shut by invisible hands'.[144] Christ appears by the altar and the dead cry out, 'Christ! Is there no God?' Christ's answer strikes such horror into the dead that they are 'ripped apart by their quaking':

'I traversed worlds, I ascended into the suns, and soared with the Milky Way through the wastes of heaven; but there is no God. I descended to the last reaches of the shadows of Being, and I looked into the chasm and cried: "Father, where art though?" But I heard only the eternal storm ruled by none, and the shimmering rainbow of essence stood without sun to create it, trickling above the abyss. And when I raised my eyes to the boundless world for the divine eye, it stared at me from an empty bottomless socket; and Eternity lay on Chaos and gnawed it and ruminated itself. – Shriek on, ye discords, rend the shadows; for He is not!'

Romantic negation of God was no part of Spencer's purpose in *The Resurrection, Cookham* and yet there can be little doubt that, by the late 1920s, Spencer was no longer illustrating Henry Slesser's 'world of the miracle and the spirit'.[145] Some viewers of *The Resurrection, Cookham* may be consoled by Spencer's suggestion that Bond's steam launch, as it appears transfigured in the top left-hand corner of the picture, really is steaming off to Heaven. But, in comparison with the earlier *Resurrection, Cookham*, the painting belongs in a modern world where the doors of Jean Paul's charnel house are swinging open. It shows Spencer moving beyond Henry Slesser's dogmatic Christian allegories, and towards the experience of the later works, in which the human body can only be an altar of praise once it has been recognised in the flesh. Slesser recoiled from the modern sceptical outlook that saw the human being as a twitching 'automaton' rather than a divine creation. By the late 1920s, however, Spencer had taken on the possibility, and Cookham would not be the only site of his engagement with that dire thought. It is there in the misshapen couples of the *Beatitude* paintings of the late 1930s, and the leg of mutton that Spencer would eventually place on a mattress next to the spread, unbeautified and, in Wyndham Lewis's phrase, 'aggressively corpulent' flesh of Patricia Preece in *Double Nude Portrait* (no.58). That encounter with the meat of life is to be found in later works too – for example, in the bulbous sausages and grasping fingers of the butcher in *The Sausage Shop* (fig.48). Spencer may indeed have remained a religious painter after leaving the Slessers. Yet he was now painting his way through a modern, predominantly secular world, in which it is the thought of the presence of God, rather than His absence, that has the power to astonish and disconcert.

1 INNOCENCE

Born in 1891, Stanley Spencer grew up in a large, gifted but socially isolated family. He was educated at home; his childhood remained unbroken, and Cookham a kind of Eden. Throughout his four years drawing from the model at the Slade in London (1908–12), Spencer travelled back each evening to his family, and all the works in this section were executed at home in Cookham.

His mind already stocked with musical and literary culture, Spencer proved responsive to the ferment of early modernist painting he encountered at the Slade. By 1909 he was attending the lectures of Roger Fry (who preached the contemporary relevance of the blockish simplified forms of Giotto and the Trecento 'primitives'). Spencer probably saw Fry's first Post-Impressionist exhibition. Certainly the foreground dappled handling in *Two Girls and a Beehive* suggests awareness of Gauguin and the Nabis. The following year, *John Donne Arriving in Heaven* (an astonishing achievement for a nineteen year old) again synthesises Giotto with Parisians such as Maurice Denis. In 1912, *John Donne* would be hung in the second Post-Impressionist exhibition. At the Slade, Spencer was located among a group known as the Neo-Primitives, including William Roberts, Mark Gertler and Christopher Nevinson.

In 1912 Spencer's first masterpiece, *The Nativity*, won the Slade composition prize, and was widely admired. *Apple Gatherers* caused even more of a stir and was purchased by the painter Henry Lamb, who became a key mentor and friend. In 1914 Spencer, now aged twenty-two, completed in Cookham probably his greatest single painting, *Zacharias and Elizabeth,* where a mysterious but compelling rite is enacted within a landscape of extraordinary intensity. His powerful self-portrait, and a landscape painted directly from the motif (both bought by a leading collector,

Eddie Marsh), together with *The Centurion's Servant,* a psychologically-charged interior, established Spencer as the most wide-ranging talent of his generation. But he stood already aside from the avant-garde experimentation that made those pre-war years so unusual in British art. Although the design of *Swan Upping* includes elements that could be related to the zig-zag constructions of the Vorticists, Spencer is essentially a 'Georgian', and almost all his major pre-war works might be described as 'altarpieces of place', deriving much of their force from their specific setting in the Cookham landscape.

Precisely because his existence had been so rooted, Spencer's art was exceptionally positioned to register displacement when the war shattered his life. Writing from the midst of the Salonica campaign in 1917, Spencer would relive the perfection of a pre-war day in Cookham: 'I go home to breakfast thinking as I go of the beautiful wholeness of the day. During the morning I am visited and walk about being in that visitation. Now at this time everything seems more definite and to put on a new meaning and freshness you never before noticed. In the afternoon I set my work out and begin the picture, I leave off at dusk feeling delighted with the spiritual labour I have done.'

In 1915, with *Swan Upping* only half completed, Spencer volunteered for the medical service. In his own account, his work never again achieved the same level; certainly never the same solidity and warmth. But the expulsion Spencer experienced during, and after, the war did open his art to complexities unguessed at in his Cookham innocence.
TH

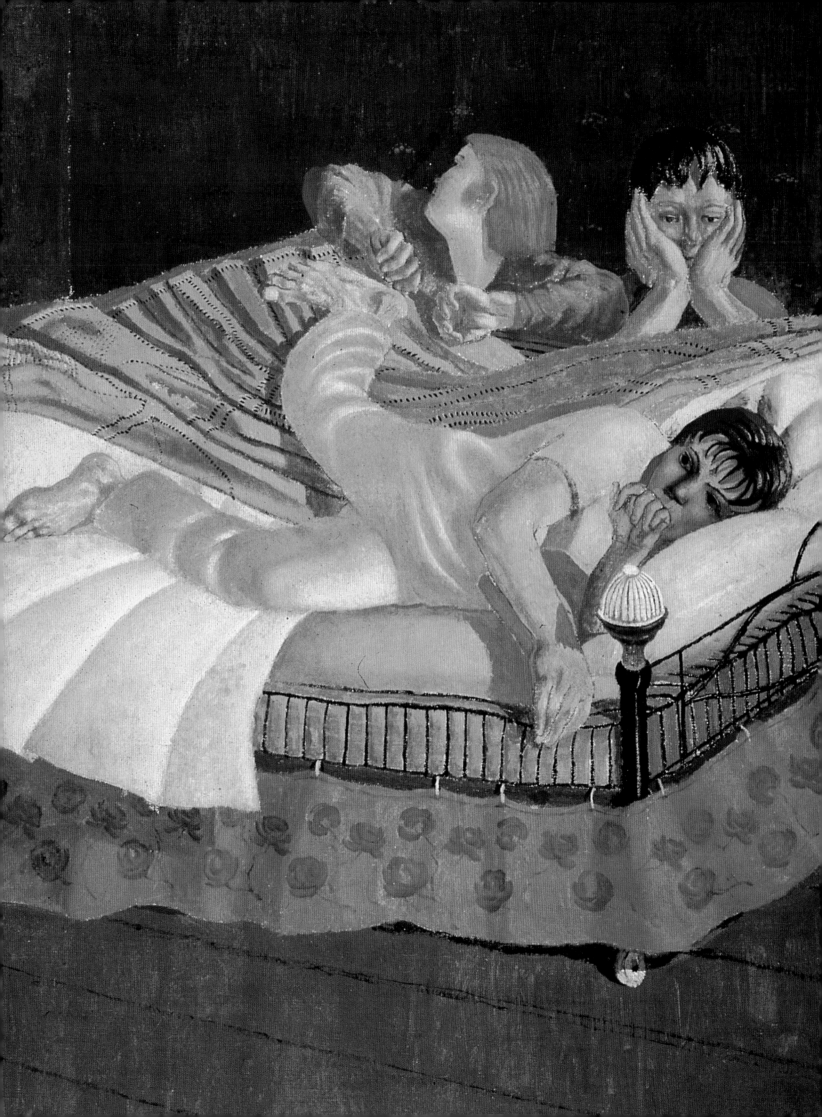

1 The Fairy on the Waterlily Leaf
c. 1909

Pen and ink on paper 41.5 × 32 cm
Lent by the Stanley Spencer Gallery, Cookham

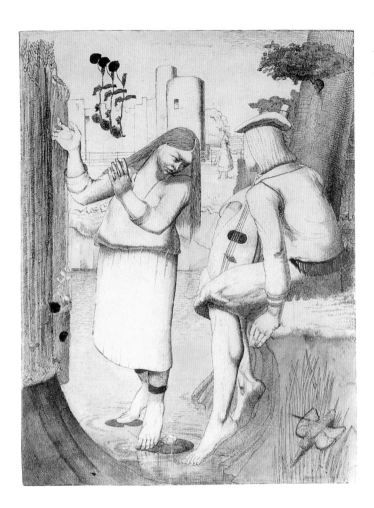

Spencer attended the Slade School of Fine Art from 1908 to 1912, commuting from Cookham each day. The modern imperial metropolis must have contrasted sharply with his home village – still a very Victorian agricultural community, albeit a Thameside one with a flourishing summer season. Slade teaching was famed for its concentration on quality of draughtsmanship, and the primacy of line. Stumping – the practice of building up form purely by soft shading, to which Spencer had been exposed at Maidenhead Tech – was anathema. Almost all of Spencer's time at the Slade was spent in drawing, and students were encouraged to admire the high principles and techniques of the old masters. These twin assets of his training came to underpin Spencer's work. In *The Fairy on the Waterlily Leaf* Spencer adopts a strong outline and subtle shading, and the style of composition and linear purity owes much to Nazarene drawings or early engravings by William Dyce, Dante Gabriel Rossetti and John Everett Millais. It was produced as an illustration to a story by a Miss White, a writer in nearby Bourne End. But she rejected it, apparently because of the abundantly temporal physique of the fairy, modelled by Spencer's friend Dorothy Wooster. In an act of synaesthetic transformation, the fairy is shown conjuring into the air from the minstrel's lute roses which resemble musical notes. This mixture of magic and medievalism is consciously Pre-Raphaelite; Spencer was familiar with the work of the Pre-Raphaelite Brotherhood from the reproductions his father hung in Fernlea, and later from the retrospective exhibitions at the Tate in 1911–12 and 1913. The Pre-Raphaelites were still a viable influence on British art in the first decade of the twentieth century, perhaps especially at the Slade (see RA 1980 pp.19–21). Indeed they were still a physical presence. Holman Hunt, whom Spencer's father reputedly visited in his studio, did not die until 1910.

RU

2 Two Girls and a Beehive c.1910

Oil on canvas 48 × 48 cm
Bell 4
Collection: Lord and Lady Irvine

This is Spencer's earliest surviving oil painting. He taught himself to paint in oils, Slade training being devoted solely to drawing. Painting was an activity undertaken in crowded corners at home in Cookham, after his return from London. His practice, evolved at this time and continued throughout his life, was a standard academic one: to make one or more preparatory composition drawings, square up the final design, and transfer it to canvas; in his early years he often made small-scale oil studies before the final version, to resolve the relationship of tone, colour and form. Spencer's first three oils were of a loaf of bread, his father, and his brother Sydney; *Two Girls and a Beehive* which followed them was therefore his first subject picture. It was made, he recalled, at a moment when he was 'becoming conscious of the rich religious significance of the place I lived in. My feelings for things being holy was very strong at this time' (733.3.1, c.1937). The setting is the end of Mill Lane in Cookham, where Spencer and his brother Gilbert often walked with the two girls in the picture. Dorothy (Dot) and Emily Wooster were the local butcher's daughters. Spencer's Edenic characterisation of Cookham and his belief in the religious, enchanted significance of everyday life there seems to have been well advanced by this early date. Dot and Emily were 'a religious inspiration' (733.3.16, 1941); 'I thought about and had visions about the girls and I was on the lookout for them every day' (733.3.21). Such feelings may also have been related to sexual attraction: Spencer described the picture as 'a fusion of my desires … the place, the girls, and the religious atmosphere' (733.3.1). Dot and Emily stand with an arm round each other in a gesture of unself-conscious tenderness and companionship. The solidity of the figures recalls pictures of Dorelia by Augustus John. The beehive which dominates the foreground of Spencer's picture may perhaps be a symbol of the perfectly balanced, industrious nature of the Cookham community. In the background, against a sunset sky, a figure of Christ appears, to make explicit the religious aspect of this ambiguous scene.

RU

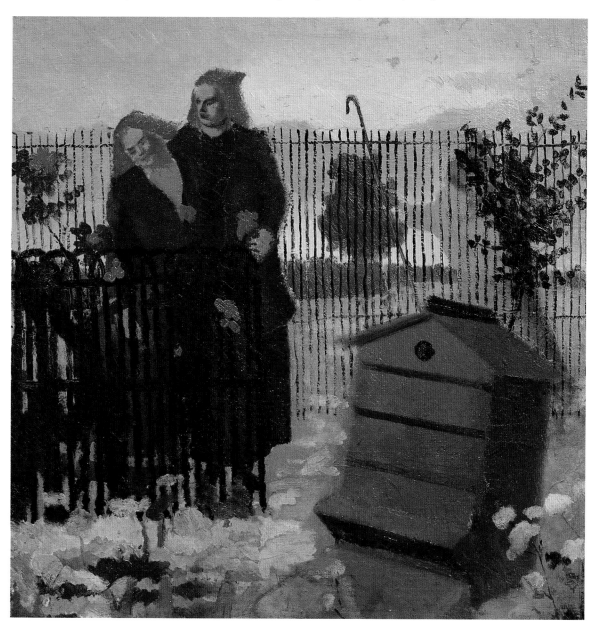

3 Man Goeth to his Long Home
1911

Pencil, pen and ink and wash on paper 43.2 × 31.8 cm
Tate. Purchased 1945

Spencer listed thirteen drawings made for the
Slade Sketch Club, of which this is one. The
assigned subject here was to illustrate
Ecclesiastes 12:5, in which a young man is
urged to remember his creator 'when they shall
be afraid of that which is high, and fears shall
be in the way, and the almond tree shall
flourish, and the grasshopper shall be a burden,
and desire shall fail; because man goeth to his
long home; and the mourners go about in the
streets'. A text often used in funeral services,
'long home' refers to the body's eternal rest in
the grave. Spencer shows a chained-off area
which must be intended to be a grave. The
figure is ambiguous, and could be a traveller,
a man risen from the dead or perhaps even
death personified, considering his next
destination. Spencer sought not to visualise
the whole verse literally, but instead produced
an image of intense contemplation. Ecclesiastes
12 is laden with symbols, and suggests that
the world around man should remind him of
his creator and of his inevitable mortality.
These were sentiments which echoed part of
Spencer's own reverence for nature. The figure
in the drawing, long-haired and robed, appears
Christ-like, perhaps suggesting the mortal path
which Jesus had to tread. The trees in the
distance are bare-leafed, but the exuberant,
lush tree occupying much of the picture space
is evergreen, an ancient emblem of eternal life
in both pagan and Christian tradition, as
Spencer was aware from reading Frazer's
Golden Bough. Religion was an active force
in family life at Fernlea, and Spencer had
a thorough knowledge of the Bible, gained
from his father's recitations and from his own
extensive readings, encouraged as a child by his
mother, who had issued him with a missionary
card to record his textual progress. Gilbert
Spencer identified the horizon landscape as the
view looking south from the corner of Carter's
shed in Cookham, the same vista as in *Joachim
among the Shepherds* (no.6).

RU

4 John Donne Arriving in Heaven 1911

Oil on canvas 38.1 × 40.6 cm
Bell 10
Private Collection

John Donne, the seventeenth-century metaphysical poet and Dean of St Paul's, was not particularly well known during Spencer's youth. However, Spencer was interested in interpretations of the Bible, and the gift of a volume of John Donne's sermons in 1911 inspired him to visualise Donne's arrival in Heaven. Donne wrote in Sermon LXVI of going 'by heaven to heaven', which Spencer misinterpreted as travelling past it. The full passage is 'As my soul shall not go towards heaven, but by heaven to heaven, to the heaven of heavens, so the true joy of a good soul in this world is the very joy of heaven' (Henry Alford (ed.), *The Works of John Donne*, III, 1839, p.177). Spencer wrote how this gave him an 'impression of a side view of Heaven as I imagined it to be, and from that thought to imagining how people behaved there … As I was thinking like this I seemed to see four people praying at different directions' (Carline 1978, p.30).

Spencer imagined Donne walking across Widbrook Common near Cookham, and here encountering Heaven. The people 'pray in all directions because everywhere is Heaven so to speak' (733.3.1, no.5). In this Spencer might subliminally have been thinking of the blessing of a church's choir, nave and transepts at its dedication and in other ceremonies, or the prayers said during the beating of parish boundaries. Spencer probably also had in mind the imagery of John Bunyan's *Pilgrim's Progress*.

The picture denoted a new experimental rigour in Spencer's painting. He adopted for the first time the high viewpoint which characterised much of his subsequent work. The forms are simplified, and the compositional perspective flattened to emphasise its pattern; the palette is restricted. These last attributes were emphatically 'Post-Impressionist'. When Spencer showed the picture to his Slade teacher Henry Tonks, Tonks remarked 'it has no colour and is influenced by a certain party at the Grafton Gallery a little while ago'. Tonks was referring to Roger Fry's 1910 exhibition of Post-Impressionists which had caused a storm and was much discussed in the Slade. Spencer angrily dismissed Tonks's suggestion (Carline 1978, p.30), but the connections are clear, and he may have felt his artistic integrity was being doubted. Clive Bell admired the picture, and included it in the selection of more extreme works in the *Second Post-Impressionist Exhibition* in 1912. Here it hung among pictures by Fry and Wyndham Lewis, as well as Picasso and Cézanne. Not universally admired, the *Connoisseur* singled it out to remark Spencer 'would do better to cast off the artificial conventions of Post-Impressionism … *John Donne* … shows a fine sense of colour and a feeling for composition. It needs all these qualities, however, to prevent the spectator from feeling that the subject is a representation of some clumsily modelled marionettes' (Nov. 1912, p.192). Spencer, never open to criticism, must have hated this stinging review. Subsequently he retreated from the austere radicalism of *John Donne*, and in truth he did not empathise with Fry's rigorous modernist aesthetic and suppression of subject.
RU

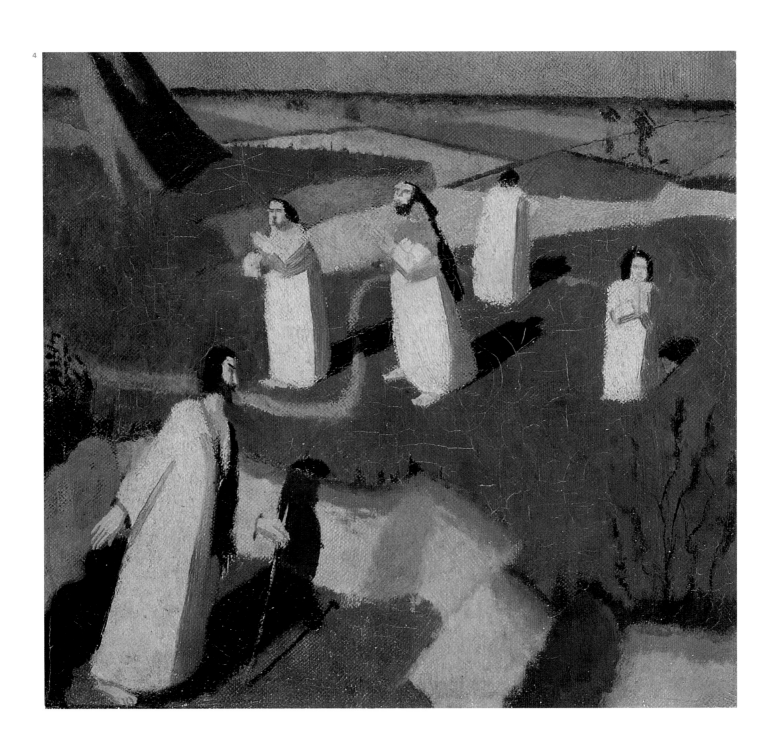

5 Study for Joachim Among the Shepherds *c*.1912

Pen and ink, pencil and wash on paper 40.6 × 37.1 cm
Tate. Presented by the Trustees of the Chantrey Bequest,
1955

Joachim was the father of the Virgin Mary, and
stories about him are told in the apocryphal
'Infancy Gospels'. Spencer was given Ruskin's
book *Giotto and his Works* by the Raverats in
1911, and was inspired by the text accompanying
the illustration of 'Joachim Retires to the
Sheepfold', and by the frescoes in the Arena
Chapel at Padua: 'Then Joachim in the
following night, resolved to separate himself
from companionship; to go to the desert places
among the mountains, with his flocks; and to
inhabit those mountains, in order not to hear
such insults. And immediately Joachim rose
from his bed, and called about him all his flocks
… and went with them and with the shepherds
into the hills' (Ruskin, *Works* 1909, XXIV, p.50).
Spencer imagined the incident relocated in
Cookham, Joachim appearing to the shepherds
on the path which led to Strand Castle, the
same location as *Man Goeth to his Long Home*
(no.3). Spencer explained how he sought out a
suitable spot: 'I liked to take my thoughts for a
walk and marry them to some place in
Cookham. The "bread and cheese" hedge up
the Strand ash-path was the successful suitor.
There was another hedge going away at right
angles from the path and this was where the
shepherds seemed to be. We had to walk
single-file along this path and the shadows
romped about in the hedge alongside of us.
And I liked the hemmed-in restricted area
feeling in that open land' (Carline 1978, p.28).
Emotionally, the path seems to have held a
memory of a specific moment when 'the shadows
romped about … us', the 'us' presumably being
Spencer and his family. Their fellowship and
warmth may have been analogous in his mind
to Joachim's association with the shepherds.
Spencer's description also mentions his strong
delight in form, and his lifelong fascination
with barriers and boundaries. Many of his early
pictures have retaining, curving walls, fences or
hedges, over which the high viewpoint allows
us to see, and these are also a typical feature of
Giotto's designs. As a child Spencer imagined
what might lie behind the high walls of Cookham.
Penetrating such 'secret' gardens might be
seen as a rediscovery or reclaiming of Eden.
RU

6 Sketch for Joachim
Among the Shepherds c.1912

Oil on paper 22.9 × 16.5 cm
Private Collection

Spencer's first treatment of the Joachim subject
was the watercolour (no.5); in 1913 he
produced a finished oil (Bell 14, National Art
Gallery and Museum, Wellington), with the
composition much revised. There Joachim fills
the foreground and the expansive background
is replaced by foliage. This is an intermediate oil
sketch. Joachim is the figure on the right. The
shepherds are divided by the hedge's strong
diagonal intersection. For the finished oil
Spencer added a fourth shepherd.

RU

7 The Nativity 1912

Oil on canvas laid down on panel 102.9 × 152.4 cm
Bell 11
College Art Collections, University College London

Spencer's entry to the 1912 Slade Summer Composition Prize was his most ambitious project so far, and brought together all the passionate interests which burned inside him. The competition rules stipulated that the work was to be of a large size, and undertaken during the long summer vacation. Spencer's picture was five feet wide, and the picture's size, and probably also the concentration its importance demanded, meant that Spencer left the crowded conditions of Fernlea to work on it in Ovey's Barn across the road, a setting which must have seemed providential for a Nativity. Although containing references to pictures from four centuries before, the painting Spencer produced was very far from being a traditional image of the Adoration. Its setting was out of doors, in Cookham, and the loosely-spread grouping of the figures creates a pictorial and emotional tension which suggests ambiguous episodes in a narrative not at once wholly recognisable as the story of the birth of Christ. Spencer seems to have wanted to create a primal image of the connection between men and women, fertility and nature, one hinting at the pagan roots of Christian belief. But it is also about the more ordinary relations between men and women, a subject with which Spencer seemed much preoccupied at this time. In 1941 he wrote: 'The couple occupy the centre of the picture, Joseph who is to the extreme right doing something to the chestnut tree and Mary who stands by the manger; they appear in their relationship with the elements generally, so that Mary to the couple in contact with one another seems like some preponderating element of life, just another big fact of nature such as a tree or a waterfall or a field or a river. Joseph is only related to Mary in this picture by some sacramental ordinance … This relationship has always interested me and in those early works I contemplated a lot of

those unbearable relationships between men and women' (733.2.85). Spencer's remark that 'the couple occupy the centre of the picture' is interesting because Mary and Joseph do not. Instead it is the passionately embracing, rapt couple which he must mean are the picture's 'centre'. Mary and Joseph seem isolated from each other, backs turned. Mary is still the Virgin, and so connected only by 'sacramental ordinance' with her husband rather than physically or sexually. Spencer seems to be making comparisons between the sexual and sexless, between the temporal and divine. Significantly, the embracing couple are outside the Nativity fold. Although the holy parents' relationship is 'unbearable' it perhaps interested Spencer because of its confluence of divinity and spirituality with physical purity and fertility.

The range of pictorial sources in *The Nativity* indicates Spencer's interests and some of the picture's intended meaning. His discovery of the early Italian painters at this time supported him throughout his life. Piero della Francesca's *Nativity* in the National Gallery may have inspired both Spencer's outdoor setting and the treatment of the infant Christ and flowers growing between the flagstones. An interest in Giotto was fired by the Raverats' gift of Ruskin's book about him, and they also sent him postcards of pictures by Fra Angelico, Masaccio, Piero, Uccello and Mantegna (8116.37, 8116.53). Gilbert Spencer described their effect on his brother as like receiving the stigmata (*Memoirs of a Painter*, 1974, p.194), and Spencer rapidly consumed the volumes of reproductions of early Italian pictures published by Gowans and Gray. The simple yet lyrical gesturalism of such painters surely found expression in *The Nativity*.

At the edge of the picture, reaching up to the tree, Joseph is partly reminiscent of Mercury in Botticelli's *Primavera*, a mystical picture about the sanctity of fertile Spring. But Spencer's Joseph is actually precisely based on Rossetti's portrayal of Joachim in *The Girlhood of Mary Virgin* (fig.49). Spencer's copy of the Gowans and Gray book on Rossetti is inscribed

fig.49
DANTE GABRIEL
ROSSETTI
The Girlhood of Mary Virgin 1848–9

Oil on canvas
Tate. Bequeathed by Lady Jekyll, 1937

1913, but his interest appears to have stretched back before this. The embracing couple appear partly derived from the pairs of angels and men, the divine and temporal, in Botticelli's *Mystic Nativity* (National Gallery). From his knowledge of Pre-Raphaelite imagery Spencer probably knew of Rossetti's use of this picture for the couples in his *Blessed Damozel*, and indeed Spencer's lovers are closer to Rossetti's than the original Botticelli source. Rossetti's picture, to a certain degree like Spencer's, is about the sanctity of love and physical connection between men and women, and of their unity of souls on earth and in Heaven. The couple to the left of Spencer's picture seem not to be embracing but almost struggling, the man's expression apparently angry, as if his access to the Nativity is denied. Gauguin may have inspired the mask-like faces of Mary and Joseph, and Robinson suggests the composition's division recalls his *Bonjour Monsieur Gauguin* and *Little Girl Keeping Pigs* (1979, p.18). Gauguin had been seen in strength in London at the exhibition at the Stafford Gallery in 1911 and in *Manet and the Post-Impressionists* in 1910–11, shows which Spencer probably saw. Spencer's sources form a complex set of references to fertility, sexual and spiritual union and isolation, the divine and the temporal, remarkable for a young man of twenty-one.

RU

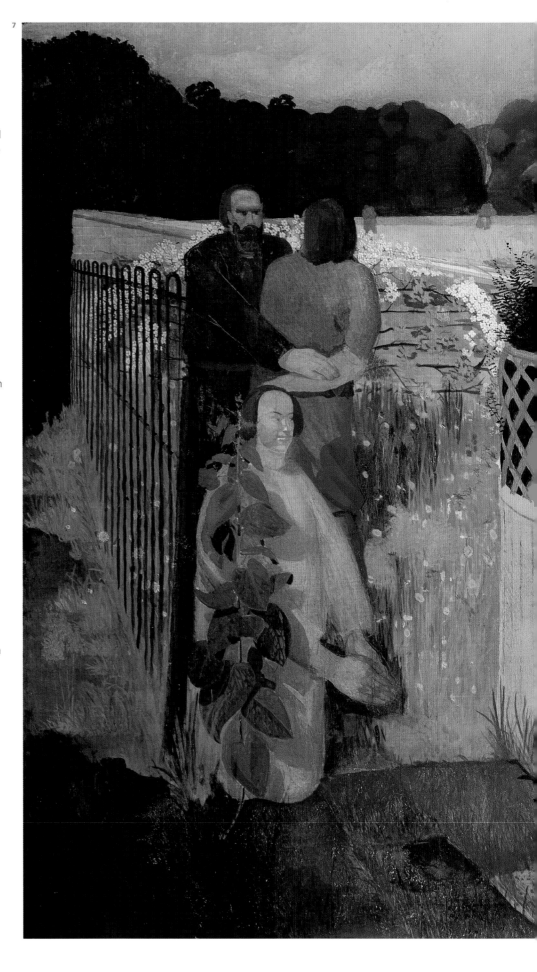

7

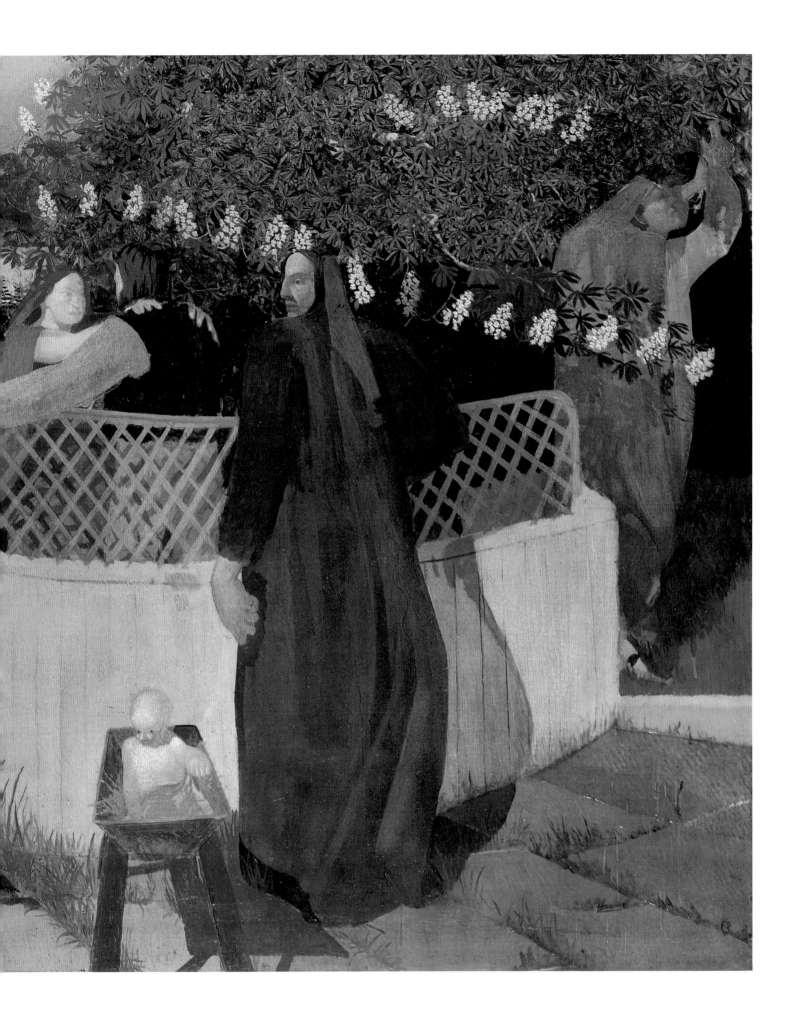

8 Study for Apple Gatherers
c.1912

Pencil, pen and ink and wash on paper 27.8 × 32 cm
Tate. Bequeathed by Sir Edward Marsh through the
Contemporary Art Society, 1954

9 Apple Gatherers 1912–13

Oil on canvas 71.5 × 92.5 cm
Bell 12
Tate. Presented by Sir Edward Marsh, 1946

'This picture', Spencer wrote in 1939, 'was my first ambitious work and I have in it wished to say what life was' (733.3.21). As in *The Nativity* (no.7) Spencer sought to give form to a pantheistic vision of connection between man, woman, nature and fertility. 'The apples and the laurel and the grass', he wrote, 'can fulfil themselves through the presence in their midst: the husband and wife of all places and elements of the picture. The central two figures are still related in this universal sense, not this time so much through any specified religion but through a consciousness of all religions … The couple in the centre here seem not to need each other in any personal way or even be aware of each other. They seem only co-existent with each other like earth and water, yet it seems a vital relationship' (733.2.85, 1941). Although Spencer says the couple 'seem not to need each other', and placed them back to back, he showed their arms intertwined, like two trees of life grown together. Their other arms are spread protectively above their children, who are adult but because of their disparity of size appear childlike. Spencer presents a timeless, golden-age scene of harmony, a rural idyll which is sacramental in its vision of harvest, and it is relevant that he was the second youngest in a family of eight. Yet it seems also to be about sex – the central figures' awkward yet firm contact contrasts with the sexually segregated arrangement of the others; all have their backs turned to each other.

Spencer seemed almost defensive in later life when he wrote 'There is no symbolic meaning whatsoever intended in "Apple Gatherers", and I cannot account for the fact I have divided the sexes' (733.3.1). A suggestion might have come from the Tudor stone relief in Cookham Church where the Babham family are shown at prayer with males and females in separate lines,

fig.50
The Babham family
memorial,
Cookham Church.

parents larger than their children (fig.50). Spencer's picture seems to suggest both connection (with nature, between sexes), and division at the same time. Spencer wrote elsewhere 'at a time when I was innocent I wanted to include in the concept the idea of men and women, something that does go past and beyond the usual conceptions to whatever the relationship is' (733.2.21). The scene was suggested by a spot on Odney Common, although it did not have an orchard, that Spencer could see from the nursery window of Fernlea. Perhaps links between the nursery and his progression to adulthood fuelled his ruminations on relations between the sexes, and nature. Painting in Wisteria Cottage in Cookham, Spencer experienced a particularly intense sense of connection with nature and an almost ecstatic self-awareness: 'In the Apple Gatherers I felt moved to some utterance, a sense of almost miraculous power, and arising

from the joy of my own circumstances and surroundings. Nothing particularised but all held and living in glory. The sons of God shouted for joy, the din of happiness all around me everywhere' (733.8.35, c.1948).

Although the product of his Cookham surroundings, the picture's distortions of form and scale, and eradication of perspective, show Spencer's interest in paintings by Gauguin which he had seen in London. Gauguin's *Christ in the Garden of Olives* may have been a particular inspiration (see *Stanley Spencer*, Arts Council 1976–7 p.16), and Spencer would have admired too Gauguin's Elysian characterisation of Brittany and Tahiti. There are also similarities with works such as *Jewish Family* (fig.16) by Spencer's Slade friend Mark Gertler. For the foreground figures in *Apple Gatherers* Spencer portrayed his own arms and hands, and drew his lips for other figures. There are notable differences between the painting and

preliminary drawing (no.8), which was undertaken as a Slade Sketch Club subject and won him £25. The principal change was to the scale and compression of the figures. In both works Spencer shows his delight in formal, geometric compositions – the strong diagonal of the line of males, the curve of the women; the horizontal of the principal woman's arm, the z-shaped arm of her partner. The male diagonal is reminiscent of the line of brothers.in Millais's *Isabella* (1848–9, Walker Art Gallery, Liverpool), which Spencer would have seen at the 1913 Tate Pre-Raphaelite exhibition. Edward Marsh bought *Apple Gatherers*, the first of a succession of purchases which made him Spencer's most important early patron. Churchill's private secretary, Marsh inherited the perpetual pension granted to descendants of the assassinated Prime Minister Spencer Perceval, and used it to collect art.

RU

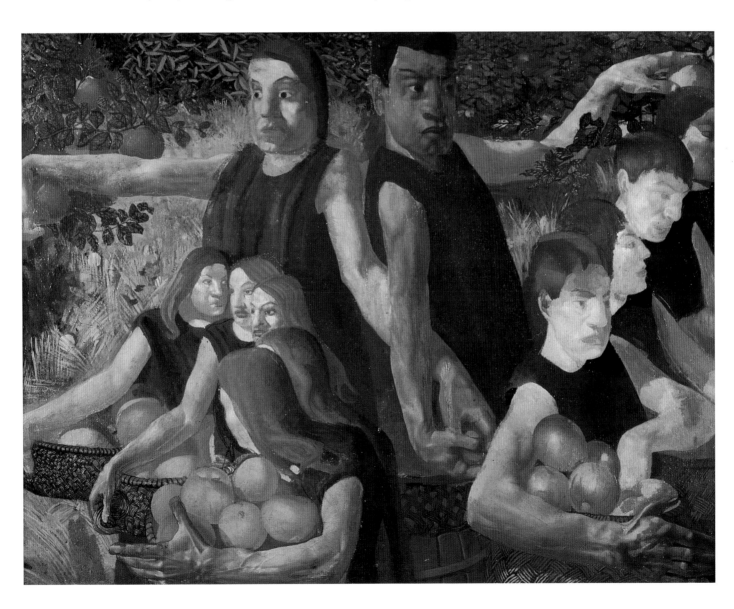

10 Study for The Visitation c.1912

Pencil, pen and ink and wash on paper 35.5 × 35 cm
Collection: Lord and Lady Irvine

After being promised at the Annunciation that one day she will bear God's child, Mary is told by the Archangel Gabriel that her cousin Elizabeth, 'her who was called barren' (see no.14), is already carrying a child. Mary leaves to find her, 'and went into the hill country with haste, into a city of Juda; and entered into the house of Zacharias, and saluted Elizabeth. And it came to pass, that, when Elizabeth heard the salutation of Mary, the babe leaped in her womb; and Elizabeth was filled with the Holy Ghost. And she spake with a loud voice, and said, Blessed art thou among women, and blessed is the fruit of thy womb' (Luke 1:39–44). Elizabeth bears John the Baptist, Christ's forerunner. Spencer sets the story in Cookham; through the door he shows the roof of the King's Arms. Dot Wooster modelled Mary and Spencer's cousin Peggy Hatch was Elizabeth. Mary strides through the doorway purposefully, grasping Elizabeth's hand with an intense expression on her face. Spencer was probably encouraged to paint the Visitation by Ruskin's praise of Giotto's treatment of the incident at Padua. But as Bell points out (no.13), Spencer based his figures partly on Masaccio's *Tribute Money,* which he knew from his Gowans and Gray book.

RU

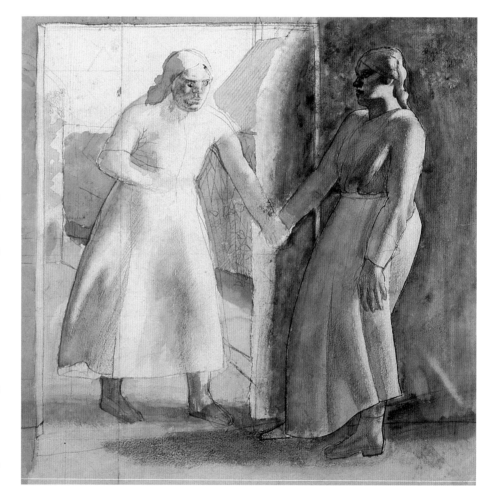

11 Self-Portrait 1913

Pen and ink, wash and red chalk on paper
35.6 × 21.6 cm
Private Collection

12 Self-Portrait 1914

Pen and ink, wash and red chalk on paper
30 × 21.5 cm
Collection: Lord and Lady Irvine

Spencer's interest in using himself in his art may have stemmed from adding his lips, hands and arms to *Apple Gatherers* (no.9). In 1913–14 he made at least four portrait drawings of himself. These two, made at the end of that year, have some of the intensity of the large oil (no.13) which was to mark the culmination of this particular cycle of self-depiction and self-absorption. The gaze is similarly direct and arresting. The thick fringe emphasises the boyishness of his face, but also strikes a bohemian note. Slade students were encouraged to look at old master drawings in the nearby British Museum and elsewhere, and to make copies from facsimiles. In old master fashion, Spencer used a rich chiaroscuro network of cross-hatching and shading to build up each drawing's form. The face becomes a multitude of planes, giving it surface vigour and animation. Abandoning the lighter outlining and shading of the Slade style, Spencer has adopted Michelangelo's distinctive way of drawing. This interest went back to 1911 when his brother Sydney recorded in his diary looking at one of Spencer's books about Michelangelo with him (see Bell 1992, no.117, p.367). Perhaps a shared interest was the reason for Spencer's announcement that he would adopt a Michelangelesque technique for a portrait drawing of Sydney in January 1913 (Bell 1992, p.29).

RU

12

13 Self-Portrait 1914

Oil on canvas 63 × 51 cm
Bell 17
Tate. Bequeathed by Sir Edward Marsh through
the Contemporary Art Society, 1953

Having completed *The Nativity* (no.7) and
Apple Gatherers (no.9), Spencer's decision
to make this impressive portrait of himself
signalled an act of confidence and self-
appraisal. It was painted in Wisteria Cottage,
the decaying Georgian house he rented as a
studio from Jack Hatch the coalman. 'I am
doing a portrait of myself', he wrote to Edward
Marsh, 'I fight against it, but I cannot avoid it'
(quoted in C. Hassall, *Patron of the Arts:
A Biography of Edward Marsh*, 1959, p.255).
Spencer brought it to completion in the
opening phase of the Great War. Painted with a
mirror, Spencer's face is impassive, the gaze
direct and penetrating. The head fills much
of the picture space, its strong jaw and face
muscles offset but also accentuated by the
vulnerability of the exposed throat, the neck
slightly elongated. Although the design is bold
and austere, its severity is softened by the deep
shadows encroaching from the right and the
chiaroscuro planes of the flesh surface. The
background is bare and blank; there is nothing
to distract from his gaze. Spencer may have
had Renaissance portraits in mind, and he said
he was specifically 'inspired by seeing
a reproduction of a head of Christ by Laini'
(733.3.1 no.14). He probably meant Bernardino
Luini, as Spencer's self-portrait is close to the
face of Luini's Christ in his *Christ Among the
Doctors* (fig.51). Spencer's lighting effects
partly follow Luini's, and also recall the
pronounced chiaroscuro of Caravaggio's
Supper at Emmaus (National Gallery). One of
the portrait's most remarkable features is its
size, some one and a half times life. Spencer
himself was five feet two (Pople 1991, p.56), a
fact which in 1914 barred him from military
service. Spencer seems to have been sensitive
about its size or of any implied criticism. Marsh
bought it and asked Spencer why it was so
large, who evaded the question by answering
'Next time I start a portrait I shall begin it the
size of a threepenny bit' (Carline 1978, p.39).
On a 1914 postcard Spencer wrote to the
Raverats: 'Marsh is a nice man even if he is a
fool' (Pople 1991, p.50, and n.20).
RU

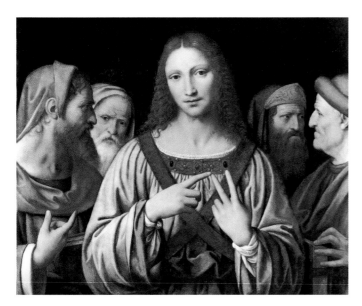

fig.51
BERNARDINO LUINI
*Christ Among the
Doctors* c.1515–30

National Gallery, London

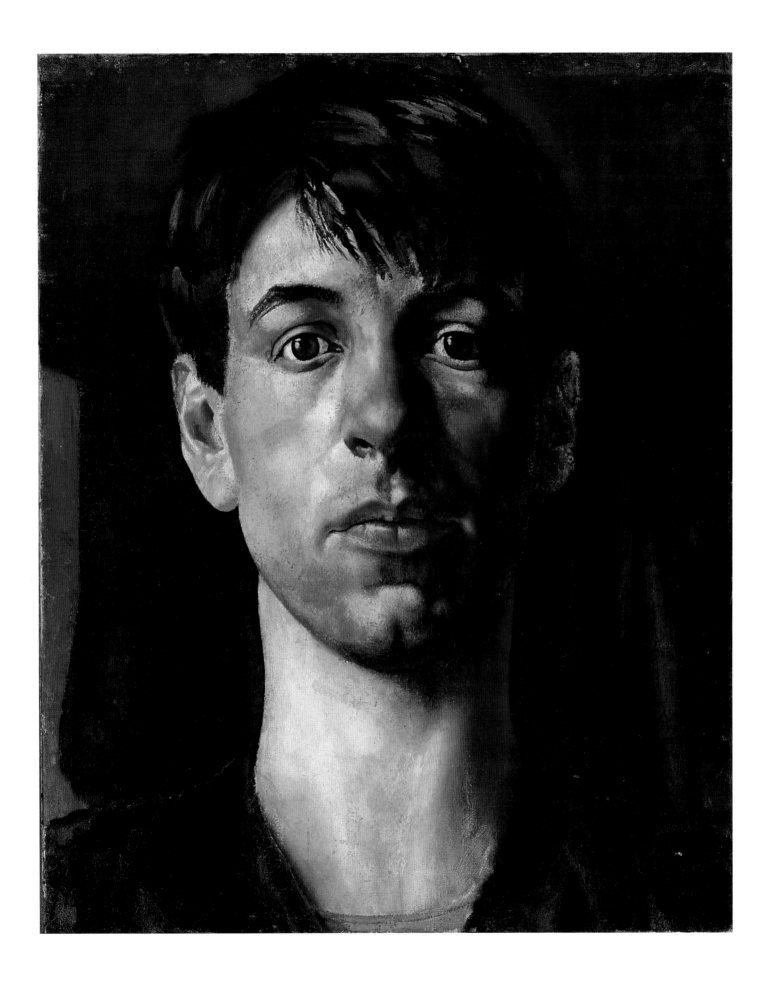

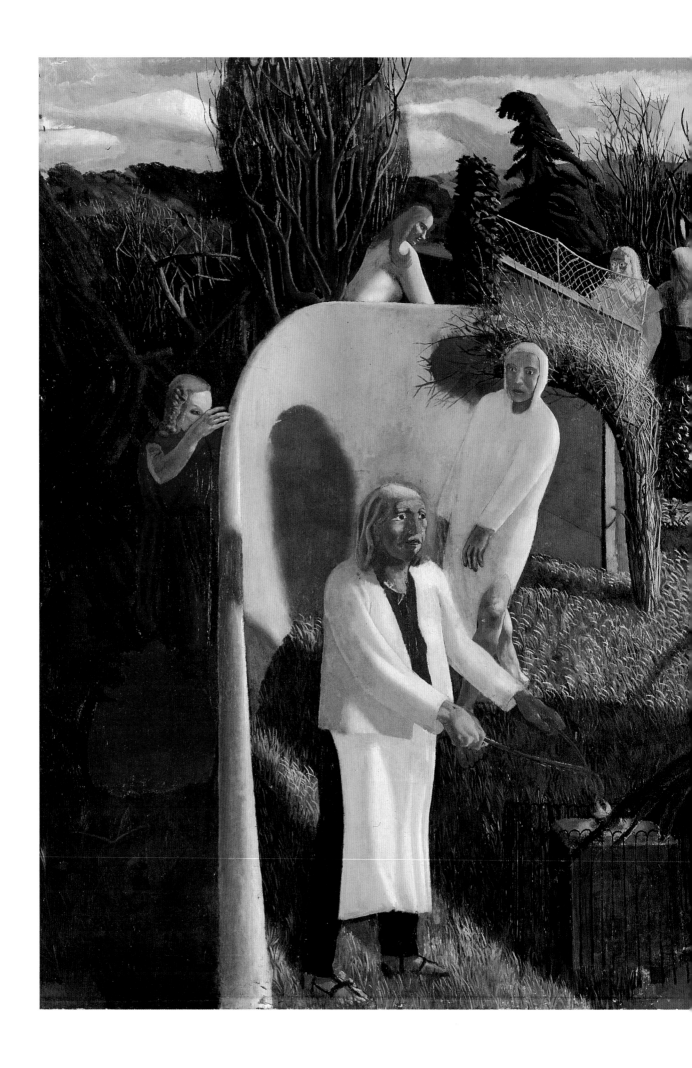

14 Zacharias and Elizabeth 1913–14

Oil on canvas 140 × 140 cm
Bell 16
Tate. Purchased jointly with Sheffield Galleries & Museums
Trust with assistance from the National Lottery through the
Heritage Lottery Fund, the National Art Collections Fund,
the Friends of the Tate Gallery, Howard and Roberta
Ahmanson and private benefactors, 1999

The story of Zacharias and Elizabeth opens
Luke's Gospel, and is the first miraculous
happening in the story of Christ's coming.
The priest Zacharias is visited by the Archangel
Gabriel while making a sacrifice in the Temple.
Gabriel tells him that although too old to have
children, his wife Elizabeth will bear a child
given her by God, who will become John the
Baptist. Spencer imagined the story set like a
mystery play in the garden of St John's Lodge
behind his Wisteria Cottage studio. It was
intended as a summation of his beliefs about
Cookham's sanctity: 'I wanted to absorb and
finally express the atmosphere and meaning
the place had for me … It was to be a painting
characterising and exactly expressing the life I
was … living and seeing about me … to raise
that life round me to what I felt was its true
status, meaning and purpose' (733.3.1, 1937).
As with early Italian pictures, the same
characters appear more than once. In the
foreground Gabriel advances mesmerically
upon an unaware Zacharias, both dressed in
white, Druid-like robes. In the background
Elizabeth appears to be questioning Zacharias,
whom Gabriel had struck dumb; Elizabeth is
also the figure visible at the top of the wall.
The girl by the grave was unidentified by
Spencer, without whose account the picture
would be difficult to understand. The figure on
the right was a gardener Spencer saw; his long
hair and beard recall images of Christ or
John the Baptist. He drags an ivy branch,
a traditional emblem of everlasting life and
the Resurrection. Behind him Elizabeth's hand
touches a yew, a symbol of the same things,
and the winter garden itself is symbolically
punctuated with evergreens. The sweeping,
smoothly sculptural wall seems dramatically
modern in this environment, and its pure
whiteness, repeated elsewhere in the picture,
also strikes a symbolic spiritual note. The
picture's force comes from the elusiveness of
its narrative, and Spencer's evocation of the
spiritual contact between Zacharias and
Gabriel. In choosing the story, Spencer
was able again to treat themes of fertility,
spirituality and relationships between men and
women. Together these early paintings form
a sequence relating to the life of Christ and the
Resurrection, subjects which were to occupy
Spencer for much of his life.

RU

15 The Centurion's Servant 1914

Oil on canvas 114.5 × 114.5 cm
Bell 21
Tate. Presented by the Trustees of the Chantrey
Bequest, 1960

The story comes from Luke 7:1–10 in which
Christ cures the Centurion's servant's illness
from some distance after a messenger tells him
about it. It is one of the events which alerts
Judea to Christ's presence and presages his
entry into Jerusalem. Spencer initially
conceived treating the subject as a diptych
with the other picture showing the messenger
meeting Christ; the boy's odd position on the
bed imitated the striding messenger. Spencer
set his picture in the maid's bedroom in
Fernlea, but he said he did not intend to show
a natural servant's setting. Instead his
motivation was to depict a room he associated
with the miraculous. He had heard the maid in
conversation there when he knew her alone
and imagined she was talking to an angel. In
fact she was speaking to the next-door servant
through the thin attic division (Carline 1978,
p.41). The figures round the bed, modelled by
Spencer in the centre, and his siblings, were
inspired by his mother's account of Cookham
villagers gathering to pray around the bed
of those severely ill. Their strange gestures
are based on Spencer's 'praying positions'
in church, and also how he would 'gaze
around church while praying and feel the
atmosphere … the state of mind I wanted in
the picture was to be peaceful, as mine was in
church, even though the miracle had occurred'
(quoted Pople 1991, p.62). The figure on the
left turns, sensing the miracle. But any peace
seems disturbed by the restless position of the
boy on the bed, also modelled by Spencer,
and his pensive gesture of hand to mouth,
and the intensity of those watching over
him. The odd atmosphere is accentuated
by contrasts between the abstract, stark
background and the slightly oppressive, florid
patterns of the bed. Spencer represents himself
younger than in 1914, perhaps a childhood
memory of being in the room. Shown at the
1915 New English Art Club exhibition, *The
Times* praised the picture (30 Sept. 1915), a
review Spencer said sustained him throughout
the war (undated letter to William Rothenstein,
733.1.1344a).

RU

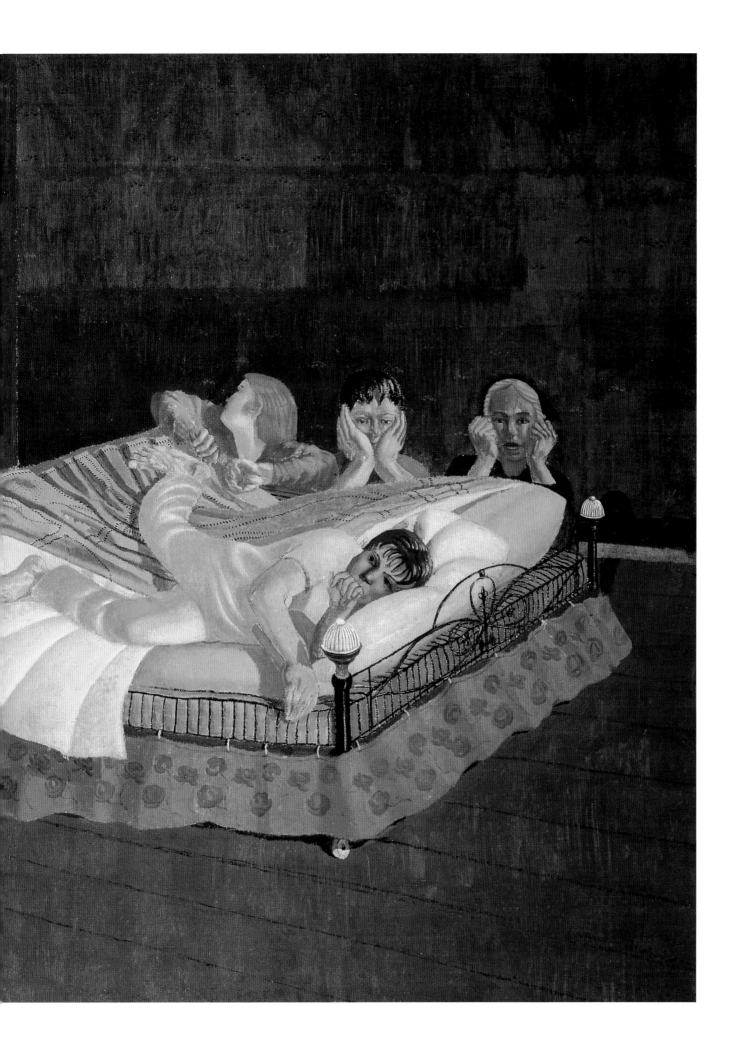

16 Cookham 1914

Oil on canvas 45.1 × 54.6 cm
Bell 19
Tullie House Museum and Art Gallery

By 1937 Spencer tried hard to remember what had motivated him to make this, his first landscape painting: 'My father wanting me to do some "out-of-door" work … possibly' (733.3.1). Unlike his figure pictures this was painted on the spot, showing the view from Terry's Lane to Winter Hill and Rowborough. The red dash below the centre horizon is a railway signal. The railway, which bisects the picture horizontally, was instrumental in transforming this part of the Thames from a declining river economy to a busy summer resort. Gilbert Spencer recalled that Terry's Lane was a regular childhood walk for the two brothers, its railway bridge being a special attraction (Chamot, Farr and Butlin 1964, II, p.633). Plein-air landscape was still associated with British Impressionist painters such as George Clausen who had lived and worked in Cookham. But Spencer's precise rendering of each detail equally recalls Pre-Raphaelite pictures by Millais and Holman Hunt. Spencer has emphasised the strong diagonal of the hedge to give geometric formality and tension to the composition. The picture was bought by Edward Marsh in 1914.

RU

17 Mending Cowls, Cookham 1915

Oil on canvas　109 × 109 cm
Bell 26
Tate. Presented by the Trustees of the
Chantrey Bequest, 1962

These oast house cowls overlooked Fernlea, and their white forms turning mysteriously in the wind was one of Spencer's childhood memories. He ascribed to them both a religious significance and an animate life of their own.

'They seemed to be always looking at something', he wrote in 1944, 'they were somehow benign. With their white wooden heads they served as reminders of religious presence' (Carline 1978, p.44). The Spencer children were forbidden to enter the oast houses, and this increased their mystery (Pople 1991, p.195). But in his picture their structure and simple mechanical nature, and reliance on human repair, is laid bare. The composition is made up of a group of geometric forms and planes, given tension by the figures'

intervention, two contained and one bisected. Spencer himself was dismissive about this aspect, writing to his friend James Wood in May 1916: 'I did that thing not because of the "composition" it made; some people say it had a "fine sense of composition", such people know nothing of the feeling which caused me to paint it. There are certain children in Cookham, certain corners of roads and these cowls. All give me one feeling only. I am always wanting to express that' (TGA Microfiche 19).
RU

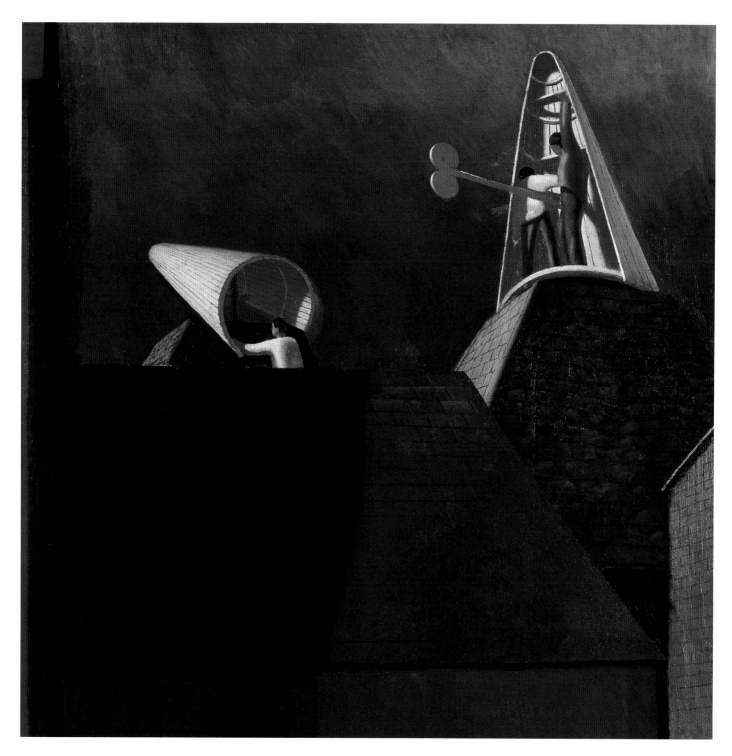

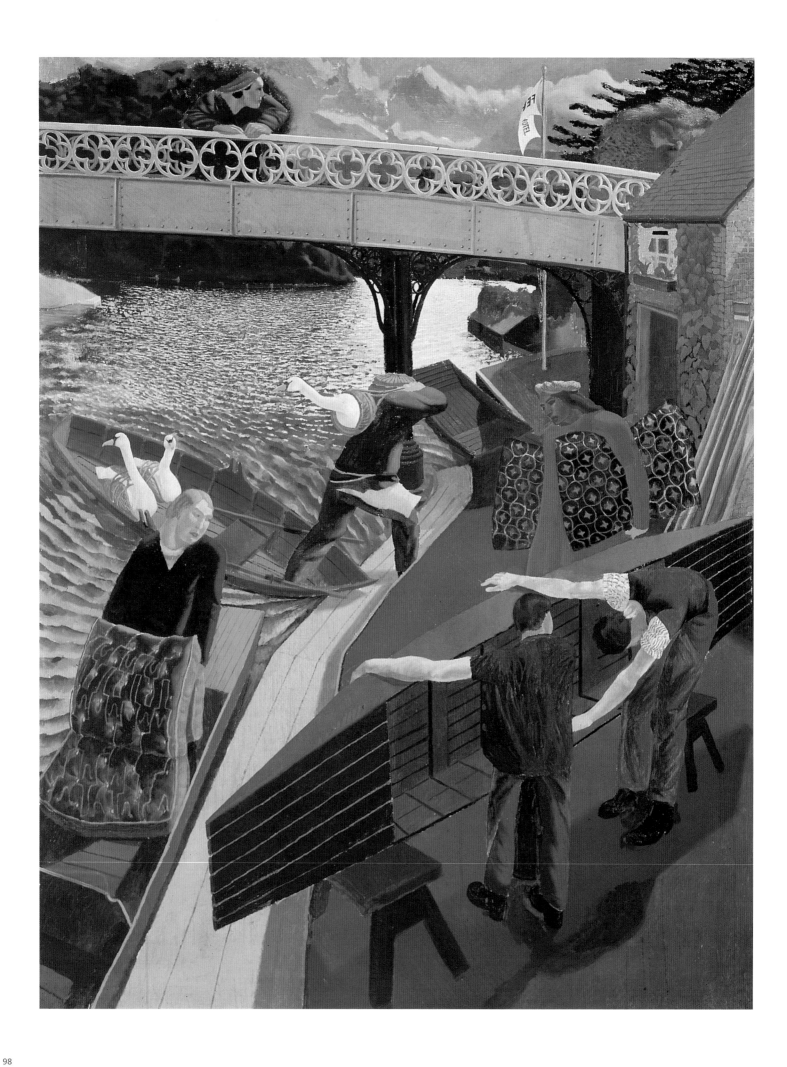

18 Swan Upping 1915–19

Oil on canvas 148 × 116.2 cm
Bell 27
Tate. Presented by the Friends of the Tate Gallery, 1962

The ancient practice of swan upping takes place every August on the Thames. The Vintners and Dyers Companies own some of the river's swans by royal licence and take up the young birds each year for marking, cutting their beaks once for the Vintners and twice for the Dyers (unmarked swans belong to the crown). The inspiration for the picture came while Spencer was in church and heard people on the river. During the service 'the village seemed as much a part of the atmosphere prevalent in the church as the most holy part of the church … when I thought of people going on the river … it seemed … an extension of the church atmosphere' (733.2.44). Spencer later saw the swans being carried in carpenters' bags and the Bailey girls carrying punt cushions to the river (733.3.1). There may just have been some mental connection too with the Flaxman memorial to Isaac Pocock in Cookham Church, where he is depicted dying in the arms of his wife while punted on the Thames (fig.52); Spencer may have been led to connected thoughts of rivers, death, Charon and the passage of life. The picture shows Turk's Boathouse (the Turk family were to hold the office of Swan Keeper for most of the twentieth century), with Cookham Bridge and the Ferry Hotel beyond. Spencer composed the scene from memory, its curious ambiguity emphasised by the men's hidden faces, their phallic, outstretched arms echoing the straining necks of the bound, powerful swans. Spencer may just have had in mind the necks of the birds in the Frederick Walker print of geese in Cookham which hung in Fernlea (fig.53). The choice of swan upping as a subject is also somewhat peculiar, the birds' eventual cutting with a knife before release is primal and ritualised, an initiation akin to circumcision.

Compositionally the picture is a network of intersecting planes and lines. There are echoes of the Douanier Rousseau in the clear design and colour of the sky and water, while the turbaned woman appears Florentine, as does the central figure on the bridge. While Spencer was painting, there were soldiers parading outside his window. The war was getting closer, and he abandoned the picture half completed to enlist in the Royal Army Medical Corps. While he was away Spencer yearned to complete it, and visualising this sustained him and acted as a talisman. 'It can be imagined', he wrote, 'what I felt when I did at last walk into my bedroom, at home to see this picture leaning with its face to the wall … I walked round the bed to it and laid my hands on it once more … there we were looking at one another; it seemed unbelievable' (733.2.44). Spencer completed it in 1919, but was aware of difficulties in painting the water he had never had before. 'Oh no', he lamented, 'it is not proper or sensible to expect to paint after such experience' (733.2.44). The war had changed him.

RU

fig.52
Memorial to Isaac
Pocock by Flaxman,
Cookham Church.

fig.53
FREDERICK WALKER
The Street, Cookham
1866

Watercolour on paper

2 WAR AND ITS AFTERMATH

'It has affected my work because it has naturally upset that confiding nature I had before the war towards people ... that serenity of spirit which I then felt to be innate in everything around me as well as in myself' (733.3.5, 38).

Spencer spent almost four years away at war, first as an orderly in a Bristol hospital, then in the Macedonian campaign. He'd brought with him several pocket monographs of early Italian masters, and in drawings (now lost) as well as in letters, he was already shaping his war experiences for an imaginary frescoed chapel. Returning to Cookham at the end of 1918, he experienced a 'Loss of Eden', unable to resume his pre-war existence, and suffering from 'war depression'. He found difficulty in completing the lower half of *Swan Upping* (no.18) which exhibits a new coldness and flatness of handling – problems that would dog much of his work of the early 1920s. *Travoys* (no.19) was an immediate success, but Spencer refused to take on further official war commissions. He left home. Living for a year at nearby Bourne End in the home of Henry Slesser (a Christian Socialist lawyer, later to serve in the first Labour government), Spencer composed several striking Biblical episodes in modern dress.

Meanwhile, he was making frequent visits to London, staying with the Carline family in Hampstead. At Downshire Hill Spencer renewed contact with a circle of painters that included Roberts, Gertler, Paul and John Nash, Nevinson and Lamb, as well as his brother Gilbert and the Carlines themselves. All of these would certainly have conceived themselves as 'modernists', but also (like so many post-war artists) as constructors of a new humanist order. Spencer fell in love with the Slade-trained painter Hilda Carline (two years his elder) and in 1922 he set off with the Carlines across Europe, spending a week in Vienna on the way to Sarajevo, and returning via Munich and Cologne. This was the only occasion he saw major collections of foreign masters outside Britain.

Spencer's little *Resurrection* of c.1921 still has much of Nabi intimacy, but in larger works such as *Christ Carrying the Cross* he strove for a fresco-like flatness: schematic, and lacking the pre-war intensity. Staying with Henry Lamb in Dorset in 1923, he drew out in detail an entire scheme for a chapel dedicated to his war experiences. These drawings were almost immediately seen by friendly patrons Louis and Mary Behrend, who decided to realise Spencer's dream, and provided him with an income for most of the next decade. While the chapel was being built, Spencer took over Lamb's studio in Hampstead and began an eighteen-foot canvas, *The Resurrection, Cookham.* Its subtext was a celebration of the sexual love shared with Hilda, who he eventually married in 1925. The onset of sexual experience, so long delayed, threatened to overwhelm his Cookham vision: 'Having grown up and having more developed sex feelings than I had before the war ... they made the earliest feelings of religion and Cookham so almost die out as to be memories of consciousness rather than consciousness itself.' From the outset, Spencer saw this *Resurrection* as a return to full-blooded imagery, 'thick and solid': 'If I get the colour in this picture cold, as is usually my fault ... it will be fatal as the whole point of this picture will be the warm sunshine' (letter to Hilda, 1 October 1923). Lit from the right, the composition fans out from the white church wall, with Spencer himself as a witness, stretched out in a kind of stone-book at bottom right.

Moving to Burghclere, Spencer became immersed for the next five years (1927–32) in a project that had really been conceived a decade earlier. He became isolated; and Hilda spent longer periods back with her family in Hampstead. Burghclere delayed, but could not forestall, the gathering crisis.

TH

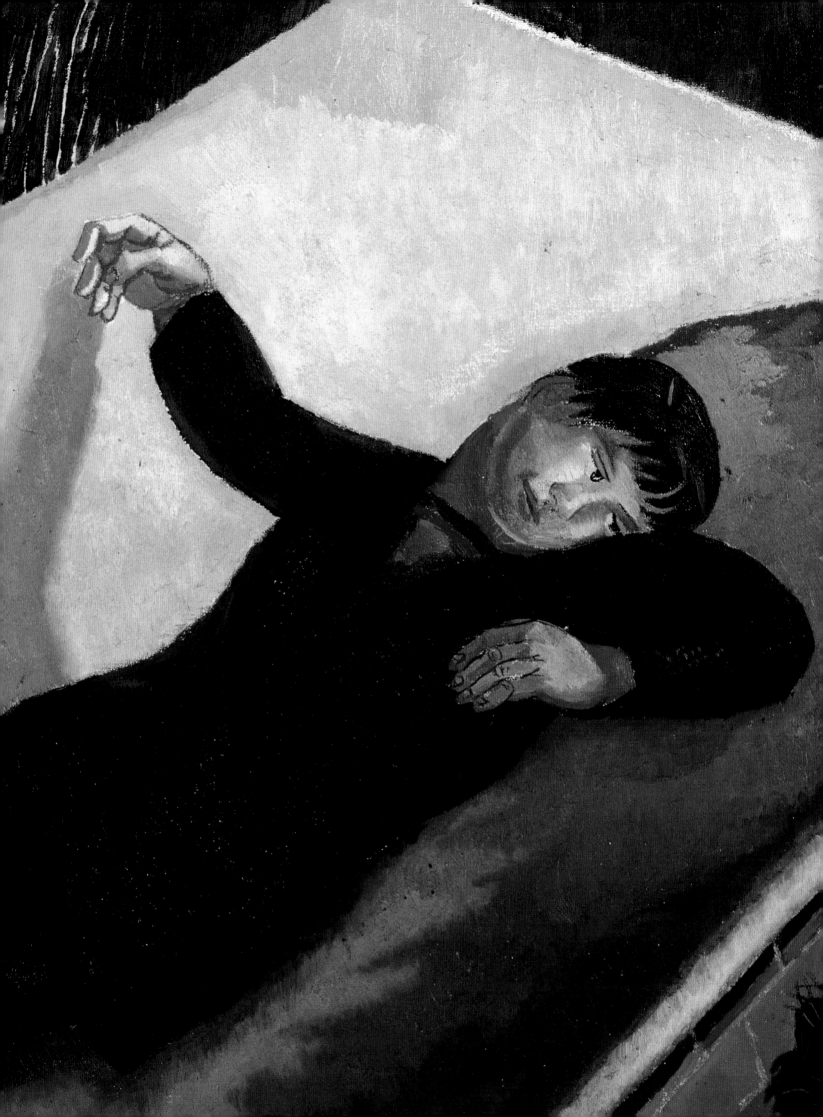

19 Travoys Passing up Sedomli Ravine on the Way to le Naze
1919

Pencil and wash on paper 21.5 × 25.4 cm
Imperial War Museum, London

20 Stretcher Bearers, Macedonia
1919

Pencil and wash on paper 21.5 × 14.6 cm
Imperial War Museum, London

21 Travoys with Wounded Soldiers Arriving at a Dressing Station at Smol, Macedonia 1919

Oil on canvas 183 × 218.4 cm
Bell 30
Imperial War Museum, London

'I meant not a scene of horror', Spencer wrote about *Travoys* (no.21), 'but a scene of redemption' (733.3.21, 1938). He based this picture on his experiences with the 68th Field Ambulance unit in Macedonia. Spencer shows wounded men brought down from the attack on 'Machine Gun Hill' in the Doiran-Vardar sector in the middle of September 1916. The mountainous terrain required the seriously injured to be transported on 'travoys', mule-drawn sledges. 'I was standing a little way from the old Greek church', Spencer wrote to Hilda Carline in 1923, 'and coming there were rows of travoys and limbers crammed full of wounded men. One would have thought that the scene was a sordid one, a terrible scene … but I felt there was a grandeur … all those wounded men were calm and at peace with everything, so the pain seemed a small thing with them. I felt there was a spiritual ascendancy over everything … the orderlies

attending them are inserting peace in the face of war …. in some communion of peace' (733.3.1; Carline 1978, p.112). Spencer saw the wounded in explicitly religious terms: 'The figures on the stretchers treated with the same veneration and awe as so many crucified Jesus Christs, and not as conveying suffering but as conveying a happy atmosphere of peace. Also like Christs on the Cross they belong to another world than those attending them' (733.3.1, 1937).

But if the picture is a Crucifixion, it is also a Resurrection through the efforts of the surgeons. Gowned like priests, their operating table an altar, their field basin like a font, they anoint and heal the smashed man. The warm light of the makeshift theatre, and the watching mules, recall traditional images of the Nativity, and so *Travoys* becomes a confluence of birth, death and resurrection. The sense of peace and stillness sometimes felt by the

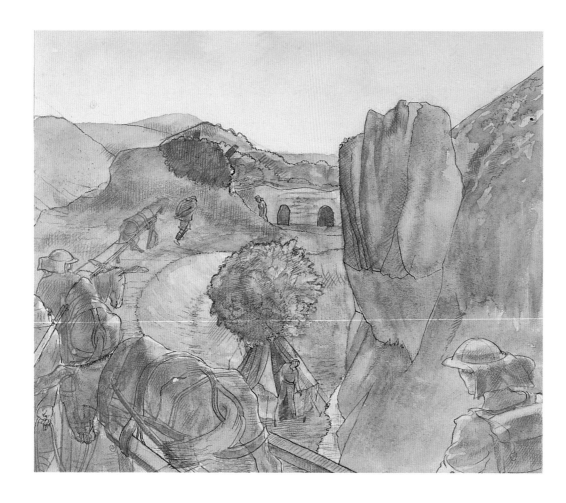

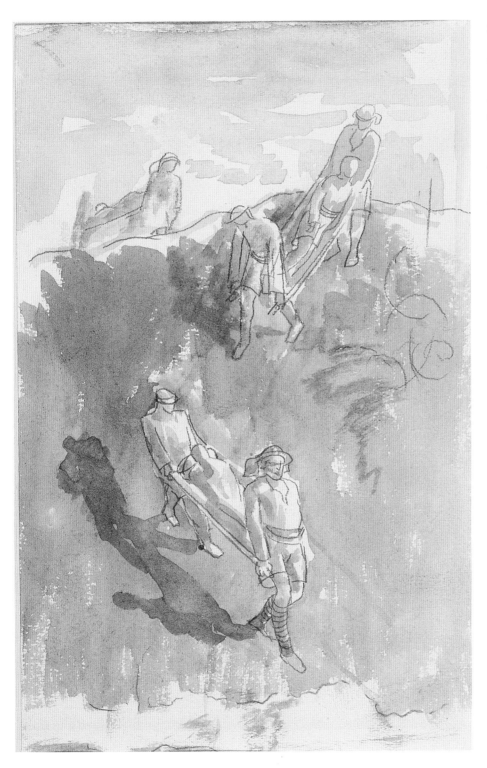

seriously ill, and the other-worldly feeling of rebirth on waking, may have been familiar to Spencer through his own affliction with malaria, contracted in Macedonia. The orderly at the centre of the travoy line closes the eyes of a dead man, his arms spread wide like the limbs of a cross, his face turned away from his patient. Few faces are visible in the picture, and the scene's impact is accentuated by the unusual poses of the orderlies and the strange forms made by the covering blankets.

The largest picture Spencer had so far made, it was commissioned by the Ministry of Information. He had been first nominated and approached by the War Artists' Advisory Committee in April 1918, who suggested he paint 'a religious service at the front' (IWM 290/7); it was Spencer's wish to show a scene relating to his own experiences. It was not until December 1918 that Spencer returned home under the malaria sufferers' scheme. All the sketches he made while he was away had been lost, and he submitted several drawings made from memory as possible compositions, including nos.19 and 20. The committee chose *Travoys*, which was an immediate success when it was shown at the large War Art exhibition at the Royal Academy in 1919.

RU

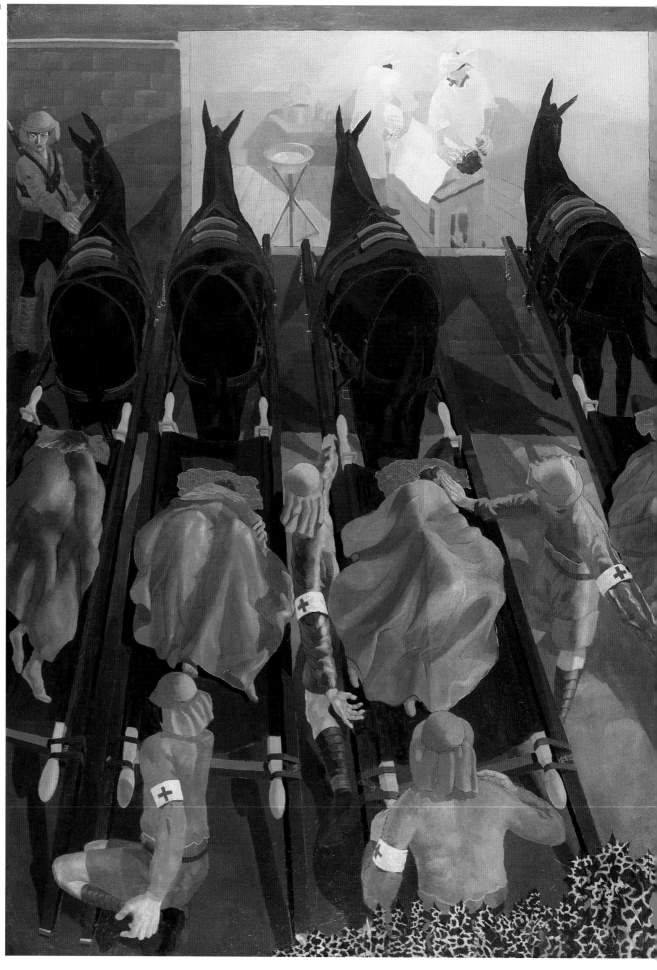

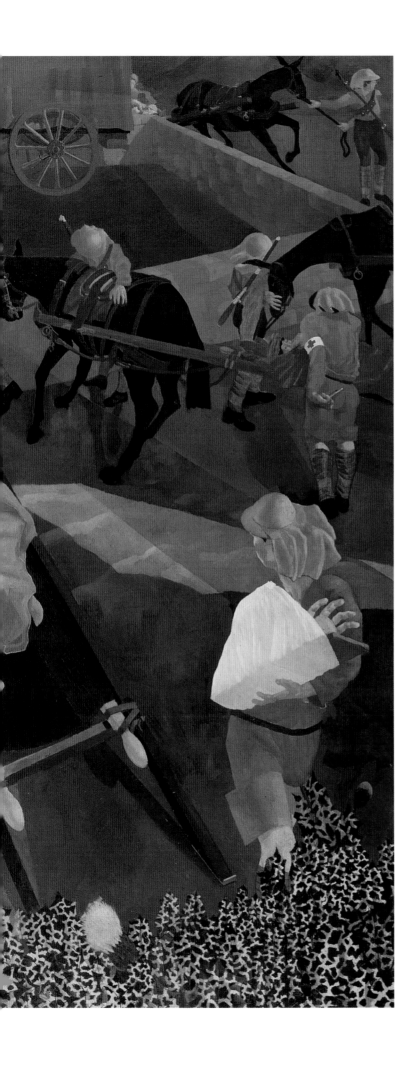

22 Study for The Last Supper
c. 1919

Pencil and brown wash on paper 53.3 × 73.7 cm
Private Collection, London

Spencer first made drawings for a Last Supper before his departure for the war in 1915. After his return he took up the theme again and made this large composition study, squared for transfer to canvas. His *Last Supper* is set in the oast house overlooking Fernlea, the cowls of which he regarded as spiritual presences, painting them in 1915 (no.17). Spencer shows the climactic moment when Christ breaks the bread, and tells his disciples 'Take, eat; this is my body' (Matthew 26:26). St John rests his head on Jesus's shoulder, whilst Judas looks shamefully away. Spencer solves the pictorial problem of the foreground with the extraordinary feature of the rhythmic row of disciples' legs, ankles crossed and toes touching like praying hands. It seems to convey something of their relaxed fellowship, and strikes a human note amidst the sacred symbolism. It may have been suggested to Spencer by St John's description of Christ washing the disciples' feet. The constrained space of the oast house, entirely filled by the figures, gives the composition considerable force. The wall behind Christ, in reality the grain bin, creates a hidden mysterious space we cannot see, perhaps hinting at the world beyond our own. In its spatial arrangement of the tables, and in the detailed brickwork, Spencer may have had in mind Donatello's relief of the *Dance of Salome* on the baptistery font in Siena Cathedral, which he knew from a book he kept with him in Macedonia (RA 1980, p.25). A further inspiration was Giotto's *Marriage Feast at Cana* in the Arena Chapel, which he knew from Ruskin's commentary and the illustration in his Gowans and Gray book on Giotto (Bell 1992, p.55).
RU

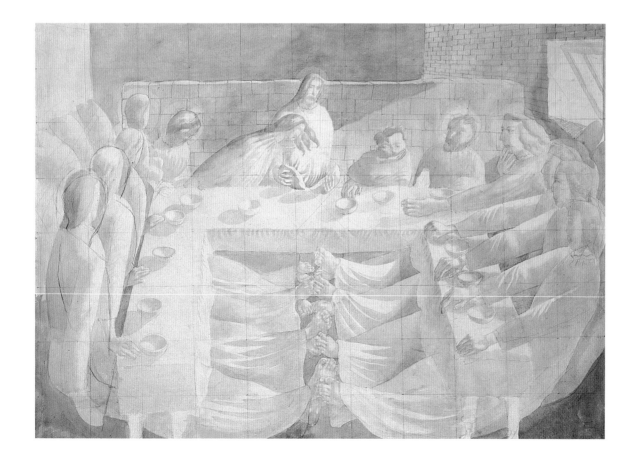

23 Study for The Bridge c.1920

Pencil and wash on paper 35.6 × 50.8 cm
Tate. Presented anonymously, 1947

This is a study for the last painting Spencer made while living with his parents, before moving to the Slessers in 1920. There may be some pictorial symbolism of this event – the bridge links Cookham with Bourne End, a mile or so up stream, where the Slessers lived. Although geographically close, the dividing Thames made Bourne End a very different environment, and leaving home again after the rigours of war must have been difficult for Spencer. The large finished oil (fig.54) did not please Spencer, who wrote: 'Still quite at a loss and cannot get my bearings at all … Quite a good idea of people leaning over either side of bridge and crossing to look from one side to the other, but somehow I felt suspended and could get no grip' (733.3.1, 1937). He had to be persuaded by Richard Carline not to destroy the oil, and it is hard not to read emotional displacement into Spencer's responses to the picture. The subject is elusive, but the picture may represent people watching the annual Cookham Regatta; the dog is an airedale terrier belonging to Guy Lacey, the man who taught Spencer to swim in the Thames. The study differs from the painting in having a counterpoint foreground row of figures and people under the bridge itself. To the right of the sheet are three small composition studies, one for *The Bridge*, another possibly related to *Joachim Among the Shepherds* (see no.6), and a further unidentified subject. On the reverse are two studies of women hanging out washing.

RU

fig.54
STANLEY SPENCER
The Bridge 1920

Oil on canvas
Tate. Presented by the
National Art Collections
Fund, 1942

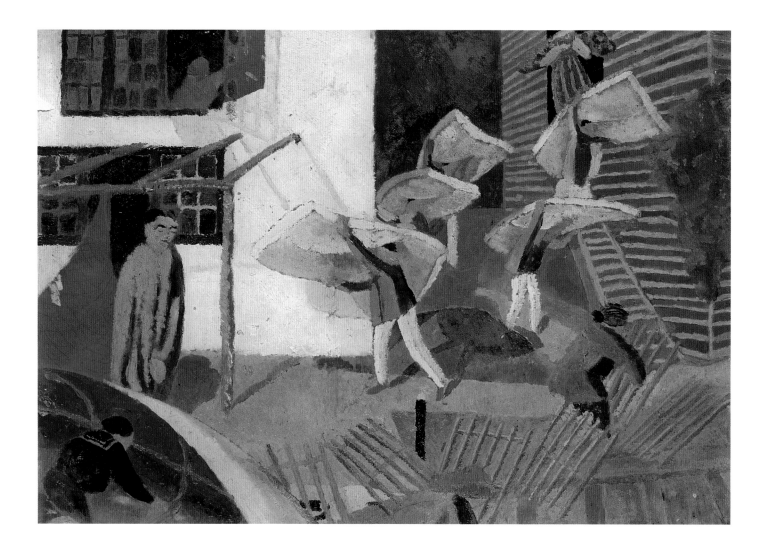

24 Carrying Mattresses *c.* 1920–1

Oil on paper laid on board 31 × 41.9 cm
Bell 43
Collection of David Bowie

Spencer here shows the preparation of punts and canoes by the river, signalling the arrival of summer. Pictorially Spencer takes pleasure in the unusual shapes made by the men carrying punt cushions on their heads, and the repeated, staggered rhythm of shapes as they come down the steps of the wooden boathouse. Behind them a figure appears to call out. In one of his notebooks Spencer titled the picture *Slessers Going on River* (733.3.1), and it might record a specific event from his time staying with them at Cornerways in Bourne End. The gowned figure on the left has the heavy eyebrows and strong features of Henry Slesser, and his costume may be an allusion to his status as a trade union lawyer. His downcast eyes and still, hieratic stance, compared to the movement of the mattress-carriers, create an atmosphere of ambiguity, but one of significance and spirituality – a Christian Socialist man of the law among friends on a summer weekend.

RU

25 The Paralytic Being Let into the Top of the House on his Bed c.1920

Oil on panel 29 × 33 cm
Bell 37
Spink-Leger, London

Continuing his cycle of pictures about the life of Christ, Spencer turned to the Miracle at Capernaum. A paralysed man is brought to Jesus on his bed, but because of the crowds of people, cannot get into the house. His companions solve the problem by removing roof tiles and lowering him directly into the room where Christ is staying. His paralysis is healed, but Jesus also tells him he is cleansed of his sins, for which the watching Pharisees

question his authority (Luke 5:18–26). Spencer showed the incident happening in his grandmother's house, 'The Nest', next door to Fernlea. He first treated the subject in a detailed drawing (RA 1980, no.49). The painting exhibited here is an intermediate study, but although squared for transfer, Spencer did not complete a finished version. His series of illustrations of the Gospels appears to have been intended for a dedicated church setting, and like Giotto's Arena Chapel, which probably partly inspired them, they were ultimately to be executed in fresco. 'When I come home', Spencer wrote to his sister Florence from Macedonia, 'I am going to learn fresco painting and then if Jacques Raverat's project holds good, we are going to build a church, and the walls will

have on them all about Christ. If I do not do this on earth, I will do it in Heaven' (quoted Pople 1991, p.194). This appears to be the earliest expression of a project which was eventually to develop in his mind into Church-House. His early commitment to such a scheme may have been suggested by Eric Gill's prestigious commission in 1913 to carve relief panels of the stations of the Cross for Westminster Cathedral. Gill was still at work on them when Spencer met him at Hawkesyard in December 1919. Although they did not get on at this meeting, there is a comparison in their lifelong preoccupation with the relation between sex, religion and artistic expression.

RU

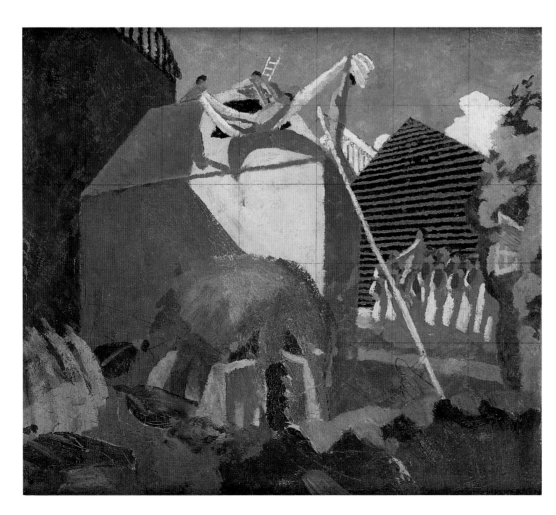

26 Study for Christ Carrying the Cross 1920

Pencil and watercolour on paper 44.1 × 35.6 cm
Tate. Presented by Nancy Carline in memory of her husband
Richard Carline, 1982

27 Christ Carrying the Cross 1920

Oil on canvas 153 × 143 cm
Bell 38
Tate. Presented by the Contemporary Art Society, 1925

Christ is shown carrying the Cross down Cookham High Street, past Fernlea. The extraordinary takes place in an everyday setting, as in an early Italian fresco, whose typically soft colours it reproduces. Spencer described it as a scene of wonder or joy, part of the natural fulfilment of the story of Christ's transfiguration (733.3.1). Yet in the foreground Mary breaks down, a portrayal prompted by hearing Henry Slesser quote the sensational *Daily Mail* description of Queen Victoria's funeral: 'Women publicly wept and strong men broke down in side streets'. Mary's pain is watched unrelentingly by a staring row of figures, backs turned to Christ, grasping railings pointed like the spear which will pierce his side. Jesus himself, partly hidden, appears calm but looks straight ahead. Above, figures burst out of every window to gaze down on him, a remarkable element suggested by something entirely different: 'The shape I liked was *one* shape with smaller shapes projecting from it … the form of a potato with little ones forming on it' (Carline 1978, p.126). Further inspiration came from seeing builders carrying ladders past The Nest: 'part of the "fact" of Christ carrying the Cross … It was joy and all the common everyday occurrences in the village were reassuring, comforting occurrences of that joy … The men carried the ladders and Christ carried the Cross' (733.10.58). With faces obscured, like the men in *Swan Upping* (no.18), the builders carry the ladders to form a St Andrew's cross. Above, a cowl peeps over The Nest, a watching, religious presence (see no.17); the oast houses were to be the setting for *The Last Supper* (see no.23). The picture's preoccupation with the act of looking was partly suggested by Spencer's boyhood: 'as youths we stood with other village youths in a gate opposite our house and watched people go by on Sundays and in evenings … The window of the ivy-covered cottage [The Nest] … is associated in my mind with my liking to be up in a large yew tree from which I could survey the world not only of our garden but other gardens beyond' (Chamot, Butlin and Farr 1964, II, p.661).

RU

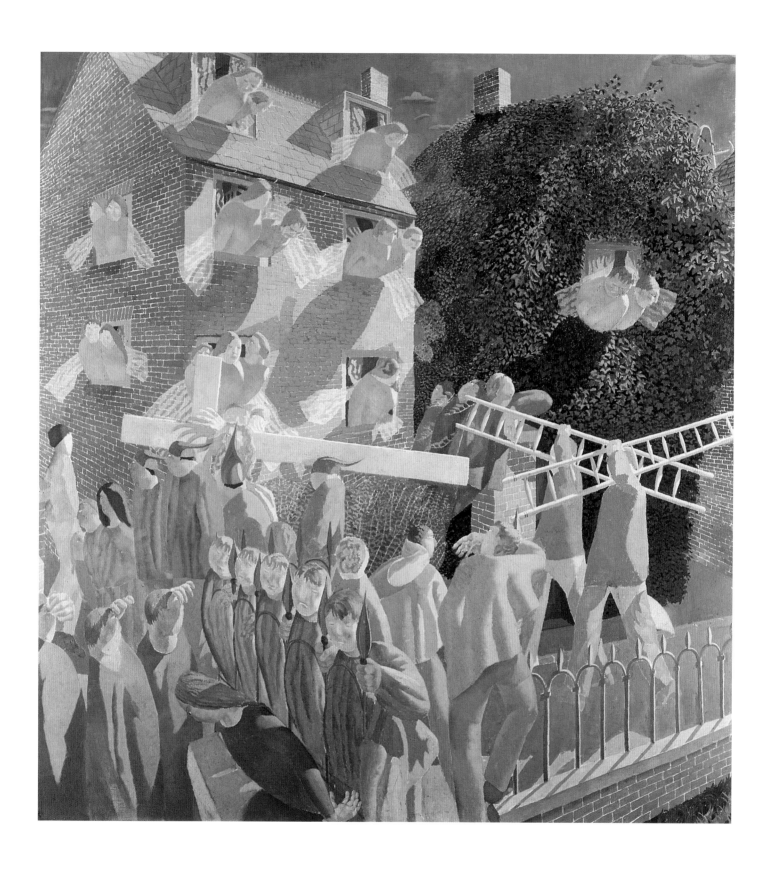

28 Durweston, Hod Hill 1920

Oil on canvas 48 × 59 cm
Private Collection courtesy of Austin Desmond Fine Art

Spencer and his brother Gilbert spent the summer of 1920 painting at Durweston in central Dorset, where they regularly met with Henry Lamb who was living in the nearby village of Stourpaine. Spencer embarked on a sequence of six landscapes painted in the open air, temporarily abandoning religious subjects due to 'war depression', as he noted in 1948 (733.10.143).

Gilbert Spencer remarked that Stanley painted Dorset with considerable grumpiness and detachment, disliking the feudalism that gripped Durweston even more than Cookham. He sought out 'nasty unhomely' views to demonstrate his contempt for picturesque landscape convention, and even favoured weeds like the yellow-flowering charlock (described as a 'vegetable rat' in Geoffrey Grigson's *Englishman's Flora*, 1955). Gilbert recalls an event that occurred while his brother was painting *Durweston, Hod Hill*:

'The picture had a lot of charlock in the foreground, painted by Stan with his usual love of detail. But when the farmer saw the picture, naturally enough he did not like the charlock. Next day when my brother arrived on the scene he found it had all been cut down. Stan enjoyed relating how the labourer who had done the job explained that the place looked better now. More surprising, Stan cut his down as well' (Gilbert Spencer, *Stanley Spencer by his Brother Gilbert*, 1961, p.156).

It is worth pausing before endorsing Spencer's own condemnation of 'these fiddling landscapes' (quoted by Gilbert Spencer, p.155) as secondary works churned out for money. There may still be charlock in the foreground, but *Durweston, Hod Hill* is actually organised around the darker turf of the Iron Age ramparts enclosing the sky-lined heights of Hod Hill, a fifty-four-acre hill fort where the ancients Britons were defeated by the Romans in AD44. Throughout the 1920s, many admirers would idealise such ancient places as part of an imagined high-land, green bastions of lost English virtues akin to those that had been destroyed in the Great War.

A suggestive contemporary context for Spencer's Durweston landscapes is provided by the post-war theory of 'Downland Man' advanced by H.J. Massingham, a former guild Socialist and follower of the naturalist and writer W.H. Hudson, who wandered the chalk downs of 'Dorset the Blest' imagining a benign prehistoric culture among the folded turf of the hill-forts and barrows. In Massingham's vision, sites like Hod Hill became monuments to a peaceable 'megalithic' way of life that had been extinguished, like the hopes of his own youth, by the coming of metal, accumulated wealth and war. A comparable resonance animates Spencer's *Landscape with Cultivator (Durweston with Harrow)* (fig.34), in which metal agricultural implements are shown at rest in the foreground of the bucolic Durweston landscape they have helped to shape. This painting gains in significance once it is recognised how strongly metal had come to symbolise war and mechanised destruction. Spencer has framed this landscape to produce a metaphorical image of swords beaten into ploughshares.

PW

29 The Sword of the Lord and of Gideon 1921

Oil on paper laid down on cardboard 62 × 56 cm
Bell 75
Tate. Presented by the Contemporary Art Society, 1942

This was the last picture Spencer made before leaving the Slessers' at Bourne End near Cookham. Turning this time to the Old Testament, Spencer chose the story of the invincible Gideon's routing of the Midianites. Gideon and the Israelites surround their sleeping foes: 'and the three companies blew the trumpets, and brake the pitchers, and held the lamps … and they cried The sword of the Lord and of Gideon. And they stood every man in his place round about the camp: and all the host ran, and cried, and fled' (Judges 7:20–1). Spencer shows the panic as a tent collapses and billows, its ropes flying out like tendrils, revealing the Midianites beneath, who throw off their blankets. The trumpeters burst out from the rocks above. The man holding a large, partly-obscured red cross is presumably Gideon. Spencer's own experience of military confusion and sleeping under canvas must have influenced the picture. He presents a remarkable composition, dominated by the visually complex, overlapping forms of rocks, tents and flying canvas. This adventurous arrangement highlights his continued fascination with form and his commitment to experimentation, its visual commotion parallel to that of the Midianites. Spencer was not satisfied with the result, describing it as 'A thing I struggled over a great deal … There was something very good there but I could not get at it' (733.3.1).

RU

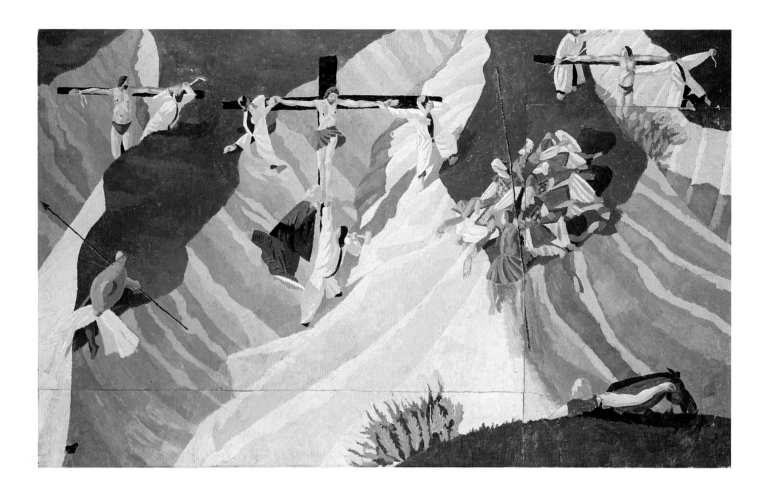

30 The Crucifixion 1921

Oil on paper laid down on canvas 70.7 × 111.6 cm
Bell 77
Aberdeen Art Gallery and Museums

Painted while Spencer was staying with the artist Muirhead Bone (1876–1953) at his house at Steep, Hampshire, this picture may be connected with a proposed decorative scheme for the local Memorial Hall. Spencer often used Cookham as the setting for his Gospel pictures, but here he turned instead to his experiences in Macedonia. The Crucifixion is traditionally depicted on a hill, but Spencer places it in three ravines. These were a memory of a mountain 'dividing Macedonia from Bulgaria. I and some Berkshire Regiment men and some Cyprian Greeks were walking over the snow to the […] quarters, and away

behind it in the dark Christmassy sky were these mountains. This particular one was quite clear and in front of the others … At intervals slices seemed to have been taken out of it: three long gashes there were … As I walked towards the range I did not at all think of a Crucifixion, every sound was muffled … But somehow though some of my worst experiences were ahead of me … I felt hopeful' (733.10.154). Spencer mentally transposed the intensity of this memory to the intensity of Golgotha, casting the sufferings of war as sacrificial but ultimately redemptive, a theme he was to expound fully at Burghclere (nos.37–40). The composition's high viewpoint allows the sight of all three ravines. The crucified thieves look as if they are emerging from graves. Spencer contrasts the violent intensity and movement of the soldiers swinging their hammers far back and Mary

sliding down the bank to kiss Christ's feet, with the almost bored languor of the watching priests and soldiers. The priests dangle their legs and lie on the grass as if at a picnic, forming a pictorially complex tangle of figures, an echo of the rippling ravine. The centurion leans back against his horse in the foreground while on the far left is the soldier who won Christ's coat in the lottery. Spencer extended the paper in several places. Ultimately he envisaged expanding the composition to include at the top a view of Jerusalem and the veil of the Temple rending in two, and to the left, resurrected saints walking the streets. There is a similarity between the slits of the ravine and the dug out in *Camouflaged Grenadier* (no.38), and the graves in *The Resurrection, Cookham* (no.35) and *Stand-To* at Burghclere.

RU

31 Study for a Religious Subject
c. 1920–1

Oil and pencil on paper 27 × 20 cm
Tate (TGA 733.3.81)

Painted on a sheet from Spencer's sketchbook, this is related to *The Crucifixion* (no.30), where the ravines are repeated, a memory of some mountain gorges Spencer saw in Macedonia, 'making huge dock-leaf shapes' (733.3.10, 154). Into these, like slit trenches, men crowd with outstretched arms, recalling Christ and the thieves in *The Crucifixion*; their blue and white copes suggest they are priests. At the top right a white figure with a smaller one pencilled in beside him leaves the scene. Fascinated by shape and form, Spencer frequently reused material in other, related contexts. The mens' outstretched arms in the trenches closely resemble the pairs of emerging Africans in *The Resurrection, Cookham* (no.35).

RU

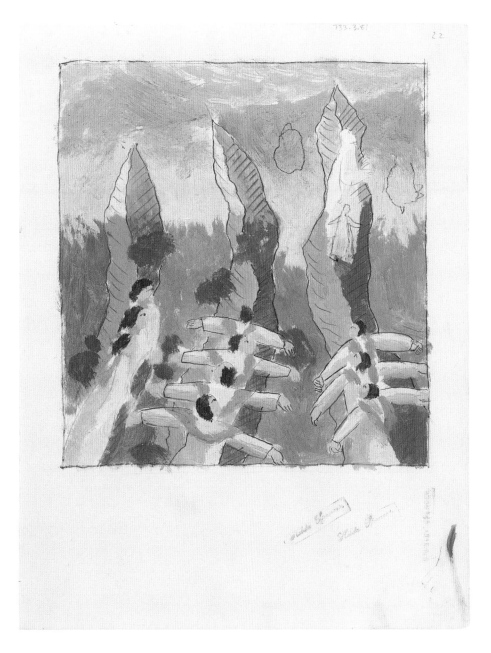

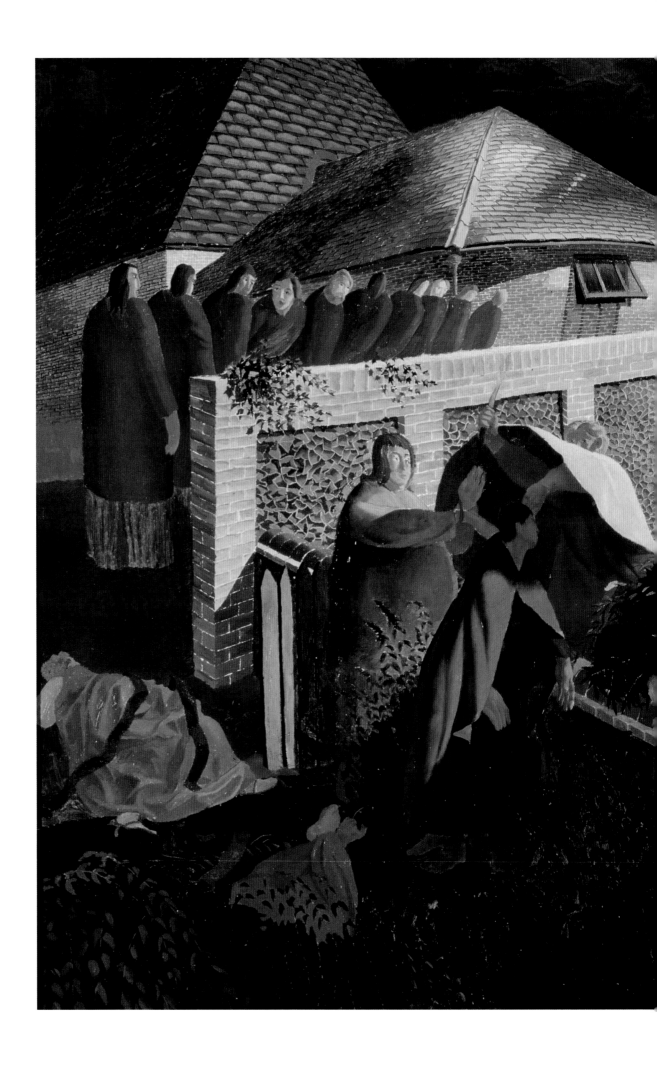

The Betrayal (Second Version)
1922–3

Oil on canvas 122.7 × 137.2 cm
Bell 91
Lent by kind permission of the Trustees of the National
Museums and Galleries of Northern Ireland

Christ's arrest in the Garden of Gethsemane
is transposed to the back garden of Fernlea,
where Simon Peter reacts with explosive anger.
Eyes staring, cloak billowing he strikes off the
ear of the High Priest's officer with his sword.
Christ raises his bound hand in a pacifying
gesture which will also heal Malchius's ear, the
last miracle he will perform. Spencer painted
his first *Betrayal* in 1914, but considerably
revised the composition when he returned to
the subject. The action is compacted, so that
many of the events in Chapter 18 of John's
Gospel occur simultaneously. When Christ
confirms his identity to Malchius the priests and
Pharisees 'went backward, and fell to the
ground' (18:6); these are the prone figures on
the left, modelled by Hilda Carline, who also
posed for Christ. Malchius consents to Jesus's
plea for the disciples to be allowed to leave,
and Spencer wrote 'For some time I had the
motive [sic] in my mind of the disciples walking
away. I was interested in the rhythm of the
movement of the disciples produced by the
thoughts of what was taking place' (733.3.1).
Further chronological slippage occurs with the
intervention into the scene of Spencer himself
and his brother Gilbert as boys, in modern dress
watching the drama from the wall next to the
tin schoolhouse where they were taught.
Spencer was fascinated as a child by the 'space
behind the corrugated sides of the school and
the wall in which space much rubbish is
thrown. this was a great hunting ground for
me and a good place for getting out of the
way' (733.3.1). Into this gap Spencer
introduces a female figure, perhaps one of his
sisters, who as girls also climbed on the wall
(see Pople 1991, p.212). The geometric
precision of the background brick and flint
wall, over which creeps ivy symbolising
everlasting life, contrasts with the oast houses.
Spencer has bent them into the composition as
if seen through a fisheye lens.
RU

33 The Resurrection, Cookham
c.1920–1

Oil on panel 31 × 44.5 cm
Bell 44
Private Collection

The Resurrection was a subject Spencer returned to repeatedly throughout his life. He abandoned his first sketch of a resurrection and painted *Apple Gatherers* (no.9) over it in 1913–14, but returned to the theme for *The Resurrection of the Good and the Bad* in 1914–15 (Bell 22–3). For the picture shown here he imagined the event taking place in Cookham churchyard, almost as a trial for part of the composition of the large *Resurrection* of 1924–7 (no.35) which he may already have been planning. All of Spencer's resurrections are quite matter of fact events, showing the dead restored

to life emerging intact from their graves. Here they lever themselves from the ground, holding onto their headstones. Spencer's composition is one of taut geometry, the strong diagonal of the path leading to the church porch balanced by the sweeping diagonal of the central figures and their gravestones. There is some similarity of feel to the rhythmic diagonals of the figures in Winifred Knights's *The Deluge* (Tate), a stylised religious scene shown to great acclaim in 1920 and widely reproduced.

A Resurrection or Day of Judgement would be a natural part of a cycle of religious scenes, and would form the traditional end-wall subject in any church setting, as in Giotto's Arena Chapel scheme and later at Burghclere (nos.37–40). For Spencer, resurrection may have fulfilled personal longings, for everyone would be together again, everything would be as it was. Cookham was much changed by

the loss of the sixty-eight men listed on the War Memorial, including one of the Hatches and Spencer's brother Sydney. Resurrection would return things to how they had been, and return Cookham to its prelapsarian state. But Spencer's fascination with death and rebirth extended long before the war. In an extraordinary letter to Gwen Raverat dated 13 June 1911 he wrote in a deliberately childish hand: 'I go to church *every* Sunday. I rose from the dead last night, it happened like this. I was walking about in the churchyard when I suddenly flopped down amongst the grave mounds. I wedged myself tightly between these mounds feet to the east and died. I rose from the dead soon afterwards because of the wet grass. But I did it in a mystifying manner. I have nothing more to tell you now. Your loving Cookham' (8116.2).

RU

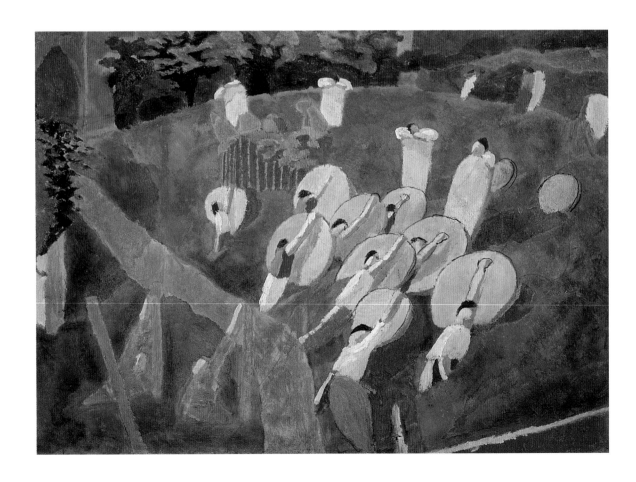

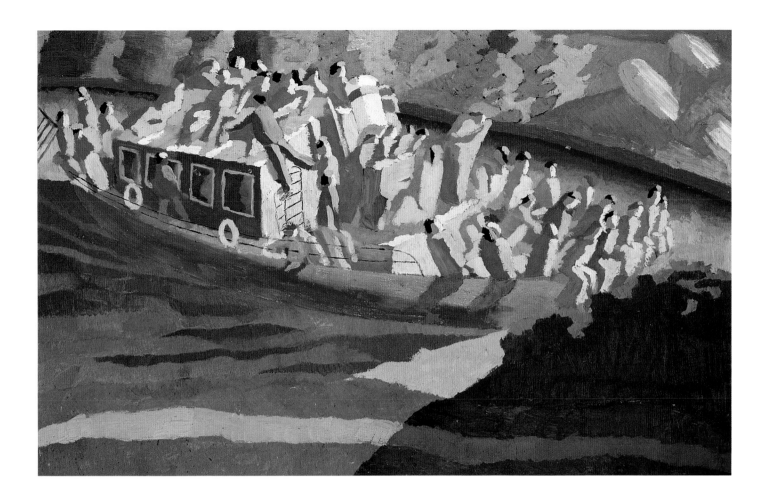

34 Bond's Steam Launch 1920

Oil on hardboard 35 × 56 cm
Bell 40
Private Collection

The Thames was an important part of
Cookham's commercial and social life. Bond's
piano-carrying launch took people for pleasure
trips up and down the river from Maidenhead
in summer. Having completed *Swan Upping*
(no. 18) in 1919, Spencer used the river in a
sequence of pictures in 1920, *The Bridge*, this
one, *Bourne End Looking Towards Marlow*,
Going on the River and *People by the River*. His
interest in the river may have been enhanced
by living with the Slessers at their house in
Bourne End, which overlooked a Thames-
bound stream. Bond's steam launch was a
passing apparition that did not stop at
Cookham, and Spencer reused it in the
background of *The Resurrection, Cookham*
(no. 35), where it ferries people across the river
to the afterlife. It seems quite possible that in
1920 Spencer already perceived the launch in
such terms, and its pleasurable associations
fitted his belief in the joyful nature of
resurrection; in his lists of pictures he titled
it 'Bond's Steam Launch full of People' in
1937 and later 'Bond's Steam Launch, Study
for the Resurrection' (733.3.12). His small
Resurrection, Cookham (no. 33) was painted
in 1920–1. Spencer's connection of the life
of the river with the holiness of church in
Swan Upping seems close to its symbolising
the passage from life to eternity. At the
Slessers, connections between religion and the
river were accentuated by their private chapel
being over their boathouse.

The simplification of forms in the picture,
and the flat, pattern-making areas of chalky
colour mark an experimental departure for
Spencer akin to his *John Donne* (no. 4). The
figures are drawn in a jerky, repetitive rhythm,
rendered in stylised light and shade. Bell has
noted the similarity to Vorticist pictures by
Lewis, Bomberg and Roberts (1992, p. 53.). The
crowded figures in the stern are expressed in a
similar idiom to those in *The Cinema* (fig. 11) by
Roberts, whom Spencer had recently met
again, renewing their friendship begun at the
Slade School.

RU

35 The Resurrection, Cookham 1924–7

Oil on canvas 274 × 549 cm
Bell 116
Tate. Presented by Lord Duveen, 1927

Spencer's vast painting of the Resurrection marked the climax of his cycle of 1920s religious pictures set in Cookham. Although the setting is clearly Cookham churchyard, the church itself is not particularly similar to the actual one. There is no tower, and the windows and porch are quite different. The picture was inspired partly by reading Donne's description of a churchyard as 'the holy suburb of Heaven' (733.3.1), and into this Spencer introduced many of his friends and family, all shown emerging from their graves. This is a very humane resurrection, and there is very little judgement. Crucially Spencer also introduced himself and his fiancée Hilda Carline a number of times. It is a picture centred around their relationship, and specifically the change Spencer experienced between his pre-sexual life and his life with Hilda. The liberation brought by sexual love was a revelation to him, and Spencer evidently thought of it in religious, sacramental terms, as a kind of resurrection into a new world. From reading Donne, Spencer came to distinguish between the 'particular Resurrection', which was the biblical Day of Judgement, and a 'general Resurrection', an intensely blissful experience attainable on earth which seemed to touch the heavenly. This second category is a metaphor for sexual delight, hinting that orgasm was a divine experience. In a highly original way, the picture combines the personal story of his love for Hilda with a vision of his friends at Cookham passing through a rebirth.

The picture's size was also significant: 'With me', Spencer wrote to Hilda Carline in 1923, 'proportion is a spiritual thing, so also size, shape and form' (Carline 1978, p.162). It was a summation of Spencer's belief in the sanctity of everyday experience, and the potential ecstasy of existence. At the time of its first exhibition in 1927 the New Leader reported Spencer telling them that he 'does not believe necessarily that the resurrection of the dead is a physical one. To him, the resurrection can come to any man at any time, and consists in being aware of the real meaning of life and alive to its enormous possibilities' (25 March, quoted Bell 1992, p.59). Spencer elaborated to Richard Carline: 'In this life we experience a kind of resurrection when we arrive at a state of awareness, a state of being in love' (Carline 1978, p.172).

The picture is an attempt to bring together the physical and the spiritual, past and present. At the centre, under the rose-twined porch, is God the Father with seated in front of him a figure intended at first to be God the Son, but who was later transformed into a mother, who holds three children. Stretched out along the side of the church are the prophets and 'thinkers', including Moses, who was based on a photograph portrait of the father of Spencer's friend Jas Wood. Spencer explained their function was to express 'different … states of spiritual thinking … contemplation, consideration, pondering, understanding … believing' (733.3.1); they represent the intellectual dimension of life. On the right hand of God are a group of Africans, resurrected from sun-baked soil, whom Spencer described as enjoying the physical pleasures of touch, 'feeling a round stone … playing with sand … touching the hem of Christ's robe' (733.3.1). The woman wearing the red dress is based on Spencer's drawing of a Grenadier emerging from a dug-out (no.38), a resurrection theme he explored for the Burghclere Chapel. In his account of the picture Spencer does not mention that the middle two pairs of Africans appear to have been resurrected in the act of making love. The characterisation of tribal culture as more in touch with itself than modernised society was well established by the 1920s, as was the private envy of its supposed sexual licence, a view encouraged by the continuing popularity of Havelock Ellis's theories. In a now jarring piece of racial stereotyping, Charles Aitken, Director of the Tate Gallery, told the Daily Mail in 1929 that the

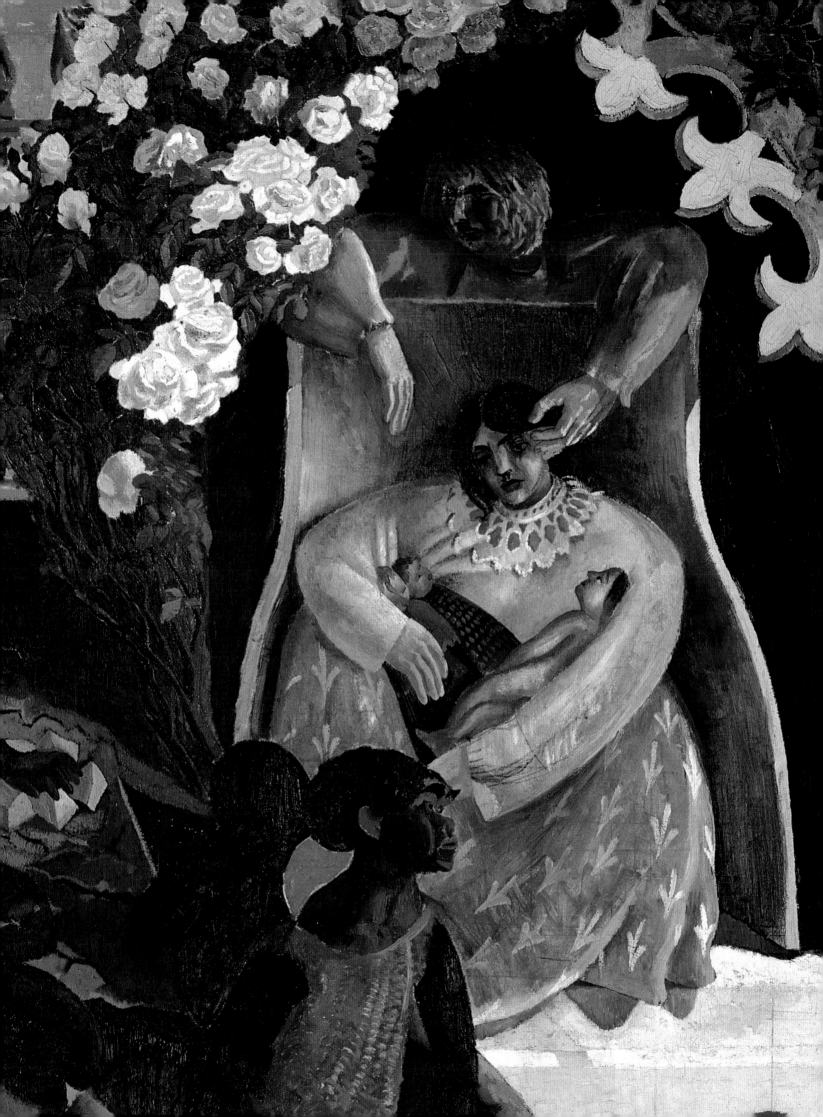

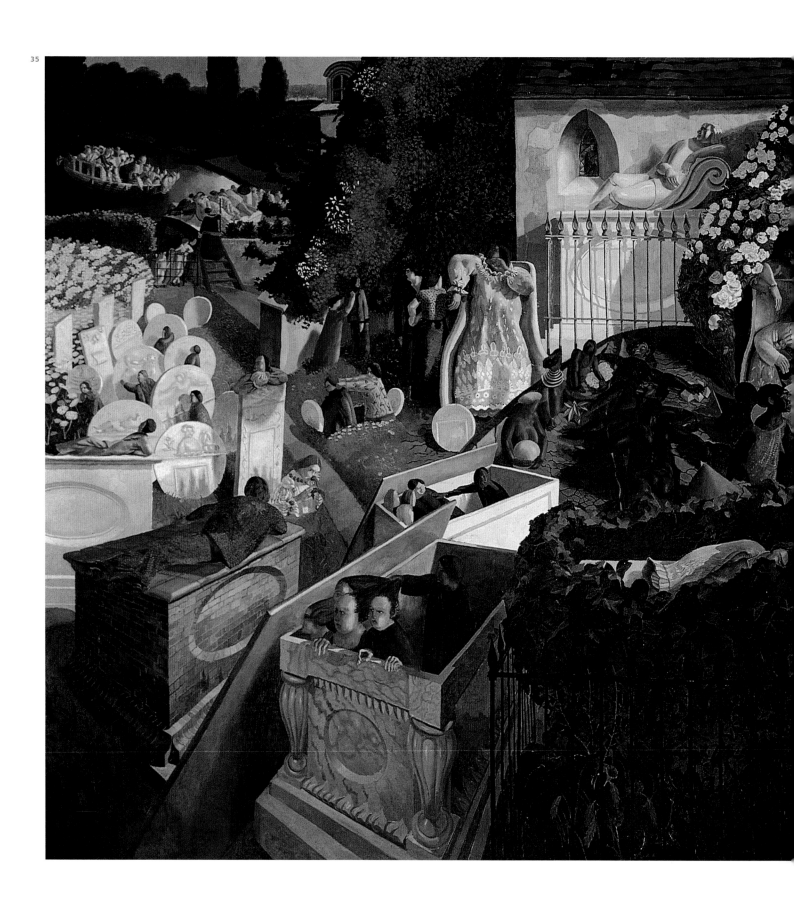

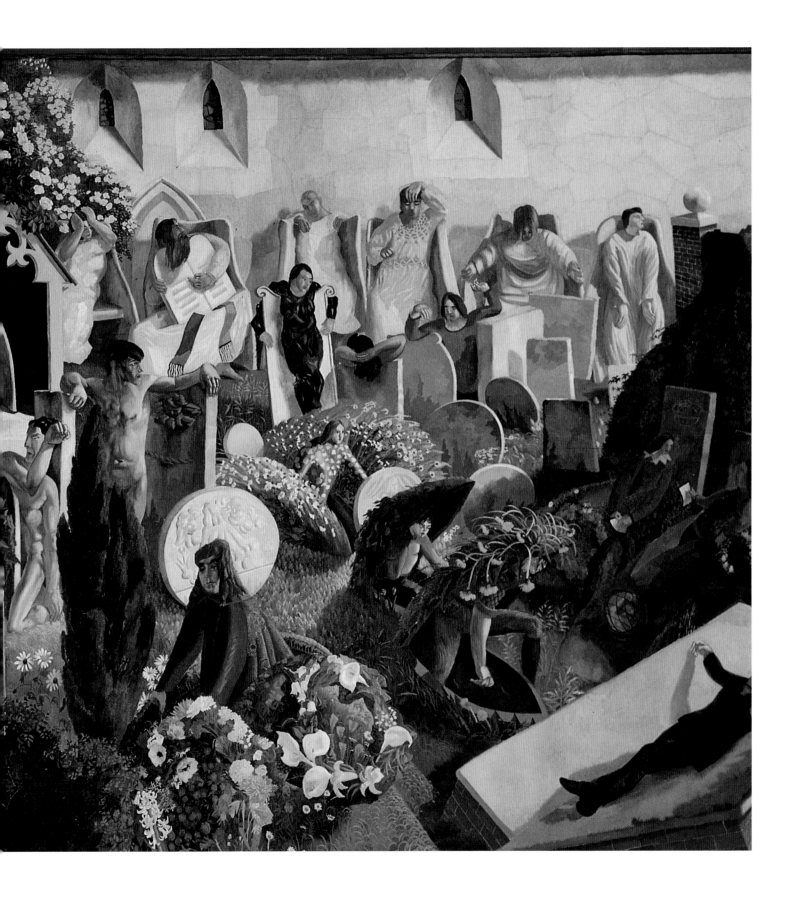

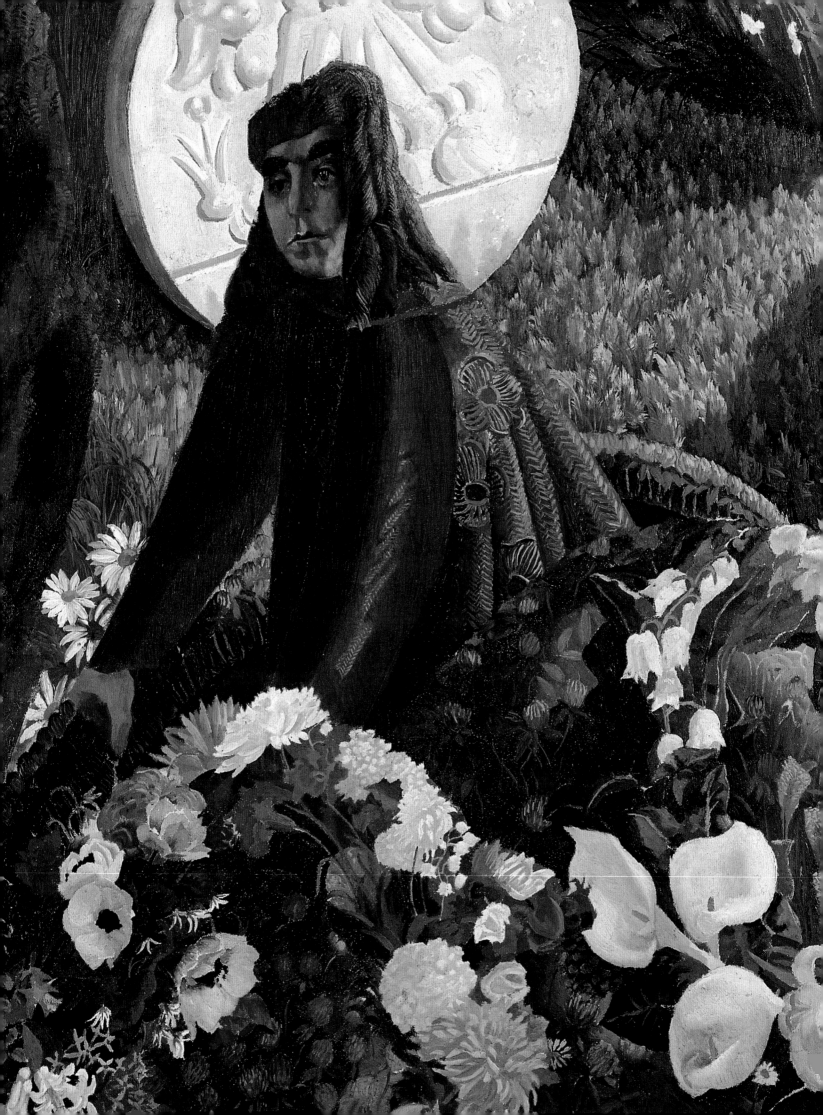

picture showed 'the waking from death of humanity – the white races … occupied with things intellectual, the black races satisfied with simple tactile shapes'.

Below the Africans, in a nest of ivy on a tomb, lies Hilda, still sleeping, like the princess in Burne-Jones's famous *Briar Rose* picture, waiting to be recalled to life with a kiss. Spencer stands naked a short distance away, physically confident, somewhat imperiously surveying the scene, a depiction perhaps partly inspired by Michelangelo's *David*. Beneath him crouches Richard Carline, Hilda's brother and Spencer's friend, although shown contorted and pinch lipped, like a Sistine Chapel ignudo. Spencer and Hilda occur elsewhere – he shows himself lying on a book-shaped tomb in the right corner, his 'signature' he said, and again on the far left gazing at Hilda smelling a sunflower. In the distance Hilda climbs over the stile to join the resurrected on the pleasure steamers, crowded like troopships, which will carry them to everlasting life. Spencer held such boats as spiritually significant, writing: 'In the left top corner is a bit of the river Thames & along it is going one of those big pleasure steam-launches. This is supposed to be people going to heaven. This is not so far fetched as it sounds. When I was at Cookham, I used to watch these big boats go by on the river. I had never been in one & had a feeling about all people who went on the river a feeling that some how they were different from me. The river was a sort of holy of holies & people who went on it had as a result a kind of magicle [*sic*] feeling about them … Then of course in the case of these steamers, they did not stop at Cookham; they came from a world I did not know & disappeared into an unknown' (TGA 998).

Spencer also included his patron Henry Slesser in the right foreground, wearing his judge's robes, with a gravestone framing his head like a halo, and surrounded by opulent floral tributes. These include traditional emblems of death such as poppies and chrysanthemums, and elsewhere Spencer uses flowers symbolically, the cypress connected with death, ivy symbolising everlasting life, the white rose purity and love. The girl bursting forth amidst daisies above Slesser was someone who loved flowers, Spencer wrote (733.3.1), but she also resembles Millais's *Ophelia*, a print of which hung at Fernlea. The pair of women on the far right are reading cards left with their wreaths, a reminiscence of a grieving girl Spencer saw in the churchyard reading a note on her friend's grave.

Spencer told Edward Marsh that *The Resurrection* showed a specific moment – 2.45pm on a Tuesday in May (Christopher Hassall, *Edward Marsh*, 1959, p.505). This may have been the moment at which the virginal Spencer first experienced the sexual world about which he had wondered for so long, leading to the fusion in his mind of the physical and the spiritual, and a belief in the spirituality of the physical, finding expression in this picture. Painted in the cramped conditions of Henry Lamb's Hampstead studio, Spencer 'experienced a spiritual exultation as I put this here and there' (733.3.1, 81). The centrepiece of his 1927 Goupil Gallery retrospective, the picture was an immediate sensation and received extensive critical coverage and praise, *The Times* declaring it 'the most important picture painted by an English artist in the present century' (28 February 1927). Spencer himself later declared: 'I was on bedrock with this picture, I knew it was impossible for me to go wrong' (733.3.81, 81).

RU

Oil on canvas 67 × 44.5 cm
Bell 118
Whitworth Art Gallery, University of Manchester

36 Making a Red Cross 1919

Oil on panel 17 × 21.5 cm
Bell 32
Private Collection

Based on his experiences in Macedonia,
Spencer shows men of his hospital unit laying
out stones and bricks to form a large red cross,
to identify themselves to aircraft and artillery
spotters. It is one of two oil sketches made
after *Travoys* (no.21), probably made in
response to the Ministry of Information's
request for further war pictures from him.
Spencer asked to be released from the
commission. Later he reused the design for the
central part of *The River Bed at Todorovo* at
Burghclere (1930–1).
RU

While staying with Henry Lamb in Poole in the
summer of 1923, Spencer started making
drawings for an imagined chapel to be filled
with decorations illustrating his war
experiences. The inspiration for this partly grew
from the much smaller, abandoned commission
to decorate the Memorial Hall at Steep,
Hampshire, given him by Muirhead Bone.
Another spur for a chapel setting may have
been the never-realised National Hall of
Remembrance, for which the War Artists'
Committee was to commission a variety of
painters to illustrate the war at home and
abroad. At Poole Spencer was visited by Louis
and Mary Behrend, the purchasers of *Swan
Upping* (no.18), who immediately
commissioned him to fulfil the project. The
Sandham Memorial Chapel at Burghclere,
Hampshire, commemorated the life of Mary
Behrend's brother, Lt. Henry Willoughby
Sandham, who had died from a malarial
infection in Macedonia in 1919. Spencer's
background in the Royal Army Medical Corps,
who had nursed Sandham, and his experience
of Macedonia and malaria must have made him
a compelling choice for Mary Behrend, and
such knowledge surely lay behind her invitation
to Poole. The Chapel's side walls were filled
with a double register and lunettes of images
of Spencer's experiences in Beaufort Hospital,
Tweseldown Camp and Macedonia. The
dramatic, elegiac altar wall depicts the
resurrection of the dead soldiers, who bring
their white crosses to Christ.

Related to the Burghclere panel *Ablutions*
(1928) showing a bathroom at Beaufort,
Soldiers Washing was originally a subject
Spencer conceived for the Steep memorial,
forming part of the composition of *Scrubbing
the Floor and Soldiers Washing* (c.1921). At
Beaufort Spencer took comfort from the
repetitive absorption of daily tasks. In *Soldiers
Washing* the austerity of the bare room is
relieved by the figure whose soapsuds and
towel transform him into a Roman general.
Spencer singled it out as 'the most intensely
felt' of all the preparatory works for Burghclere.
RU

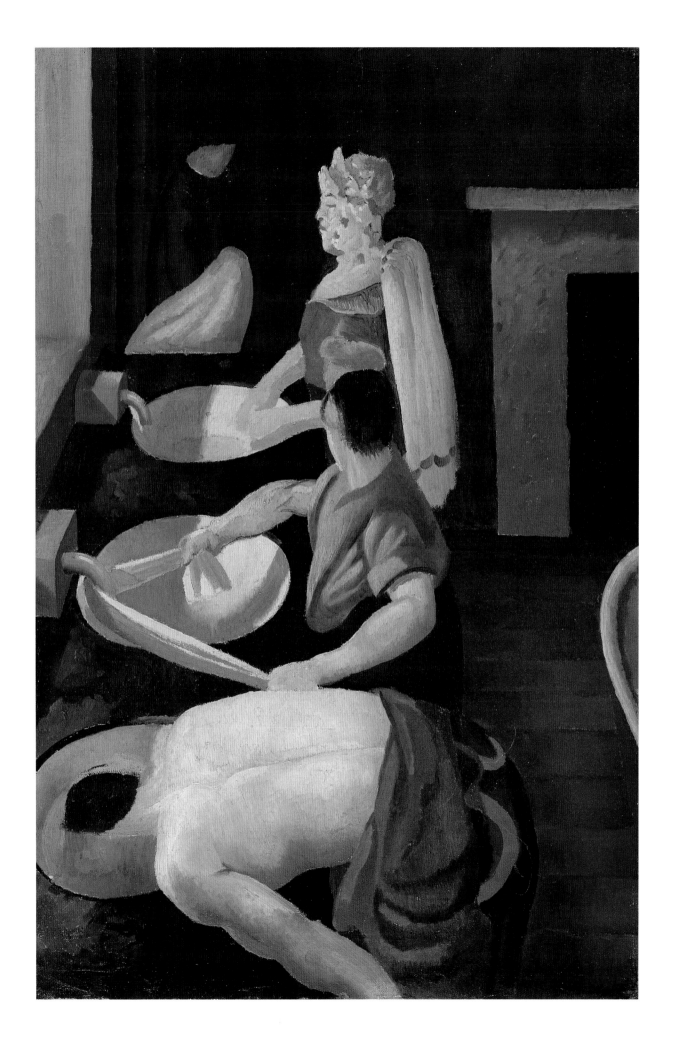

Camouflaged Grenadier
1922–3

Pencil and watercolour on paper 50.5 × 37.1 cm
Tate. Purchased 1927

According to Spencer's brother Gilbert, this was
a particularly brave soldier Spencer knew who
was killed in Macedonia. He is shown emerging
from a dug-out, camouflaged with ferns and
with rifle grenades attached to his tunic.
Spencer incorporated the design into his
Burghclere panel *Dug Out* (1928) which he
explained stemmed from a longing for peace:
'The idea … occurred to me in thinking how
marvellous it would be if one morning, when
we came out of our dug-outs, we found that
somehow everything was peace and that war
was no more. That was one thing – the thought
of how we would behave. Another thing I
noticed at that time was the quiet way the
sergeant would stroll out of his dug-out and
tell the men to get ready' (Carline 1978, p.184).
Spencer reused the figure of the emerging
grenadier for the African woman in the red
dress in *The Resurrection, Cookham* (no.35),
and the dug-out is similar to the rippling
ravines in *The Crucifixion* (no.30) and *Study for
a Religious Subject* (no.31). The experience of
being underground, perhaps under
bombardment, and then emerging must have
been linked in Spencer's mind to the
Resurrection, and he contemplated using the
Grenadier composition as part of *The
Resurrection of Soldiers* at Burghclere. On the
back of this sheet are two composition
sketches for how Spencer originally conceived
the Burghclere *Resurrection*, showing men
entangled in barbed wire being freed by Christ.
'But every composition I did of it turned out
wrong', Spencer wrote (Carline 1978,
pp.186–90), and he instead considered
'making the men coming out of dug outs …
the main central motif of it'. This too was lost
from the *Resurrection* finally, but explains the
Grenadier's pairing with the original
Resurrection designs on the same sheet.

RU

39 Study for The Resurrection
of the Soldiers, Burghclere
c.1927–8

Pencil on paper 30.4 × 23 cm
Tate. Presented by the American Fund for the Tate Gallery,
Courtesy of Robert Littman, in honour of the Director, 1989

An early study for the altar wall at Burghclere,
Spencer shows ranks of soldiers levering up
their headstones in a manner similar to the
small *Resurrection, Cookham* (no.33). They are
watched by a line of men lounging against
their gravestones, a motif drawn from passages
in the large *Resurrection* (no.35). Beneath, or in
front of the altar, Spencer shows a predella, a
feature absent in the finished Chapel. Spencer's
design of the Burghclere decorations was
heavily influenced by the format of Giotto's
Arena Chapel in Padua, which he had long
admired; on gaining the Behrend's commission
he remarked 'What ho, Giotto!'

RU

**40 Study for The Resurrection of
the Soldiers, Burghclere** *c.*1928

Oil and pencil on paper 28.5 × 49 cm
Bell 120
Private Collection

A study for the central section of *The
Resurrection of Soldiers* (1928–9), this
composition was inspired by Spencer's memory
of seeing a limber which had been hit by a shell
in Macedonia, its smashed riders lying between
the dead mule team, a sight he described to
Richard Carline as 'gruesome' (Carline 1978,
p.194). Here, they are all restored at the
Resurrection; the rider's cross which he will
carry to Christ briefly sketched in with pencil.
The remarkable shape created by the
simultaneous turning of the mules, who look
back towards Christ in the finished design, was
also inspired from life. 'How I thought of those
two mules turning their heads round in
opposite directions was one day up in the Vale
of Health studio', Spencer wrote, 'Looking out
of the window as usual, I saw the oil-cart,
which was always drawn by two sleek-looking
horses, and they were both looking round in
this manner' (Carline 1978, p.194). Spencer
hated cruelty to animals and was fond of the
mules used to carry patients in Macedonia; the
Resurrection naturally extends to them as well
as humans. He explained that sandwiched
between the mules the rider is experiencing the
same 'cosy' feeling he had as a child when he
slept between his parents if he had had a
nightmare.

RU

41 The Garage 1929

Oil on canvas 101.6 × 152.4 cm
Bell 128e
The Sir Andrew Lloyd Webber Art Foundation

In 1929 Spencer was commissioned to make a sequence of poster designs by the Empire Marketing Board, the body responsible for colonial trade. They were to be on the theme of 'Industry and Peace', and Spencer produced five paintings in just seven weeks – *The Garage*, *The Art Class*, *Cutting the Cloth*, *The Hat Stand* and *The Anthracite Stove*. Initially he conceived these compositions as one continuous strip, but the Empire Marketing Board rejected this as unsuitable for a poster. Even the separate finished panels would, Spencer admitted, require special billboards to be constructed, and they were never actually used as posters. However, Spencer's initial concept of a long panoramic composition prefigured such 1930s works as *Love Among the Nations* (no.82) and in interest in the world of work, the Port Glasgow pictures (nos.97–103). In *The Garage*, Spencer returned to his fascination with the juxtaposition of geometric forms, from the circles and ellipses of the tyres, to the angularity of the mechanic's measure. He also contrasts textures – the tyres' rubber hardness, the flaccidity of the inner tubes, the fur of the woman's collar, and the planes of the unfolded map. The rhythm and subject are reminiscent of William Roberts, Spencer's Slade contemporary, with whom he had rekindled his friendship after the war. Spencer's interest in a garage scene may also have stemmed from his recent acquisition of a motor car, of which he was an erratic driver. The maps anticipate the Burghclere *Map Reading* panel of 1932. The exuberance of the image puts Spencer at some distance from the preservationist who saw the car only as a despoiler of the English scene.

RU

3 FORSAKING THE VISION

I had a howling rotten time doing the last few panels at Burghclere because I was having to do landscape in order to keep going, and I am in no hurry to do that again.
Spencer to Gwen Raverat, 1933

In the 1930s Spencer gave more of his energy than ever before to painting directly from life. He had always made superb portrait drawings (as in the three here of Hilda, from 1931). But from 1932 onwards, weather permitting, Spencer could usually be found with his easel set up in the open air somewhere around Cookham. From 1935 he began also to paint his series of 'naked portraits' of Patricia Preece, working always at night. Seeing them together with the landscapes, we can recognise both as products of the same tight procedures – the same kind of attentiveness to the detail of untransfigured, factual appearance.

While still completing Burghclere Chapel, Spencer moved into his newly purchased seven-bedroom house at Cookham, some thirty miles away. His stipend from the Behrends was now coming to an end. He needed to make a new body of work for his 1933 show at Tooths. He was also becoming more involved with Preece, and by 1934 he was wooing her with increasingly valuable presents. Spencer himself would later refer to 'money need' as a chief cause of 'this complacent stream of landscapes', and he resented being distracted from his more ambitious imaginative compositions. Yet his best landscapes do participate in his wider project, to render sacred all that is most 'ordinary'. And one way we might view Spencer's development from the 1930s onwards is as a radical divergence from the formalising doctrines of Fry and Bell – a passionate espousal of *insignificant* form.

By 1932 Preece and her long-standing partner Dorothy Hepworth were facing destitution; Spencer, already partly estranged from Hilda, seemed to offer himself as willing dupe for Preece's survival strategy. As Spencer came to understand, 'I was an interloper,

an unwanted intrusion ... I lost confidence in myself and ... feared terribly to lose her; became anxious, apprehensive and finally *impotent*' (quoted in Carolyn Leder, *Stanley Spencer, The Astor Collection*, London 1976).

When Spencer brings his landscape procedures to bear on Preece, an extraordinary psychological charge is created – a kind of numbness, that becomes in itself expressive and meaningful. The 1937 *Leg of Mutton Nude,* painted only two months before their wedding, is an unparalleled confrontation with fleshly fact, for which the raw meat in the foreground is such a startling metaphor. Later in the same year, with Preece already returned to Hepworth, Spencer would visit Hilda in Hampstead in a 'futile attempt' at remarriage. In *Hilda, Unity and Dolls,* painted in those days, an apparently 'objective' depiction again embodies a narrative, with Hilda turning wearily away, and empty-eyed dolls crowding their child.

In all these paintings, Spencer comes close to the verism of 'New Objectivity' (*Neue Sachlichkeit*) – the return to descriptive realism that in Germany in the 1920s reflected the post-war mood of disillusionment. For Spencer himself, his turn towards realism was always associated with crisis, with a failure of imaginative vision.
TH

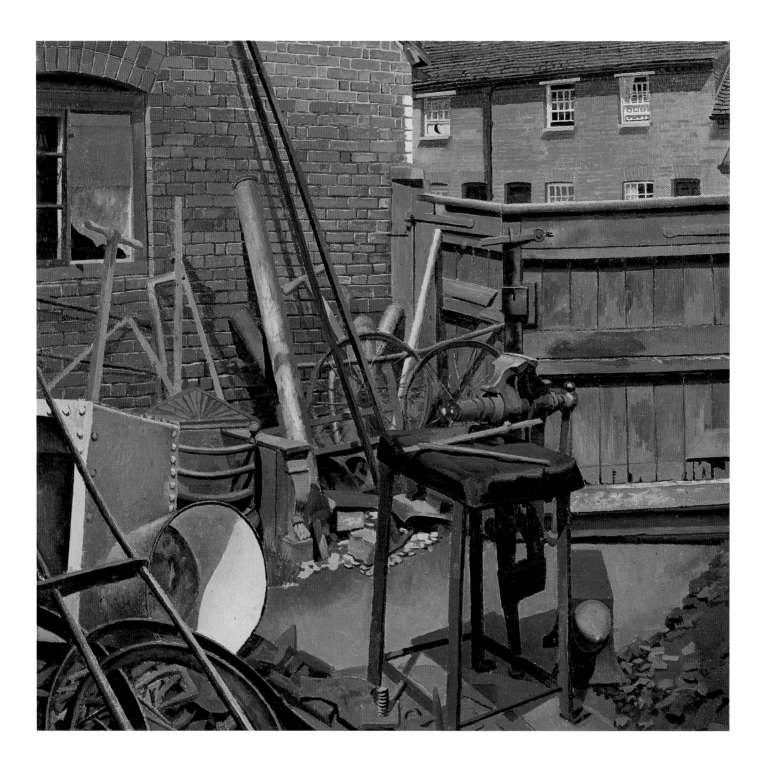

42 **The Blacksmith's Yard, Cookham**
1932

Oil on canvas 70 × 76.2 cm
Bell 139
Private Collection

Spencer had always insisted that his
landscapes were painted chiefly as pot-boilers,
and in the 1920s some of his motifs had been
almost cloyingly picturesque. But in this, one
of his first paintings on his return to Cookham,

he seems to have lighted on an exceptionally
unappealing corner. Spencer gives his
attention to the ordinarily unregarded flotsam
around him – discarded bicycle wheels, a
rusted grate, a holed bucket, a battered stool.
In its celebration of metal, *The Blacksmith's
Yard* anticipates his later work, especially *The
Scrapheap* (no.105) of 1944. The aesthetic of
untransfigured fact can be paralleled in
German *Neue Sachlichkeit* or verist painting of
the early 1920s.

TH

43 The Jubilee Tree, Cookham
1936

Oil on canvas 91.5 × 76.2 cm
Bell 213
Collection Art Gallery of Ontario, Toronto. Purchase, 1936

Classical in its centred composition, wonderfully lucid in its transition from foreground nettles to distant street, *The Jubilee Tree* is among the most masterly of all Spencer's landscapes. On one level it is a simple rendering of a local motif – the sapling planted in 1935 at the edge of Cookham Moor to mark the twenty-fifth year of the reign of George V – it can also be seen as a complex emblem. By the time it was painted, the old king was already dead, and his son Edward VIII's reign under threat. Behind the fragile, buttressed tree, caged in metal, the white war memorial shines out, commemorating among others Spencer's favourite brother Sydney. Already the artist was at work on his *Last Day* cycle, with the war memorial as rallying-point for the love-making of *A Village in Heaven* (no.86).

TH

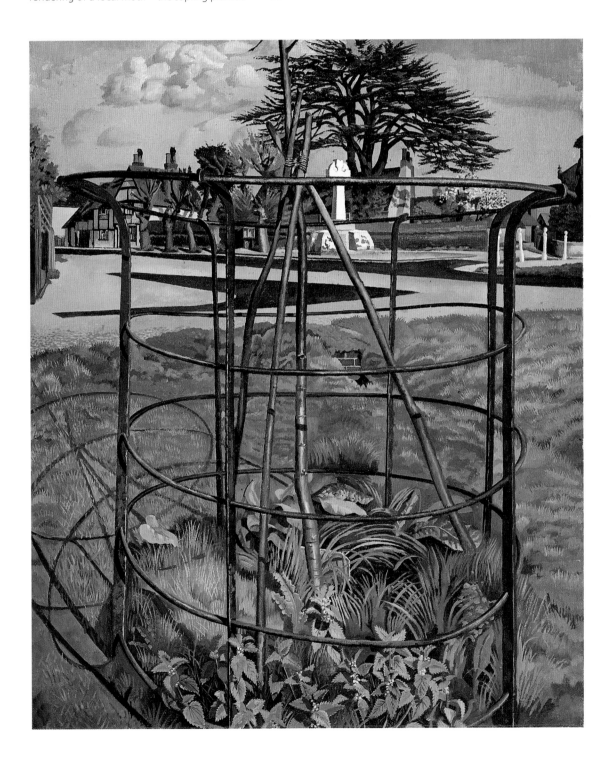

44 Gardens in the Pound, Cookham
1936

Oil on canvas 91.5 × 76.2 cm
Bell 208
Leeds Museums and Galleries (City Art Gallery)

The narrow street that leads beyond Cookham Moor towards the station remains instantly recognisable even today (though nowadays often clogged with traffic). Spencer delighted in painting the brick walls and iron railings of Cookham houses, some of them built by his grandfather Julius Spencer (Rothenstein 1962, p.20). Two years earlier, in *Sermons by Artists*, he had written of his excitement as he walked about Cookham: 'The instinct of Moses to take his shoes off when he saw the burning bush was very similar to my feelings. I saw many burning bushes in Cookham. I observed this sacred quality in the most unexpected quarters.'

Like several of Spencer's more ambitious landscapes, *Gardens in the Pound* could be seen as an emblem of English identity, of a village vernacular or cottage culture, holding out against the modern world. Yet Spencer was also engaged in a quest to exalt the humdrum, 'this special and unique meaning that an ordinary object has'. He became astonishingly resourceful in finding painterly equivalents for surfaces such as gravel, moss or flint; here, unexpectedly, the pavement seen through railings seems to dissolve into a cluster of white dots.

TH

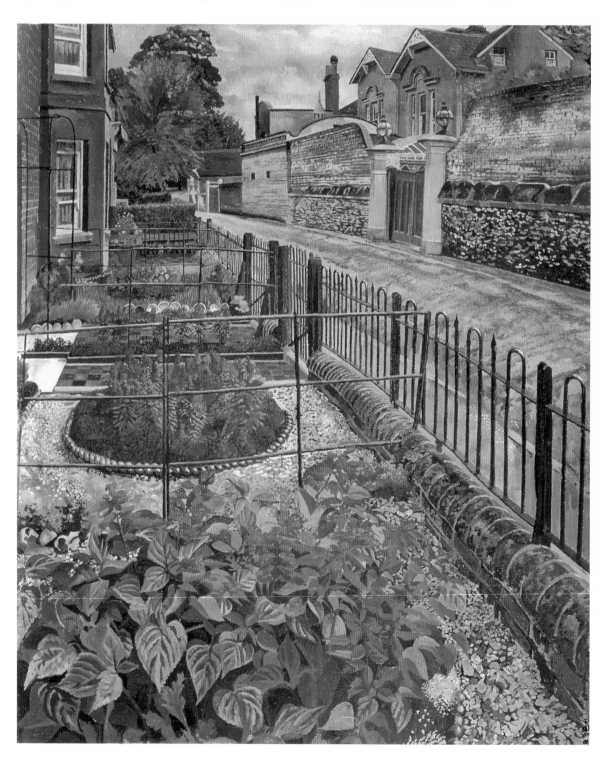

45 The Boatbuilder's Yard, Cookham 1936

Oil on canvas 86 × 71 cm
Bell 210
Manchester City Art Galleries

The scene is Turk's Boatyard, where *Swan Upping* (no.18) had been set two decades earlier. But whereas in 1915 he had deliberately avoided visiting that actual spot so as to hold on to his imaginative conception, here he sets up his easel to submit to every last detail of it. What results is an image of exceptional complexity, but with every element seen under a cold, hard light – a 'disillusioned' seeing that could hardly seem further from the nostalgia-laden Thameside paradise garden of his youth. The brutally ugly metal fishtank and crazy paving are harshly juxtaposed to the rockery plants, yet we may sense a kind of visual joke in the displacement of the fishes.

TH

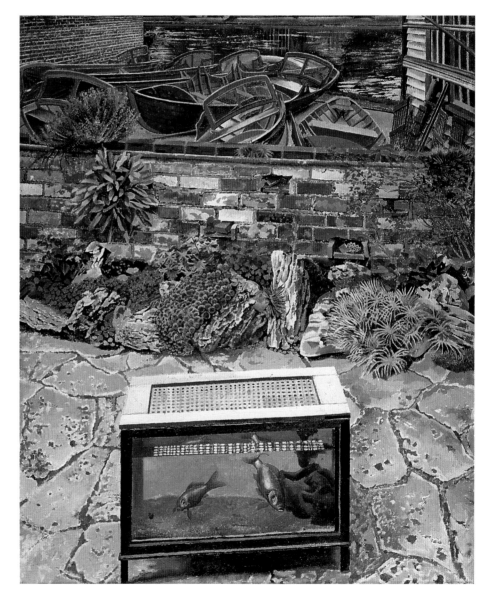

46 From the Artist's Studio 1938

Oil on canvas 50 × 76.2 cm
Bell 251
The Hayward Bequest, Carrick Hill Trust, Adelaide, South
Australia

Completed in February, this is a view from an
upper window of 'Lindworth', the large house
at the centre of Cookham which Spencer had
already made over to Patricia Preece (see
nos.52-3) and from which he would soon be
turned out. The image evokes a very specific
English village world, a brick-built vernacular of
ageless outhouses, old roofs and chimneys,
with the still-wintry countryside beyond. Yet
the picturesque is matched by a rawness, with
the early daffodils flung randomly into an
enamel bowl, and corrugated iron visible
alongside the mellow tiles. Later each day, he
would work on one of his series of *Beatitudes*
(nos.62–6), turning from continuity and
'coziness' to a very different imaginative realm.
TH

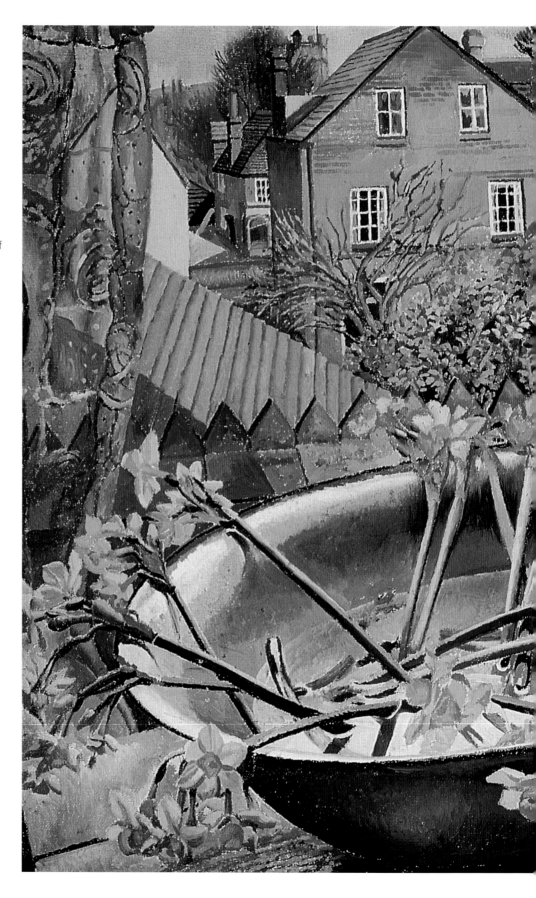

47 Cookham Rise 1938

Oil on canvas 46 × 61 cm
Bell 265
Leamington Spa Art Gallery and Museum (Warwick District Council)

Coming out of Cookham station, one can turn right towards Cookham Village, or left towards Cookham Rise – the outlying, unpicturesque and working-class area of Cookham that visitors seldom see. Spencer selects here a particularly unpromising motif – a raw, red estate that differs little from thousands of similar developments that were outraging preservationists across Southern England. Yet the image does repay long looking. Like all Spencer's best designs, it is structured as a series of contrasted zones: the strong diagonal shadows in the foreground foliage, the spatial markers of back-garden fence-poles, the impastoed white of the central house. Spencer was just about to lose his large house behind the High Street; from 1945 to 1957 he would himself be living on the 'wrong-side-of-the-tracks', in Cookham Rise.

TH

48 Cookham from Cookham Dene
1938

Oil on canvas 66 × 117 cm
Bell 268
Bradford Art Galleries and Museums

Monumental and panoramic, this picture has a grave beauty that sets it apart from most of the potboiler Cookham works. Spencer himself singled it out as containing 'strong elements of the Religious and Domestic needs but also a special atmosphere in which I find a peace … In all my ceaseless effort to cater for my own needs this landscape … came nearest to obliging me' (733.2.87).

It was probably the last landscape Spencer completed before his flight to London in October 1938 – both a summation, and a valediction.

TH

49 Portrait of Hilda 1931

Pencil on paper 50.8 × 35.2 cm
Scottish National Gallery of Modern Art, Edinburgh

50 Hilda with Hair Down 1931

Pencil on paper 78.8 × 62.8 cm
Tate. Lent by Francis Carline and Hermione Hunter, 1983

51 Hilda with Beads 1931

Pencil on paper 70 × 55 cm
Private Collection

These three masterly pencil drawings are
known to have been made in the evenings,
when Spencer returned from his long days at
work in Burghclere chapel. They continue the
tradition he'd learned under Tonks at the Slade,
drawing with the point of a hard pencil, and
lightly modelling within the contour. Although
Spencer often disparaged his drawings of this
kind as 'a stupid, meaningless habit', each of
these three carries a strong emotional charge.
In a letter to Hilda (28 June 1930) he writes: 'I
would so love to do a drawing of you with your
hair down, not because I think it suits you,
although it gives you one special look I love,
but because it would be such fun to do'. His
relationship with Hilda was increasingly
problematic, and *Hilda with Hair Down*
emanates a distrustful, almost accusatory glare.
Yet the nakedness of both the other Hildas
conveys tenderness. *Hilda with Beads* was
squared up for transfer to canvas, a picture
completed in 1942 (Bell 307).

TH

49

50

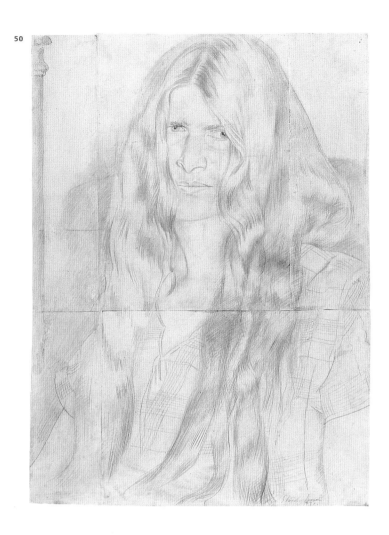

51

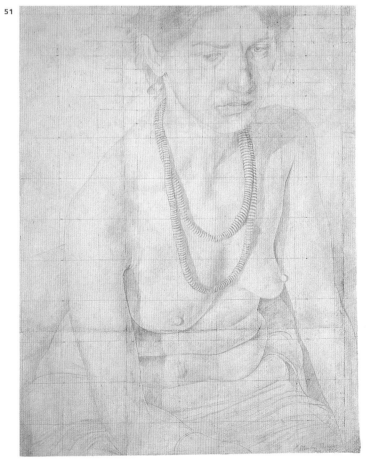

52 Portrait of Patricia Preece 1933

Oil on canvas 84 × 74 cm
Bell 154
Southampton City Art Gallery

Spencer first met Patricia Preece in 1929 when
he spent a few weeks holidaying in Cookham;
she was helping out at the local tearoom.
By the time he settled at Lindworth in 1932,
Preece and her partner Dorothy Hepworth
were facing destitution and were close to
relinquishing 'Moor Thatch', their own
substantial property a few minutes' walk away.
Spencer appeared as a possible solution to their
financial predicament. From 1933, Preece
began to come over in the evening to pose for
him. In this first relatively conventional portrait,
she poses rather self-consciously in front of
Spencer's gramophone (see also no.76); yet the
effect is awkward and coarse. Spencer had
painted few portraits from life since the 1914
Self-Portrait; here he applies the almost
mechanical procedures of his landscape
practice.

TH

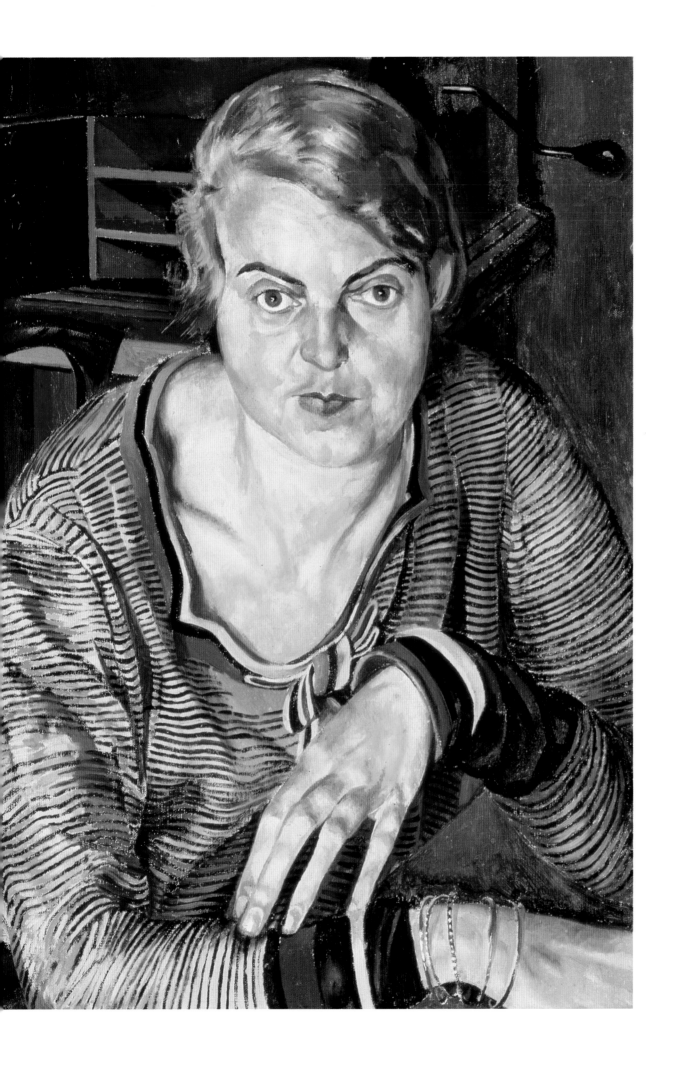

53 Nude (Portrait of Patricia Preece) 1935

Oil on canvas 76.2 × 50.8 cm
Bell 165
Ferens Art Gallery: Kingston Upon Hull City Museums and
Art Galleries

This was Spencer's first 'naked portrait'.
By 1935 he was heavily involved with Preece,
and had already transferred ownership of his
house to her name. To paint her naked was not
a transaction between artist and model.
This is not a conventional nude, so much as
a nocturnal, direct confrontation with the
object of the artist's sexual obsession.
Preece (who was already in her forties,
though Spencer believed her to be six years
younger), is exposed under a harsh,
unflattering light, emphasising her veined and
sagging breasts. Her expression is unsmiling
and a little hunted – reminiscent of 'The Victim'
in some lurid crime thriller. Built into the
composition is a counterpoint between leather
upholstery-buttons, eyes and nipples; between
concave black-leather swirls, and convex white
breasts. Shortly after, Spencer would embark
on the extraordinary sprawled and smiling
naked portrait of Preece (fig.18), whose
rhythms may reflect his admiration for the
large-breasted Indian temple figures of
Khajuraho.
TH

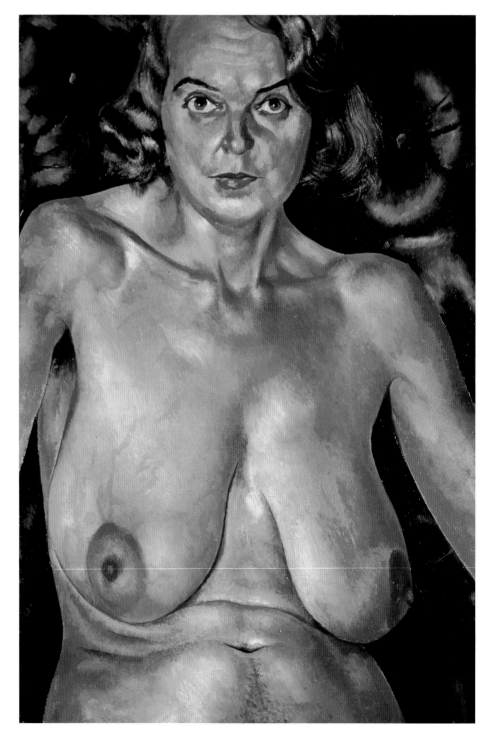

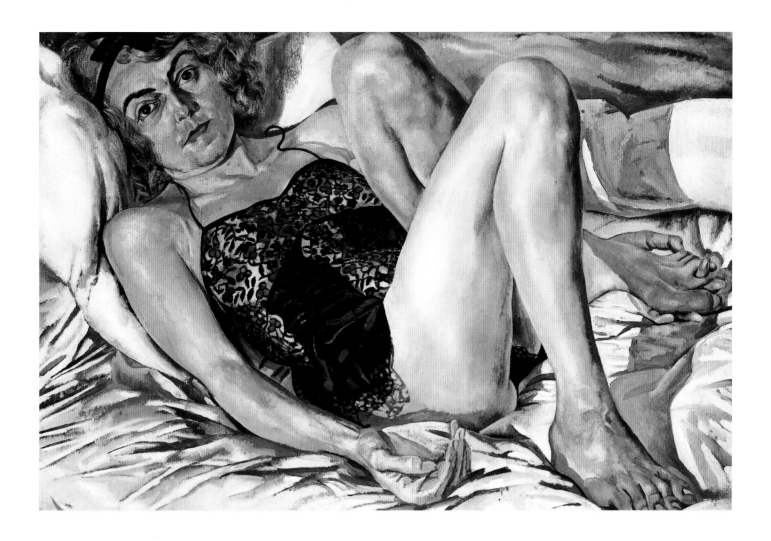

54 Nude (Portrait of Patricia
Preece, or Girl Resting) 1936

Oil on canvas 61 × 91.5 cm
Bell 222
Private Collection; courtesy of Ivor Braka Ltd, London

Working again by a harsh, almost interrogatory
light, Spencer paints Preece posing in the lacy
lingerie that he insisted on buying for her.
Doggerel from a Spencer notebook (733.3.54)
tells of 'Happy world of woman's skin/That my
own thoughts can make love in.' Another
poem, *In the Garden*, includes:

I will buy my God a chemise
To wear over her
I embrace her with suspenders
And worship her with drawers
My adoration dresses her
Covering her with loveclothes

Patricia's pose is awkward, and the expression
that of an unwillingly submissive slave, pinned
to the bed. The knee drawn up and the hand
threaded into the foot contribute to the air
of posed discomfort; one notes also the
strange shadow thrown by the lace onto
her yellow thigh.

TH

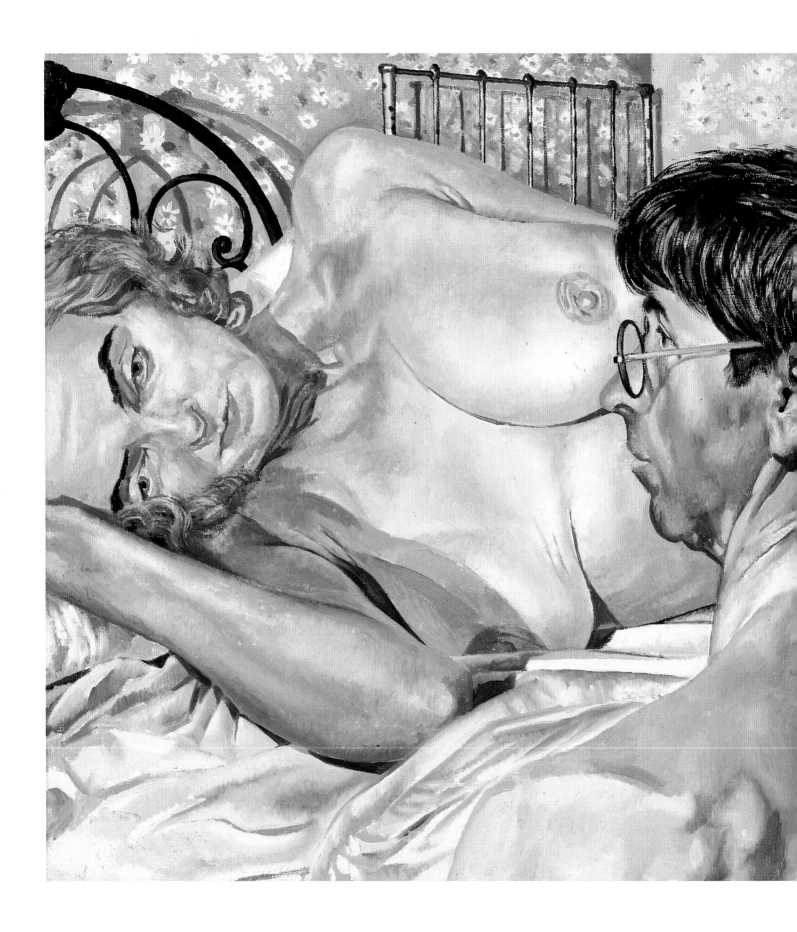

55 Self-Portrait with Patricia Preece
1936

Oil on canvas 61 × 91.5 cm
Bell 223
Lent by the Syndics of the Fitzwilliam Museum, Cambridge

Spencer's procedure in painting most of his
'naked portraits' seems to have closely
followed that of his landscapes, with no
preparatory drawing except on the canvas, and
no broad underpainting. Each was completed
patch by patch, working steadily across the
surface in about ten evening sessions. He used
only small brushes, and it was in the context of
this picture that he likened his activity to the
crawling of an ant over every inch of the skin.
Detail and finish are essential to the close
focus, and the sense of Preece's raw nakedness
is heightened with every variation of flesh-hue
registered.

 But in both the double portraits, there must
have been some preliminary charting of the
composition. The Preece figure was probably
almost complete when Spencer cut his profile
into it. The effect is to create a psychological
interaction entirely different from any
traditional engagement with the nude model.
The artist is now himself a naked participant,
and the spectator becomes a voyeur, a witness
of Spencer's indiscretion. Moreover, although
his open-eyed, almost fatuous expression might
suggest the hunter's pride in his trophy, Preece
is unmistakably inert, turned off, and sexually
non-functional.

TH

56 Clothed Study for Double Nude Portrait: The Artist and his Second Wife c.1937

Watercolour on paper 17.7 × 22.3 cm
Tate. Presented by the American Fund for the Tate Gallery,
courtesy of Robert Littman, in honour of the Director, 1989

57 Naked Study for Double Nude Portrait: The Artist and his Second Wife c.1937

Pencil on paper 17.7 × 22.9 cm
Tate. Presented by the American Fund for the Tate Gallery,
courtesy of Robert Littman, in honour of the Director, 1989

58 Double Nude Portrait: The Artist and his Second Wife (The Leg of Mutton Nude) 1937

Oil on canvas 83.8 × 93.6 cm
Bell 225
Tate. Purchased 1974

Two months before his marriage to Preece, Spencer completed his most ambitious and compelling 'verist' picture. The preliminary drawings already echo the traditional compositional juxtaposition of the Virgin and the dead Christ, the pietà, only with the genders reversed – Stanley laments the 'dead' Patricia. In the first watercolour, they are clothed, and she faces him, both confined within a kind of box construction. In the second, swifter and more incisive pencil sketch, they are naked, and she turns her back to us, almost an odalisque, with her head now at the left. In the eventual composition, she is again on the right, but now in profile, arms raised, legs spread. All possibility of eye contact has been cancelled.

But the image is given an extraordinary twist by the addition of the meat. In a notebook of 1955 (733.8.2) Spencer would look back on it:

This big double nude is rather a remarkable thing. There is in it male, female and animal flesh … It was done with zest and any direct painting capacity I had.

The uneaten flesh has been variously seen as referring to their unconsummated sexual relationship, or to a sacrament (bringing to mind the Lamb of God). Certainly the picture becomes a kind of anthology of different kinds of flesh. But it is not, as might at first appear, the record of some post-coital *tristesse*; there is pain, but also something of what Francis Bacon would later call 'exhilarated despair'. In all the Preece portraits we may need to recognise in Spencer's position a vein of pleasurable suffering. As he explains in a letter to Hilda in September 1936 (733.3.31): 'the more severe and austere, the bigger the thrill. Every inch I gain with Patricia is real achievement – it is so extraordinary to get near to her at all.'

The *Leg of Mutton Nude* seems never to have been publicly exhibited in Spencer's lifetime. When it entered the Tate in 1974, it soon revived Spencer's reputation, becoming also a key icon for many young painters in their attempt to renew the project of realism. It had an influence on the later work of Lucian Freud, whose success in turn contributed to Spencer's rehabilitation in the 1980s. Extraordinarily courageous in its genital exposure, this work remains very strong meat, even when set beside a Christian Schad, a Balthus or a Bacon.

TH

93ᴬ

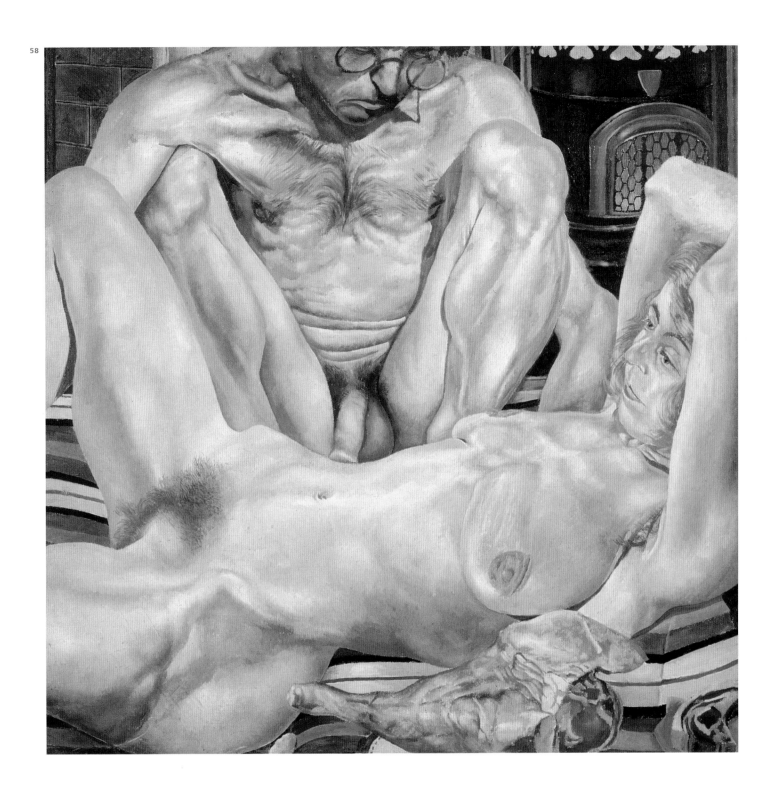

59 Self-Portrait 1936

Oil on canvas 61.6 × 45.7 cm
Bell 224
Stedelijk Museum, Amsterdam

Spencer painted two other self-portraits in
1936–7, in which he was posed with, or at
least painted himself into, portraits of Patricia
Preece naked (nos.55 and 58). The confessional
and full frontal character of those startling
nudes is also evident here. He wears an open
neck vest, as an image of the working artist in
his private room, unlike the conventional jacket
and tie he wore in public, even when painting.
The dramatic lighting contrasts the light and
shade of his face with the shade and light in
the painted background. His eyes are slightly
different shapes, as in his later self-portraits,
and here also different colours, and he looks
downwards, as if he were tall. This is the most
vigorous of all his self-portraits and Spencer
was consciously inviting comparison with his
early masterpiece of 1914.

The painting was bought in 1936 by the
Stedelijk Museum. This was Spencer's first
acquisition by a foreign museum, and was a
token of the beginning of an international
reputation, continuing in a modest way with
his exhibition at the Venice Biennale in 1938
and the acceptance of *The Nursery* (no.84) by
the Museum of Modern Art in New York in
1940.

DFJ

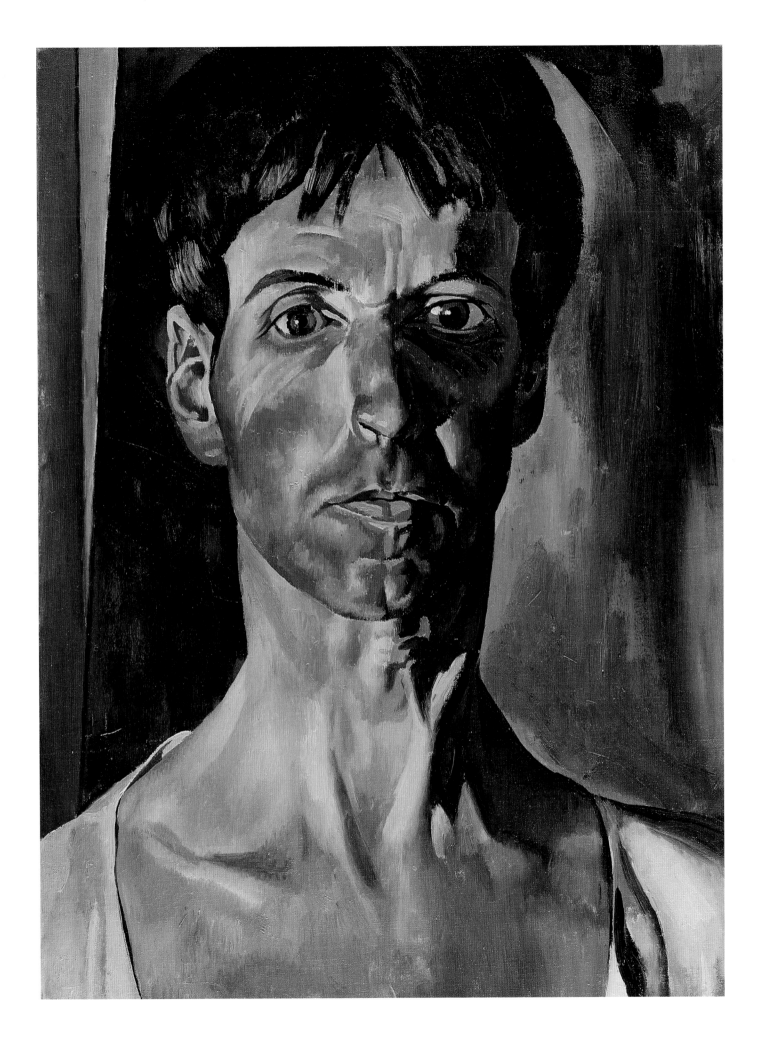

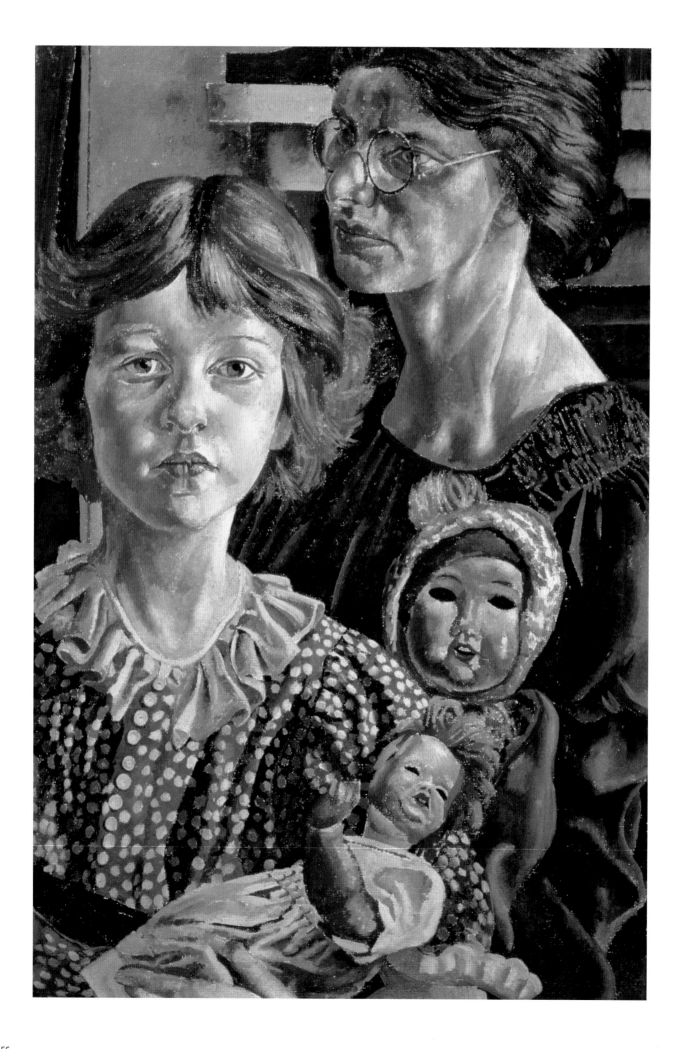

60 Hilda, Unity and Dolls 1937

Oil on canvas 76.2 × 50.8 cm
Bell 229
Leeds Museums and Art Galleries (City Art Gallery)

One of Spencer's supreme achievements in 'straight painting', this apparently objective depiction turns out to be as complex in its psychological overtones as the *Leg of Mutton Nude* of five months before.

It was completed (along with *Helter Skelter*, no.61) in a ten-day visit to Hampstead. After the fiasco of Spencer's honeymoon in St Ives that summer, he'd found himself living alone in Cookham; Patricia Preece had now returned to Dorothy Hepworth for the rest of her life. In late August he journeyed up to London, to stay at 17 Pond Street, where Hilda and his younger daughter Unity (aged seven) were living with the Carline Family. He wanted Hilda to recommence some kind of partnership. Her refusal would mark a crux in all their lives; and it is this breakdown of relationship that is so poignantly embodied in the composition.

We are pushed into close intimacy with the child's intent gaze at the left, while the adult looks wearily away. The two blind-eyed dolls seem sinister presences, the central one appearing over Unity's shoulder– fat cheeked, open-mouthed, almost mocking; the smaller, a terrible baby, thrashing about in Unity's arms. Each element in the composition must have been painted in separate sessions, then spliced together. The contrast between the lined and haggard flesh of the almost fifty-year-old Hilda, her child's milky radiance, and the artificial 'flesh' of the dolls, once again vindicates Spencer's 'dogged' landscape procedures.
TH

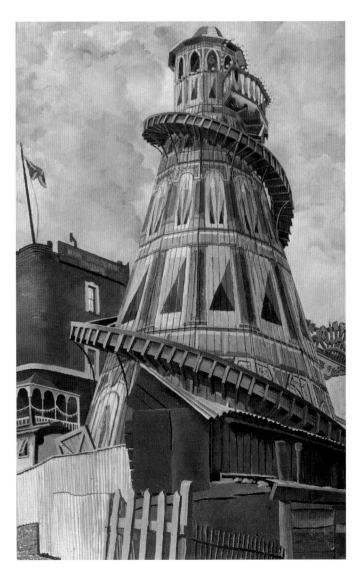

61 Helter Skelter, Hampstead Heath 1937

Oil on canvas 91.5 × 58.5 cm
Bell 244
Sheffield Galleries and Museums Trust

The circumstances in which this picture came about are poignant. The helter skelter was the chief feature of the ramshackle permanent fairground beside the Vale Hotel, where Spencer had lived with Hilda in the happy early years of their marriage. Tate's *Resurrection* (no.35) was painted in the Vale studio in 1924–7; it filled an entire eighteen-foot wall. According to one legend, the only way Spencer could view the painting at any distance was by climbing the helter skelter and glimpsing it through a window as he shot past. But now, in 1937, the marriage was over. Spencer was staying with the Carlines in nearby Downshire Hill, painting *Hilda, Unity and Dolls* (no.60), and failing to persuade her to join him again, in Suffolk or in Cookham. By painting the helter skelter he was revisiting the scene of his past happiness in the Vale of Health. More generally, *Helter Skelter* shows Spencer responding to the brightly coloured world of popular imagery, along with several other English artists of the later 1930s.
TH

4 THOSE COUPLE THINGS

In the winter of 1937, with both his marriages now collapsed, Spencer found himself painting alone in the empty spaces of 'Lindworth', and gave himself up to a prolonged meditation and fantasy about the relations of 'husbands and wives'. *The Beatitudes* are praise-images for the existence of love – a love that will flower even between the most grotesquely ugly protagonists. Figures so hideous as these have usually been confined to satire, as in Cranach's *Ill-Matched Couples* (see fig.20) or the repulsive lovers painted by Otto Dix in the 1920s (fig.19). Spencer himself used the word 'degenerate' of his *Beatitude* figures – a very loaded term in 1938, since he would certainly have been aware of the 'Degenerate Art' campaign in Hitler's Germany. And these bodies seem strikingly 'Northern' in language, as though the art Spencer had seen in 1922 in Vienna, Munich and Cologne were now surfacing; a tradition of the impure, ignoble body, finally putting to flight all trace of the Italian ideal.

Yet, as becomes clear from the written narratives Spencer composes around these images, he is wholly in sympathy with his 'ill-favoured' figures: 'these people, every one of them, are the beloved of my imaginings' (733.3.2). In the words of Spencer's brother Gilbert, an image such as *Knowing* 'which some see as cruelly misshapen ... represents the triumph of love over every physical disadvantage ... Her arm, sensitively elongated, stretches right across to his heart – the heart of her husband' (Gilbert Spencer, *Memoirs of a Painter,* London 1974, p.198).

The Beatitudes were conceived in solitude and deprivation as part of Spencer's love-temple, the ever-expanding Church-House. Within 'a house that was a forest of rooms', the spectator would encounter *The Beatitudes* as separate 'cubicles about bathroom size', each of them forming 'the climax wall, the altarpiece wall ... The notion of the altar wall being the husband and wife in their unified life'. To either side would be 'the wife in her individual capacity, the husband in his ditto' (733.2.252).

In 1940, after his wilderness year in London, Spencer rediscovered with Daphne Charlton the experience of loving intimacy, and embarked in Gloucestershire on the series of over 100 pencil compositions known as the *Scrapbook Drawings.* Many have long (still unpublished) inscriptions on the back, making explicit their role as 'illustrations' to the autobiographical texts he was then assembling. Most are also squared-up for transfer to canvas, and each was conceived within the overall scheme of the Church-House, where the couple-theme would be explored in terms of Spencer's own life.

In 1950 the painter Sir Alfred Munnings came across some of the paintings and drawings of the 'couple' period, and initiated a police prosecution against Spencer for obscenity. On the 4 October, the *Daily Express* reports that the owner (unidentified) has agreed to destroy these 'saucy' pictures; a little later, that he has 'put his foot' through them. These lost works probably included at least one of the Beatitudes. As a result of this upsetting attack, Spencer is known to have hidden the *Leg of Mutton Nude* (no.58) under his bed, and to have removed the two lavatory drawings (and perhaps others) from the scrapbooks. It may also account for Spencer's not continuing to explore this vein of sexual radicalism in his final decade.

TH

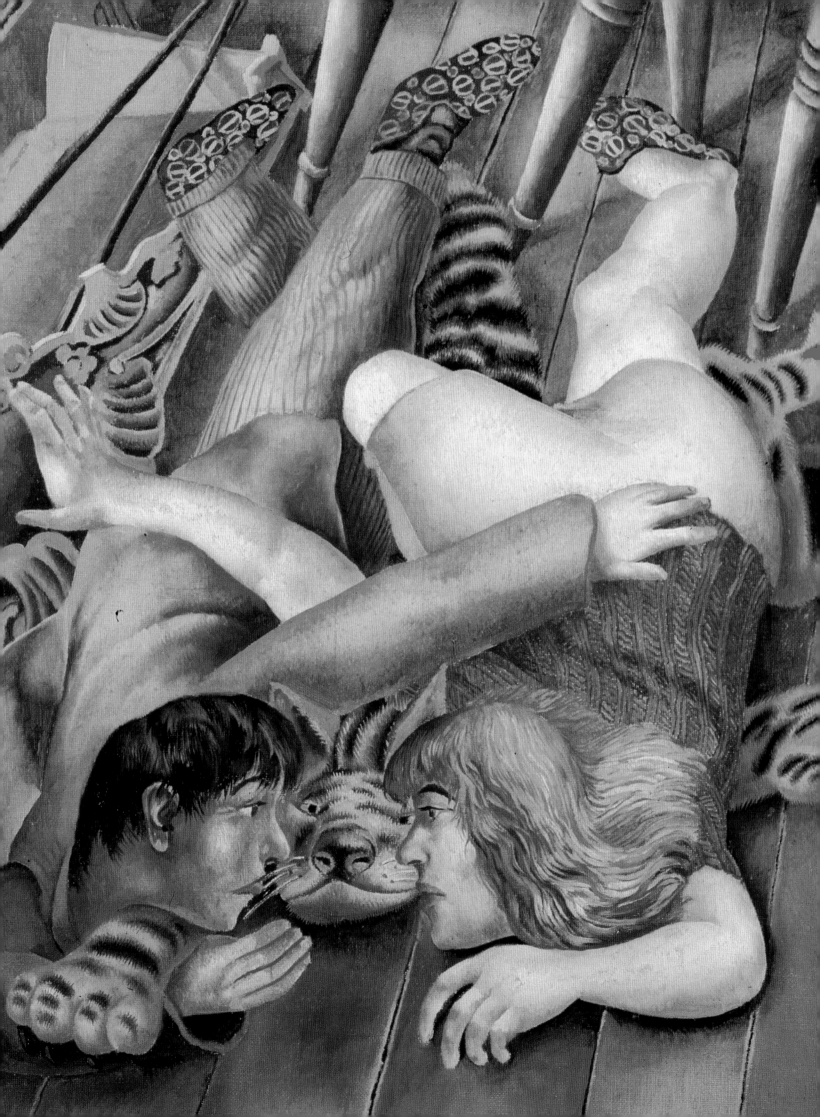

62 Toasting (or Sociableness)
c.1937–8

Oil on canvas 76.2 × 50.8 cm
Bell 274j
Lent by David Inshaw

Among the least-reproduced of the *Beatitudes* series, *Toasting* partly springs from a memory of those occasions when, in the earliest years of living together in the Vale of Health studio, Hilda and Stanley would strip and continue their everyday lives in naked companionship. As Spencer explains (733.3.3, p.22): 'Behaving in this way would express to me a feeling of friendliness and affability between a husband and a wife'. Alone at Lindworth, having lost both his wives, Spencer relives a lost era of intimacy and firelit cosiness. The Hilda figure is shown with her hair down, powerfully built, towering above the little self-figure, a kind of shrivelled child. The strange writhing object in the top left is a carved picture-frame seen from the side.

In striking contrast to the numb naturalism of the naked couple in the *Leg of Mutton Nude* (no.58) of a few months earlier, Spencer now reinterprets the body in a language expressive of affection, but open to 'distortion', especially striking in Hilda's long neck. In a notebook narrative (733.3.3) the couple are made into shop assistants: 'But in this story there are to be no clothes. She sits in an armchair in the sitting room and shells some peas she has in her naked lap … He writes love letters to her and hides them in the room & she has to find them.'

One of the underlying themes in all the *Beatitudes* is a renunciation of bodily vanity, and especially of male pride. Further on in the narrative, when more characters enter and join in the love-making, a young man exclaims: '"Oh, how lovely! … That hateful business of estrangement caused by false maleness is gone, isn't it?" They were healing the wounds of years and had a sense of each now putting everything back in its proper place and perspective.'

TH

63 Desire (or Passion) 1937–8

Oil on canvas 76.2 × 50.8 cm
Bell 274d
Private Collection c/o Alex Reid and Lefevre, London

Spencer remembered this as being the first of the *Beatitude* designs. The theme of emotional neediness is portrayed though the desire of a small man for a large woman – an apparent mismatch which in a Cranach or a Gillray would be associated with mockery. Yet as Spencer explains, 'It is meant to be a very happy picture … I think it is so good' (733.3.3). When we recall Spencer's training, with years of drawing in the Slade life rooms in the approved Tonks manner, or consider the noble trecento figures of his early work, these new figure-types are astonishing. Their lineage seems to be partly from early Northern painting (such as he had seen in Cologne and elsewhere in 1922), and partly from a more popular vein, ranging from children's illustration to end-of-pier comic postcards.

TH

64 Consciousness c.1938

Oil on canvas 76.2 × 56 cm
Bell 274f
Private Collection

Even more than in any other of the *Beatitudes*, *Consciousness* drives home Spencer's message – that the blessedness of love may be best articulated not through the beautiful people, but through the 'ugly'. In Spencer's own words, 'Beauty to me is expressiveness, and that is as far as I can say. And a duck is as expressive as a swan & as eloquently so' (733.3.3, p.28). This is a moment of sudden mutual recognition: 'I call it Consciousness because it is like waking up and recognising all that one has been missing while asleep' (733.3.3).

TH

65 Knowing c.1938

Oil on canvas 66 × 56 cm
Bell 274b
Private Collection

Most of the *Beatitudes* are stage encounters, with two figures lit against the darkness. In *Knowing*, they rise up at us, seeming to 'act out' their strange relationship for the spectator. They are somewhere between a freak show and an archetype. The looming and brutal hulk of the male is rendered lonely and vulnerable, the fist bunched forward at us, astonishingly contrasted with his butterfly-like mate's delicate hand. In Spencer's Church-House, each *Beatitude* would be seen from the threshold of its own eight-foot cubicle, and *Knowing* conveys this sudden intrusion on a couple's privacy. The colour is low-key but beautifully judged, the gold waistcoat pitched against the pink polka-dot dress.

Spencer's biographer Kenneth Pople believes this image originates in the terrifying figure of Sergeant-Major Kench at Beaufort Hospital in 1915–16. He sees the tiny, fragile wife beside him as an aspect of the artist's self, the 'Little Stanley' who recurs elsewhere (Pople 1991, p.389).

TH

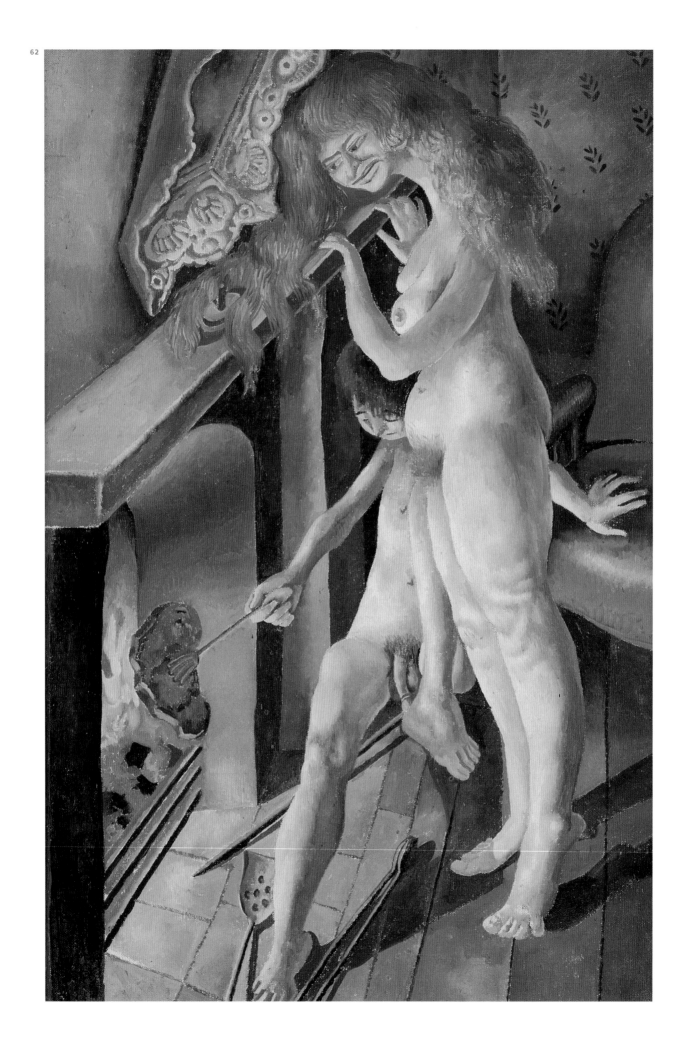

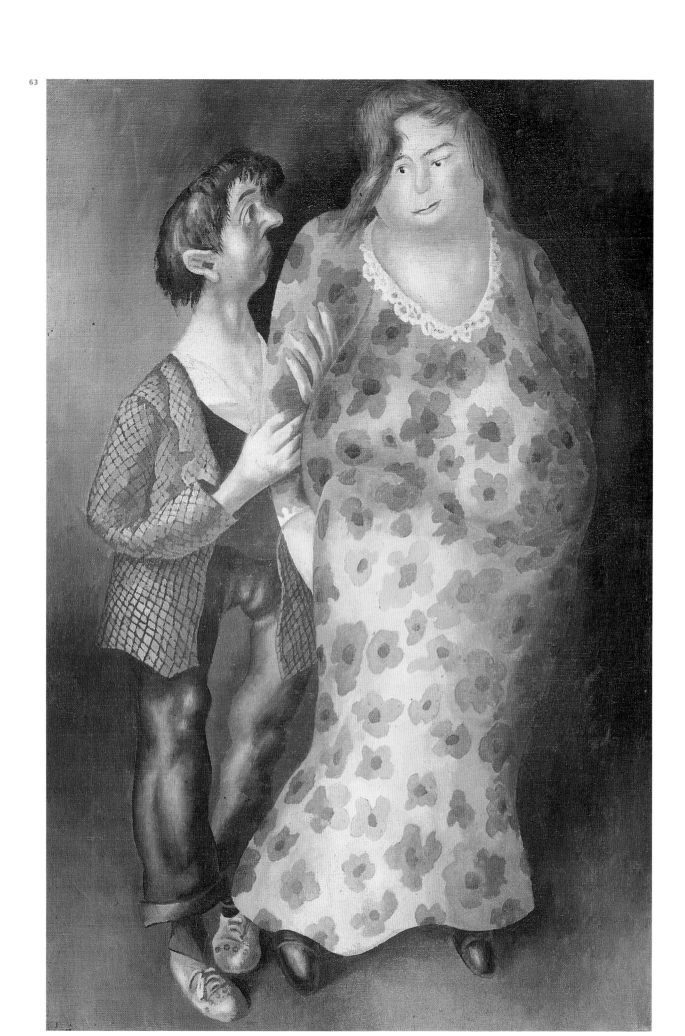

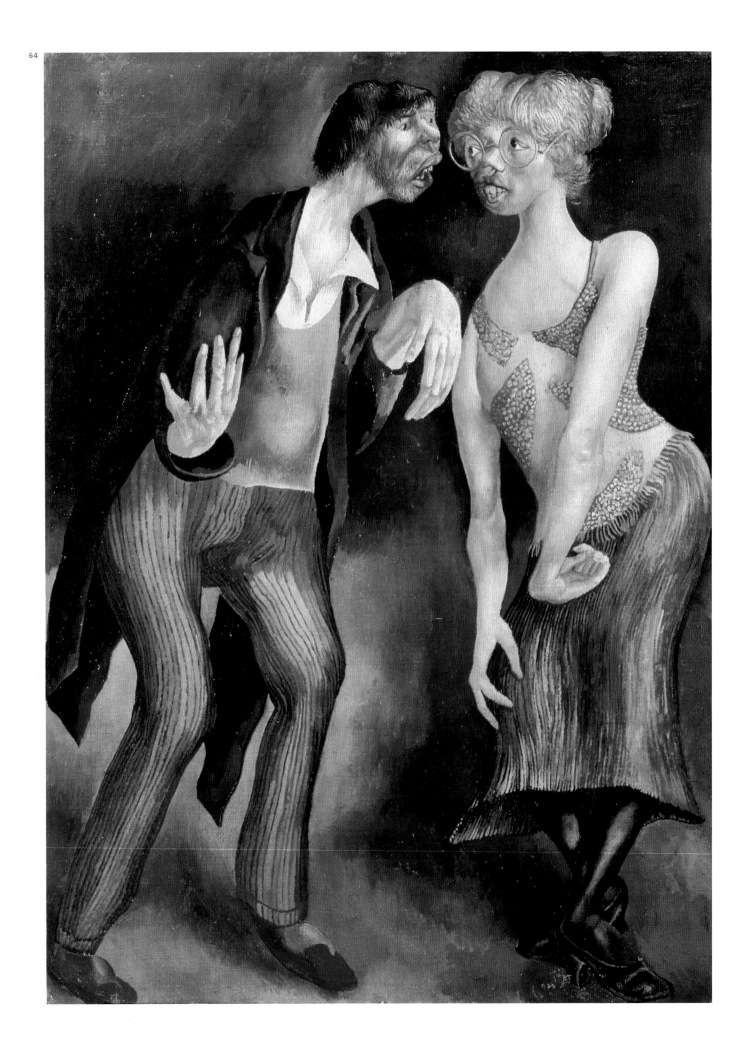

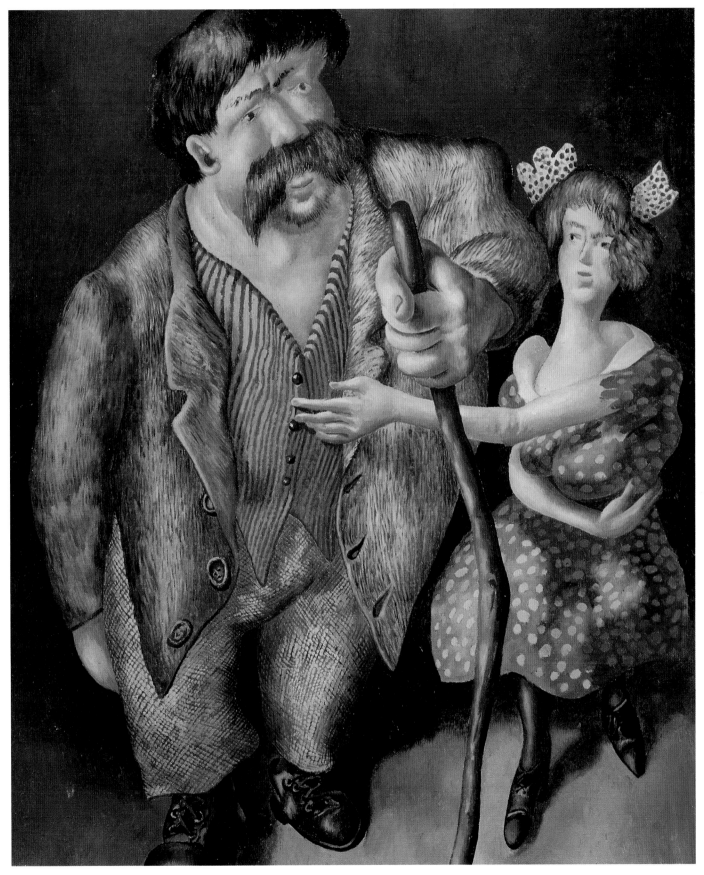

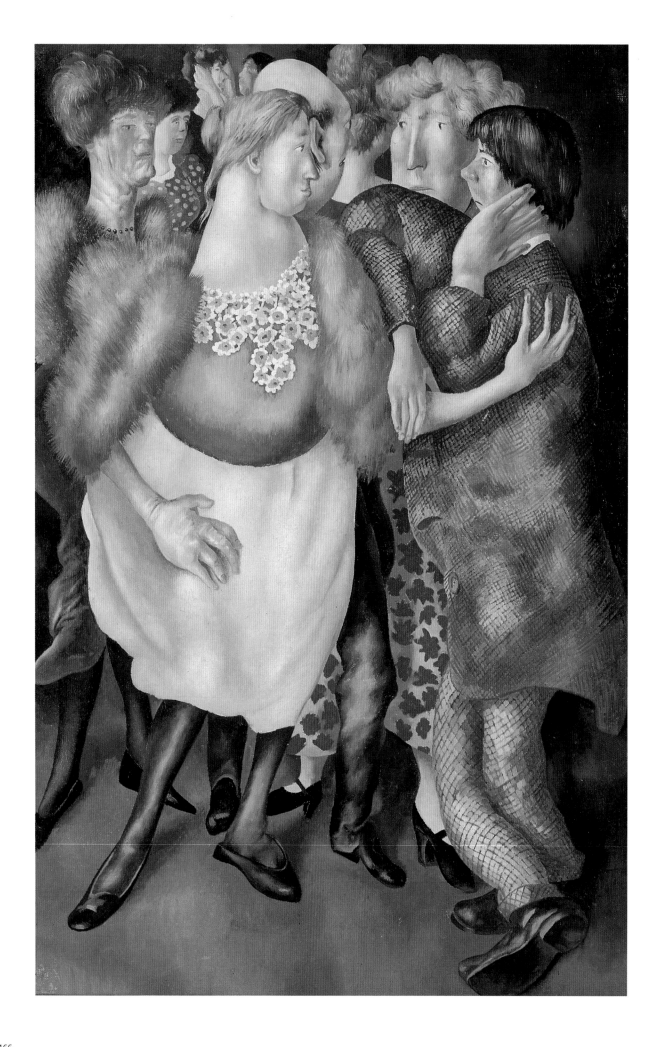

66 Contemplation *c*.1938

Oil on canvas 91 × 61 cm
Bell 274e
Lent by the Stanley Spencer Gallery, Cookham

The rapt couple who stare and stare ('as though', wrote Spencer, 'they will never stop looking') are not alone. They are under observation from some of their party, a kind of dowager or Lady Bracknell figure and a personage with a huge moon face. The lovers themselves – like all Spencer's invented figures of the 1930s – have very small heads and tiny tapering feet, with their bodies billowing shapelessly between. The woman's body here is vast. She stares at her lover, close to tears, with an utter vulnerability, her commonplace profile dwarfed by the monstrous ear of the bald man behind. Her lover drapes himself on her shoulder, and with one hand she half supports him, while the other – a hideous chicken claw – lies awkward and inert.

TH

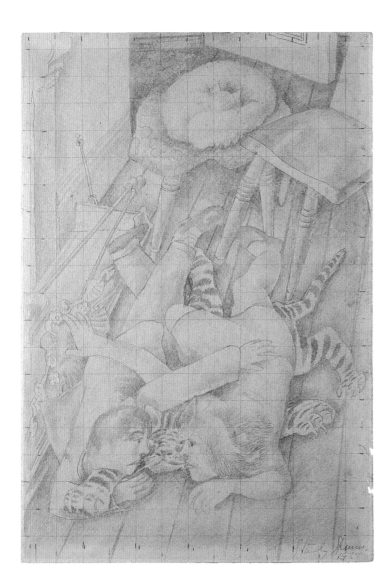

67 Drawing for On the Tiger Rug
1939

Pencil on buff paper 40.2 × 27.4 cm
Visitors of the Ashmolean Museum, Oxford. Bequeathed by
Mrs Ursula Tyrwhitt, 1966

68 On the Tiger Rug 1940

Oil on canvas 91.5 × 61 cm
Bell 294
Lord Lloyd-Webber

After his 'wilderness' year in London (see
nos.92–6), Spencer returned to the
couple theme, but now in more explicitly
autobiographical mode. He was living in
the Gloucestershire village of Leonard
Stanley in a room above a pub, and enjoying
a rumbustious affair with Daphne Charlton
(while her husband, George, spent the week
in Oxford). It was at this time that Spencer
began his *Scrapbook Drawings*, and the sheet
now in the Ashmolean is of exactly the same
scale as these – perhaps the first to be squared
up and transferred to canvas. Although the
composition is virtually unchanged, the heads
register more strongly in the oil painting, with
Daphne's profile considerably enlarged.

Confronting one another across the absurd,
melancholy face of the tiger (with its claw
tucked under Stanley's chin), the lovers meet
in such a way as to combine solemn
communion with comedy. Maurice Collis (1962,
p.62) quotes Spencer: 'How wonderful would
Tiger Rug be as a Resurrection picture … How
near is the meaning of resurrection and sexual
union.' The rug protects them from the cold
floorboards (the painting was completed in
February), while Daphne's hand is outstretched
towards the unseen fire. There may be some
intentional counterpoint between the white
domestic cat curled up on the stool, and the
dead wild feline between them. Perhaps it's
worth recalling that Spencer's family nickname
was Tiger.

Listed in Bell's catalogue of 1992 as
'whereabouts unknown', *On the Tiger Rug*
only resurfaced at auction in 1998.

TH

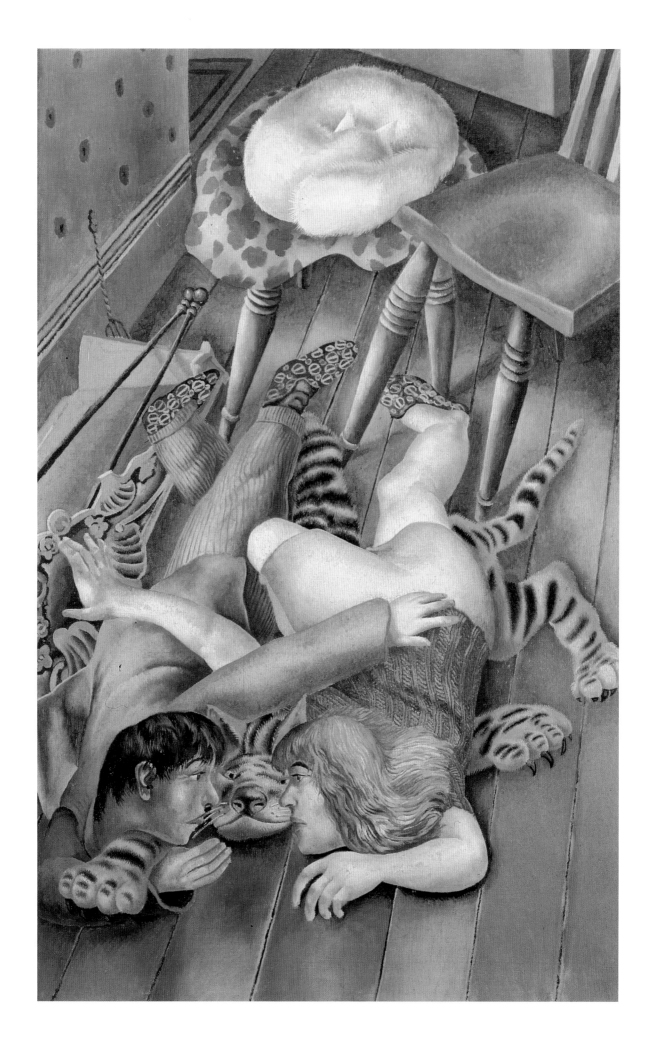

69 Untitled c.1937–40

Pencil on canvas 76.2 × 50.8 cm
Private Collection, Courtesy of Ivor Braka Ltd, London

Transferred to the canvas from a squared-up
drawing (one of a series of nude-couple
designs listed by Spencer, but so far mostly
untraced), this very original composition was
never painted. As Jane Alison has explained,
these new couples were probably intended for
the Church-House bedroom/chapel: 'Other
"alleyways" would be devoted to "showing
men and women at different stages of
undressing", leading to a room or chapel
of "people lying about" and "making love"'
(Barbican 1991, p.21).

 The cast is probably Little Stanley and Big
Daphne. In contrast to the earlier, more
archetypal *Beatitudes*, these encounters take
place in a domestic setting, in this case on the
floor and between two beds. The worship of
buttocks, and close communion with them,
is consistent with Spencer's espousal of 'Dirt'.
As with so much of Spencer's work in the
1930s, these figures see-saw between humour
and wonder.

TH

70 Trying on Stockings c.1940

Pencil on paper 31.1 × 31.4 cm
Mrs Shirley Taliano, Canada

This amusing composition probably relates to
the undressing scenes that would adorn the
passage leading to the bedroom/chapel in
Church-House (see no.69). But it is also a slice
of remembrance from the 1920s; Spencer was
by now spending several hours of each day

writing his autobiography. Stanley in garters
and combinations happily assists Hilda in
baring her legs. (The title should surely be
'Removing Stockings'.) The atmosphere is one
of cosiness and intimacy, rather than of sexual
overture.

 A squared-up canvas with a similar pencil
drawing was auctioned at Christie's in the
Spencer studio sale of 8 November 1998
(no.241).

TH

71 Tea in Bed *c.*1940–3

Pencil on buff paper 40.5 × 28 cm
Private Collection

72 Lavatory 1 *c.*1940–3

Pencil on buff paper 40.5 × 28 cm
Private Collection

73 Lavatory 2 *c.*1940–3

Pencil on buff paper 40.5 × 28 cm
Private Collection

74 Fetching Shoes *c.*1940–3

Pencil on buff paper 40.5 × 28 cm
Private Collection; on loan to the Stanley Spencer Gallery

Each of these four *Scrapbook Drawings* celebrates a moment of shared domestic intimacy within the everyday life of a sexual partnership. The theme was first broached in the small paintings of 1936 known as *Domestic Scenes*, with titles like *Choosing a Petticoat* and *At the Chest of Drawers*. But by the time Spencer embarked on the series of large drawings, made in Derwent scrapbooks purchased at the local stationery shop in Leonard Stanley, he was engaged in writing his autobiography, and most of these images are to some extent illustrations to his own life, present and past.

Of *Tea in Bed* he writes: 'This is a subject that has been a part of the world & life of love … mentally I have been "bedridden" all my life' (Leder 1976, p.10). Probably the two lavatory scenes were intended for the 'smallest room' in Church-House; commentators have differed over whether this companionable toilet design is Stanley's, or records an actual type. With typical fearlessness, Spencer registers the cross-over between sexual curiosity and bowel function. The overgrown children are probably Little Stanley and Big Daphne again (see no.69). *Fetching Shoes* seems a misnomer. The scene is one of pleasurable discomfort. She sits on his lap in the cosy wicker chair while both struggle with some awkwardness to retrieve the shoes – or perhaps remove them.

The cheap paper Spencer used for these drawings has discoloured dramatically.

TH

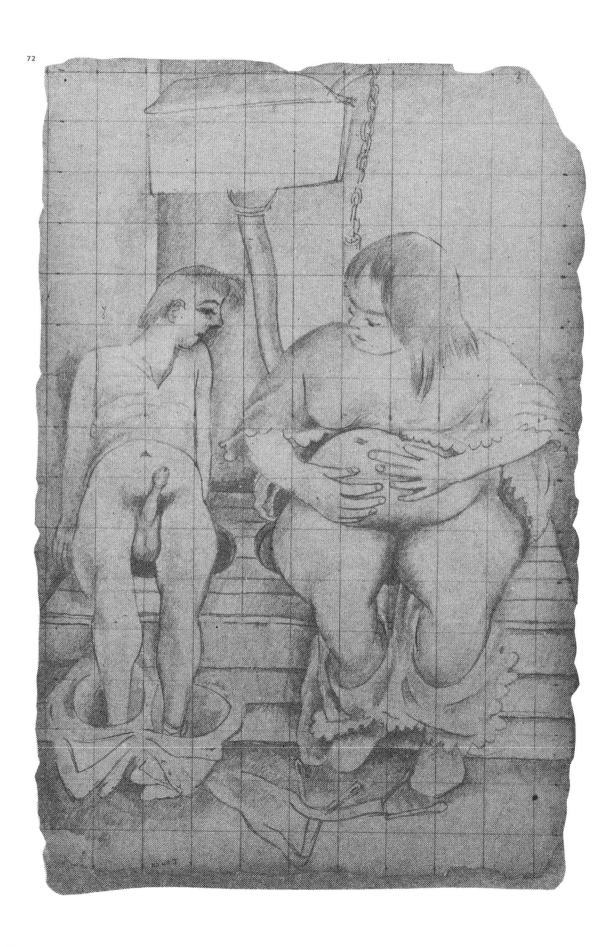

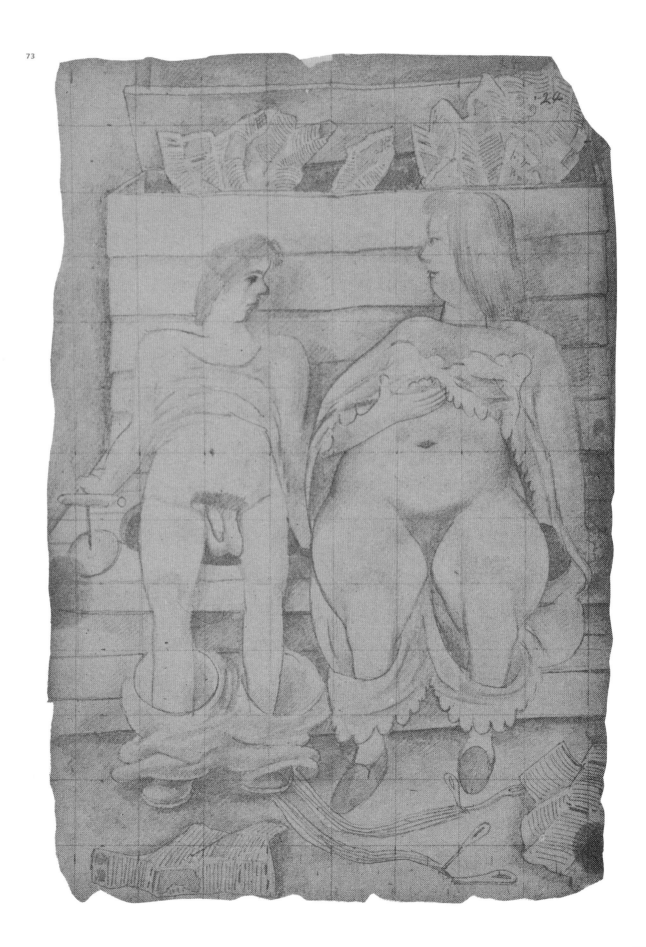

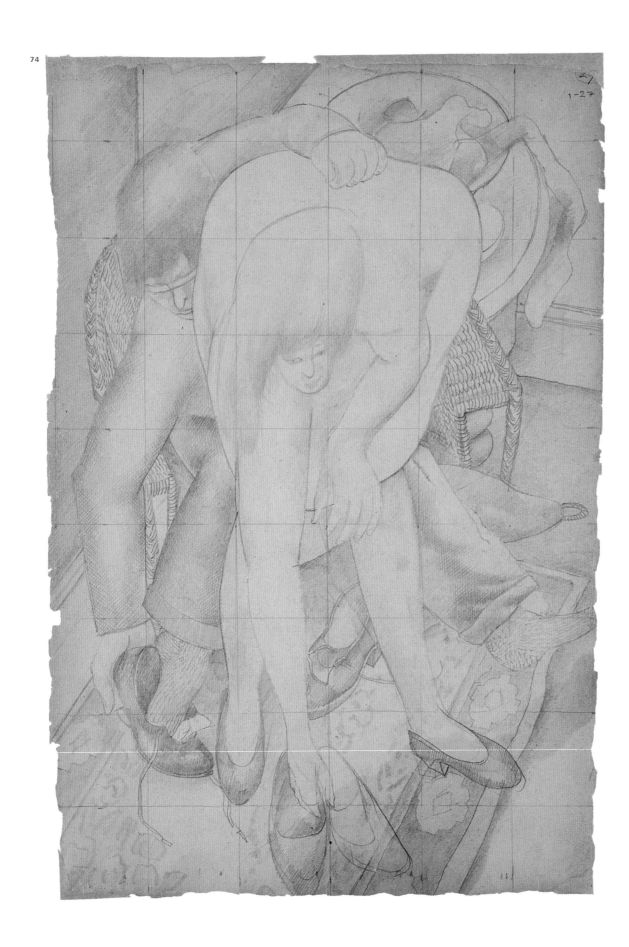

75 Naming Elephant c.1943–4

Pencil on buff paper 40.5 × 28 cm
Private Collection

Although squared up for transfer to canvas,
neither this, nor the beautiful companion
image *Naming Rhino* (fig.24), seem to have
become paintings. Ostensibly a biblical theme,
with Adam and Eve engaged in naming the
animals, the sense is more of a tender
caressing. Church-House was a temple of love,
in which the Edenic couple could innocently
recover the primal love between man and
beast. As Spencer may have been aware, in the
Khajuraho temple complex that was one key
model for the Church-House, two men make
love to a horse.

TH

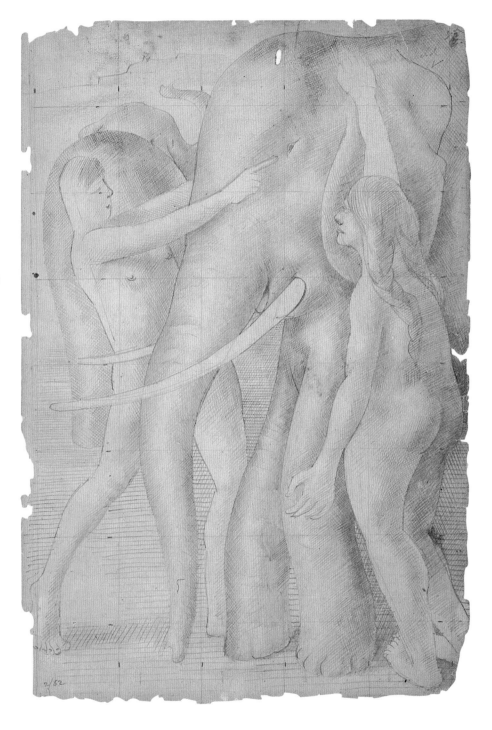

2/12

76 Patricia and Gramophone
*c.*1943–4

Pencil on buff paper 40.5 × 28 cm
Private Collection; on loan to the Stanley Spencer Gallery

77 Patricia Shopping *c.*1943–4

Pencil on buff paper 40.5 × 28 cm
Private Collection; on loan to the Stanley Spencer Gallery

Despite the fiasco of his marriage to Preece, Spencer planned to commemorate their times together in one of the principal chapels of Church-House. Both these drawings, squared up for transfer to canvas, depict episodes from Spencer's courtship of Patricia in the mid-1930s. At Lindworth, Patricia has stripped to her underwear and kicks out wildly as she dances to the gramophone. Stanley has his back to her, and is rummaging in a sack. As in many of these drawings, they are blessed, or encouraged, by one of Spencer's 'disciple' figures – a bearded old man in Trecento robes.

Patricia Shopping is set on a pavement, perhaps in Maidenhead where Spencer often took her on shopping expeditions. Here he depicts her sinuous, elegant figure as he squires her about among the passers-by. A 'disciple' sprawls at her feet. In another, related drawing Patricia flirts with a large dog, with Stanley on all fours behind her.

TH

77

5 THE CHURCH OF ME

Almost all the images in this section relate to Spencer's conception of a 'Church-House'. His first ideas for a chapel of peace and love date from the 1914–18 war, becoming more defined while he worked at Burghclere. Spencer now saw himself as primarily a mural artist. As he explained to Gwen Raverat in a letter of 1933, 'I would like, as I used to be able, to do small pictures, but have now trained my powers in the direction of elaborating a scheme, until that is what I truly love to do and what I am sure I should do'. By October 1935, he begs her: 'Could you not find someone who would let me do one of these schemes in their house; or better still, could I not be paid so much a year to fill this house in Cookham?' (Pople 1991, pp.285 and 351). Spencer would eventually conceive a complete fusion of domestic and sacred, of home and place of worship. The Church-House would be organised to mirror local topography – the nave as Cookham High Street, the aisles as School Lane and the river. But its various secondary structures must include bedroom-chapels, and even 'bathrooms and lavatories' (733.3.12). A fireplace becomes an altar; the picture above the mantel, an altarpiece. Painting's sacred function would be reclaimed within the domestic setting.

In the absence of a patron, Spencer embarked on a cycle of easel pictures – a narrative of *The Last Day*, imagined as a public love-making, pivoted on Cookham War Memorial. As Spencer recalled, 'During the war, when I contemplated the horror of my own life and the lives of those around me, I felt that the only way to end the ghastly experience would be if everyone decided to indulge in every degree and form of sexual love.' For his chapel of sexual healing, one model was provided by the love-making figures on the temples of Khajuraho (first encountered in a book of Indian Sculpture purchased in Munich in 1922). The long formats of paintings such as *Promenade of Women* and *A Village in Heaven* echo temple-friezes, as well as early Italian predellas, while the scheme as a whole takes up Spencer's earliest aspiration to revive the Trecento fresco cycle. Yet the actual figures now embody an entirely opposed tradition, veering between the Northern grotesque and the comic types of children's books. This stylistic shift signals Spencer's deeper transition in the 1930s – away from monumental Christian idealism to confront both sexual fantasy and raw reality, however conflictual or awkward the consequences for his art.

At the end of 1938, exhausted by landscape production, deep in debt and excluded from Lindworth by Preece, Spencer fled to London. His very solitary existence in a top-floor bed-sitting room in Swiss Cottage (an area then full of Jewish refugees) he recalled as a time of self-exploration. 'I used sometimes to go to bed after lunch because I wanted to live my inner self.' Reading Thoreau's *Walden*, Spencer embarked on the *Christ in the Wilderness* sequence, originally intended as forty paintings (one for each day) to be meditated upon in the Church-House. In these compact and monumental images, Spencer seems to return to the Trecento idiom of his earliest work.

In the autobiographical *Scrapbook* compositions a year later (as in the two episodes here, intended for the Elsie Chapel), Trecento-style disciples migrate into the humdrum domestic scene. Thus by the 1940s the Church-House had expanded in function as well as in complexity. It would heal stylistic conflict as well as sexual wounds; it would link past and present and apocalyptic future; it would locate Spencer's personal autobiography within a Christian context – a 'Church of Me'.

TH

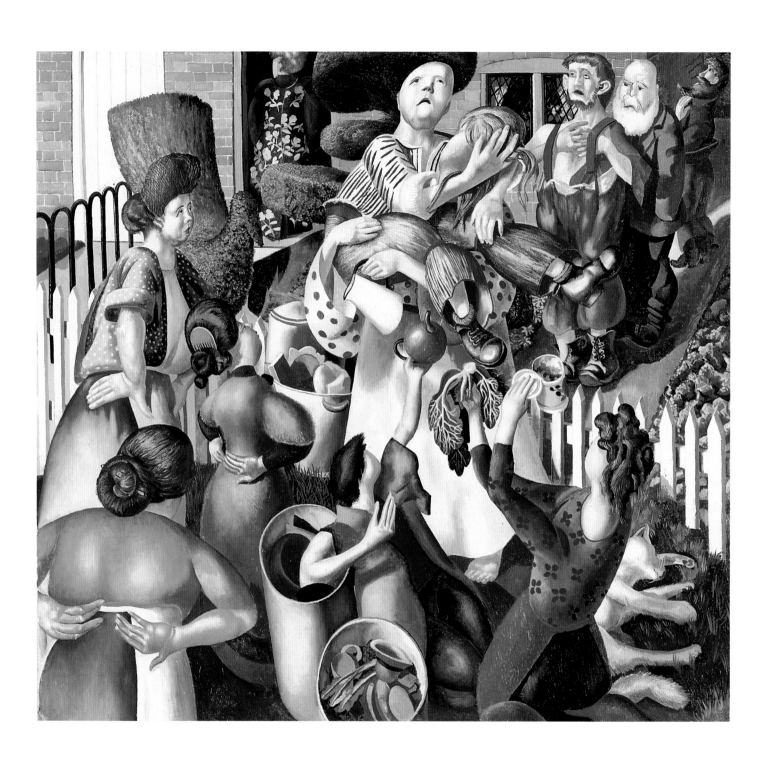

78 The Dustman (or The Lovers) 1934

Oil on canvas 114.9 × 122.5 cm
Bell 163
Laing Art Gallery, Newcastle upon Tyne (Tyne and Wear Museums)

The earliest of the *Last Day* compositions in this show, *The Dustman*, was already conceived in 1932, when Spencer wrote to Gwen Raverat (20 December 1932, quoted in Pople, p.299): 'Dustbins are looking up … It appears that I became so enamoured of the dustman that I wanted him to be transported to heaven while in the execution of his duty. So I got a big sort of wife to pick him up in her arms while children in a state of ecstasy hold up towards him an empty jam-tin, a tea-pot, and a bit of cabbage stalk with a few limp leaves attached to it. This scene occurs – Cookham people will say: "We have seen strange things today" – a little away from the centre of the road in the village … The left group is a sort of washerwomen onlookers, the right group is the other dustman and a poor old ragged man expecting and hoping for a ride also. This is all very nice in its way, but some sort of terrible quality has crept in.'

The half-humourous tone of helpless wonderment at his own conceptions is telling, and establishes the uneasy, partly comic character of all of the *Last Day* narratives. But it also makes clear that the 'madness' of these works should not be only attributed to the malevolent influence of Patricia Preece. Yet the eventual realisation of *The Dustman* does seem exceptionally awkward; his bald head seems to get an odd 'hat' from the elaborate topiary-hedge behind; his wife's head is as featureless as a rag-doll; the white sleeping (or dead?) cat on the lower right corner seems spatially unconvincing.

Spencer anticipated trouble from 'Roger' – i.e. Roger Fry – but not from the Royal Academy, when he submitted *The Dustman* for the Summer Exhibition. Its rejection led to his resignation.

The Dustman is best seen as a transitional work, which nevertheless announces very explicitly the sacramental themes that had become clear in the Burghclere years (733.3.75): 'I resurrect the tea-pot and the empty jamtin and cabbage stalk, and as there is a mystery in the Trinity, so there is in these three objects and in many others of no apparent consequence.' And again, 'The picture is to express a joy of life through intimacy. All the signs and tokens of homelife and place, such as the cabbage leaves and the teapot, which I have so much loved that I have had them resurrected from the dustbin … As a child I always looked on rubbish heaps and dustbins with a feeling of wonder … In this Dustman picture I try to express something of this wish and need I feel for things to be restored' (733.3.74).

TH

79 Study for Adoration of Old Men
c.1937

Pencil on paper 57 × 68 cm
Private collection

80 Adoration of Old Men 1937

Oil on canvas 90.6 × 110.5 cm
Bell 227
Leicester City Museums Service

The pair of 'Adoration' paintings, 'of Girls' and 'of Old Men', were painted while Spencer was living alone at Lindworth, and were intended for Church-House as part of his vision of Cookham on the Last Day. In this future utopia, after the Resurrection and before the end of the world, conventional barriers that restrained human affection will be superseded. There are three ages of Cookham villagers in the *Adoration of Old Men*. In the distance a crowd of schoolgirls take little notice of the foreground, as they are too young. On the left, a group of five women have fallen in love with the extremely elderly and eccentric looking men on the right. Spencer wrote that he identified with the woman who kneels on the ground, supported by a provocatively dressed woman (resembling Patricia) who encourages her to reach adoringly towards an old man with a stick. These unlikely men, already looking surprised to be again in this world, will share their experience with Spencer, in the guise of a woman, who has overcome the differences of both age and gender. He wrote of the painting: 'I have imagined a girl who is supposed to be me and to have my feelings sexually … The thing that is prompting their awe is the thought of going to bed with any of them. The disciple here is one of the girls who supports another woman who is rejoicing as the old man bends forward on to her supporting hands. She is almost fainting with the joy that she is to be alone with him' (733.3.2, quoted by Pople 1991, p.380).

The composition is centred on the interlocking group of three people on the left. Their peculiar actions, and the interpretation of their roles, depend on theatrical gestures. As always with Spencer, these are fully worked out in the preparatory drawing, as exact as the cartoon of a Renaissance fresco. 'I am very pleased', he wrote in about 1938 of this picture, 'with the girls girlishness and their floral patterned dresses mingle with and merge into the old mens overcoats a great solid mass of them unrelieved by even a button hole' (733.3.2.91).

The vehement gracelessness of Spencer's figures, and their agitated grouping, is comparable to paintings by the American 'regional painters' of the mid 1930s, Thomas Hart Benton and John Steuart Curry. It is likely that Richard Carline had shown Spencer reproductions of their work.

DFJ

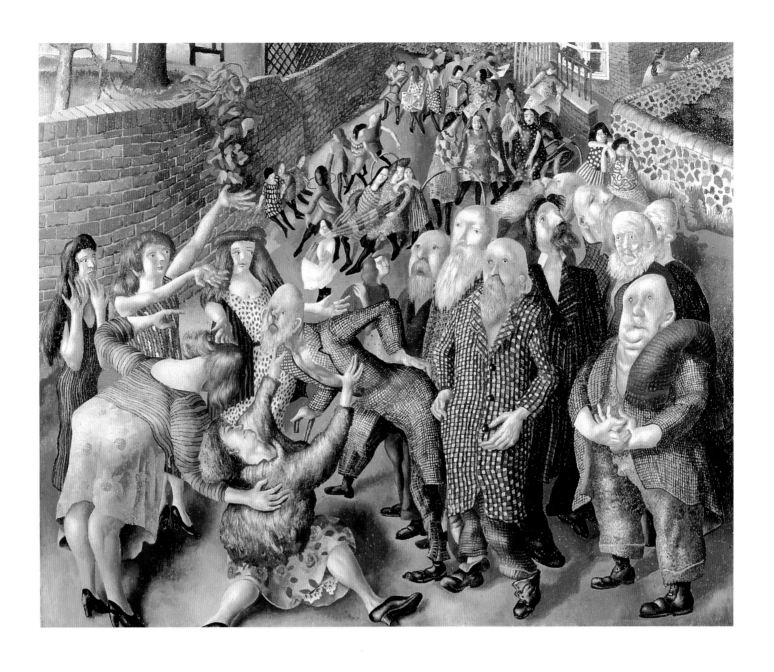

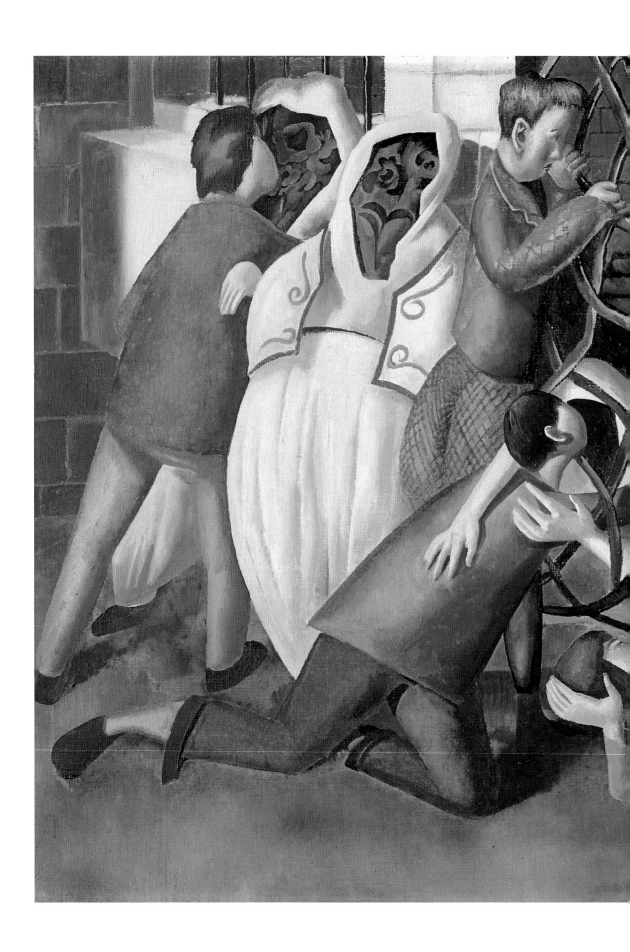

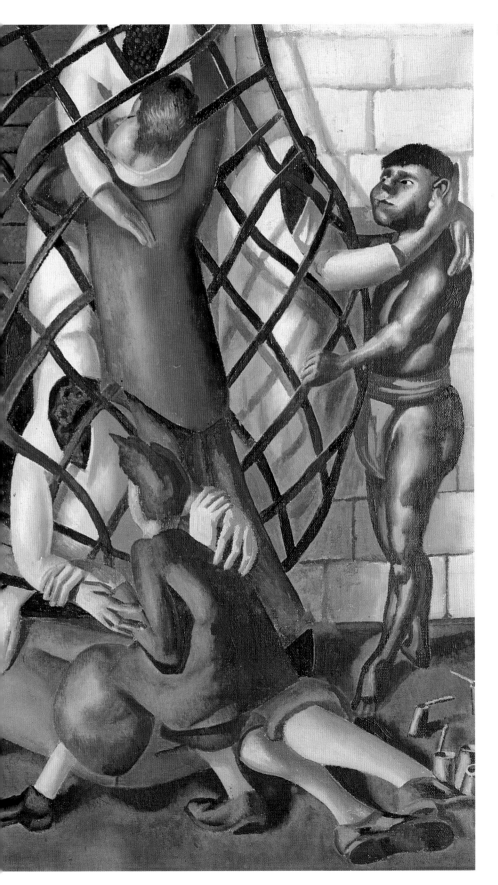

81 The Turkish Window 1934

Oil on canvas 61 × 86 cm
Bell 162
J.M.R. Saunders Watson, Rockingham Castle

The Turkish Window was originally designed
by Spencer to be at one end of a much larger
painting, the remainder of which became
Love Among the Nations (no.82). He planned
in the summer of 1933 two very long paintings
which would serve as linking friezes along the
walls of Church-House. Both *Love on the Moor*
(Fitzwilliam Museum, Cambridge) and *Love
Among the Nations* expressed his new belief
in liberated sexuality, and looked towards a
new society on two different scales, local
and international. He himself appears in the
pictures, and Hilda is at the centre of *Love
on the Moor*. Spencer was then falling in
love with Patricia Preece, who lived near
him at Cookham, and there was a personal
motivation for his enthusiasm for free love.
However the paintings also develop long-
standing interests, and follow from the theme
of his Resurrections, in which local society
is reborn into a paradise on earth. In *The
Resurrection, Cookham* (no.35) it is families
who are re-united, but in these 'Love' paintings
strangers and people of different races are
brought together.

These schemes were first planned in
drawings, and *The Turkish Window* may have
been the first section to be painted. Its subject
matches Spencer's first title for the whole
painting, 'Love Without Barriers'. A group
of men, one of them an African, are shown
attempting to make at least the preliminaries
of love with some Turkish women who are
imprisoned behind the iron window grille of
a harem. Two women, their faces hidden
behind flowered veils, have already escaped.
In choosing this least promising site for love,
Spencer illustrated the general theme that
love conquers physical confinement.

DFJ

82 Love Among the Nations 1935

Oil on canvas 95.5 × 280 cm
Bell 172
Lent by the Syndics of the Fitzwilliam Museum, Cambridge

Spencer was not a keen traveller. He had been sent to Macedonia in the war, and later returned to Yugoslavia via Germany with the Carlines. He and Patricia Preece were twice taken to Switzerland by Sir Edward Beddington-Behrens, and towards the end of his life he joined a British cultural mission to China. Otherwise, he did not leave Britain, and had never been to Paris nor seen the old masters in Italy, and does not seem to have regretted it. His occasional but passionate interest in foreign things is like that of someone who admires photographs in the National Geographic Magazine while staying at home. He painted a group of black Africans in a central position in *The Resurrection, Cookham*

(no.35), where they are associated with the sense of touch, but it is only in several paintings of the mid-1930s, and especially *Love Among the Nations*, that Spencer takes a delight in people of different races, an attitude that Simon Schama has described as 'childishly racist (*New Yorker*, 17 Feb. 1997, p.60).

Love Among the Nations was part of the same decorative scheme as *The Turkish Window* (no.81), and was intended for display in Church-House. The painting is made up of a series of episodes. Clusters of costumed people of different races are shown in groups of two and three taking pleasure in exploring each other's bodies, in a quite delicate if determined fashion, with the Europeans and Asians

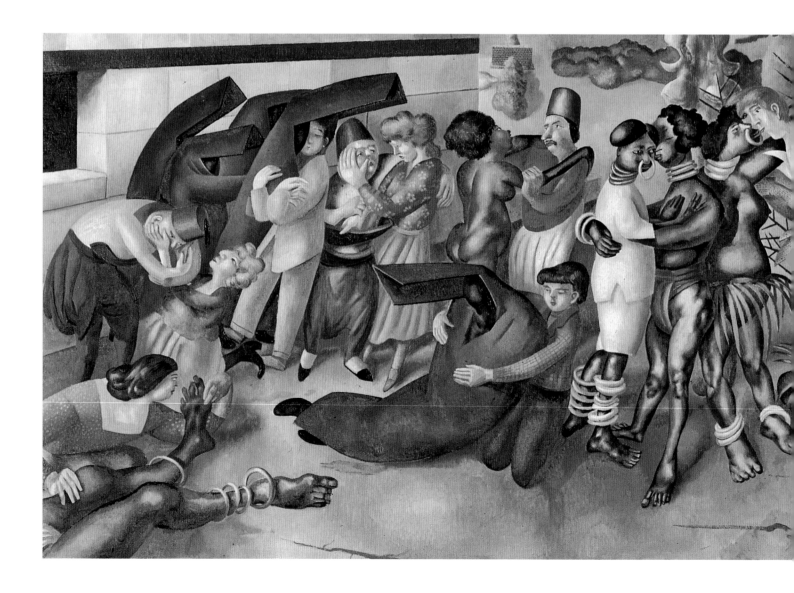

seeming slightly reluctant at the right, but more enthusiastic towards the left side of the painting. The message, told with wit and extravagance, is that sexual love should be enjoyed, ignoring conventions of race and age. Spencer appears to believe that this can be learnt by the over-decorous Europeans from the habits of Africans, especially women. Some kind of similar belief was a factor in the work of Epstein, Burra, Roberts and Moore in the late 1920s, but Spencer used none of the formal innovations liked by these artists, nor did he use the elegances of Slade School composition. He did not draw the figures from life, but designed in a spontaneous and abstracted fashion with an interest in pattern and

caricature. In a general sense Spencer was responding in the opposite way to the subject of love between races that concerned the Nazi party in Germany at the same time, and he was aware of racist literature, as noted in a day-book in February 1934: 'Read horrid bits out of [Brown's] "Races of Mankind" … not a good word to say for anyone black' (733.4.4).

The painting was exhibited at Tooths in 1936 with the title 'Humanity', and was bought by J.L. Behrend, the patron of the Sandham Memorial Chapel at Burghclere.
DFJ

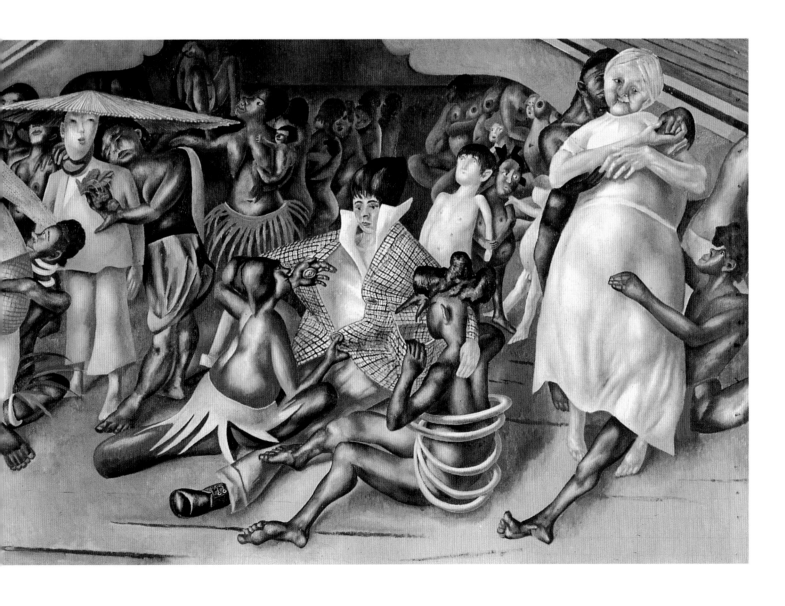

83 Illustration for The Nursery 1926
Chatto and Windus Almanack

Pencil over print on paper 16.5 × 13 cm
Tate Archive 733.4.2.159

84 The Nursery, or Christmas Stockings 1936

Oil on canvas 76.2 × 91.8 cm
Bell 197
Museum of Modern Art, New York.
Gift of the Contemporary Art Society, London, 1940

Spencer wrote of this: 'The picture shows
a scene in a nursery at Christmas time.
The children, who have their hair done up
in bits of rag called curlers, have come to the
bottom ends of their respective beds to see
what is in their Xmas stockings. On the floor
a child is playing with paper nuns, making a
long procession of them. As children one cut
these out of paper, bent them over and there
was a nun' (Bell 1992, p.442).

The painting combines two drawings made
nine years apart. The upper half, with the girls
feeling their presents in the stockings, was
designed in 1926 as an illustration for the
month of December in the Chatto and Windus
Almanack. The lower half, with the boy playing
on the floor, Spencer drew independently in
1936 and then altered to make this painting
(Bell 1992, p.443). His description makes
simple a rather complex subject. The scene
presumably follows from his childhood memory
of going into his elder sisters' bedroom at
Cookham early one Christmas morning.
The 'Nuns' have a different association, and
irresistibly recall the lines of army tents in
Macedonia which Spencer painted for
Burghclere, as J.T. Soby has suggested
(Bell 1992, p.443). Typically of Spencer's work,
this does not undervalue their role both as the
'Nuns', comparable to the hooded figures in
Love Among the Nations (no.82), and as
memories of the cowls of the oast houses in
Cookham (no.17). On the floor there is a male
world, in which the nuns or army tents are
playthings. On the beds, the girls dangle their
legs over the edge, while feeling the feet of
their stockings, several of which are crammed
with their playthings, toy soldiers.

DFJ

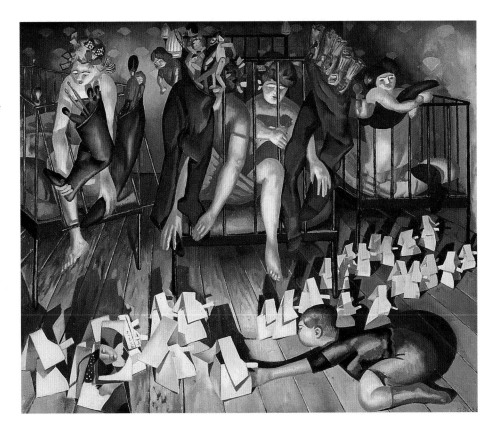

85 Christmas 1936

Oil on canvas 91.5 × 91.5 cm
Bell 221
Private Collection – Courtesy Massimo Martino
Fine Arts & Projects, Mendrisio

Spencer described this as 'Christmas paper objects ... bonbons and things' (Bell 1992, p.447). The patchwork elephant holds a bunch of flowers in his trunk. The assembly looks odd in a corner of the room, and the provisional and transient placing of these presents may reflect the separation of Spencer's family in the winter of 1936. Stanley was living in Cookham at Lindworth, near Patricia, and Hilda and the children, aged eleven and six, were living with her family in Hampstead. These may be their presents ready for delivery.

DFJ

86 **A Village in Heaven** 1937

Oil on canvas 45.7 × 182.9 cm
Bell 228
Manchester City Art Galleries

The Cookham war memorial is the setting for
this imaginary scene of public love. The cross
at the top of the memorial and the inscribed
names of the dead are not shown, and the
exaggerated roughness of the corner stones,
which were pitted, but not to that extent,
give it the unusual air of an altar, against which
leans a figure in a white robe whom Spencer
described as a 'disciple'. This disciple
encourages the ordinary people of the village

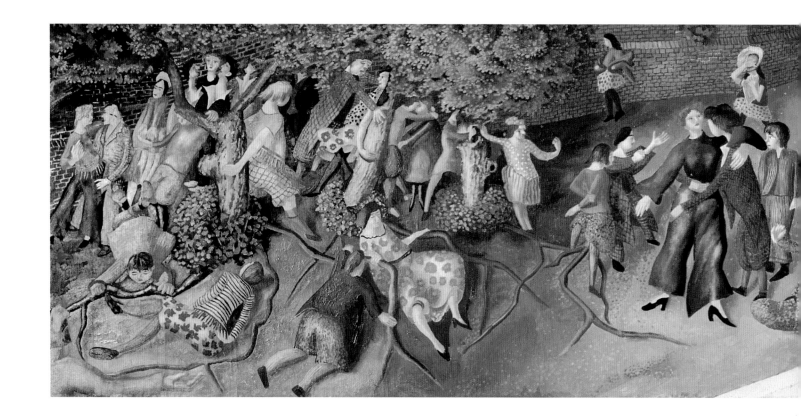

to make amorous advances to each other. He seems to pat one woman on her behind, and in front of him a couple hug each other, while a reluctant boy is encouraged to approach two girls. On the left a rather polite communal love scene takes place against three trees. A small group of people are fondling the roots of trees that lie between them, which Spencer likened to the worship of snakes in Buddhist temples (Pople 1991, p.374). He liked the way some couples beckoned to each other, and 'the thought of the intervening distance being a space full of desire without their being anyone in that space' (TGA 733.3.2.122). A group of schoolchildren are walking onto the Green from the street at the top, and on the right a few begin to show off, and to undress each other. The scene is carried further in *The Village Lovers* (Private Collection, Bell 230).

Spencer first wanted to call this painting 'The Celebration of Love in Heaven', and intended it for a place in the nave of Church-House. He consciously used the wide and shallow format of the predella of an Italian altarpiece, although the picture was to be placed to look more like a frieze on the wall. Cookham for him became heaven in its future state after the Resurrection, and in this utopia love would be exchanged openly between the villagers.
DFJ

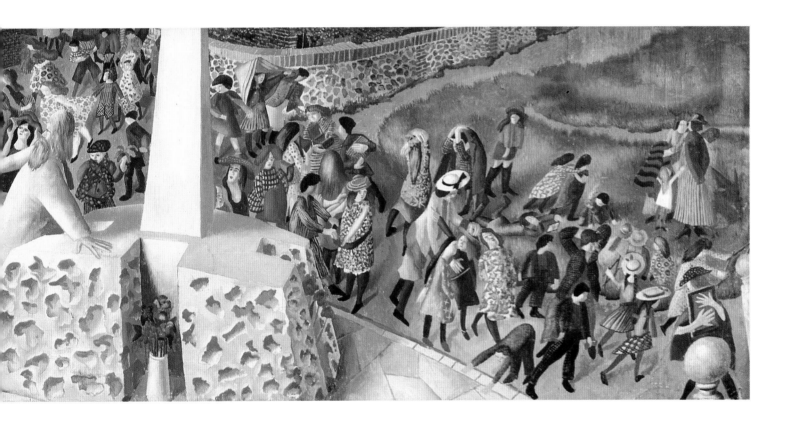

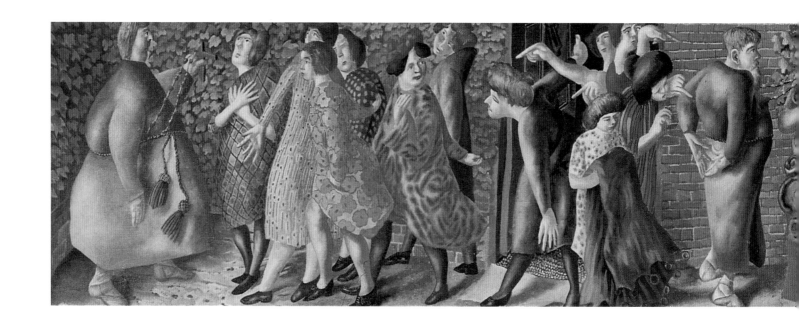

87 Promenade of Women,
or Women Going for a Walk
in Heaven 1938

Oil on canvas 45 × 230 cm
Bell 246
Private Collection

The 'Heaven' of the longer of the two titles, which was Spencer's first choice, is the village of Cookham at the Last Day, the period after the Resurrection. When Spencer painted the subject of 'love' for the interior of Church-House, it was often depicted as a variety of adoration. Although the pictures do not depict anything more than proposition, in his writing he makes clear that the scenes lead on to full sexual love. Here, he wrote that the women were in 'ecstasy upon seeing the crucifixes'. This is an unusually explicit association of love with religion, since most of the Church-House paintings were secular in subject.

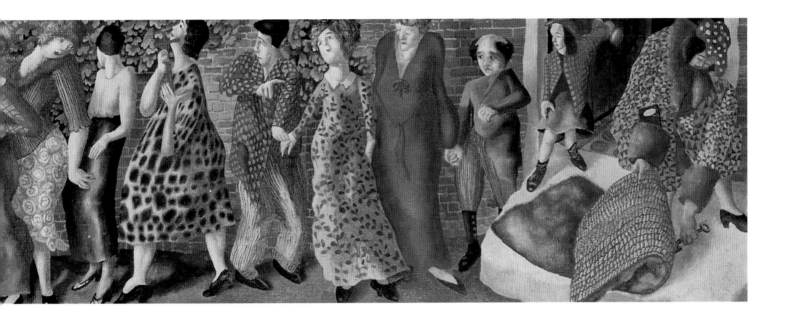

Spencer's motivation for this painting was in part the pleasure of visualising, at this period of dislocation in his personal life, the variety of women who appealed to him. He wrote of this picture in the year he painted it: 'I always felt a difference in people in feeling what they were like to me before they reached my door and the feeling of them after they had passed it and I wanted to convey this difference in this picture. On the left is one of the bringers of peace or celebrators of heaven holding out a crucifix to an oncoming group of 6 girls who are in an extasy of joy at looking at it. Then comes a number of women of the house standing in the doorway and watching the girls go by and pointing out who is who. Being Heaven it is not the least rude to point and no one is offended. The pointing is not done derisively but in admiration and pleasure. The green material with the rings on it is the awning that covers the front door to keep the sun off the paintwork. Then comes [a] piece of human heaven; by which I mean the next old man in the dressing gown with hands behind his back. [These] women are in an extasy of love for him and for the crucifix which they hold affectionately as being part of him … I had great joy in painting this going for a walk picture because painting each girl was like suddenly meeting them and talking to them and living with them … I have painted and emphasized the way I like their individual shapes and their differences. But none of this liking is from any physicologicle detached interest; but always from a passionate lust and directed [by] those instincts' (733.3.2.72–3).

DFJ

88 Taking in Washing, Elsie 1943–4

Pencil on paper 40.6 × 28 cm
Private Owner; on loan to the Stanley Spencer Gallery

89 Elsie Chopping Wood in the Coal Cellar c.1944–5

Pencil on paper 40.6 × 28 cm
Thomas H. Gibson

Both these drawings are from volume 2 of Spencer's *Scrapbook Drawings*; the titles are those inscribed by the artist on the back. Spencer was planning a Church-House 'chapel' in honour of his family domestic Elsie Munday, first employed in 1928 at Burghclere, and then at Cookham. In a letter to Hilda of 1929, he praises the 'appetite for life' of Elsie, bracketing her with 'the Preece girl'. Hilda's own masterpiece as a painter was her portrait of Elsie in 1930, and she would remain helpful both at Lindworth and in Hampstead for much of the decade. What Spencer was commemorating in the drawings is the presence of the young Elsie, and the 'attractions' he feels towards her. As he writes in 1930: 'I have the utmost respect for these attractions and for the Elsies that unwittingly cause them.'

In *Elsie Chopping Wood* , she is working alongside him in the coal-cellar, while in the foreground appears one of those 'disciples' who are a constant feature of Spencer's *Last Days* mythology: 'emissaries sent from me … just to show them what I feel about them' (Letter to Louis Behrend, 4 Nov. 1932, 733.882.5) Here the 'holy' man 'squats on an eggbox, looking up Elsie's skirt and spreading his own thighs in excitement'. (One could also relate the image of Spencer's early reminiscence: 'as I sat in the cellar or kitchen at Wisteria Cottage all by myself and imagined a young girl squatting in front of me such a profound feeling', Pople 1991, p.215.) To raise this desire to the level of an altarpiece in his temple of love, is to endow it with permanence and monumentality.

In another beautiful composition, also prepared for transfer, Spencer is on his knees by the garden fence drawing in a sketchbook, while the majestic Elsie plucks stockings from a clothes line. It comes as a doubletake to see rising up beside her, the ecstatic 'disciple', who is actually holding the basket of pegs.

TH/DFJ

90 Me and Hilda, Downshire Hill
*c.*1943–4

Pencil on paper 40.5 × 28 cm
Private Collection

Not exhibited

The *Scrapbook Drawings* were partly conceived
as illustrations to Spencer's autobiography, in
which his relationship with Hilda would have a
central place. This is one of a sequence, in
which she is depicted as a shapeless, vast,
umbrella-wielding grotesque – a comical
gorgon, alongside a tender, mild, submissive
self. (The entire series is reproduced in Carolyn
Leder, *Stanley Spencer: The Astor Collection*,
London 1976). The present drawing is squared-
up, and inscribed on the back: 'Hilda and I …
Hampstead/Panel of Hilda Memorial Scheme',
indicating its place in the Church-House. It was
indeed transferred to a four-and-a-half foot
high canvas, probably in the 1950s (Bell 1992,
no.449), though this remains unfinished.
Hilda's family, the Carlines, lived in Downshire
Hill, and this scene probably recalls the
protracted period of engagement when they
were 'walking-out' together. In the chapel, the
predella-panel below would have shown them
stretched out together, clothed, on a bed
(see Bell 1992, p.520).

TH

91 Flower Piece
(or Flower Decoration) 1939

Oil on canvas 76.2 × 50.8 cm
Bell 277
Private Collection – Courtesy Massimo Martino
Fine Arts & Projects, Mendrisio

Having survived his winter of seclusion at the
top of the house in Swiss Cottage, seldom
venturing outside, Spencer now painted this
odd explosion of cut-flower colour in the midst
of his bedroom. One possibility is that he has
been presented with this amazing bouquet in
honour of his forty-eighth birthday (30 June).
The picture may have been intended as a pot-
boiler, and was sold almost immediately. The
format of thirty by twenty inches is a favourite
of Spencer's. In one way or another, this picture
seems to signal his return from the wilderness,
to the world; and at the end of July he began
his life with the Charltons in Gloucestershire.

TH

92 Self-Portrait Nude 1938–9

Pencil on wallpaper 213.4 × 53.4 cm
Private Collection – Courtesy Massimo Martino
Fine Arts & Projects, Mendrisio

This is one of two extraordinary drawings at
over life-size. (The second, sadly unavailable for
loan, stands some eight feet tall.) Both the
scale and the nakedness have few precedents,
and they may be best understood in the
context of Spencer's solitary crisis in his Swiss
Cottage year, his 'wilderness'. The project of
naked self-exposure was central to Spencer's
life work, both as a painter and writer. This was
already clear in the *Leg of Mutton Nude*,
though his nakedness there appears abject. But
in the present drawing, of perhaps eighteen
months later, Spencer presents himself
stripped, without any association of sexual or
psychological humiliation. His own nakedness
is his 'tabula rasa', a place from which to begin
again his life and his art. It is as though,
standing before us, he is a kind of 'Ecce Homo'
figure (the words by which Pontius Pilate
presents Christ to the world: 'Behold the Man').
TH

93 Self Portrait, Adelaide Road
1939

Oil on canvas 76.2 × 50.8 cm
Bell 281
Private Collection, London

In jacket and tie, seemingly 'posing' with slim
sable brush in his hand, this has always
appeared in black-and-white reproduction as
one of Spencer's less sympathetic self-portraits.
Yet the effect of *Contre Jour* – of Spencer set
in darkness against the pale wintry gardens
of Adelaide Road – is dramatic, and the
expression of his red-and-black visage much
more uncertain than those preening hand-
gestures at first suggest. The gaze is frowning,
anxious, the eyes moist behind the spectacles,
the mouth close to weeping. The gesture of the
left hand could be compared to the male figure
in *Consciousness* (no.64) of a year earlier. It is,
like the naked wallpaper drawings from the
same months (see no.92), a confrontation with
the self at its most vulnerable – a true work of
wilderness.

TH

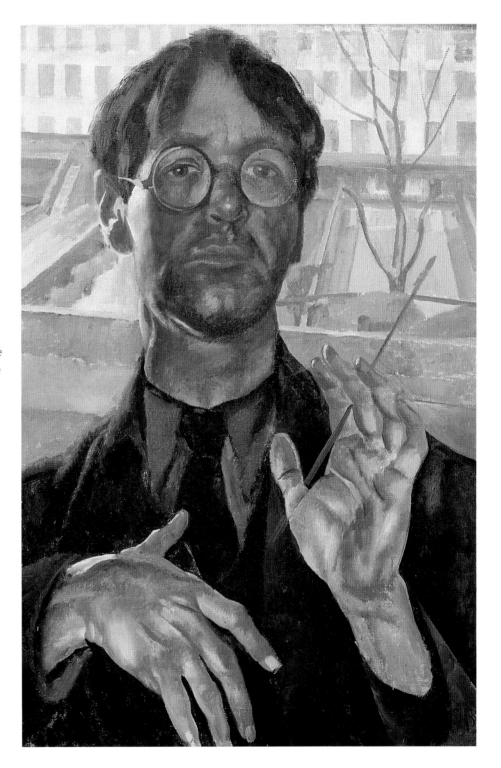

94 The Foxes Have Holes 1939

Oil on canvas 56 × 56 cm
Bell 283a
Collection, Art Gallery of Western Australia

95 The Scorpion 1939

Oil on canvas 56 × 56 cm
Bell 283c
Collection, Art Gallery of Western Australia

96 The Eagles 1943

Oil on canvas 56 × 56 cm
Bell 283g
Collection, Art Gallery of Western Australia

The six months that Spencer lived alone in the winter of 1938–9 were a watershed in his adult life. He was temporarily homeless after losing Lindworth, which he had made over to his second wife Patricia, and, with no possessions, he moved into a room in Swiss Cottage, at 188 Adelaide Road. His notes from this time suggest that he sought to take his painting in a new direction, to contrast with the paintings of crowded scenes with lovers and disciples that he had made for Church-House. Spencer had no studio, and was not able to work on a large scale in his room. He turned to the Gospels for a subject, and planned a series of small paintings presenting the 'forty days and forty nights' that Christ stayed alone in the wilderness, an episode that marks the break between childhood and adult life (Matthew 4:2). Elaborating this idea, Spencer gave an original personality to the young and solitary figure of Christ. The pictures referred to Christ's parables, many from the Sermon on the Mount, that emphasised his isolation from mankind and his closeness to animals and plants.

Spencer drew on one sheet of paper a group of single figures, all in a square format, and then developed some of these into paintings. He considered making all forty, and intended them for the ceiling panels of Church-House, which he imagined having square spaces between beams, like the choir ceiling of Cookham Church. In the end he painted eight, all but one of them by 1943, and the last in about 1954 (all now in the collection of the Art Gallery of Western Australia).

The text of the first painting comes from Matthew (8:20), where Christ laments, 'The foxes have holes and the birds of the air have nests; but the Son of man hath not where to lay his head'. The scorpions refer to the text 'I give unto you power to tread on serpents and scorpions, and nothing shall by any means hurt you' (Luke 10:19), in which Christ gives his disciples protection, not a fellow-feeling, as does Spencer. The last refers to 'For wheresoever the carcase is, there will be the eagles gathered together' (Matthew 24:28). The foxes are appropriate to someone who is homeless, but Spencer generally used the texts to give a feeling of sympathy with the flora and fauna. He is deliberately bringing himself to the level of nature, and unusually not in the context either of Cookham or of his family. He wrote of the scorpion picture 'although there are none about I feel this is Christ giving the once-over to the fleas and bugs and lice department' (Bell 1992, p.464). This sense of starting from the simplest insects suggests the figure of Christ-Spencer was also a Prodigal Son in exile.

DFJ

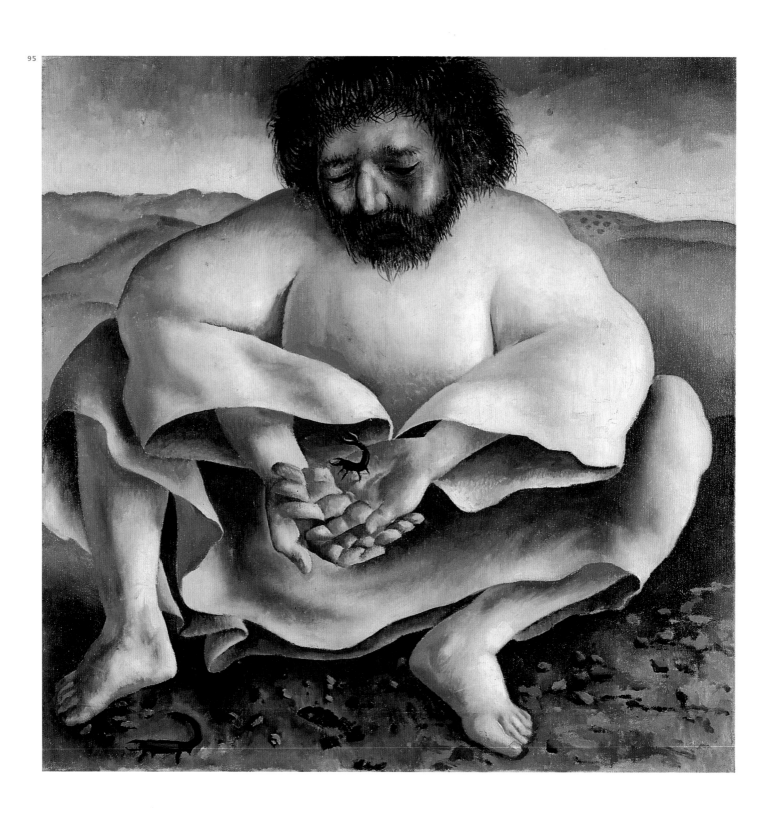

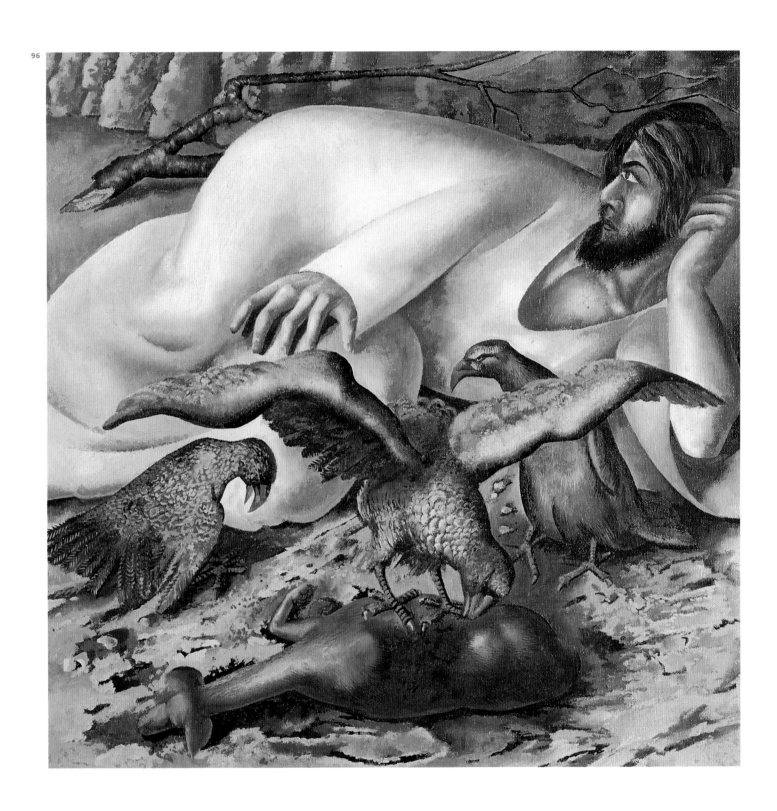

6 A WONDERFUL DESECRATION

The Second World War returned Spencer to engagement with the outer world, and to a more public art. Commissioned to record the process of building tramp-steamers in a Clydeside shipyard, Spencer conceived a sequence of 'altarpieces' which together would make up a frieze some seventy feet long. Once again he seems happiest in a format that implies endless extension, so that every figure takes on equal importance. The first two parts, *Burners* and *Welders*, were painted in sections in his small bedroom above a Gloucestershire village pub. Spencer makes us share his wonder at the infernal glare and dazzle of these industrial processes, bringing his 'mechanical' landscape eye to bear on all the detail of metal. The closest English art has come to Social Realism (and Spencer certainly knew about Diego Rivera's Detroit murals anatomising the manufacture of a Ford combustion engine), his shipbuilding cycle remains determinedly homely and non-heroic.

When Hilda suffered a mental breakdown in 1942, the shipyard project began to lose momentum. Spencer moved closer to her, living first in Epsom, then back in Cookham. His autobiographical exploration intensified in letters and scrapbook compositions. During an extended stay in Glasgow he began a new affair with Charlotte Murray, a German-born analyst trained by Jung in Zurich. Some contact with Jungian psychoanalysis continued throughout the remainder of his life. Spencer's later religious paintings are full of compositional invention and interest, but disappointingly dessicated in paint handling. In this exhibition, we have selected only *The Raising of Jairus's Daughter*. The twenty-two foot *Resurrection, Port Glasgow* has recently been prominently shown in the opening hang of Tate Modern, while the unfinished *Christ Preaching at Cookham Regatta* remains permanently on exhibition at the Stanley Spencer Gallery in Cookham.

By contrast, several much smaller paintings, made on the spot, retrieving and 'redeeming' places normally unregarded, are extraordinarily compelling. As he writes, 'I am always taking the stone that was rejected and making it the cornerstone in some painting of mine.' At the core of his vision is the belief that every material thing, however insignificant, will ultimately be redeemed. To paint *The Scrapheap* or *Goose Run* is to enact a kind of resurrection.

Love Letters, Spencer's last great couple-image, is based on a drawing made at Burghclere, but now charged with the thousands of pages that had passed in those intervening years between himself and Hilda. Designated as the altarpiece for the Church-House Hilda chapel, the image presents them together as eternal children, though she was now dying of cancer. Spencer's later work shares with Bonnard, Munch, Chagall, Beckmann and several other twentieth-century painters (though not with any of his English contemporaries) a quest to understand the self, not only in the self-portraits, but in such autobiographical narratives as *Hilda and I at Pond Street* (no.111). In his continuing correspondence with the dead Hilda, he reaches for a kind of maturity; he writes of their love as having been 'a wonderful desecration of most of the childhood hopes because it is sexual and non-innocent but it *is* grown-up'. At the end of a notebook of 1957, he imagines them walking together through an allegorical landscape: 'we scramble our way ... to get to the various blind alleys of our love ... the sky says I want rain and the grass says tread on us, watch us, look at us, be with us. The land spreads for us to walk on. It is all for us.'

Spencer's last words – written, since he was unable to speak – were 'sorrow and sadness is not for me'.
TH

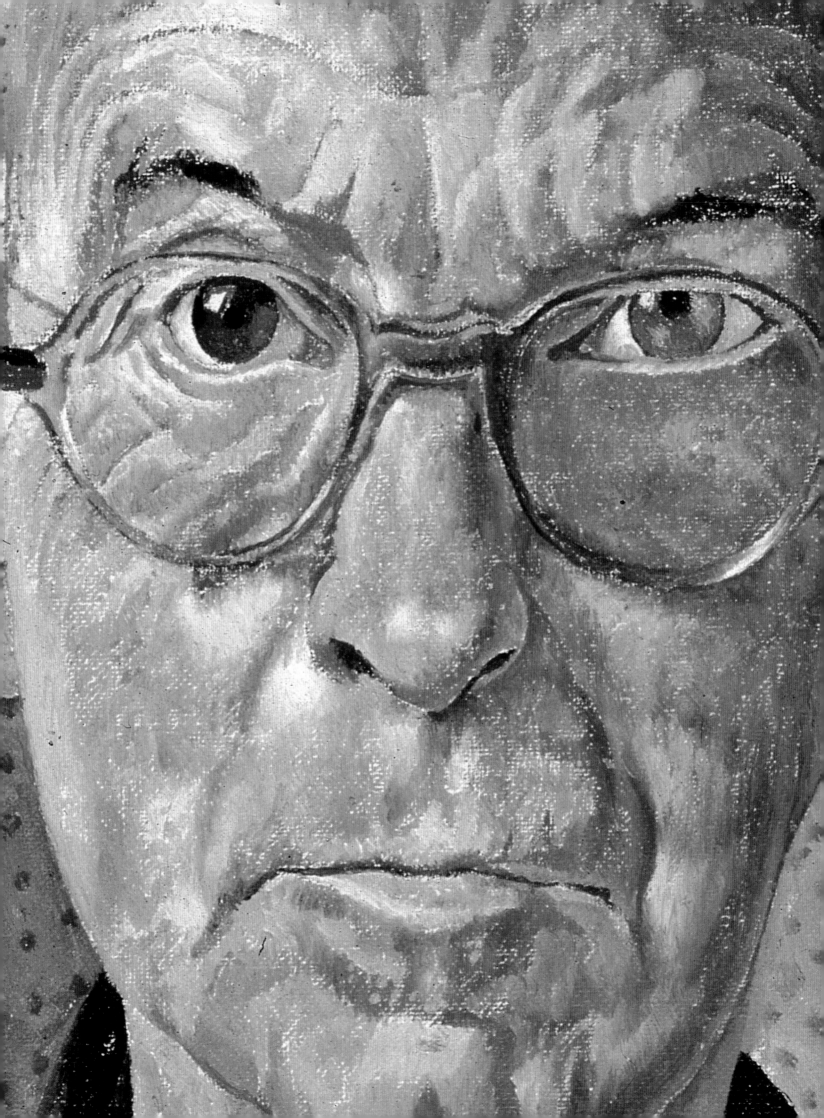

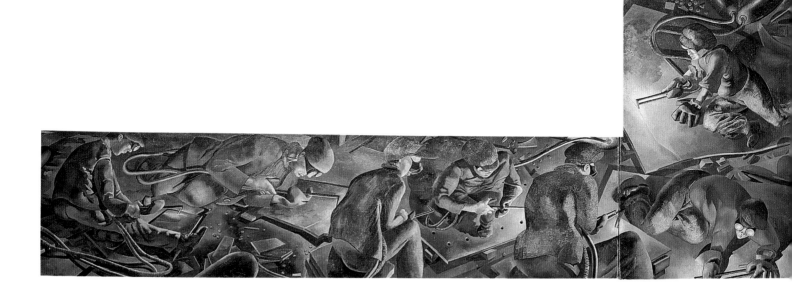

97 Burners 1940

Oil on canvas Centre 106.7 × 153.4 cm
Each side 50.8 × 203.2 cm
Bell 328b
Imperial War Museum, London

In March 1940, only six months after the outbreak of war, the War Artists' Advisory Committee, chaired by Kenneth Clark, invited Spencer to record the war effort by focusing on the shipbuilding industry. *Burners* was the first of the shipbuilding works to be completed and was based on drawings made in May 1940 in Lithgow's shipyards on the Clyde at Port Glasgow, which Spencer submitted to the WAAC. On viewing these drawings they made a commitment for a total of five paintings, for which Spencer was to

be paid £300. (The WAAC had originally only offered £50 for a shipyard scene, which was well below the commercial prices Spencer's work was then achieving.) Spencer began in July and worked with such eagerness that by the end of August the painting was complete and was sent to London to be exhibited in October at the War Artists' Exhibition at the National Gallery.

In *Burners*, the men are shown viewed from above, isolated by the geometric shapes of the steel plates they are working on.

Their job was to cut these plates with oxy-acetylene torches, following the complex chalked lines which the shearing machine could not manage. In a letter from Spencer to Elmslie Owen, he commented: 'In this burners painting I have treated the burners as a series of decorative figures because of the interesting variety of positions they naturally assume' (November 1942, Imperial War Museum). As with all the canvases, the strong pattern of the composition allows for a sense of unity despite the complexity of the shapes created

by the men and the metal panels. The warm tone of the colours conveys the sensation of heat and light. In the central panel, which is the focus of the work, the decorative element is enhanced by the way the steel plates are laid out as if petals. The figure in the top right-hand corner of the central panel can be read as Stanley himself.

KS

98 Plumber, Carrying a Pipe 1945

Pencil on paper 56.8 × 20.6 cm
Imperial War Museum, London

This study for *Plumbers* depicts a worker
carrying a bent section of pipe on his shoulders.
The plumbers would bend the pipes by first
filling them with sand (to support the metal),
heating them, then emptying out the sand.
This particular figure does not appear in the
subsequent painting, which was completed
by March 1945.

KS

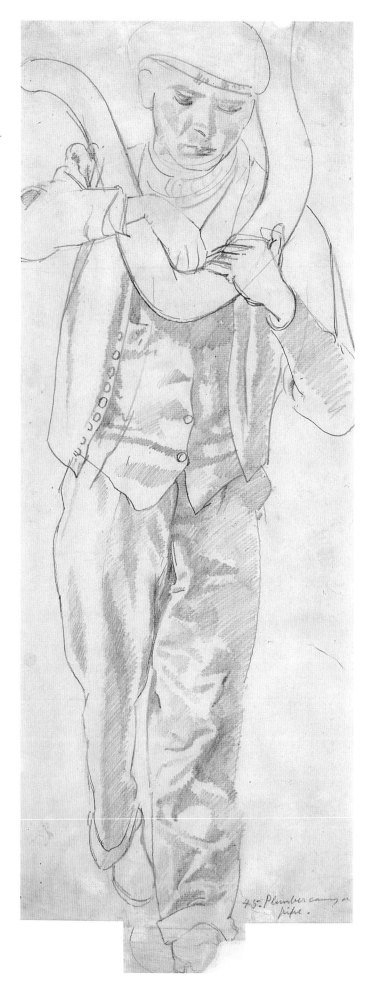

99 Self for Welders 1940–1

Pencil on paper 50 × 36 cm
Imperial War Museum, London

The sketch of himself for *Welders* (no.100) shows Spencer's close identification with his subject and the people working around him. This is the only explicit self-portrait drawing in the *Shipbuilding* series, although it seems likely that Spencer used himself as a model for some of the other figures. This was in part because he often gave away the portrait studies to the sitters, writing that he gave away nine of the best drawings he did of people so that he only had five left (Spencer-Moodie correspondence, 6 October 1943, Imperial War Museum).

KS

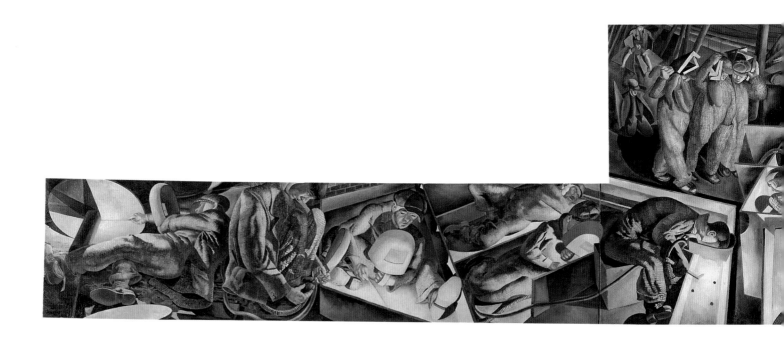

100 Welders 1941

Oil on canvas 50.8 × 580.7 cm
Bell 328c
Imperial War Museum, London

Welders was intended as a companion piece to *Burners* and was finished in March 1941. Unlike other skills in the yard, welding was a new invention. By the time of the Second World War it had superseded most riveting since it was quicker and produced a watertight join. It was also less labour intensive, needing only one welder rather than three or four riveters. The welder's job was to bond the plates

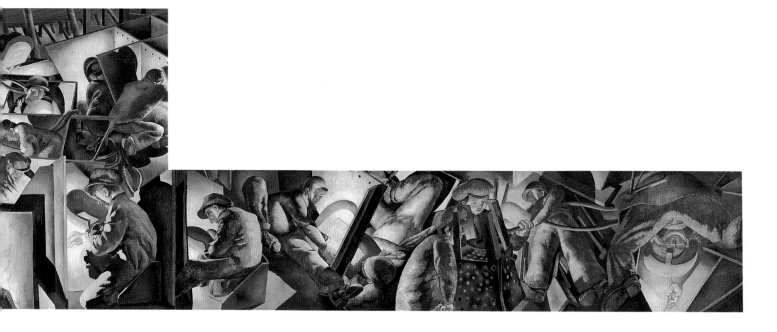

together in prefabricated sections before they went down to the building berth. The box-like shapes in the painting were to form the double hull of the ship. Since less physical strength was required, welding was one of the jobs that women could do, yet although Spencer had sketched many women welders, none of them appeared in the painting.

To a greater extent than in *Burners*, each man is separated from the others by the metal section he is welding. The way the figures are crowded into the shaped canvas, and the contorted positions they assume, reflect their working conditions. The foreshortening of the figures in the painting and the intense white light from the torches makes this work one of the most dramatic in the series. The figure with his back to us in the bottom centre of the painting can be read as Stanley himself. This demonstrates that he saw himself, not as a detached observer, but as an individual closely involved with the war effort. He viewed his work at the shipyard as a collaboration with the workers and later campaigned for his completed works to be exhibited specially for the shipbuilders.

KS

213

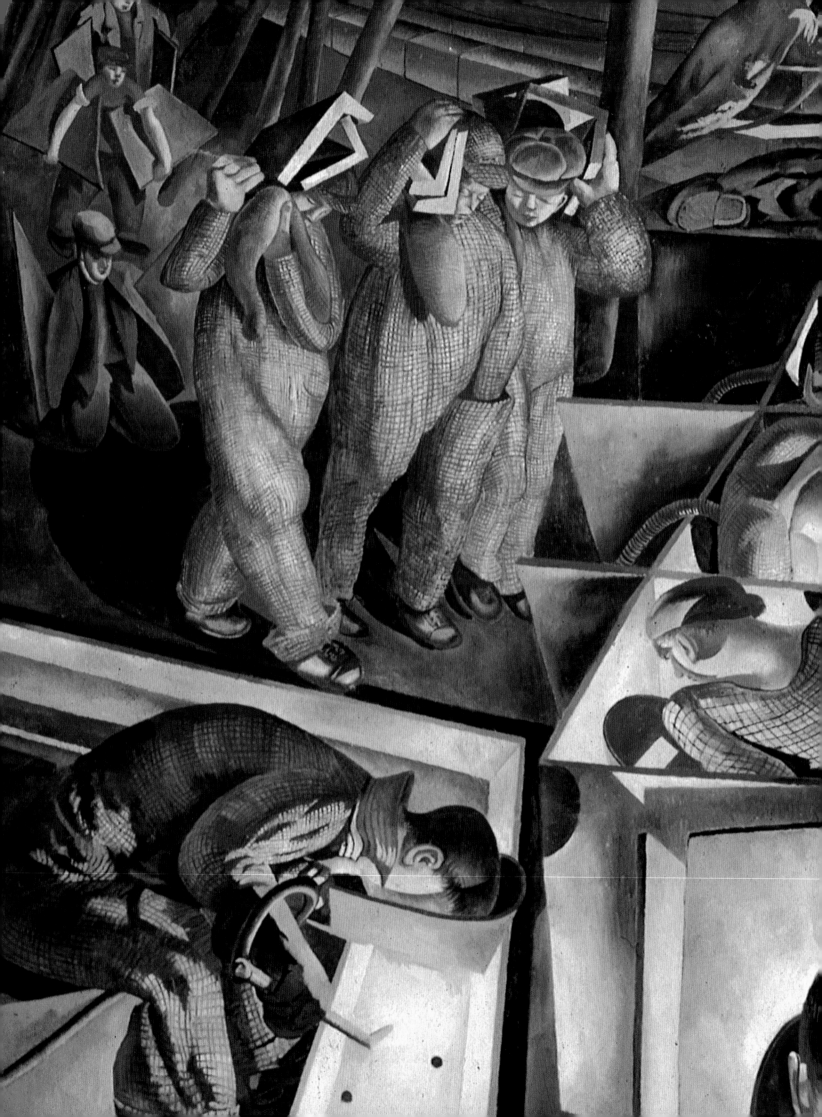

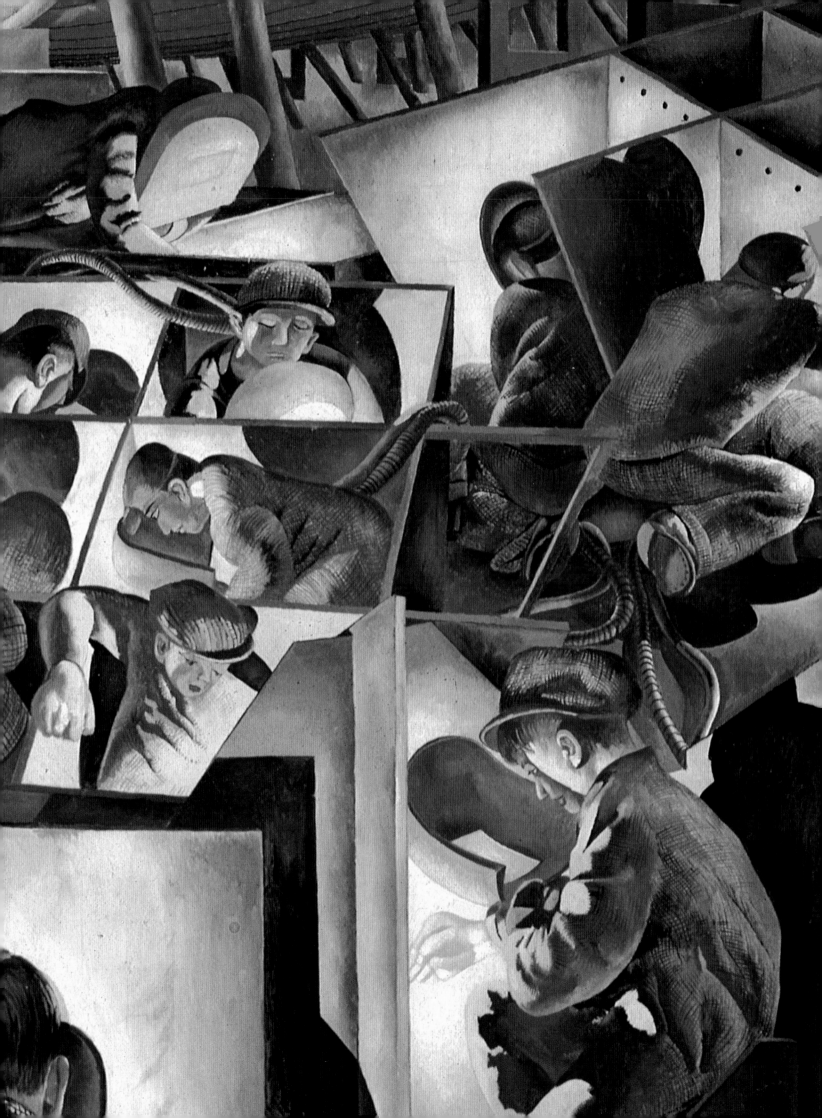

101 Compositional Sketch for Furnaces 1940

Pencil on paper 49.7 × 35.5 cm
Imperial War Museum, London

This drawing is a study for *Furnaces* (1946), the last shipbuilding work made by Spencer, which was intended to be the central painting in the series. Spencer had planned to paint three other Furnace paintings, but by 1946 he had become engrossed in the Resurrection series. The study is squared, ready to be transferred to full size on the canvas. It shows the men working in unison to pull out a section of angle iron from the intense heat of the furnace. The furnace provides the central focus for the work and in the painting this effect is enhanced by the dramatic depiction of intense light and heat emanating from it, casting the men into shadow.

KS

102 Lunch Break in a Propeller
1940–2

Pencil on paper 55 × 75.5 cm
Imperial War Museum, London

Spencer wrote of his desire 'to do some
drawing of the women folk especially as
hereabouts they still carry their babies in the
style where the shawl is wrapped tightly round
themselves and the baby for support'. In this
drawing the women and children are delivering
lunch to workers who sit on the blades of a
large propeller. Since children would not have
been allowed in the shipyard (for obvious safety
reasons), it seems that Spencer created this
scene in order to represent the workers' lives
beyond their daily jobs. The figures of a mother
and child feature in *The Template* (1942) next
to a worker who tenderly strokes the baby's
cheek.

KS

103 Cable on a Truck 1940–1

Pencil on paper 37.7 × 75.6 cm
Imperial War Museum, London

This working drawing for *Riveters* (1941) shows
Spencer's fascination with the abstract qualities
of the materials around the shipyard. The
workers are dwarfed by the metal chains and
the effect is almost cartoon-like – the chains
appear to have a life of their own and threaten
to overpower the men. The three foremen in
bowler hats, a rare appearance of the
management in these works, will later appear
in the right-hand corner of the painting.

KS

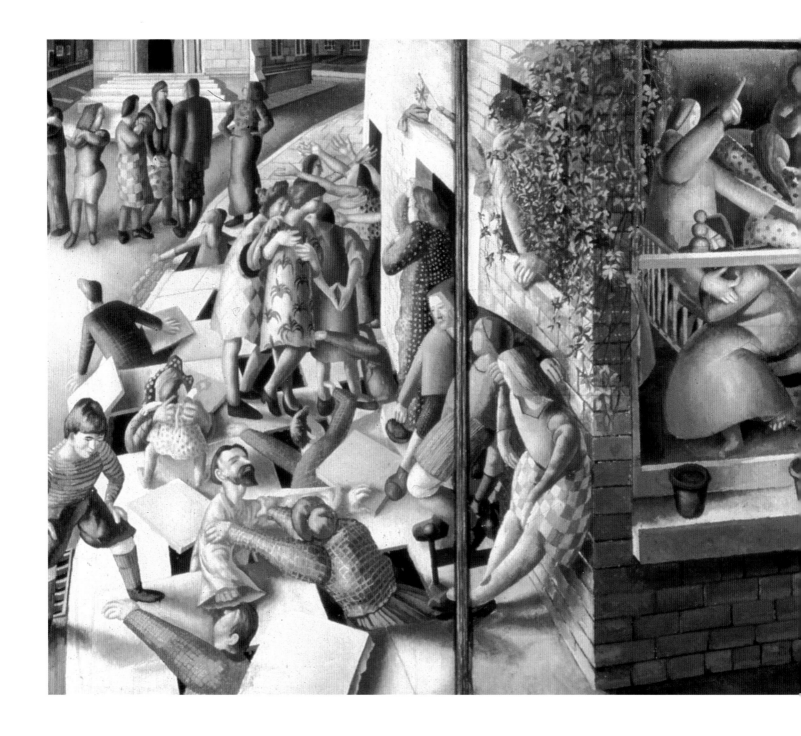

104 The Resurrection with the
Raising of Jairus's Daughter
1947

Oil on canvas Triptych, centre 76.8 × 88.3 cm,
Each side 76.8 × 51.5 cm
Bell 358g
Southampton City Art Gallery

Two resurrection scenes are set together in this triptych. The side canvases, which derive from *Scrapbook Drawings* made in the winter of 1939–40, show a modern resurrection in two ordinary streets. The central canvas is also set in a modern house, and was designed and painted with the whole triptych in 1947. It depicts a miracle from the Gospel of St Mark (5:21–43), the raising from the dead of the daughter of Jairus, the 'ruler of the Synagogue'. Jairus is still despairingly clutching a bedpost, unaware that behind him his daughter is being pulled by her hand to life by

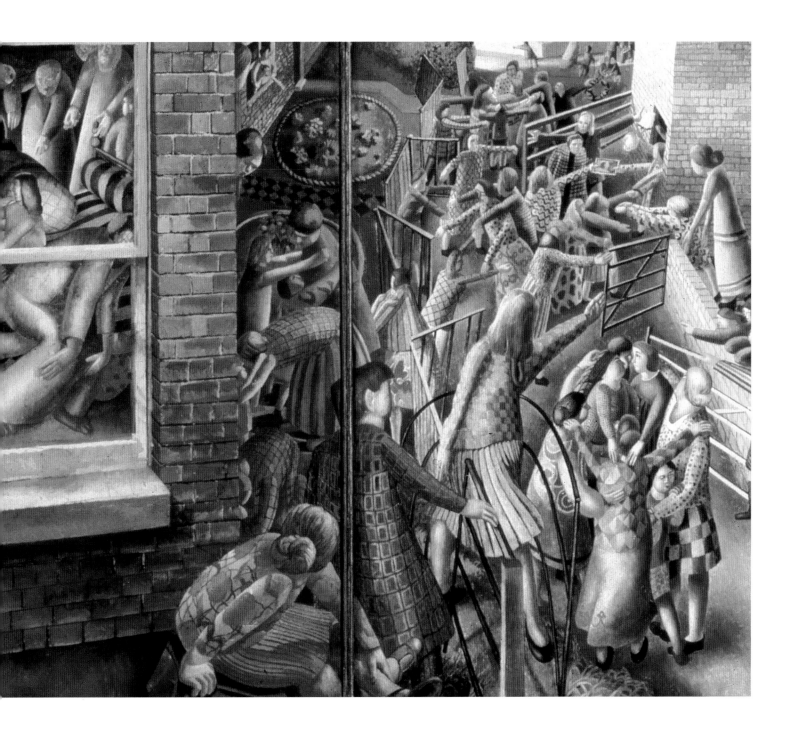

Christ, who points upwards. Those who had scorned Christ are pointing at the daughter with amazement. The three scenes are combined in a single town view.

The scenes at the sides were drawn in Gloucestershire, when Spencer and Daphne and George Charlton were staying in the village of Leonard Stanley, near Stroud. He noticed on the wall of his lodging a framed photograph of Stonehouse church, where his landlady's daughter had been married. The church was circled by streets, like the one in the top left of the painting, and Spencer immediately thought of the dead at the resurrection emerging from their tombs through the pavement. There are flags over the doors to welcome the dead back to their houses, as had happened at the end of the war to welcome soldiers returning home, something that was again in people's minds at the beginning of another war (Wilenski 1951, p.20).

The triptych was painted at the same time as a series of paintings of resurrections set in Port Glasgow, all of them destined in Spencer's mind for display in a chapel of their own.
DFJ

105 The Scrapheap 1944

Oil on canvas 50.8 × 76.2 cm
Bell 317
Collection: Art Gallery of New South Wales –
Gift of the Contemporary Art Society, 1944

The culminating work of all Spencer's
explorations of 'dirt' – of the discarded – this
extraordinary image was almost certainly
painted in the Lithgow Shipyard at Port
Glasgow. Much of the previous three years had
been spent depicting the precise qualities of
burnished, pristine metal in his *Shipbuilding on
the Clyde* series (though all were actually
painted from memory, drawings and
imagination back in his various South-of-
England bedroom studios). Now, in an
extended visit to the yard, he set up his easel
and applied his more 'dogged' landscape
procedure to this pile of insignificant forms.
The result is a kind of transubstantiation – a
completely unexpected beauty. The brightness
of the active broken heap is contrasted to the
rust-and-grey, more structured piles that fill
most of the picture. And above, floating off to
the left, raising all to a kind of fantasy, is the
graffito of a three-funnelled boat on a sea of
black corrosion, flag flying at stern.

TH

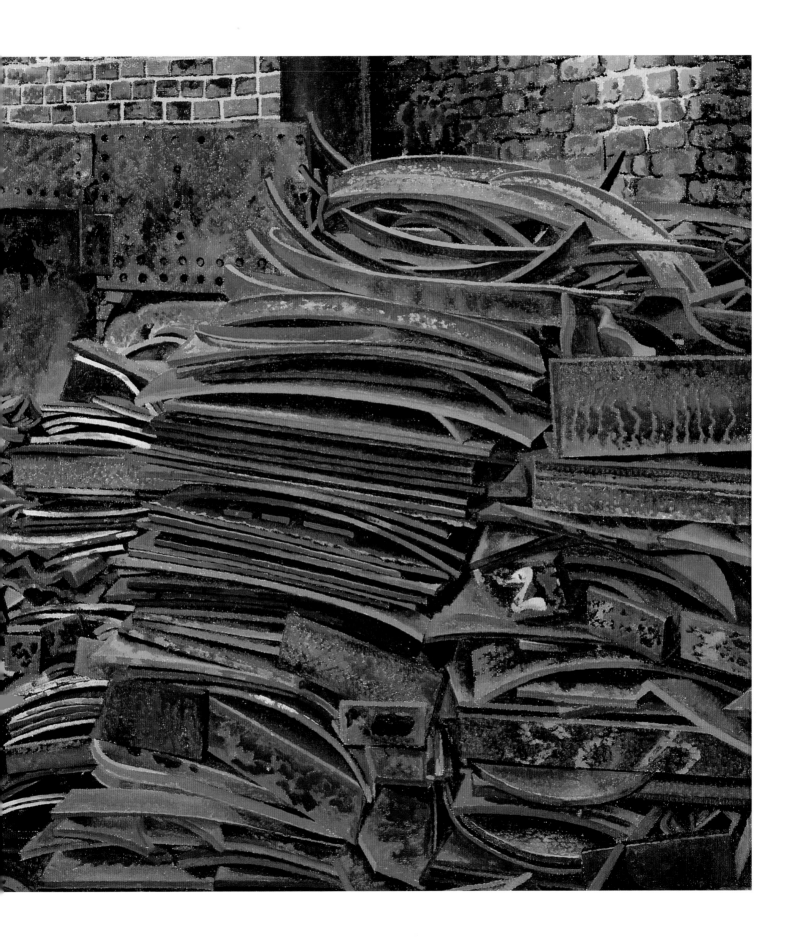

107 Goose Run, Cookham Rise 1949

Oil on canvas 76.2 × 50.8 cm
Bell 344
Private Collection – Courtesy Massimo Martino
Fine Arts & Projects, Menrisio

In the summer of 1945 Spencer moved into a
small house in Cookham Rise, 'Cliveden View',
that had belonged to his grandfather, and
which his older sister Annie had recently left.
This local view of rubble and dilapidated
garden sheds, a kind of no-man's land between
properties, is a contrast to the more
commercial landscapes of the village gardens
which made up most of his first exhibition since
the war at Tooths in May 1950. He was then for
the first time free of worries about money. His
pictures were selling, and it cannot be the case
that he was painting landscape for commercial
motives only, as he at times had claimed. A
review of the Tooths exhibition suggested that
Spencer 'loved the place so much that every
nook and corner seemed equally thrilling to
him and he must record it in minute detail'.
DFJ

106 The Farm Gate 1946

Pencil on paper 40.6 × 28 cm
Private Collection; on loan to the Stanley Spencer Gallery

The subject of this *Scrapbook Drawing* reverts
to an early memory of Cookham, as Stanley
hooks open the gate to Ovey's farmyard,
opposite Fernlea in the High Street. A figure
of Hilda keeps the gate open as the herd of
cows goes in. Spencer made a painting from
this drawing in 1950 which he gave to the
Royal Academy as a diploma painting on being
elected an Academician in the same year.
The work was also part of the scheme for the
imaginary Hilda chapel at Church-House.
It stands for the association of Hilda with the
familiar countryside routines of the village, as
well as with the imagery of coupling
appropriate to her engagement to Stanley and
their early life together.
DFJ

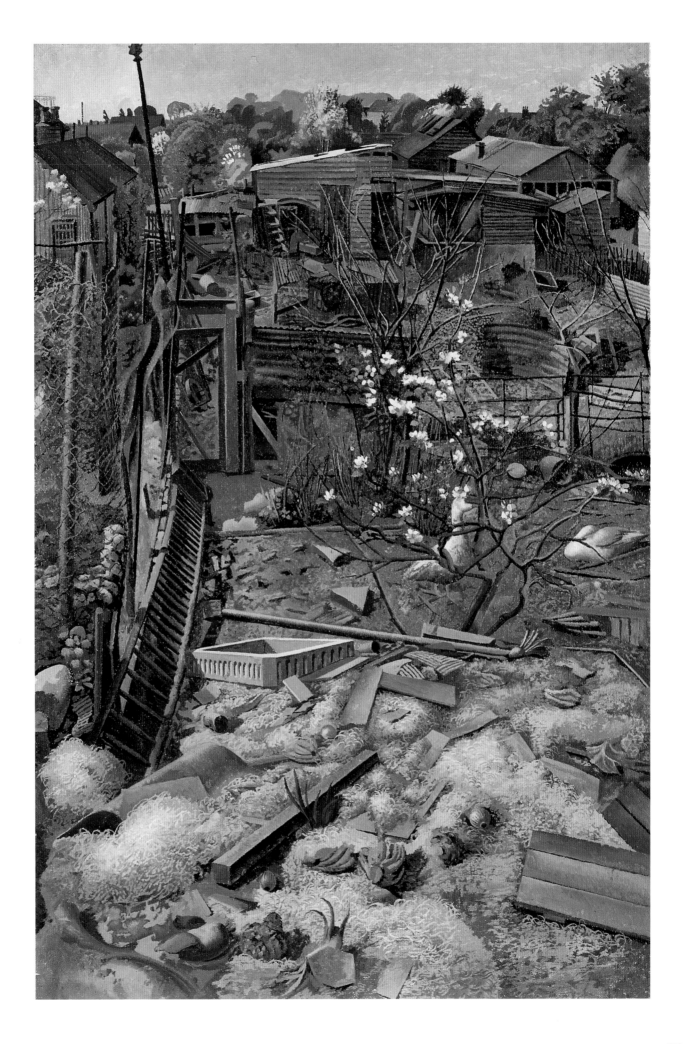

223

108 Merville Garden Village near Belfast 1951

Oil on canvas 59.5 × 91 cm
Bell 369
Collection of the Dunedin Public Art Gallery.
Purchased 1952 with funds from the Dunedin Public Art
Gallery Society and the National Arts Collection Fund

Harold Spencer, one of Stanley's elder brothers,
a musician, lived in Northern Ireland. Spencer
stayed there and painted several portraits of
Harold's daughter Daphne in 1951, 1952, and
then again twice in 1953. On his first visit he
also painted this view near his brother's house
in the Garden Village at Whitehouse, beside
the Lough near Belfast. The flats in Merville
were new, and had been completed in 1949. It
was the first Garden Village in Northern Ireland,
and the architect E. Prentice Mawson followed
French and English modernist designs. The area
enclosed a pre-existing garden behind older
walls, and Spencer chose to paint this contrast
of old and new. It is a view that swivels around
a wide angle, with the street on the left,
beyond the red post and telephone boxes,
leading to more conventional housing.

DFJ

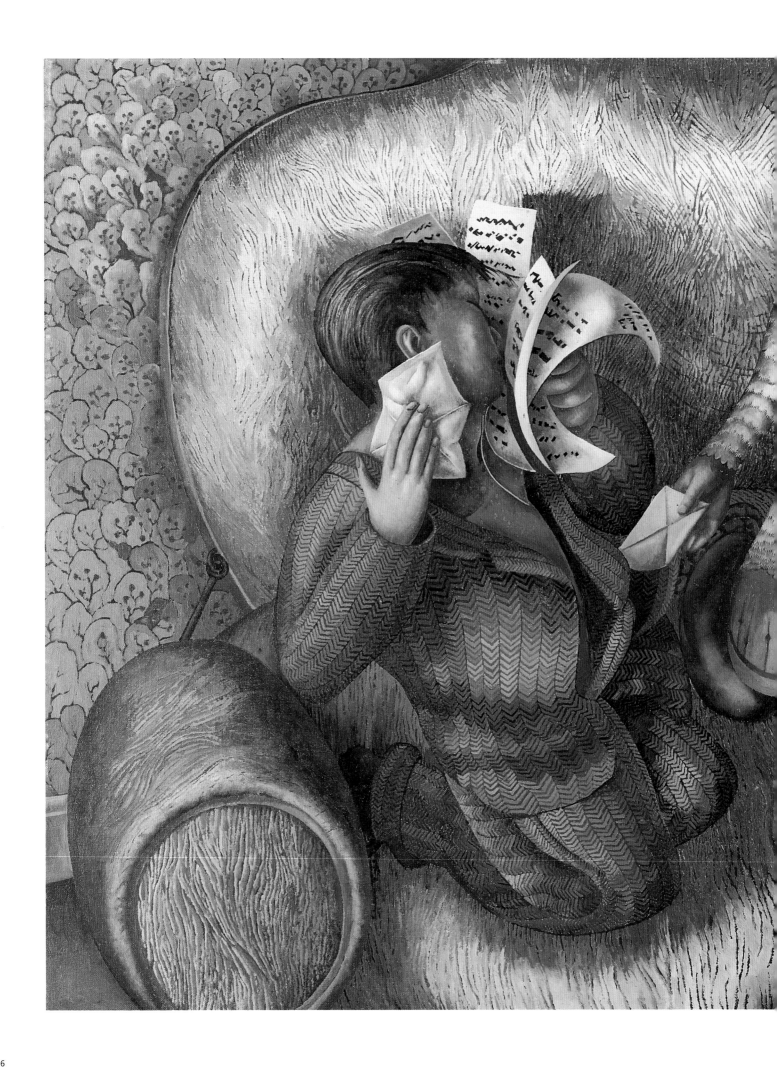

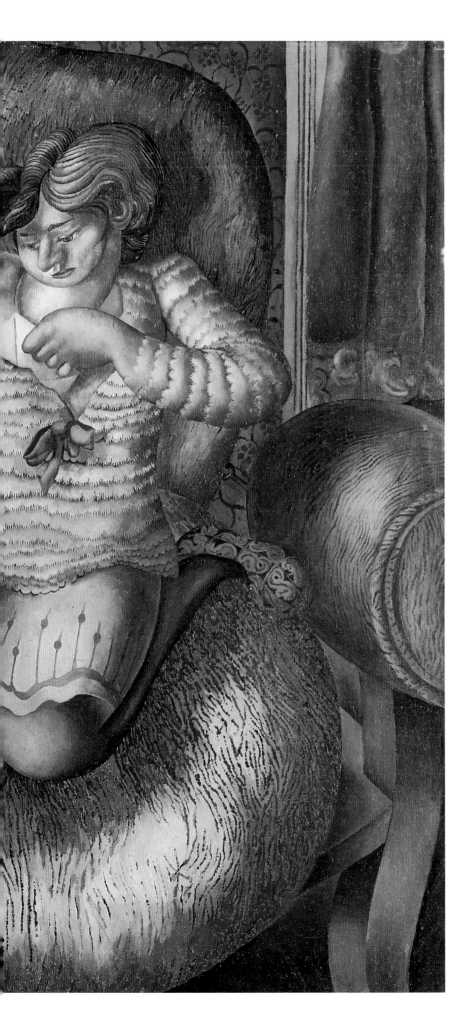

109 Love Letters 1950

Oil on canvas 86.4 × 116.8 cm
Bell 359
Thyssen-Bornemisza Collection, Lugano

Spencer finished *Love Letters* shortly before Hilda died in November 1950. He had visited her often in Hampstead and in hospital, and for the last few years of her life he had hoped that they could marry again. From 1950 he began a series of paintings that proclaimed their closeness, which Spencer imagined displayed in a Hilda Chapel in Church-House. *Love Letters* was planned to be the central altar-piece. The composition first occurs in a sketch he drew in a letter to her of 1930 (fig.27). They had often written letters to each other when they were living together, sometimes writing them side by side, and then reading them out loud to each other.

The figures seem lost in a huge chair (in which Spencer characteristically notes how the hinging device worked), where they squat in their bedroom slippers, becoming in scale like children. It is not the verbal content of the letters, but their transfer from her bosom to his lips, with the implicit appeal to the senses of touch and smell, that is the subject of the painting, and for the sake of which Spencer closes his eyes.

DFJ

110 Self-Portrait 1951

Oil on canvas 38 × 27 cm
Bell 364
Private Collection

Painted in his small studio at Cliveden View a
few months after Hilda's death, with his sixtieth
birthday approaching, this is the most subtle
and reflective of all Spencer's self-portraits. In
the 1940s his mistress in Port Glasgow,
Charlotte Murray, herself trained by Jung in
Zurich, had put Spencer in touch with other
analysts in the South. Keith Bell writes
perceptively of how this and other late self-
portraits convey 'a balanced, if serious, idea of
self' which may have been achieved with the
help of the psychoanalyst Dr Karl Abenheimer
(Bell 1992, p.364). The sagging vest (Spencer's
favourite garment) might imply solitude or
destitution; yet the thoughtful tilt and
searching gaze, along with the modest scale,
do suggest a man who has come to terms with
his demons.

TH

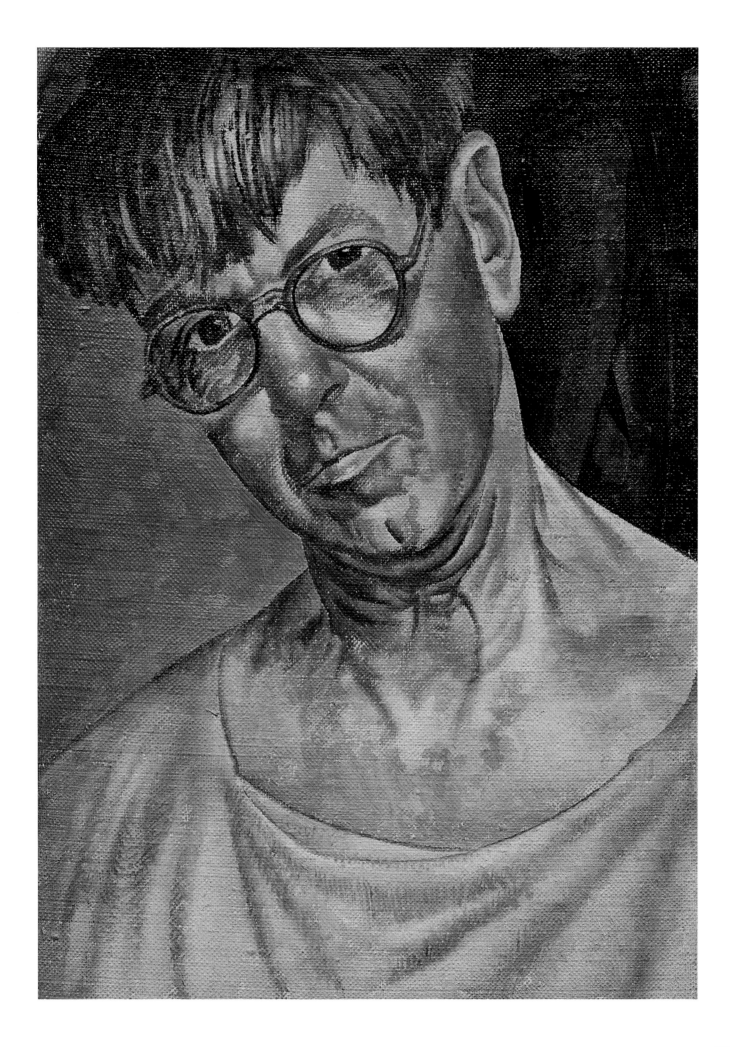

111 Hilda and I at Pond Street 1954

Oil on canvas 50.8 × 76.2 cm
Bell 391
Collection Museum of Contemporary Art, Chicago,
Promised gift of Mary and Earle Ludgin Collection

After the separation of Stanley and Hilda
Spencer in 1934, Hilda returned to her family
in Hampstead. In 1937 the Carlines moved to
17 Pond Street, where Hilda was able to have
larger rooms for herself and her younger
daughter, Unity. She remained living there
until her death from cancer in 1950.

Spencer visited her often, especially during
her illnesses, and after her death he continued
to write letters to her in his notebooks. He also
painted a series of imaginary double portraits
of them which he intended for the 'Hilda
Chapel' in Church-House. Hilda leans back
against cushions, still in pain after her return
from hospital. Stanley kneels on one knee
beside her, looking younger than he was at the
time, and wearing a check suit like the costume
of a harlequin. He takes a huge spray from
a florist's box, the box itself as large as a coffin
and lined with tissue which resembles a shroud.
As he holds the flowers, they seem to caress
Hilda's body, and to offer their scent to her to
smell. He holds his extended left hand over her
head, with thumb and fingers spread out,
as if to bless. The posture is unusual, but is
explained by his first drawings for this group.
He had first designed the painting with an
'archangel' positioned beside Hilda, whose
outstretched arm suggests that he was
visualising this in the guise of a traditional
Annunciation of the Death of the Virgin.
DFJ

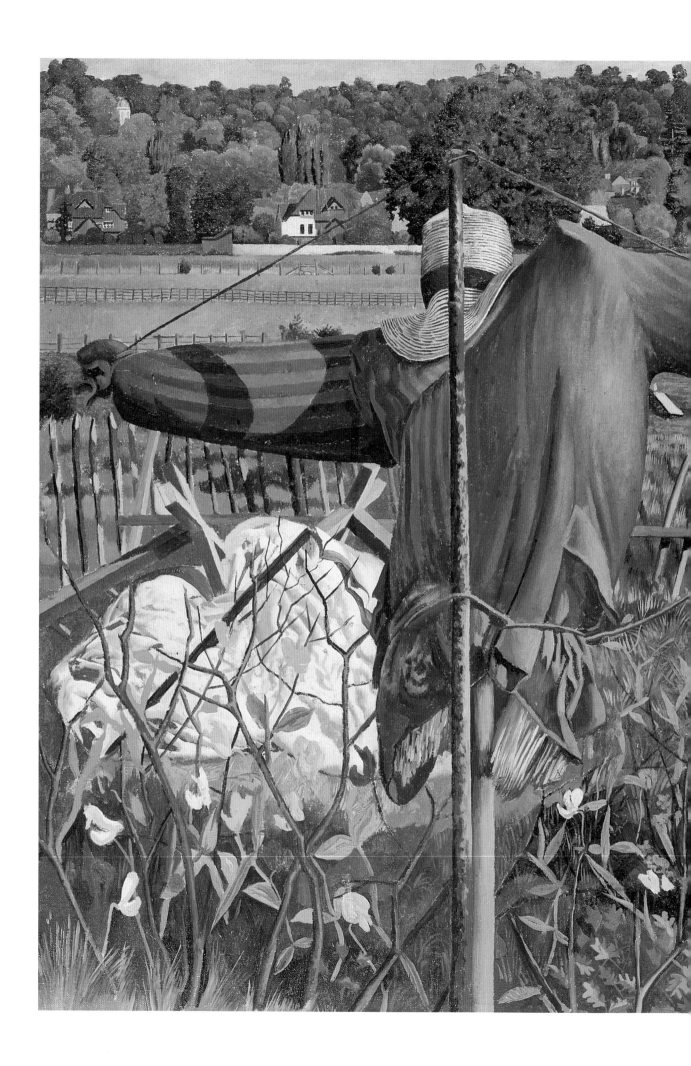

112 The Scarecrow, Cookham 1934

Oil on canvas 70 × 75 cm
Bell 160
Private Collection

This scarecrow hanging from an iron pole looks unusually disturbing in comparison to the more straightforward landscapes of Cookham that Spencer painted during the summer months of the 1930s. He noticed the scarecrow beside the garden of Rowborough House near Cookham Rise, where he had gone to paint the view from the hill, looking across the gardens in flower. In this painting the scarecrow itself fills the whole canvas, standing in an abandoned plot of land used as a dump, with a view beyond towards Cookham and Cliveden Woods. It resembles a crucified figure, as if this garden were at some Golgotha on the edge of the village. Spencer may have been referring to the sacrifice made by soldiers who had died in the war, as he carefully included the Cookham war memorial in the picture, just visible to the right. He wrote that the scarecrow appealed to him particularly as it had been abandoned to decay: 'Left and deserted … it was like a person slowly changing into part of nature' (733.3.37, quoted by Bell 1992, p.432). The Christian implication of the subject was made explicit when he was commissioned later in 1934 to paint a Crucifixion. For this slightly larger painting he added figures in the foreground, and turned the scarecrow into the body of Christ, keeping the posture the same. This painting became the basis of Spencer's final *Crucifixion* of 1958 (no.113).

The painting was one of three by Spencer that the Royal Academy displayed in the summer exhibition of 1935, where his separated wife Hilda and his brother Gilbert were also exhibiting. It was the second time he had exhibited there after his election as ARA in 1932, but he resigned when two other paintings he also sent, *St Francis and the Birds* and *The Dustman (or The Lovers)* (no.78) were not accepted.

DFJ

113 The Crucifixion 1958

Oil on canvas 216 × 216 cm
Bell 441
Private Collection Australia, courtesy Richard Nagy,
Dover St Gallery, London

This is among the last paintings that Spencer completed, and the most violent in expression of his whole career. Christ is being nailed to a makeshift cross, while the two thieves are crucified at either side, and Mary Magdalen collapses at his feet. It is not the physical suffering of Christ that is shown, but the cruelty of his tormentors. Since the viewpoint is behind Christ's head, it is as if the spectator of the painting were also a victim. The faces of the two carpenters are made to look monstrous by the nails held between their lips. The greatest ferocity is in the face of the bad thief, who stares vehemently at Christ.

The painting looks the more threatening since much of it is homely. The scene is Cookham High Street, which Spencer had seen littered with piles of earth when it was being excavated for laying new drains. Spencer drew from memory the face of a local builder for the hammering figure on the left (see p.55), and used the figure of a man working on a telegraph pole for the figure in the background tying the wrists. The quite harmless actions of three workmen are made to reappear here in a new light, in a situation of extreme horror, while ordinary people do nothing, staring stupidly from their window.

Spencer's patron J.E. Martineau, who had already commissioned portraits of his family, was Master of one of the City of London guilds, the Brewers Company. He arranged for him to paint two altarpieces for the chapel at Aldenham School, Elstree, a Brewers' school. The subject was agreed with Spencer, who had just made several paintings of The Passion, and had already begun to design a Crucifixion. Many people went to see the painting when it was shown in Cookham church, but there was some criticism, and Spencer defended it in a letter to *The Times* (12 June 1958). At a talk about the picture at Aldenham School, Spencer explained that he had shown the carpenters wearing brewer's caps because 'it is your Governors, and you, who are still nailing Christ to the cross'.

DFJ

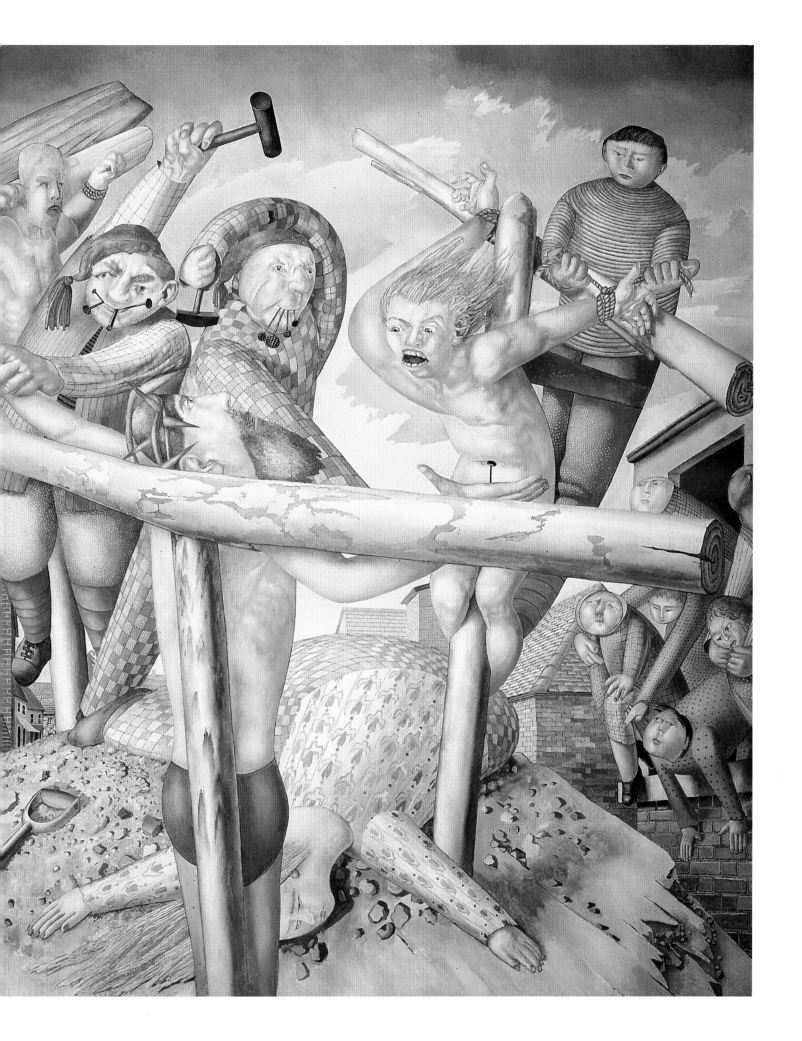

235

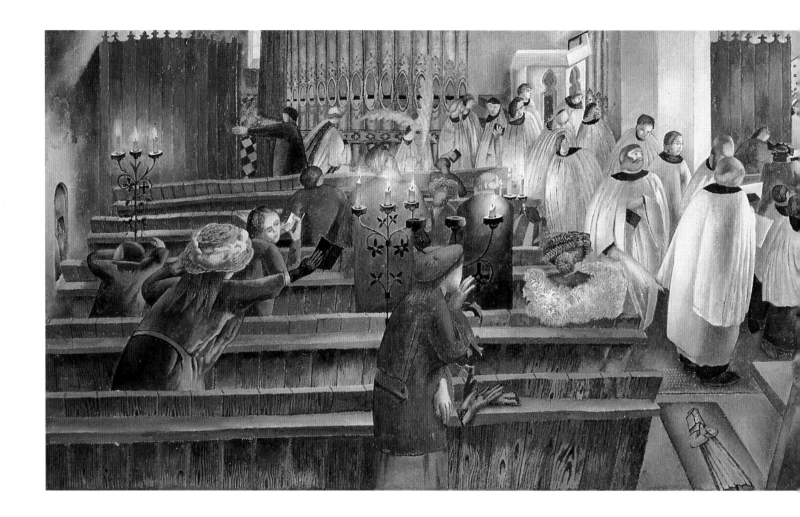

114 In Church 1958

Oil on canvas 61 × 21.6 cm
Bell 442
Private Collection Australia, courtesy Richard Nagy,
Dover St Gallery, London

This scene of a choir procession in church –
perhaps at Easter since there are two choirboys
at the end carrying flowery fronds – was
apparently drawn by Spencer as a recollection
of a service at Cookham which he had
attended as a child. It was intended to be
displayed beneath *The Crucifixion* (no.113)
as a predella.

DFJ

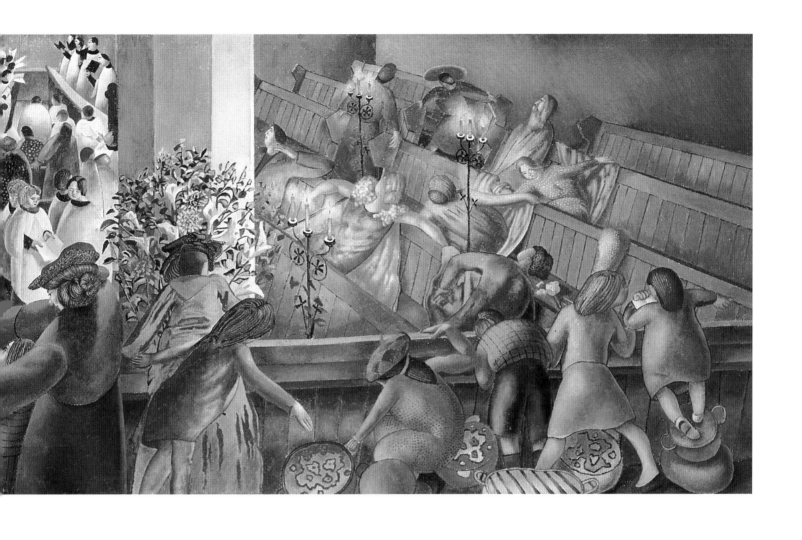

115 Self-Portrait 1959

Oil on canvas 51 × 40.6 cm
Bell 447
Tate. Presented by Friends of the Tate Gallery, 1982

Spencer's final self-portrait was completed
in five days over the summer of 1959
(12–16 July) when he was staying with friends
in Dewsbury, Yorkshire. He had been operated
on for cancer earlier that year, and probably
knew he was dying. Certainly the picture has
an air of a testament (perhaps consciously
intended as a counterpart to his similarly close-
up and frontal self-portrait of 1914, no.13) and
is a last *tour-de-force* of straight painting. The
gaze is so penetrating as to be discomforting,
the eyes appearing very different through
each spectacle lens, and each depicted in
a contrasted manner. But the paint-surface
all across the face is as brittle as a dry biscuit,
the stringy neck and wrinkled contracted brow
strongly emphasised. We see the back of his
head in the mirror behind against the very
bright-light source; and his white hair crisply
outlined against the wall's shadow. The dotted
pattern of the wallpaper establishes recession,
crowding to the left, thrusting the head
forward. The total effect is of a fierce, almost
defiant courage and truthfulness.

TH

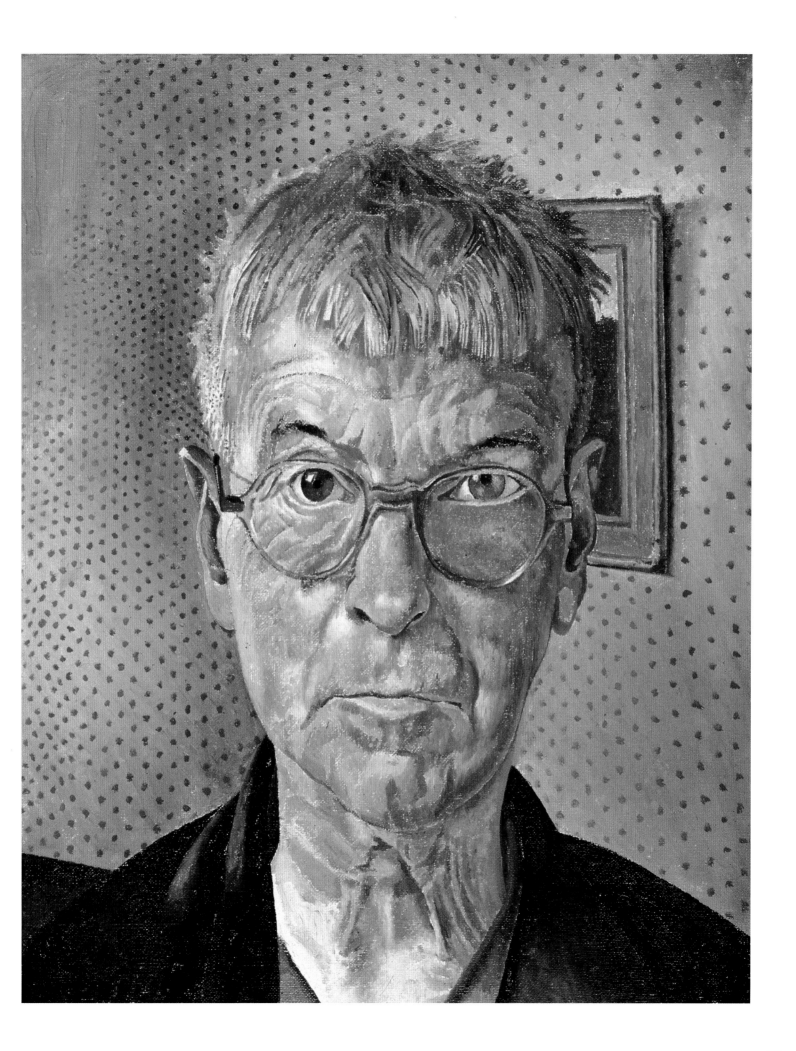

TIMOTHY
HYMAN

A NOTE ON BURGHCLERE

THE SANDHAM MEMORIAL CHAPEL 1927–32

The Burghclere commission provided the sole occasion when Spencer's lifelong aspiration, to create a cycle of imagery within an architectural setting, could be fulfilled. It needs to be seen *in situ*; but no account of Spencer's achievement can be complete without it.

Soon after leaving his posting at Beaufort Hospital (and despite what he called 'a most blighting atmosphere' there), Spencer began to see his humdrum duties as material for monumental painting. He wrote to Henry Lamb (4 July 1916): 'I wish I could do a picture of each different thing I had to do in the hospital, so wonderful in their difference.' And later, to Jas Wood: 'I am still thinking about the hospital, which the more I think about it, the more it inspires me. I am determined that when I get the chance, I am going to do some wonderful things – a whole series of big frescoes.'

In Macedonia he continued to translate everyday experiences into a projected cycle of imagery, and to make compositional and landscape drawings. (Almost all would be lost, apparently left behind in camp.) Frustrated by the impossibility of painting, he was nevertheless storing images and memories. 'This place has a great hold on my mind', he writes to Desmond Chute on 3 June 1918. 'Mountains and mule lines are all my thought'.

Yet though he completed *Travoys* (no.21) immediately on his return to England, and made a few drawings from memory (nos.19, 20), he refused the offer of further official commissions as a war artist. For several years, the war seemed an area his art could not accommodate. (Similarly, the German artist Otto Dix, Spencer's exact contemporary, who had fought in the trenches, would wait until

1922 before beginning work on the fifty etchings of *Das Krieg* (The War), his masterpiece.) Thus it was only in the summer of 1923 that Spencer at last brought together his Beaufort and Macedonian experiences, to draw out in pen and wash a virtually complete scheme for a Chapel of Peace (see fig.14). This would be built, with few alterations, by the Behrends at Burghclere.

The task was colossal, including eight seven-foot lunettes, a twenty-one-foot-high end wall (*The Resurrection of the Soldiers*) and, in some ways the most original of all, the irregular strips between lunettes and ceiling, each twenty-eight feet long. Although eventually dissuaded from his ideal medium of fresco, Spencer painted almost entirely on site, on canvas glued in place.

Burghclere already has seeds of his more problematic art of the 1930s. There are sudden shifts in scale, as in *Map Reading*, where a snoozing foreground figure has one leg almost twice the size of the other. Already the humourous dimension is strong, though with no loss of dignity. And those upper strips, fields full of imagery without end or beginning, anticipate the processional predella formats of *Love Among the Nations* and *Welders* and *Burners*. Spencer himself saw his work as a kind of excorcism, freeing him from the shadow of war: 'The Burghclere memorial redeemed my experience from what it was, namely something alien to me. By this means I recover my lost self.'

fig.55
STANLEY SPENCER
The Camp at Karasuli 1930

Sandham Memorial Chapel,
Burghclere

fig.56
STANLEY SPENCER
Reveille 1929

Sandham Memorial
Chapel, Burghclere

fig.57
STANLEY SPENCER
Dug Out or *Stand To* 1928

Sandham Memorial
Chapel, Burghclere

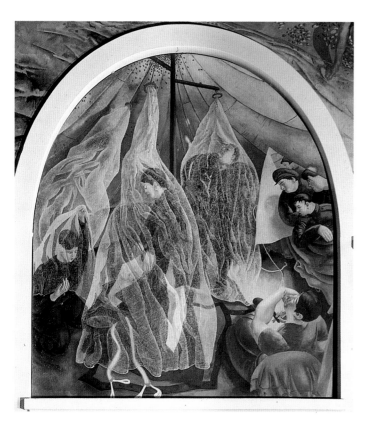

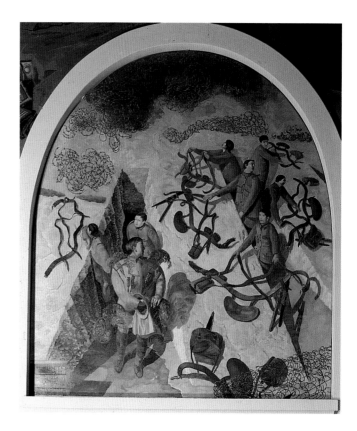

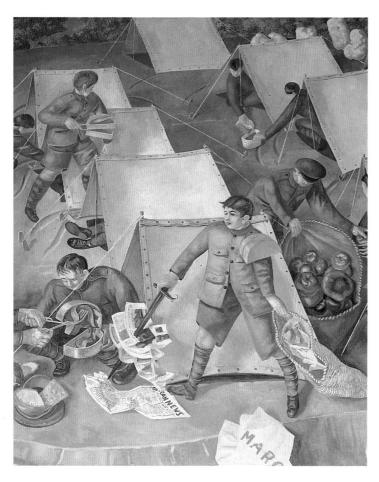

fig.58
STANLEY SPENCER
The Camp at Karasuli (detail)
1930
Sandham Memorial Chapel, Burghclere

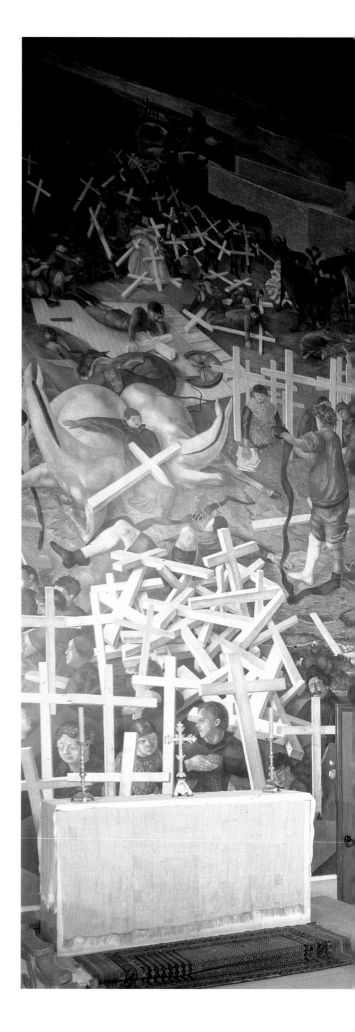

fig.59
A view of the interior,
showing *The Resurrection
of the Soldiers* on the end
wall and *Riverbed at
Todorova* at the top.
Lunettes, from left to
right: *Reveille*, *Filling
Water Bottles*, *Map
Reading*. Predellas,
below: *Frostbite*, *Tea in
the Hospital Ward*, and
Bedmaking.

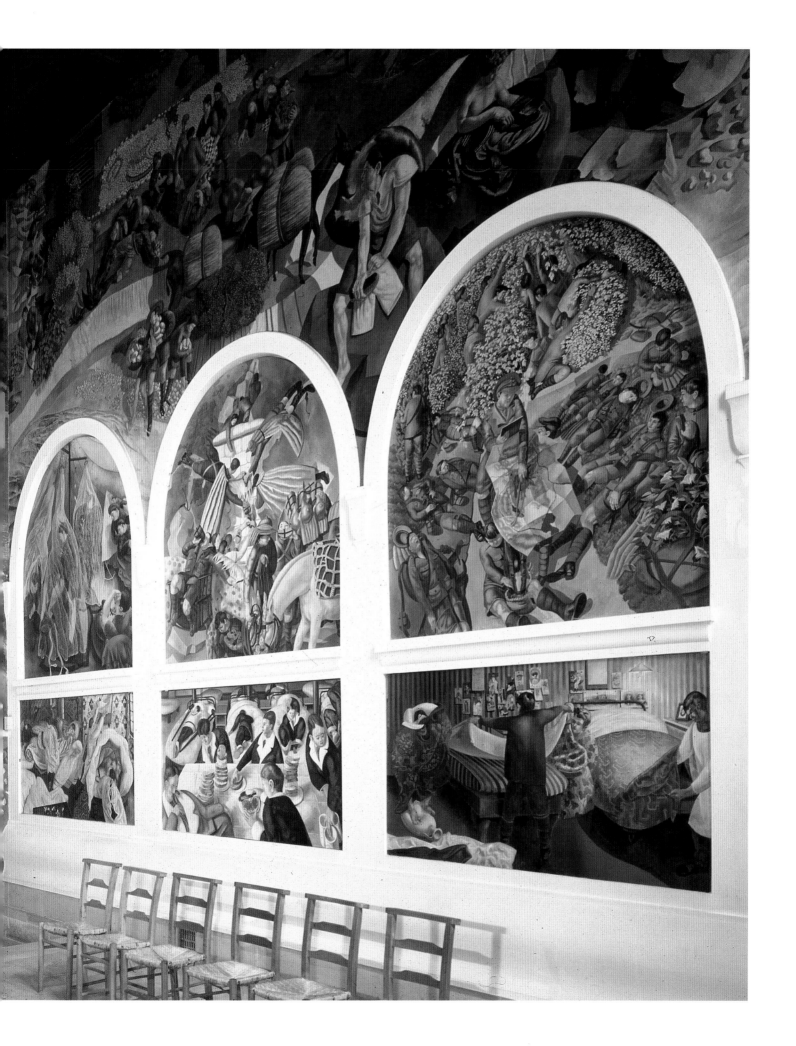

243

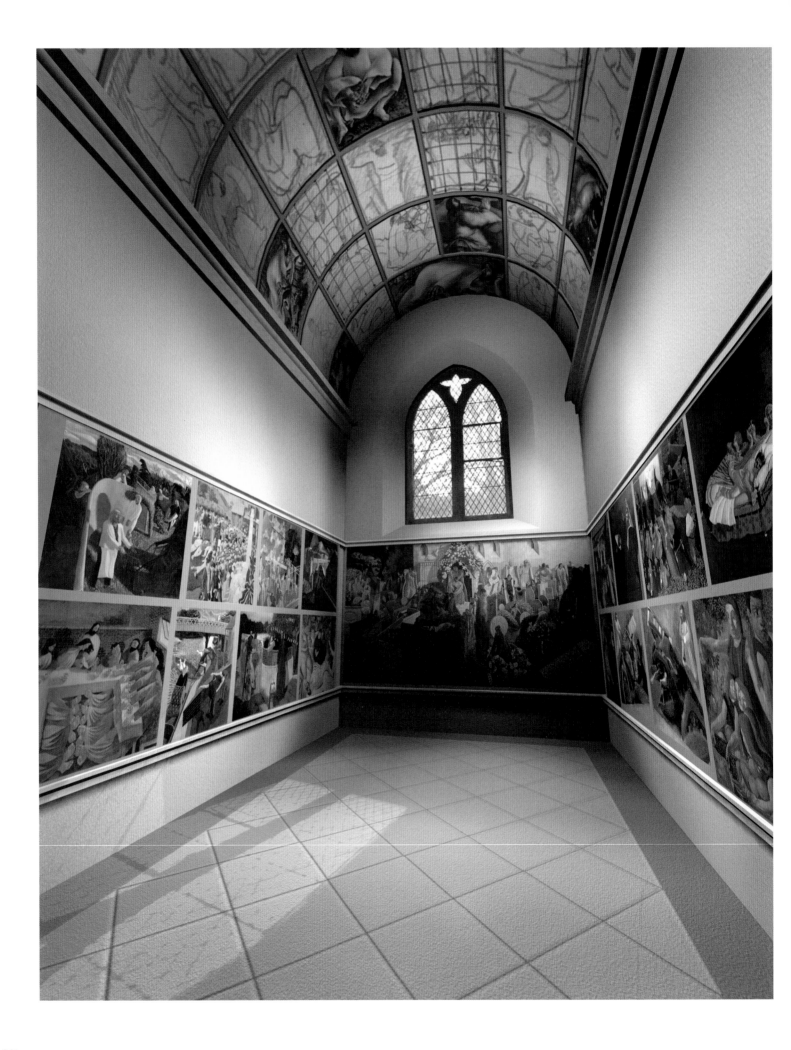

CHURCH-HOUSE VIRTUAL REALITY PROJECT

CURATED BY
ADRIAN
GLEW

TEXT BY
KATHARINE
STOUT

fig.60
A still from the virtual
reconstruction of
Spencer's Church-House
project: the Chancel

Centre for the Advanced
Study of Architecture at the
University of Bath

fig.61
STANLEY SPENCER
*Sketch for the Chancel of
Church-House* c.1926

Tate Archive

As early as 1918, in a letter to his sister Florence, Stanley Spencer first expressed a desire to 'learn fresco painting & then, if Jacques Raverat's project holds good, we are going to build a Church & the walls will have on them all about Christ. If I don't do this on earth, I will do it in heaven' (733.1.757).

However, it was not until the late 1920s that Spencer was able to develop, in earnest, various schemes around the idea of a 'Church-House', describing, in both words and images, a series of church-like spaces and domestic interiors which would be built specifically to house his paintings, old and new. The Church-House idea, which he worked on until his death, should be viewed as part of Spencer's lifelong interest in narrative schemes for purpose-built spaces, following on directly from his experience of painting the Sandham Memorial chapel at Burghclere (1927–32), a building which Spencer helped design. Spencer was fascinated by such spaces and admired buildings as diverse as Giotto's Arena Chapel in Padua and the temple-complex at Khajuraho in India.

There was never a single definitive plan for the Church-House: 'As this scheme develops I may continually change and alter it so that anything I say about it is only provisionally stated. The subject matter of the main pictures of the church is to consist of religious subjects namely Gospel stories, etc. taking place among secular subjects & in this I hope to show how near in spirit to each other these different emotions are' (733.6).

The subjects covered in Spencer's works for the various spaces move seamlessly between biblical narratives, memorials to areas in Cookham, and semi-religious homages to the women he loved. The project served as a way of bringing together Spencer's vision for raising the domestic to the status of religious subject matter.

For this exhibition, a unique virtual reality computer-generated tour has been conceived to allow this unrealised project to be visualised. A computer programme has been used to create certain spaces digitally, matching as closely as possible Spencer's drawings of the individual Church-House chapels or rooms. Spencer's works have been placed in each space according to his plans, as outlined in his notes and sketches now housed in the Tate Archive.

The virtual Church-House has been constructed by the Centre for the Advanced Study of Architecture (CASA) at the University of Bath. The project has been conceived and curated by Adrian Glew, curator in the Tate Archive, through a close reading of the large collection of Spencer archive material. At CASA Professor Robert Tavernor has overseen the architectural interpretation of the Church-House and the images have been modelled on computer by Henry Chow. Tate Britain is particularly grateful to Shirin and Unity Spencer for their support of this innovative project.

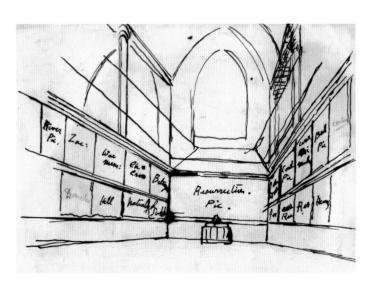

ADRIAN
GLEW

ARCHIVE
CURATOR

STANLEY SPENCER'S LISTS

For archivists, lists are manna from heaven, the result of weeks, months or sometimes years of cataloguing (or more simply 'listing', as it is known). Archival material usually arrives in a chaotic state in cardboard boxes or suitcases. Order is imposed and records are eventually neatly placed in acid-free stationery, each item logically arranged and numbered, and with the list acting as key. Lists to Spencer were also keys – keys to unlock the meanings behind his

paintings, chronicles of reflection and reminders for future action. Like his paintings, letters and other writings, they reveal an artist of remarkable insight and sometimes brutal honesty. A selection is reproduced here to illustrate how Spencer used his lists, and to show a tiny proportion of the wealth of Spencer material housed in the Tate Archive, most of which was purchased in 1973.

1

1 Flora in Paintings
Sketchbook c.1927 [TGA 998]

Found at the back of a sketchbook, Spencer carefully compiled this list of flora from depictions of plants found in his own paintings. He seems to have begun it to explore the variety in his landscapes, and then carried on through his early paintings listing from memory the plants in each of them. Growing up near the river in an agricultural community, long before the use of pesticides, Spencer would have encountered a profusion of flora and fauna. Within this list, there are references not only to plants in and around Spencer's home, Fernlea – such as the ivy and privet in *Christ Carrying the Cross* (no.27), but also to many of the native species such as cow parsley, cornflowers and marguerites found in the meadows that surrounded Cookham, and which appear throughout *The Resurrection, Cookham* (no.35). Most of these meadows and surrounding open spaces have remained intact as common land or are now owned by the National Trust.

2 Jewellery Expenses
Notebook 1938 [TGA 733.3.46]

This list appears to be an inventory of the jewellery purchased by Spencer in the 1930s for Patricia Preece, who became his second wife, and illustrates the lavishness of his attention. In a later note Spencer admitted that this was a period when he had both health and financial troubles.

3 Times When I Liked My Life ...
Numbered Writing 28 December 1942 [TGA 733.2.135]

During the Second World War when Spencer had relatively more time on his hands, he was able to reflect on those periods of his life that meant most to him. Significantly, all of these had been either when he and Hilda were together or when he was on his own. Although they were no longer married, both Stanley and Hilda became much closer during the 1940s and there was even talk of remarriage.

4 Landscapes
Notebook 1942–3 [TGA 733.3.48]

Spencer would often refer to his landscapes as 'pot boilers' and in the 1930s he had to paint more and more of them to make ends meet. Although his imaginative work did sell during this period, there was a much higher demand for landscapes, street scenes and garden views. However, writing in 1941, Spencer divided his landscapes into five categories and was able to reassess them. For instance, he would have liked to have had an exhibition of some of his landscapes with his nudes, and in another note he made detailed plans about displaying some of the landscapes in the unrealised Church-House scheme.

1912-13-14 Three Landscapes
1919-21 Fourteen "
1922-23 Twelve "
1924-26 Eleven "
1927-31 Eleven "
1932-34 Ten "
1935 Ten "
1936 Ten "
1937 Thirteen "
1938 Thirty one "
1939 Six "
1940 Four "
1941 began two "
1942 Four "

5 Paintings and Drawings up to 1907
Notebook ?1945 [TGA 733.3.45]

6 Paintings and Drawings from 1909 to 1913
Notebook [TGA 733.11.3]

The two lists below (list 5 is illustrated) are typical of the inventories of watercolours, drawings and paintings that Spencer compiled throughout his life. Although he often said that he had a poor memory, he had a remarkable aptitude for remembering precise details about his works, such as when and where they were painted and who bought them.

1909
1 Maternity
2 Man and woman on chairs with Cookham Church in background
3 Girl feeding calf
4 Roger de Coverly
5 Young girls and boys in barn
6 Scene in Paradise. The property of Slade School

1910
7 Descent from the Cross. Sold to Henery Tonks
8 Girl standing on water and boy with mandolin on bank
9 Jacob and Esau. Sold to Ruth Lowe
10 The coming of Christ. Sold to Mr Hutchinson
11 David. Sold to C K Butler
12 Christ in the vinyard and two women. Sold to Henery Tonks

1911
13 John Donne entering Heaven. Sold to Mrs Bluett
14 John Donne entering Heaven, painting. Sold to Jacques and Gwen Raver
15 Girl and man leaning against wall
16 Gathering Apples. Sold to E. Marsh

1912
17 Gathering Apples, painting. Sold to E. Marsh
18 Job and his Comforters
19 Man going to his long home
20 Adoration of the Sheepherds, painting. Slade School
21 Joachim among the Sheepcotes. Sold to C K Butler

1913
22 Joachim among the sheepcotes, painting
23 " " " woodcut
Sold to Geoffrey Keynes/Darcey Japp/W. Behrend

1914
24 Zacharias. Sold to Frank Rinder
25 Zacharias. Painting. Sold to Muirhead Bone
26 Visitation. "
27 Bed Picture. " Sold to Henry Lamb

7 Diary Entry
Notebook c.1944–6 [TGA 733.3.56]

Spencer occasionally made a list – like a diary –
to remind himself of what he had
accomplished. So on one side of this notebook
page there are the astonishing details of a
month's work whilst staying in Scotland in
1944. For example, Spencer provides titles for
some of the figures in his Resurrection
paintings. On the opposite page, Spencer – like
many people – makes a list of 'things to do'.
These include contacting his supplier of artists'
materials, Bryce Smith; his dealer, Dudley
Tooth; and a possible publisher of his
autobiography, Victor Gollancz. Mrs Whiteford
was one of the people who let a room for
Spencer to stay and work whilst in Glasgow. As
it was wartime, bureaucratic pieces of paper
needed to be completed or obtained, including
the all important Ration book.

[left-hand page]
Sept 23rd
Came up 22nd August
Have written 249 pages of Chap 4
Drawn 21 compositions
Composed Plumbers
Painted five feet
Titles of resurrected ones

6.	"I think that is Sarah"
18.	Night out
20.	I suppose it's time to get up
21.	"Putting on flesh"
22.	"Making them presentable"
23.	Spotted
24.	Souvenirs
25.	Eternal holy day

[right-hand page]
Get colours ring Bryce Smith
Get money ring Tooth
Get Ration book ring BE24
Get room
Write? Gollancz
Send envelopes to
 Mrs Whiteford
Glas[gow] Rd Glencairn
 Port Glasgow
Send letter also ditto
Find out date of Ticket expiration
Tell Tooth about Landscape
Also ask if claims made have been agreed upon.
Take Envelopes of drawings
 " Sticks
 " bag of ordinary drawings
 " Stretcher
 " Stool
 " Colours & brushes
Ring church

8 Contents of Writings
Notebook c.1947 [TGA 733.3.59]

Spencer believed his writings to be as
important as his paintings, the one informing
the other. By the 1930s, he hoped to publish his
'autobiography', which would have been a
melange of critical essays through which the
reader would discover the artist's ideas and
character. (Although it was never published,
significant extracts are now available for the
first time in *Stanley Spencer: Letters and
Writings*, London 2001, ed. Adrian Glew.)

CHRONOLOGY

STANLEY SPENCER 1891–1959

1891

Stanley Spencer was born 30 June at Cookham on Thames, Berkshire. He was the eighth of nine surviving children of William Spencer, church organist and piano teacher, and his wife Anna. The family lived in 'Fernlea', a house built on the High Street by his grandfather. Spencer was educated at home at a morning school run by his sisters, and took his first painting classes from local artist Dorothy Bailey. He and Gilbert (1892–1979) who also became an artist, were the youngest sons.

1907

Began to study art at Maidenhead Technical Institute.

1907–12

Spencer went to study at the Slade School in London under Henry Tonks. Among his contemporaries were David Bomberg, Dora Carrington, Mark Gertler, Paul Nash (for a brief period), C.R.W. Nevinson, Gwen Raverat, William Roberts, Isaac Rosenberg and Edward Wadsworth. He lived at home and travelled to the Slade each day, where his nickname was 'Cookham'. He was awarded a Slade scholarship in 1909 and the Melville Nettleship Prize.

1909–13

From 1909 Spencer attended Roger Fry's Slade lectures on Giotto and Cézanne. In November 1910 Fry presented the exhibition *Manet and the Post-Impressionists* at the Grafton Galleries which included the work of Gauguin and Maurice Denis. In 1912 Spencer exhibited *John Donne Arriving in Heaven* (no.4) and some

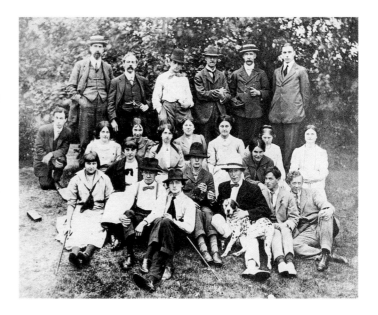

drawings in Fry's *Second Post-Impressionist Exhibition*. In 1912 he began to paint *Apple Gatherers* (no.9) which was included in the first public exhibition of the Contemporary Art Society (formed in 1910 by Lady Ottoline Morrell and Roger Fry) in the summer of 1913. In 1912 he painted *The Nativity* (no.7) for which he won a Slade Composition Prize.

fig.61 Slade students and teachers on a summer outing in 1912. On the back row, third from left is David Bomberg, and seated at the front are (from left) Dora Carrington, ?Edward Wadsworth, Mark Gertler, C.R.W. Nevinson, Adrian Allinson and Stanley Spencer.

1914

In this year Spencer completed *Zacharias and Elizabeth* (no.14) and *The Centurion's Servant* (no.15). The exhibition *Twentieth Century Art: A Review of Modern Movements* opened at the Whitechapel Art Gallery, which included *Apple Gatherers*. He began his *Self-Portrait* (no.13). In August, Britain declared war on Germany.

1915–18

Spencer started work on *Swan Upping* (no.18) and had completed less than half when he decided to follow Gilbert and enlist in the Royal

fig.62 Beaufort Hospital, 1915
(Stanley Spencer with arm raised, bottom right)

Army Medical Corps. During his four years at war he lacked the opportunity to paint, although he continued to sketch as well as read widely. He worked as a medical orderly at the Beaufort War Hospital, Bristol, from July 1915. In 1916 he was posted to the war in Macedonia, having spent time in Salonika in Greece serving with the Field Ambulances. In August 1917 he volunteered as an infantryman and joined the 7th Battalion, the Royal Berkshires. He returned to England in December 1918 and went back to Cookham. His brother Sydney was killed in action in September 1918.

1919

Commissioned to paint *Travoys with Wounded Soldiers Arriving at a Dressing Station at Smol, Macedonia* (no.21) by the Ministry of Information. In January Spencer spent a weekend in the company of Eric Gill at the Dominican priory at Hawkesyard, Staffordshire. In Hampstead he met Hilda Carline (1889-1950), an artist studying part-time at the Slade.

fig.64 [LEFT]
Hilda Carline
at Hampstead,
1919

fig.65 [RIGHT]
Hilda Carline,
Self-portrait
1923
Tate

1920–1

Spencer lived with his parents in Cookham until April 1920 when he went to stay with Henry Slesser and his wife at Cornerways in nearby Bourne End until 1921. During this time, he worked on a group of works for an 'oratory' in the Slessers boathouse. In the summer of 1920, he and Gilbert stayed in Durweston, Dorset with Henry Lamb. The following year he went to stay with the artist Muirhead Bone at Steep, near Petersfield, Hampshire and was invited to work on a mural scheme for a village hall which would serve as a war memorial. This project later collapsed and Spencer moved to lodgings in Petersfield.

1922

In May 1922 Spencer's mother died. He began to spend more time at the Carline household in Hampstead, where he was already part of the 'cercle-pan-artistique of Downshire Hill' that had been meeting regularly since 1919. This included William Roberts, Mark Gertler, C.R.W. Nevinson, Jas Wood as well as John and Paul Nash and the Spencer brothers. He accompanied the Carline family on a painting holiday to Yugoslavia in summer 1922, stopping off at Vienna, Munich and Cologne to visit the art collections. Upon their return Hilda and Spencer became engaged, and Spencer moved to Hampstead in December 1922.

1923–4

Enrolled at the Slade School for the spring term, 1923. Spencer joined the artist Henry

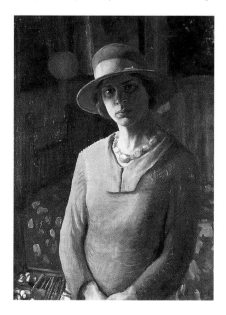

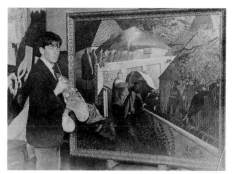

fig.63 Spencer painting *The Betrayal*, c.1923

Lamb at Poole, Dorset for the summer and worked on war compositions for an imaginary chapel. On the basis of these drawings, Louis and Mary Behrend, already patrons of Spencer's work, commissioned a cycle of paintings as a memorial to Mrs Behrend's brother, who had been in the Salonika campaign and had died in 1919 from malaria contracted during the war. The paintings were to be for a chapel to be specially built in the Berkshire village of Burghclere. He returned to Hampstead in October 1923, to sublet Henry Lamb's studio on the top floor of the Vale Hotel in the Vale of Health where he painted *The Resurrection, Cookham* (1924–7).

fig.66 Hilda and Shirin Spencer, 1926

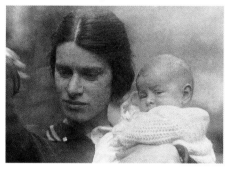

1925

On 23 February, Hilda Carline and Stanley Spencer were married at Wangford, near Southwold, where Hilda had worked during the war. Their first daughter Shirin was born in November.

1927–32

Spencer had his first solo exhibition at the Goupil Gallery in London in spring 1927. *The Resurrection, Cookham* was purchased by Lord Duveen and presented to the Tate Gallery. Spencer moved with his family to Burghclere in 1927 to work on the paintings for the Sandham

Memorial Chapel, which were completed in 1932. This monumental work refers back to his wartime experiences over fifteen years before. He also received other commissions during this period: in 1927 he completed a series of pen-and-ink sketches for an almanack for Chatto and Windus; in 1929 the Empire Marketing Board commissioned a series of five paintings on the theme of Industry and Peace.

Whilst in Cookham for several weeks in 1929 he met Patricia Preece (1894–1966), an artist who had recently moved to Cookham with her partner, fellow artist Dorothy Hepworth.

His second daughter, Unity, was born in May 1930. His relationship with Hilda during this time became difficult, partly owing to the fact that she missed her family and friends, and

fig.68 James (Jas) Wood, Stanley, Hilda, Shirin and Mrs Carline, c.1928/9

fig.69 Shirin, Hilda and Stanley, c.1929

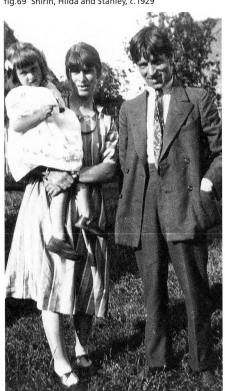

partly owing to his own ill health and consequent irritability (Spencer suffered from painful kidney stones from 1930–4, when he had his final operation to remove them). During his periodical visits to Cookham in 1930–1, he called on Patricia Preece and Dorothy Hepworth, who were then in financial difficulties.

1932

In 1932 the family, along with their maid Elsie Munday, moved to Cookham, to 'Lindworth', a large house off the High Street. Hilda, however, continued to spend long periods at the Carline household in Hampstead because of the illness and then death in Christmas 1932 of her brother George. Back in Cookham, Spencer painted his surroundings – landscapes and observational studies. For the next several years his production of these naturalistic paintings, exhibited at Tooths, were important for him financially. It is around this period that he began to work on his ideas for an ambitious architectural scheme to house his works, which he called the Church-House. Although a patron never came forward he continued to develop plans for this project for many years. He was elected an Associate of the Royal Academy and exhibited five paintings and five drawings at the Venice Biennale. In October, Dudley Tooth became his sole agent.

1933–5

During 1932–3 the friendship between Patricia Preece and the Spencers deepened. Patricia first modelled for Spencer in 1933, and he became more involved with her. In the summer, Spencer was invited to Saas Fee in Switzerland, by Edward Beddington-Behrens to paint landscapes, and Patricia joined him there.

1935–6

Spencer resigned from the Royal Academy after the rejection of *Saint Francis and the Birds* and *The Dustman* (or *The Lovers*) (no.78) from the summer exhibition. In 1935 he visited Switzerland for a second time with the Beddington-Behrens, accompanied by Patricia. Back in Cookham, she was paid to come to Lindworth in the evenings to pose. Patricia started to manage Spencer's finances and he made the house over to her name. In summer

fig.67 Patricia Preece at Moor Thatch, Cookham, 1930

1935, Hilda moved with the children to the Carline family home in Hampstead. Spencer envisaged the possibility of a three-way relationship, with Hilda and Patricia. By 1936 he had spent a large sum of money on jewellery for Preece and was in debt. In 1936 Spencer painted the first *Double Nude Portrait* (no.55) featuring himself with Patricia.

1937–8

Spencer painted the *Double Nude Portrait* (known as the 'Leg of Mutton Nude', no.58), and continued to produce his popular landscapes. He was divorced by Hilda and a week later married Patricia Preece at Maidenhead Registry Office on 29 May 1937. He never lived with her, although they spent a 'honeymoon' month together in St Ives accompanied by Preece's partner Hepworth, and the marriage was never consummated. He went to stay briefly in Hampstead with Hilda and the Carlines where he painted *Hilda, Unity and Dolls* (no.60). He tried to win Hilda back, but she resisted his attempts. He then travelled on his own to Suffolk where he painted at Southwold. During the winter he began work on *The Beatitudes*, paintings on the theme of relationships between unlikely couples.

1938–9

Spencer was in financial difficulties, borrowing beyond his means and struggling to support his family and second wife. He exhibited at the Venice Biennale in the British Pavilion. In late summer Preece rented out Lindworth, effectively evicting Spencer. He began to break free from Preece, and in the autumn Dudley Tooth took over managing his business affairs. In October he fled to London, arriving at the Rothensteins in Hampstead with no possessions, and stayed with them for six weeks without painting. John Rothenstein had recently become Director of the Tate Gallery. By early December Spencer was installed in a bedsit at 188 Adelaide Road in Swiss Cottage (through the generosity of Malcolm MacDonald and others), where he began the *Christ in the Wilderness* series. In June he moved to another room on Adelaide Road. At about this time, Spencer started his autobiographical writings.

1939–40

In September 1939 Britain declared war on Germany, by which time Spencer was staying at the White Hart Inn at Leonard Stanley in Gloucestershire with the artists George and Daphne Charlton. He and Daphne began an affair whilst George was away teaching at the Slade School in Oxford. He began the *Scrapbook Drawings* and worked on them over the next ten years; these compositions were intended to be painted for the various chapels of the Church-House.

1940–3

In March 1940 the War Artists Advisory Committee commissioned Spencer to record the war effort with *Shipbuilding on the Clyde*, a project which would eventually span six years. He made drawings at Lithgow's Yard, Port Glasgow, on the Firth of Clyde. *Burners* (no.97) was exhibited at the National Gallery at the *War Artists* exhibition and then sent to the Museum of Modern Art in New York with other war paintings as an example of the British war efforts. In May 1941 Spencer moved to Epsom to be with his children and Hilda. In spring 1942 Hilda suffered a mental breakdown. Spencer visited her frequently in Banstead hospital, spending time writing to her and reading each other's letters aloud.

1944–6

In spring 1944 Spencer paid another visit to Port Glasgow for a few months. In Glasgow he began an affair with Charlotte Murray, a German-born analyst trained by Jung. She persuaded him to undertake analysis with fellow Jungian Dr Karl Abenheimer, and other Jungians were consulted later both in Cookham and in London. In 1945 he returned to Cookham, living in 'Cliveden View' which had previously belonged to his brother Percy. He began *The Resurrection, Port Glasgow* series.

1947

Spencer continued to visit Hilda, now suffering from cancer, at the Carline house in Pond Street. The Oratory Chapel at Burghclere was presented to the National Trust by Mr and Mrs J.L. Behrend. Spencer completed *The Raising of Jairus's Daughter* (no.104).

1950–4

In 1950 the outgoing Royal Academy president, Sir Alfred Munnings, initiated a police prosecution against Spencer for the alleged obscenity of some of his sexual imagery from the later 1930s (see p.158). He rejoined the Royal Academy as Associate, exhibited the *Resurrection, Port Glasgow* series and was elected Academician. He was created CBE. On 1 November 1950 Hilda died from cancer. Spencer painted *Love Letters* (no.109), designated as the altarpiece for the Hilda Chapel in Church-House. He visited Ulster, staying with his elder brother Harold and his family. In 1954 he visited China as part of a cultural delegation.

fig.71 Spencer in China, September 1954

fig.70 Unity, Mabel Sharp, Stanley and Mrs Clifford Bax, c.1955

1955

Retrospective exhibition at the Tate Gallery, November to December. Around this time Spencer began a final ambitious series of paintings, *Christ Preaching at Cookham Regatta*.

1958

Spencer painted *The Crucifixion* (no.113), which was exhibited for the first time in Cookham Church. In December he fell ill and was taken to the Canadian War Memorial Hospital in the grounds of Cliveden, where, diagnosed with cancer, he had an operation.

1959

With the help of Lord Astor he moved back into his childhood home, Fernlea. Received a knighthood. Painted his last *Self-Portrait* (no.115), in Yorkshire. Stanley Spencer died on 14 December at the Canadian War Memorial Hospital, Cliveden.

NOTES

Notes pp.11–41
TIMOTHY HYMAN

This essay is dedicated
to the memory of
Elizabeth Collins,
1904–2000.

When Spencer's notebooks
and letters were first
trawled through by
Maurice Collis, Richard
Carline, Anthony Gormley
and others, they were
completely disorganised,
unnumbered, and
therefore impossible to
reference. But several
fascinating quotations
discovered in those first
years have never been
tracked down again, in
what is now the Spencer
Archive at the Tate, at last
beautifully ordered and
catalogued. These
problems are reflected
in some of my notes.

1 Spencer to Hilda Carline,
June 1923. Quoted in
John Rothenstein, *Stanley
Spencer: The Man*, London
1979, p.26.

2 In Pam Gems's play
Stanley (1996), Antony
Sher talked as a Berkshire
yokel; an earlier radio play
had Donald Pleasance
twanging in semi-Cockney.
In fact Spencer's recorded
voice turns out to be well-
spoken, almost
schoolmasterly.

3 To Hilda, 10 November
1922. Quoted in Richard
Carline, *Stanley Spencer at
War*, London 1978, p.137.

4 Quoted in Maurice
Collis, *Stanley Spencer*,
London 1962, p.139.

5 Tate Archive 733.13.2.

6 Carline 1978, p.30.

7 As first noted by Richard
Lofthouse, Spencer wrote

(apropos of Donatello's
Prophets) in 1914 to Gwen
Raverat: 'Roger Fry used to
show us them on the
screen in his lectures'
(811.16.45).

8 Roger Fry in the
Burlington Magazine,
no.16, Jan.–Feb. 1910.

9 Paul Nash, in *Outline*,
London 1949, pp.92–3.

10 Among the other 'Neo-
Primitives' were C.R.W.
Nevinson and the ill-fated
John Currie.

11 Rupert Brooke in the
Cambridge Magazine,
23 November 1912.
Quoted by Andrew Causey
in *Stanley Spencer*, exh.
cat., Royal Academy,
London 1980, p.22.

12 Letter to Desmond
Chute, 17 November 1926.
Quoted in Rothenstein,
Stanley Spencer: The Man,
pp.21–2.

13 Letter to Desmond
Chute, May–end of June
1930, ibid., p.38.

14 Florence Image (née
Spencer). Quoted in
Kenneth Pople, *Stanley
Spencer*, London 1991,
p.38.

15 The blossoms are
chestnut 'candles', usually
flowering in May. But the
foliage behind suggests the
onset of autumn. Frances
Spalding, who is writing
a biography of Gwen
Raverat, has informed me
of Eric Gill's response to
The Nativity at the Slade in
1912: 'Oh damn the P-I's
when there is piety like
Spencer's to be
worshipped'.

16 It is also, as has often
been pointed out, oddly
prescient of the post-war
white architecture of Le
Corbusier, and Purism.

17 From Thomas
Traherne's opening to
The Third Century.

18 733.3.22 (December
1938).

19 'The Bogeys'. Quoted
in Christopher Hassall,
Edward Marsh, London
1959, p.283. Nash 1949,
p.138: 'staying at Eddie
Marsh's where groups of
dwarfs by Gertler and
Spencer seemed to menace
me from every wall'.

20 Edward Marsh to
Rupert Brooke, 26 August
1913. Quoted in Hassall
1959, p.244. Marsh would
buy Gertler's *Jewish Family*
in September, before
acquiring *Apple Gatherers*.

21 See, for example,
Keith Bell in his invaluable
*Stanley Spencer:
A Complete Catalogue of
the Paintings*, London
1992, p.385; he misdates
Lamb's *Fisherfolk* to 1912,
and hence assumes that
'Lamb's influence was
probably decisive'.

22 The Strachey portrait
was conceived in 1912, but
only satisfactorily realised
through the example of
Spencer in 1914, just as
the First World War began.
Lamb bought *Apple
Gatherers* for £30; Eddie
Marsh (Winston Churchill's
private secretary, and
already a prominent
collector of younger artists)
offered £50, as did Michael
Sadler (who formed the
outstanding international
avant-garde collection of
his generation in Britain).
Marsh eventually paid £55;
Lamb passing on the extra
£25 to Spencer.

23 William Roberts,
*A Press View at the Tate
Gallery*, London 1956,
quoted in Bell 1992, p.26.

24 *The Westminster
Gazette*, 21 May 1914

(the author is probably
J. Middleton Murry).
Quoted in Lisa Tickner,
*Modern Life and Modern
Subjects*, London 2000,
p.224, n.32.

25 Walter Sickert in *The
New Age*, 28 May 1914.

26 Isaac Rosenberg
(Spencer's fellow-student
at the Slade and war poet,
1890–1918) writing to
Sidney Schiff (translator
of Proust and purchaser
of Spencer's *Two Girls
and a Beehive*). Quoted in
*Collected Works of Isaac
Rosenberg*, London 1979.

27 Letter to Eddie Marsh,
October 1914. Quoted
in Hassall 1959, p.255.

28 At the outbreak of war,
a parallel anthology of
Georgian Drawings was
being planned, including
work by the Spencer and
Nash brothers, Gertler,
Roberts, Nevinson, Gaudier
and Rosenberg.

29 Letter to Desmond
Chute (the young Catholic-
inclined friend he'd made
while at the Beaufort
Hospital in Bristol), March
1917. The letter was first
published in *The Game*,
edited by Eric Gill's
associate Hilary Pepler,
1919. See Rothenstein
1979, pp.17–20.

30 See Keith Clements,
Henry Lamb, Bristol 1985,
p.213. Spencer writes to
Lamb: 'If you have any
Lorenzettis you can give
me, give them to me by
return of post if possible';
and again, in reference to
promised postcards, 'Do
not forget the Lorenzettis.'

31 733.2.370 (16 January
1948). Quoted in *Stanley
Spencer*, exh. cat., Tate
Gallery Liverpool 1992,
p.20.

32 'Divine sequence',
the phrase used by
Spencer at his first meeting
with John Rothenstein,
described in *Modern
English Painters*, London
1956, p.94.

33 733.2.128.

34 Draft of a letter
to Gwen Raverat, in
a sketchbook now in
the British Museum
(1992 4.4.98).

35 Letter to Hilda,
28 December 1919. Quoted
in Carline 1978, p.120.

36 Letter to Hilda, c. 1930.
Quoted in Rothenstein
1979, p.45.

37 Letter to Henry Lamb,
summer 1920. Quoted in
Pople 1991, p.198.

38 Letter to Florence
Image. Ibid., p.194.

39 Letters to Michael
Sadler, 24 November 1921
and 30 November 1922.

40 Letter to Henry Lamb,
10 March 1923. Quoted in
Carline 1978, p.139.

41 From Spencer's
introduction to his 1955
Tate retrospective.

42 Quoted in Carline
1978, p.142. Henry Lamb's
lost portrait of Spencer
confirms how 'gorgeous'
he was in the early 1920s.

43 1922 coincides with the
emergence of the *Neue
Sachlichkeit* artists; Dix was
especially visible in
Cologne.

44 Carline 1978, pp.145
and 148.

45 The Behrends were pre-
war friends of Lamb; in
1919, they'd introduced
Spencer to the Slessers (see
Patrick Wright, below).
They already owned
Mending Cowls and *Swan
Upping*, as well as Lamb's

great Lytton Strachey
portrait.

46 5 December 1924.
Quoted in Rothenstein
1979, p.30.

47 Ibid., to Hilda, c.1930,
p.30.

48 Letter to Michael
Sadler. The subtext of
The Resurrection is
probably Spencer's rebirth
through sexual union
with Hilda.

49 Letter to Hilda,
1 October 1923. Quoted
in Carline 1978, p.161.

50 Carel Weight writing
on *The Resurrection,
Cookham* in David Piper
(ed.), *Enjoying Paintings*,
London 1964.

51 These exchanges
(September–November
1922) between Nash and
Bottomley are quoted from
Poet and Painter, Bristol
1990, pp.151–8.

52 Henry Lamb to Richard
Carline, 10 May 1924
(Tate Archive, Box 8216).
Quoted in Bell 1992, p.369.

53 Quoted in Alison
Thomas, *The Art of Hilda
Carline*, exh. cat., Lincoln
1999, p.27.

54 Shirin Spencer to the
author, August 2000.

55 Stanley Spencer's
'Sermon', in *Sermons by
Artists*, Golden Cockerel
Press, 1934, p.52.

56 16 January 1948
(as note 31).

57 Letter to Desmond
Chute, 17 November 1926
(as note 12).

58 Ibid.

59 See the catalogue of
Jean Clair's brilliant
exhibition *Les Realismes*
(Centre Pompidou, Paris,
1980) where Spencer's *Leg
of Mutton Nude* was

included within the wider European context of 'realism' between the wars.

60 Bell 1992, p.300.

61 733.3.22. Quoted in *Stanley Spencer*, exh. cat., Tate Gallery Liverpool 1992, p.15.

62 She may have suffered from belladonna addiction, which produced the side-effect of a permanently enlarged iris (seee note 64).

63 His expenditure on gifts to Preece in 1934–7 is thought to have totalled about £2,000 – that is, twice the cost of his seven-bedroom house. Preece never sold two major pieces – an enormous emerald-and-diamond ring, and a ruby necklace – despite Spencer's terrible financial difficulties after 1937; their present value would be well over £150,000. Spencer's doggerel poem, 'Jewels', probably dates from 1935, and includes the couplet: 'Shining glorious girl resplendent/Today she wears her diamond pendant' (733.3.54). See also the list of jewellery on p.249.

64 I am grateful to Michael Dickens for generously sharing his research on Patricia Preece and Hepworth. His biographical study will be published shortly by Fourth Estate.

65 Her entry in a contemporary *Dictionary of Artists* reads: 'Patricia Preece (née Hepworth)'.

66 Diary entry, 24 February 1932. Fry's vehemence confirms the truth of Richard Carline's evidence (1978, p.32, note 14): 'Stanley was never welcomed by him. I recall occasions when Fry ostentatiously turned his back on him.'

67 In 1933–4 day-book, 31 December 1933.

68 733.8.2. For 'anthology', see Simon Wilson quoting Richard Morphet in *Les Realismes* (see note 59).

69 From the notebook headed 'Novel of Married Life' (733.3.76).

70 It was also in these days that he'd revisited the Vale of Health, scene of his early years with Hilda, and painted *The Helter-Skelter*.

71 733.3.3.

72 733.3.2, p.126. Quoted in Bell 1992, p.146.

73 Gilbert Spencer, *Memoirs of a Painter*, London 1974, p.184.

74 733.3.3.

75 This comes from 'Essay 2' on 'Distortion' in Spencer's notebooks (733.3.2).

76 Shirin Spencer relates *The Beatitudes* to Jewish prayers for the misshapen, which her father may have known: e.g. 'Praise be to God who does so wonderfully vary the forms of his creatures'.

77 Spencer to William Rothenstein. Quoted in his *Men and Memories*, vol.2, London 1932, p.225.

78 733.3.7. The full text is transcribed in *Spencer*, exh. cat., Barbican Art Gallery, London 1991, p.58.

79 The drawing from Degas: 733.3.52.

80 Notebook 3.87 (pp.81–2).

81 733.3.3, p.42.

82 733.3.33. Quoted in *Stanley Spencer*, Tate Gallery, Liverpool, 1992, p.16.

83 733.3.3, p.84.

84 733.3.3, p.97.

85 Letter to Mary Behrend (733.3.75).

86 733.3.1.

87 Walter Sickert, letter to the *Sunday Times*, 5 May 1935. I am grateful to Anna Gruetzner Robins for drawing my attention to this, included in her edition of *Walter Sickert: The Complete Writings*, Oxford 2000.

88 733.3.76.

89 Mikhail Bakhtin, *Rabelais and His World* (written in 1939), Cambridge, Mass., 1968, p.48.

90 Quoted in Anthony Gormley, *The Sacred and the Profane in the Art of Stanley Spencer*, Brighton 1976, p.21.

91 Implicit in Carlo Carrà's monograph *Giotto* (published in English by Zwemmer in 1925, and almost certainly known to Spencer) had been a new role for the modern mural painter in a reconstructed post-war society.

92 Undated, probably late 1932. I am grateful to Kenneth Pople for showing me the text of this letter, now part of the Preece/Hepworth archive.

93 This important passage was first cited by Collis, *Stanley Spencer*, pp.138–9. I have not been able so far to trace the manuscript source in Tate Archive.

94 The names listed on the memorial include Spencer's favourite elder brother Sydney; the only name with a Military Cross.

95 See Keith Bell, *Stanley Spencer*, 1980, p.163: 'Spencer owned a number of loose plates of Indian temple sculpture, later found among his papers.'

96 733.3.7; 733.3.5, p.76.

97 Quoted by Richard Carline in *Stanley Spencer*, exh. cat., Royal Academy, London 1980, p.12, dated to 'early 1920s'.

98 David Jones, *Epoch and Artist*, London 1959, p.243 (probably written c.1941).

99 Dr John MacGregor in *The Outsider*, winter 1998.

100 Adolf Wölfli (1864–1930) and Henry Darger (1892–1973). Each devoted much of his life to producing a vast prose narrative, interspersed with imagery; they are, in my view, the two greatest outsider artists of the twentieth century.

101 733.3.22 (1938).

102 Henry David Thoreau, *Walden*, Signet Classics, New York 1964, p.66.

103 Letter to Hilda, 1 June 1943.

104 Jane Alison, 'The Apotheosis of Love', in Barbican Art Gallery 1991, p.16.

105 The War Artists' Advisory Committee at first offered him only £50, at a time when his landscapes were fetching about three times that amount.

106 Soon after, Spencer's sister Annie was discovered on Cookham Moor attempting to dig her own grave, leading to her being institutionalised from 1944; her house, 'Cliveden View', fell empty, and Spencer moved in.

107 For a summary of Spencer's Jungian contacts, see Bell 1992, p.185.

108 Vaudray Mercer in Rothenstein 1979, p.133.

109 Letter to Hilda, 14 February 1949. 733.3.69.

110 Quoted by Anthony Gormley, *Stanley Spencer*, Brighton 1976, p.23.

111 A friend at Cookham in his later years asks Spencer what he likes, what interests him most; he replies: 'rubbish'. 'So I said, "what do you mean by that?" and he said: "I love disorder".' See Ray Lovery, in conversation with Adrian C. Roest. Quoted in Rothenstein 1979, p.137.

112 Quoted in Collis 1962, p.203.

113 Vincent van Gogh to his sister Wilhelmina; St Rémy, October 1889. *The Complete Letters of Vincent van Gogh*, vol.3, London 1999, p.458.

114 Spencer, letter to *The Times*, 12 June 1958. Quoted in Bell 1992, p.516.

115 Quoted in Peter Everitt's radio play based on Collis 1962 (BBC Radio 3, 1975).

116 733.3.59. See list no.8, reproduced on p.251.

117 Hilda died in November 1950, by which time Spencer had almost certainly completed *Love Letters*. But in the very large unfinished canvas which supplanted *Love Letters* as altarpiece for her chapel, *The Apotheosis of Hilda*, the same letters multiply across the Hampstead landscape as a kind of magical litter.

118 733.2.182.

119 I am grateful to Merlin James for sending me the unedited text of his Spencer review in *The Times Literary Supplement*, 1 February 1991, for which this passage was intended.

120 Bell 1992, p.461.

121 1956. Quoted in Barbican Art Gallery 1991, p.31.

122 Quoted in Tate Gallery Liverpool 1992, p.54.

123 Paul Overy, *The Times*, 27 July 1976.

124 William Feaver, *Observer*, 8 August 1976.

125 Wyndham Lewis, *Listener*, 18 May 1950.

126 David Sylvester, *Britain Today*, no.171, July 1950.

127 *Stanley Spencer*, exh. cat., Tate Gallery, London 1955.

128 John Rothenstein, *Modern English Painters*, vol.2, London 1956, p.185.

129 William Townsend, *Stanley Spencer*, obituary in the *Listener*, 24 December 1959.

130 Herbert Read, Preface to *A Concise History of Modern Art*, London 1958. The book is still in print.

131 As the poet William Empson, who'd come to know him in Hampstead, protested in a letter to *The Times* (27 May 1962): 'Stanley Spencer when observed at a party made everyone else look fretful, because he radiated so much expansive contentment … All this stuff about how miserable he was seems absurd.'

132 John Bratby, 'Stanley Spencer's Early Self-Portrait', *Painters on Painting*, London 1969.

133 Once again, Jean Clair's *Les Realismes* must be cited as marking a key moment not only in Spencer's 'rehabilitation', but for that of all his figurative contemporaries. (See note 59.)

134 Hilton Kramer in the *New York Times*, 2 February 1980.

135 Charles Harrison, *English Art and Modernism 1900–39*, London 1981, pp.133–4. Speaking on *The Late Show* (19 March 1991) Harrison condemned Spencer for his 'moral immaturity … This is painting that has failed to grow up, failed to become modern'.

136 Merlin James. See note 119.

137 Anthony Gormley, foreword to Tate Gallery Liverpool 1992. Gormley wrote his Cambridge MA thesis on Spencer in the 1970s.

138 Red Grooms, conversation with the author, October 1998. Gladys Nilsson and Jim Nutt, conversation and e-mail with the author, October 2000.

139 The late Josef Herman spoke to me in 1980 of Spencer as an 'irreplaceable'.

**Notes pp.42–73
PATRICK WRIGHT**

1 Henry Slesser, 'The Return of Dogma', in *Religio Laici and other Essays and Addresses,* London 1927, p.101.

2 For a discussion of Charles Marriott's novel *Subsoil* (1913), see Lisa Tickner, *Modern Life and Modern Subjects*, London and New Haven 2000, p.98.

3 Charles Marriott, 'This Business, "Art"', in *Modern Art 1919*, London 1919, pp.12–13.

4 Charles Marriott's judgement of Burghclere appeared in *The Times,* 17 December 1932, and is here quoted from Keith Bell, *Stanley Spencer: A Complete Catalogue of the Paintings,* London 1992, p.88. Marriott would later describe Spencer as the inheritor of 'the Preraphaelite interest in the specific character of things' and as an artist 'gifted with an extraordinary intensity of vision combined with a complete disregard for plausibility.' See Charles Marriott, *A Key to Modern Painters,* London 1938, pp.135–6.

5 Quoted in Bell 1992, p.164.

6 Charles Marriott, 'Eric Gill as Carver' in J. Thorp, *Eric Gill,* London 1929, p.8.

7 Stanley Spencer quoted in Richard Carline, *Stanley Spencer at War,* London 1978, p.191.

8 Simon Schama, 'The Church of Me', *New Yorker,* 17 February 1997, p.57.

9 Samuel Hynes, *A War Imagined: The Great War and English Culture*, London 1990, p.460.

10 Carline 1978, p.185.

11 Ibid., p.184.

12 Letter to Florence, ibid., p.155.

13 Carline 1978, p.197.

14 Stanley Spencer, speaking to camera in John Read's film 1956 television film 'War and Peace'.

15 Geoffrey Hartman, 'Structuralism: the Anglo American Adventure' in *Beyond Formalism: Literary Essays, 1958-70*, London and New Haven, p.221.

16 Carline 1978, p.154.

17 Ibid., p.194.

18 Ibid., p.193.

19 Ibid., p.195.

20 Sue Malvern, 'Memorizing the Great War: Stanley Spencer at Burghclere', *Art History*, vol. 23, no.2, June 2000, pp.182–204.

21 Stanley Spencer, quoted in Bell 1992, p.52.

22 This passage is quoted from one of Spencer's notebooks (Tate Archive 733.3.28). See Malvern 2000, p.198.

23 Letter to Henry Lamb, 23 June 1930, Quoted in Carline 1978, p.197.

24 H. Collinson Owen, *Salonica and After: The Sideshow that Ended the War*, London 1919, p.52.

25 H.J. Massingham, *People and Things: An Attempt to Connect Art and Humanity*, London 1919, p.22.

26 Carline 1978, p.197.

27 Stanley Spencer speaking in the second of John Read's BBC television films 'Stanley Spencer 1956: 2 War and Peace', transmitted 20 June 1956.

28 Samuel Hynes, *A War Imagined: The First World War and English Culture*, London 1990, p.461.

29 George Behrend, *Stanley Spencer at Burghclere*, London 1965, pp.134–5.

30 'Yalding Bridges' in Edmund Blunden, *The Mind's Eye*, London 1934, p.175.

31 Mary Butts, 'Speed the Plough' in *Speed the Plough and Other Stories*, London 1923, p.16.

32 D.H. Lawrence's story 'The Blind Man', is collected in *The Complete Short Stories of D.H. Lawrence*, vol.2, London 1955, pp.347–65.

33 Quoted from 'On Preservation' (1931) in Blunden 1934, p.179.

34 For a fuller description of Massingham's post-war raising of the chalk downland see my *The Village that Died for England*, London 1995, pp.108–113. Massingham's most concentrated exposition of his theory appeared in his *Downland Man*, London 1926. See also *Fee, Fi, Fo, Fum: The Giants of England*, London 1921; *The Golden Age: The Story of Human Nature*, London 1927.

35 H.J. Massingham, *Remembrance: An Autobiography*, London 1942, p.40.

36 Ibid., p.3.

37 Massingham 1919, p.185.

38 Ibid., p.176.

39 H.J. Massingham, 'Maiden Castle: A Theory of Peace in Ancient Britain', *In Praise of England*, London 1924, pp.147–203.

40 Massingham 1926, p.245.

41 John Rothenstein, *Modern English Painters 2: Lewis to Moore*, London 1956, p.180.

42 Gilbert Spencer, *Stanley Spencer by his Brother Gilbert* (1961), Bristol 1991, p.147.

43 Behrend 1965, p.31.

44 Keith Pople, *Stanley Spencer*, London 1991, p.132.

45 Carline 1978, p.192.

46 Viscount Lymington's preference for the wooden ploughshare is recorded in Rolf Gardiner, *England Herself*, London 1943, p.135.

47 Carline 1978, p.190.

48 Pople 1991, p.76.

49 737.3.83.

50 William Morris, 'News From Nowhere', in *Three Works* by William Morris, London 1968, pp.347 and 332.

51 733.3.1.

52 Fenner Brockway and Frederic Mullally, *Death Pays a Dividend*, London 1944, p.2.

53 A photograph of this Roman arrow head lodged in an Ancient British spine appears as plate LVIII in R.E.M. Wheeler, *Maiden Castle, Dorset*, Oxford 1943. The object itself has long been a prominent exhibit at Dorset County Museum in Dorchester.

54 For an interesting account of Cookham as it appears to a present-day follower of William Morris, see John Payne, *Journey up the Thames: William Morris and Modern England*, Nottingham 2000, pp.98–122.

55 Pople 1991, p.490.

56 Carline 1978, p.49.

57 Stanley Spencer to Desmond Chute, June 1918, quoted in Carline 1978, p.97.

58 Gilbert Spencer 1991, p.154.

59 Stanley Spencer, notes dated 11 July 1942, 733.2.128.

60 Gilbert Spencer 1991, p.152.

61 For a description of this exhibition see 'Modern Drawings at Cambridge', *Cambridge Magazine*, 29 November 1919, p.114. Gilbert Spencer's *The Angels Appearing to the Shepherds* was reproduced in the *Cambridge Magazine*, 13 December 1919.

62 733.2.128.

63 Gilbert Spencer 1991, p.153.

64 Patricia Burstall, *The Golden Age of the Thames*, Newton Abbot 1981. Burstall dates this 'Golden Age' from around 1870 to 1914.

65 Burstall 1981, p.69.

66 See Grahame's article 'Loafing', first published in the *National Observer* in January 1891, reprinted in Kenneth Grahame, *Paths to the River Bank*, London 1983, pp.34–7.

67 See, for example, T.F. Powys, *Mr. Weston's Good Wine*, London 1928. For a discussion of Powys's unstable villages see my *The Village that Died for England*, pp.130–6.

68 Burstall 1981, p.117.

69 Ibid., p.140.

70 William Morris, 'News from Nowhere', in *Three Works*, London 1968, p.350.

71 Burstall 1981, p.115.

72 G. D. Leslie, ibid., p.121.

73 Burstall 1981, p.120.

74 Jerome K. Jerome, *Three Men in a Boat* (1889), London 1957, p.127.

75 733.3.1.

76 Spencer in the notebook page about the Cookham Resurrection acquired by Tate Archive in the studio sale, Christie's, 5 November 1998

77 733.2.128.

78 Stanley Spencer, letter to Henry Lamb, 19 September 1920, quoted in Carline 1978, p.125.

79 Bell 1992, p.55.

80 For Slesser's misgivings, which Spencer described in the first of John Read's 1956 television films, see Pople 1991, p.230.

81 The Rt. Hon. Sir Henry Slesser, *Judgement Reserved*, London 1941, p.243.

82 Ibid., p.28.

83 Henry H. Schloesser, letter in *The New Age*, 25 January 1908.

84 Henry H. Schloesser and Clement Game, *Machinery: Its Masters and its Servants*, Fabian Tract no.144, London 1909.

85 Slesser 1941, p.39.

86 Ibid., p.42.

87 Ibid., p.57.

88 Ibid., p.87.

89 H.J. Massingham, *People and Things*, 1919, p.103.

90 Ibid., p.5.

91 Slesser 1927, p.6.

92 Ibid., p.39.

93 Ibid., pp.40–1.

94 Ibid., pp.12–13.

95 Slesser 1941, p.126.

96 Henry Slesser, *The Nature of Being: An Essay in Ontology*, London 1919.

97 Sir Henry Slesser, letter to Lou Klepac (1975), quoted in Klepac, 'Perth's Great Spencer', *Bulletin 1979*, The Art Gallery of Western Australia, Perth, p.7.

98 H.J. Massingham, *Remembrance*, p.32.

99 Slesser 1927, p.5.

100 733.2.128.

101 Slesser 1941, p.21.

102 At one point in *The Nature of Being*, Slesser had described locality as 'the condition of obstructed effort' (p.208), a spiritual version of purblind parochialism, yet he also suggested that the essence of life was a matter of 'continued local existence' (p.175).

103 Slesser 1927, p.122.

104 'The Sacrament of Brotherhood' in Slesser 1927, p.29.

105 Wyndham Lewis, 'Round the London Art Galleries', *Listener*, 18 May 1950, p.879.

106 Slesser 1927, p.110.

107 Ibid., p.33.

108 'The Return of Dogma' in Slesser 1927, pp.98–9.

109 'The Perfection of the Church' in Slesser 1927, p.27.

110 TGA 733.3.82. Clarifying what he does believe in, Spencer writes: 'I believe in the inspiration of service from the Bible. I believe in Bach. I believe in Blake. And I believe in myself'.

111 Gilbert Spencer 1991, p.159.

112 Slesser 1941, p.269.

113 Lord Justice Slesser, *The Pastured Shire and other Poems*, Arrowsmith 1935, p.77.

114 Hilaire Belloc, *The Four Men: A Farrago* (1902), London 1971, p.308.

115 Hilaire Belloc, 'Thoughts about Modern Thought', *The New Age*, 7 December 1907, p.108.

116 G.K. Chesterton, 'On Wells and a Glass of Beer, *The New Age*, 25 January 1908, p.250.

117 G.K. Chesterton, 'Why I am not a Socialist', *The New Age*, 4 January 1908, p.190.

118 G.K. Chesterton, 'The Last of the Rationalists', *The New Age*, 29 February 1908, p.349.

119 G.K. Chesterton, *The Flying Inn* (1914) quoted from *A G.K. Chesterton Omnibus*, London 1932, p.589.

120 Ibid., p.434.

121 Ibid., p.537.

122 Ibid., p.492

123 Ibid., p.589.

124 Ibid., p.423.

125 Gilbert Spencer 1991, p.186.

126 John Rothenstein, *Modern English Painters 2: Lewis to Moore*, 1956, p.172.

127 G.K. Chesterton, *Heretics* (1905) in *The Collected Works of G.K. Chesterton*, vol.1, San Francisco 1986, pp.59–60.

128 Ibid., p.62.

129 John Flint, 'Who *Are* the English? A Plea for Scrapping National Humility', *John Bull*, 5 January 1918, p.6.

130 From the speech 'England; at the Annual Dinner of the Royal Society of St. George, at the Hotel Cecil, 6 May 1924', in Stanley Baldwin, *On England*, London 1926, p.7.

131 Perturbed by what he considered the 'abnormal growth of Jewish power', Hilaire Belloc was of the view that 'the new strength of Anti-Semitism is largely due to the Jews themselves'. See his *The Jews*, London 1922, p.159.

132 Slesser 1941, p.269.

133 Wyndham Lewis, 'Round the London Art Galleries', *Listener*, 18 May 1950, p.878.

134 733.2.128.

135 733.3.1.

136 Letter to Richard Carline 1929, quoted in Carline 1978, p.93.

137 Letter to Hilda Carline, 15 June 1922, in Carline 1978, p.131.

138 Roy K. Kiyooka's book of poems based on Spencer's work, *Nevertheless These Eyes* (1967), is collected in Roy Miki (ed.), *Pacific Windows: Collected Poems of Roy Kiyooka*, Vancouver 1997, pp.29–58.

139 Stanley Spencer, letter to Henry Lamb, 7 June 1921, in Carline 1978, pp.126–7.

140 Stanley Spencer's brother Gilbert provided four drawings for T.F. Powys's *Fables* (London 1929).

141 Pople 1991, p.246.

142 Bell 1992, p.59.

143 Stanley Spencer, letter to Hilda, 1924, quoted in Carline 1978, p.162.

144 Quoted from Jean Paul's 'Speech of the Dead Christ from the Universe that there is No God' in T.J. Casey (ed.), *Jean Paul: A Reader*, Baltimore and London 1992, pp.182–3.

145 Slesser 1927, pp.98–9.

SELECT BIBLIOGRAPHY

A comprehensive Spencer bibliography would now run into several thousand items. The one indispensable source is Keith Bell's monumental *Stanley Spencer: A Complete Catalogue of the Paintings* (London 1992). It assembles an extraordinary amount of information and the introductory text, condensed and factual, is also full of new material. It supersedes Bell's 1980 Royal Academy exhibition catalogue, but this includes a memoir by Richard Carline, and Andrew Causey's biographical analysis. The *Complete Catalogue* has now been republished, together with the colour plates, but without the *catalogue raisonné* (London 2000). For a brief overview of Spencer's life and work see Kitty Hauser, *Stanley Spencer*, in Tate Publishing's British Artists series (London 2001). See also Fiona MacCarthy's *Stanley Spencer: An English Vision* (exh. cat., British Council 1998); like Bell, it does not cover the drawings; and Duncan Robinson, *Stanley Spencer*, London 1980. Further relevant materials are cited in the Notes, pp.254–6.

SPENCER'S WRITINGS

A new anthology from the Tate's vast Spencer archive, *Stanley Spencer: Letters and Writings* has been selected by Adrian Glew (London 2001). Two key sources are *Stanley Spencer at War* (London 1978) by the artist's brother-in-law Richard Carline; and *Stanley Spencer the Man: Correspondence and Reminiscences* edited by John Rothenstein (London 1979). Further interesting and previously unpublished writing was selected by Judith Nesbitt for *Stanley Spencer: A Sort of Heaven* (exh cat., Tate Liverpool 1993).

BIOGRAPHY

Kenneth Pople's *Stanley Spencer* (London 1991) is a detailed and rewarding account by an author from outside the art world – risky, but always generous spirited and courageous. The pioneering biography by Maurice Collis (London 1962) quotes extensively from the artist's previously unknown writings and remains a compelling book. In 1972 Louise Collis, Maurice's daughter, ghosted Patricia Preece's unreliable account *A Private View of Stanley Spencer*. There is a moving evocation of the artist's childhood in *Stanley Spencer by His Brother Gilbert* (London 1961, reprinted Bristol 1991), and Gilbert Spencer's later *Memoirs of a Painter* (London 1974) also has vivid glimpses of Stanley. John Rothenstein wrote well on Spencer in the three volumes of his *Autobiography* (London 1966–70), and in *Modern English Painters* (London 1976). Alison Thomas's *The Art of Hilda Carline* (Lincoln 1999) throws much oblique light on Spencer. Two forthcoming biographies, Michael Dickens's study of the Preece-Hepworth ménage, and Frances Spalding's book on Gwen Raverat, should be revelatory. Keith Clements's biography of *Henry Lamb* (Bristol 1985) has a long section on his relation to Spencer. For Spencer's pre-war context, see David Fraser Jenkins, 'Slade School Symbolism' in *The Last Romantics*, exh. cat., Barbican Art Gallery 1989.

STUDIES OF SPECIFIC WORKS

Carolyn Leder's *Stanley Spencer: The Astor Collection* (London 1976) reproduces all the *Scrapbook Drawings*, with helpful introduction and notes. On Burghclere Chapel, the best and most recent studies are Duncan Robinson's *Stanley Spencer at Burghclere* (National Trust 1991) and Sue Malvern, 'Memorising the Great War', *Art History*, vol.23, no.2, June 2000, pp.182–204. For the Church-House, see *Stanley Spencer: The Apotheosis of Love* (exh. cat., Barbican Art Gallery 1991) with essays by Jane Alison and Timothy Hyman, and some well-chosen extracts from Spencer's writings. The Art Gallery of Western Australia, Perth has published a useful small monograph on the *Christ in the Wilderness* series. *Spencer in the Shipyards* (exh. cat., Arts Council 1981) includes some fine photographs by Cecil Beaton, while unrivalled fold-out plates of the shipbuilding paintings appear in *Men of the Clyde: Stanley Spencer's Vision at Port Glasgow* (exh.cat., Scottish National Portrait Gallery 2000). R.H. Wilenski, author of the first Spencer monograph *Stanley Spencer* (London 1924), also compiled a small study with notes by the artist: *Stanley Spencer: The Resurrection Pictures* (London 1951). For a fascinating assembly of Spencer's working drawings (and a good interview with the artist's daughters) see the catalogue of the Stanley Spencer studio sale (Christies, London, 5 November 1998).

SHORT REFERENCES

The following references are used in the catalogue entries:

Bell 1992: Keith Bell, *Stanley Spencer: A Complete Catalogue of the Paintings*, London 1992

Carline 1978: Richard Carline, *Stanley Spencer at War*, London 1978

Chamot, Farr and Butlin 1964: Mary Chamot, Dennis Farr and Martin Butlin, *Tate Gallery Catalogues: The Modern British Paintings, Drawings and Sculpture*, London 1964

Hassall 1959: Christopher Hassall, *Edward Marsh*, London 1959

Pople 1991: Kenneth Pople, *Stanley Spencer*, London 1991

RA 1980: *Stanley Spencer*, exh. cat., Royal Academy, London 1980

Robinson 1979: Duncan Robinson, *Stanley Spencer: Visions from a Berkshire Village*, London 1979

Rothenstein 1962: John Rothenstein, *British Art Since 1900*, Oxford and London 1962

Wilenski 1950: R.H. Wilenski, *Stanley Spencer: The Resurrection Pictures, 1945-50*, London 1951.

References beginning 733 are to Spencer's papers in the Tate Archive.

LENDERS
AND CREDITS

PRIVATE COLLECTORS

Private Collections: 4, 6, 11, 21, 22, 33, 34, 36, 40, 42, 51, 64, 65, 71, 72, 73, 75, 79, 87, 90, 93, 110, 112

Private Collecton, courtesy of Austin Desmond Fine Art 28

David Bowie 24

Private Collection; courtesy of Ivor Braka Ltd, London 54, 69

Thomas H. Gibson 89

David Inshaw 62

Lord and Lady Irvine 2, 10, 12

Lord Lloyd-Webber 68

The Sir Andrew Lloyd Webber Foundation 41

Private Collection – Courtesy of Massimo Martino Fine Arts & Projects, Mendrisio 85, 91, 92, 107

Private Collection Australia, courtesy of Richard Nagy, Dover Street Gallery, London 113,114

Private Collector, courtesy of Alex Reid & Lefevre 63

J.M.R Saunders Watson, Rockingham Castle 81

Spink Leger, London 25

Private Collection, on loan to the Stanley Spencer Gallery 74, 76, 77, 88, 106

Mrs Shirley Taliano, Canada 70

Thyssen-Bornemisza Collection, Lugano 109

PUBLIC COLLECTIONS

Aberdeen Art Gallery 30

Art Gallery of New South Wales, Sydney 105

Art Gallery of Ontario, Toronto 43

Art Gallery of Western Australia, Perth 94, 95, 96

Ashmolean Museum, Oxford 67

Bradford Art Galleries and Museums 48

Carrick Hill Trust, Adelaide, South Australia 46

Dunedin Public Art Gallery, New Zealand 108

Ferens Art Gallery, Kingston Upon Hull 53

Fitzwilliam Museum, Cambridge 55, 82

Imperial War Museum, London 19, 20, 21, 97, 98, 99, 100, 101, 102, 103

Laing Art Gallery, Newcastle Upon Tyne 78

Leamington Spa Art Gallery and Museum 47

Leeds City Art Gallery 44, 60

Leicester City Museums 80

Manchester City Art Gallery 45, 86

Museum of Contemporary Art, Chicago 111

Museum of Modern Art, New York 84

Sheffield Galleries and Museums Trust 61

Scottish National Gallery of Modern Art, Edinburgh 49

Southampton City Art Gallery 52, 104

Stanley Spencer Gallery, Cookham 1, 66

Stedelijk Museum, Amsterdam 59

Tullie House Museum and Art Gallery, Carlisle 16

Ulster Museum 32

College Art collection, University College London 7

Whitworth Art Gallery, University of Manchester 37

COPYRIGHT CREDITS

All works by Stanley Spencer are © DACS, London 2001, except for: no.35 © Tate; nos.54, 104 © Southampton City Art Gallery

Hilda Carline © DACS, London 2001

Maurice Denis © AGADP, Paris and DACS, London 2001

Otto Dix © VG Bild-Kunst, Bonn and DACS, London 2001

Mark Gertler © Estate of the Artist

Dorothy Hepworth © DACS, London 2001

Henry Lamb © Tate 2001

Paul Nash © Tate 2001

John Nash © Estate of the Artist

Diego Rivera © Banco de México, Diego Rivera & Frida Kahlo Museums Trust, Mexico City

William Roberts © Estate of the Artist

Christian Schad © DACS, London 2001

All illustrations in the Chronology are © Estate of Stanley Spencer, with the exception of fig.67 which is © Estate of Dorothy Hepworth

PHOTOGRAPHIC CREDITS

FIGURE ILLUSTRATIONS

Ashmolean Museum, Oxford/ Bridgeman Art Library 4; Gisbert Bauer 22; Paula Bray for Art Gallery Gallery of New South Wales 42; Bridgeman Art Library 2, 18; Museum of Fine Arts, Budapest, Hungary/ Bridgeman Art Library 20; Henry Chow, Centre for Advanced Study of Architecture at the University of Bath 60; David Clarke, Tate Photography 61; Detroit Institute of Arts, USA/ Bridgeman Art Library 26; The Fine Art Society plc, 7; Kröller-Müller, Otterlo, The Netherlands 1; Peter Nahum at The Leicester Galleries 9; Tate Gallery Archive/ Tate Photography/ Rodney Tidman 21; Tate Photography 6, 8, 10, 11, 19, 41; National Trust Photo Library/ Roy Fox and AC Cooper 28–31, 35–7, 55–9; Neidersachsische Landesmuseum, Hanover, Germany/ Bridgeman Art Library 16; Newport Museum and Art Gallery/ Bridgeman Art Library 49; Art Gallery of Western Australia, Perth 46b; Stanley Spencer Gallery, Cookham 39, 45; Stanley Spencer Gallery, Cookham/ Bridgeman Art Library 46a, 46c; Victoria and Albert Museum/ Bridgeman Art Library 3

CATALOGUE ILLUSTRATIONS

Aberdeen Art Gallery and Museums
Ashmolean Museum, Oxford
Barbican Art Gallery
Bradford Art Galleries and Museums/ Bridgeman Art Library
Ivor Braka Ltd, London
The British Council
Carrick Hill Trust, Adelaide, South Australia
Jenni Carter for Art Gallery of New South Wales
Carlo Catenazzi, Toronto
Kate Chertavian Fine Art
Museum of Contemporary Art, Chicago
Christie's Images Ltd.
The Cotswold Studio, Oxford
Prudence Cuming Associates Ltd
Dunedin Public Art Gallery
Studio Edmark, Oxford
Ferens Art Gallery, Kingston upon Hull City Museums and Art Galleries/ Bridgeman Art Library
Fitzwilliam Museum, Cambridge
Imperial War Museum, London
Leamington Spa Art Gallery and Museum/ Bridgeman Art Library
Leeds Museums and Galleries (City Art Gallery)/ Bridgeman Art Library
The Lefevre Gallery, London
College Art Collection, University College London
MacConnal-Mason Gallery, London
Manchester City Art Galleries
Massimo Martino Fine Arts & Projects, Mendrisio, Switzerland
Museum of Modern Art, New York
Museums and Galleries of Northern Ireland
New Walk Museum, Leicester City Museum Service/ Bridgeman Art Library
Art Gallery of Western Australia, Perth
Phaidon Press Ltd
P.J.Graphics Ltd
Glen Reichwein, Art Gallery of Ontario, Toronto
Scottish National Gallery of Modern Art, Edinburgh
Sheffield Galleries and Museums Trust/ Bridgeman Art Library
Southampton City Art Gallery/ Bridgeman Art Library
Spink-Leger, London
Stanley Spencer Gallery, Cookham/ Bridgeman Art Library
Stedelijk Museum, Amsterdam
Tate Photography/ Andrew Dunkley, Marcus Leith and David Lambert
Fondazione Thyssen-Bornemisza, Switzerland
Tullie House Museum and Art Gallery, Carlisle
Tyne and Wear Museums
The Whitworth Art Gallery, The University of Manchester

INDEX

SUPPORTING TATE

Tate relies on a large number of supporters – individuals, foundations, companies and public sector sources – to enable it to deliver its programme of activities both on and off its gallery sites. This support is essential in order to acquire works of art for the Collection, present education, outreach and exhibition programmes, care for the Collection in storage and enable art to be displayed, both digitally and physically, inside and outside Tate.

Your funding will make a real difference and enable others to enjoy Tate and its Collections, both now and in the future. There are a variety of ways in which you can help support Tate and also benefit as a UK or US taxpayer. Please contact us at:

The Development Office
Tate, Millbank, London SW1P 4RG
Telephone: 020 7887 8000
Facsimile: 020 7887 8738

American Fund for the Tate Gallery
1285 Avenue of the Americas (35th fl)
New York
NY 10019
Telephone: 001 212 713 8497
Facsimile: 001 212 713 8655

DONATIONS

Donations, of whatever size, from individuals, companies and trusts are welcome, either to support particular areas of interest, or to contribute to general running costs.

Gifts of Shares
Since April 2000 we are able to accept gifts of quoted shares and securities. These are not subject to capital gains tax. For further information please contact the Campaigns Section of the Development Office.

Gift Aid
Through Gift Aid, you are able to provide significant additional revenue to Tate for gifts of any size, whether regular or one-off, since we can claim back the tax on your charitable donation. Higher rate tax payers are also able to claim additional personal tax relief. A Gift-Aid Donation form and explanatory leaflet can be sent to you if you require further information.

Legacies and Bequests
Bequests to Tate may take the form of either a specific cash sum, a residual proportion of your estate or a specific item of property such as a work of art. Tax advantages may be obtained by making a legacy in favour of Tate; in addition, if you own a work of art of national importance you may wish to leave it as a direct bequest or to the Government in lieu of tax. Please check with Tate when you draw up your will that it is able to accept your bequest.

American Fund for the Tate Gallery
The American Fund for the Tate Gallery was formed in 1986 to facilitate gifts of works of art, donations and bequests to Tate from United States residents. It receives full tax exempt status from the IRS.

MEMBERSHIP PROGRAMMES

Members and Fellows
Individual members join Tate to help provide support for acquisitions for the Collection and a variety of other activities, including education resources, capital initiatives and sponsorship of special exhibitions. Benefits vary according to level of membership. Membership costs start at £24 for the basic package with benefits varying according to level of membership. There are special packages for supporters of Tate Liverpool and Tate St Ives.

Patrons
Patrons are people who share a keen interest in art and are committed to giving significant financial support to Tate on an annual basis, specifically to support acquisitions. There are four levels of Patron: Associate Patron (£250), Patrons of New Art (£500), Patrons of British Art (£500) and Patrons Circle (£1000). Patrons enjoy opportunities to sit on acquisition committees, special access to the Collection and entry with a family member to all Tate exhibitions.

Tate American Patrons
Residents of the United States who wish to support Tate on an annual basis can join the American Patrons and enjoy membership benefits and events in the United States and United Kingdom. Single membership costs $1000 and double membership $1500. Please contact the American Fund for the Tate Gallery for further details.

Corporate Membership
Corporate Membership at Tate Liverpool and Tate Britain, and support for the Business Circle at Tate St Ives, offers companies opportunities for exclusive corporate entertaining and the chance for a wide variety of employee benefits. These include special private views, free admission to paying exhibitions, out-of-hours visits and tours, invitations to VIP events and talks at the workplace. Tate Britain is only available for entertaining by companies who are either Corporate members or current Gallery sponsors.

Founding Corporate Partners
Until the end of March 2003, companies are also able to join the special Founding Corporate Partners Scheme which offers unique access to corporate entertaining and benefits at Tate Modern and Tate Britain in London. Further details are available on request.

Corporate Investment
Tate has developed a range of imaginative partnerships with the corporate sector, ranging from international interpretation and exhibition programmes to local outreach and staff development programmes. We are particularly known for high-profile business to business marketing initiatives and employee benefit packages. Please contact the Corporate Fundraising team for futher details.

Charity Details
Tate is an exempt charity; the Museums & Galleries Act 1992 added the Tate Gallery to the list of exempt charities defined in the 1960 Charities Act. The Friends of the Tate Gallery is a registered charity (number 313021). The Tate Gallery Foundation is a registered charity (number 295549).

Tate Britain Corporate Members

PARTNER LEVEL

BP
Merrill Lynch
Prudential plc

ASSOCIATE LEVEL

Cantor Fitzgerald
Credit Suisse First Boston
Drivers Jonas
Freshfields Bruckhaus Deringer
Global Asset Management
Honda (UK)
Hugo Boss
Lazard
Linklaters
Morgan Stanley Dean Witter
Nomura International plc
Robert Fleming Holdings Ltd
Simmons & Simmons
The EMI Group
Tishman Speyer Properties
UBS AG

Founding Corporate Partners

AMP
Avaya UK
BNP Paribas
CGNU plc
Clifford Chance
Dresdner Kleinwort
 Wasserstein
Energis Communications
Freshfields Bruckhaus Deringer
GLG Partners
Goldman Sachs International
Lazard
Lehman Brothers
London & Cambridge
 Properties Limited
London Electricity plc, EDF
 Group
PaineWebber
Pearson plc
Prudential plc
Railtrack PLC
Reuters
Rolls-Royce plc
Schroders
UBS Warburg
Whitehead Mann GKR

Tate Britain Founding Sponsors

BP
Campaign for the Creation of
 Tate Britain (1998–2000)
Displays from the Collection
 (1990–2002)
Tate Britain Launch (2000)

Ernst & Young
Cézanne (1996)
Bonnard (1998)

Tate Britain Benefactor Sponsors

Channel 4
The Turner Prize (1991–2001)

Prudential plc
Grand Tour (1996)
The Age of Rossetti, Burne-Jones
 and Watts: Symbolism in
 Britain 1860–1910 (1997)
The Art of Bloomsbury (1999)
Stanley Spencer (2001)

Tate Britain Major Sponsors

Aon Risk Services Ltd
in association with ITT
London & Edinburgh
In Celebration: The Art of
 the Country
House (1998)

Glaxo Wellcome plc
Turner on the Seine (1999)
William Blake (2000)

Magnox Electric
Turner and the Scientists (1998)

Morgan Stanley Dean Witter
Constructing Identities (1998)
John Singer Sargent (1998)
Visual Paths: Teaching Literacy in
 the Gallery (1999–2002)

Sun Life and Provincial
Holdings plc
Ruskin, Turner & the
 Pre-Raphaelites (2000)

Tate & Lyle PLC
Tate Friends (1991–2000)

Tate Britain Sponsors

AT&T
Piet Mondrian (1997)

BT
Tate Britain Launch (2000)

The Guardian/The Observer
Jackson Pollock (1999)
Media Sponsor for the Tate 2000
 launch (2000)

Hiscox plc
Tate Britain Members' Room
 (1995–2001)

Reuters
Art Now: Art and Money Online
 (2001)

Rowe & Maw
Turner's Gallery, House and Library
 (2001)

Tate Britain: Donors to the Centenary Development Capital Campaign

FOUNDER

The Heritage Lottery Fund

FOUNDING BENEFACTORS

Sir Harry and Lady Djanogly
The Kresge Foundation
Sir Edwin and Lady Manton
Lord and Lady Sainsbury of
 Preston Candover
The Wolfson Foundation

MAJOR DONORS

The Annenberg Foundation
Ron Beller and Jennifer Moses
Alex and Angela Bernstein
Ivor Braka
The Clore Duffield Foundation
Maurice and Janet Dwek
Bob and Kate Gavron
Sir Paul Getty KBE
Mr and Mrs Karpidas
Peter and Maria Kellner
Catherine and Pierre Lagrange
Ruth and Stuart Lipton
William A. Palmer
John and Jill Ritblat
Barrie and Emmanuel Roman
Charlotte Stevenson
Tate Gallery Centenary Gala
The Trusthouse Charitable
 Foundation
David and Emma Verey
Clodagh and Leslie Waddington
Sam Whitbread

DONORS

The Asprey Family Charitable
 Foundation
The Charlotte Bonham Carter
 Charitable Trust
Giles and Sonia Coode-Adams
Thomas Dane
The D'Oyly Carte Charitable Trust
The Dulverton Trust
Friends of the Tate Gallery
Alan Gibbs
Mr and Mrs Edward Gilhuly
Helyn and Ralph Goldenberg
Pehr and Christina Gyllenhammar
Jay Jopling
Howard and Linda Karshan
Anders and Ulla Ljungh
Lloyds TSB Foundation for England
 and Wales
David and Pauline Mann-
 Vogelpoel
Sir Peter and Lady Osborne
Mr Frederick Paulsen
The Pet Shop Boys
The P F Charitable Trust
The Polizzi Charitable Trust
Mrs Coral Samuel CBE
David and Sophie Shalit
Mr and Mrs Sven Skarendahl
Pauline Denyer-Smith and
 Paul Smith
Mr and Mrs Nicholas Stanley
The Jack Steinberg Charitable
 Trust
Carter and Mary Thacher
Dinah Verey
Gordon D. Watson
The Duke of Westminster
 OBE TD DL
Mr and Mrs Stephen Wilberding
Michael S. Wilson
and those donors who wish to
 remain anonymous

Tate Collection

FOUNDERS

Sir Henry Tate
Sir Joseph Duveen
Lord Duveen
The Clore Duffield Foundation

BENEFACTORS

American Fund for the Tate
 Gallery
Gilbert and Janet de Botton
The Friends of the Tate Gallery
The Heritage Lottery Fund
National Art Collections Fund
National Heritage Memorial Fund
The Patrons of British Art
The Patrons of New Art

MAJOR DONOR

Robert Lehman Foundation, Inc.

DONORS

Howard and Roberta Ahmanson
Lord and Lady Attenborough
Mr Tom Bendhem
Robert Borgerhoff Mulder
The British Council
Neville and Marlene Burston
Mrs John Chandris
The Clothworkers Foundation
Edwin C Cohen
The Daiwa Anglo-Japanese
 Foundation
Judith and Kenneth Dayton
Foundation for Sport and the Arts
Mr Christopher Foley
The Gapper Charitable Trust
The Gertz Foundation
Great Britain Sasakawa
 Foundation
HSBC Artscard
Sir Joseph Hotung
Mr and Mrs Michael Hue-Williams
The Idlewild Trust
The Japan Foundation
The Kessler Family Re-Union
Mr Patrick Koerfer
The Henry Moore Foundation
The Leverhulme Trust
Peter and Eileen Norton,
 The Peter Norton Foundation
Mr David Posnett
The Radcliffe Trust
The Rayne Foundation
Mr Simon Robertson
Lord and Lady Rothschild
Mrs Jean Sainsbury
Scouloudi Foundation
Stanley Foundation Limited
Mr and Mrs A Alfred Taubman
The Vandervell Foundation
Mr and Mrs Leslie Waddington
and those donors who wish to
 remain anonymous

SPONSOR

Carillion plc
Paintings Conservation
 (1995–2000)

Tate Britain Donors

MAJOR DONORS

Bowland Charitable Trust
Mr and Mrs James Brice
Robert Lehman Foundation, Inc.
The Henry Luce Foundation
The Henry Moore Foundation

DONORS

Howard and Roberta Ahmanson
David and Janice Blackburn
Cadogan Charity
Ricki and Robert Conway
The Elephant Trust
The Hedley Foundation
Robert Holden Ltd
John Lyons Charity
Kiers Foundation
The Kirby Laing Foundation
Leche Trust
London Arts
The Paul Mellon Centre
Sally and Anthony Salz
and those donors who wish to
 remain anonymous